Lasting Impressions

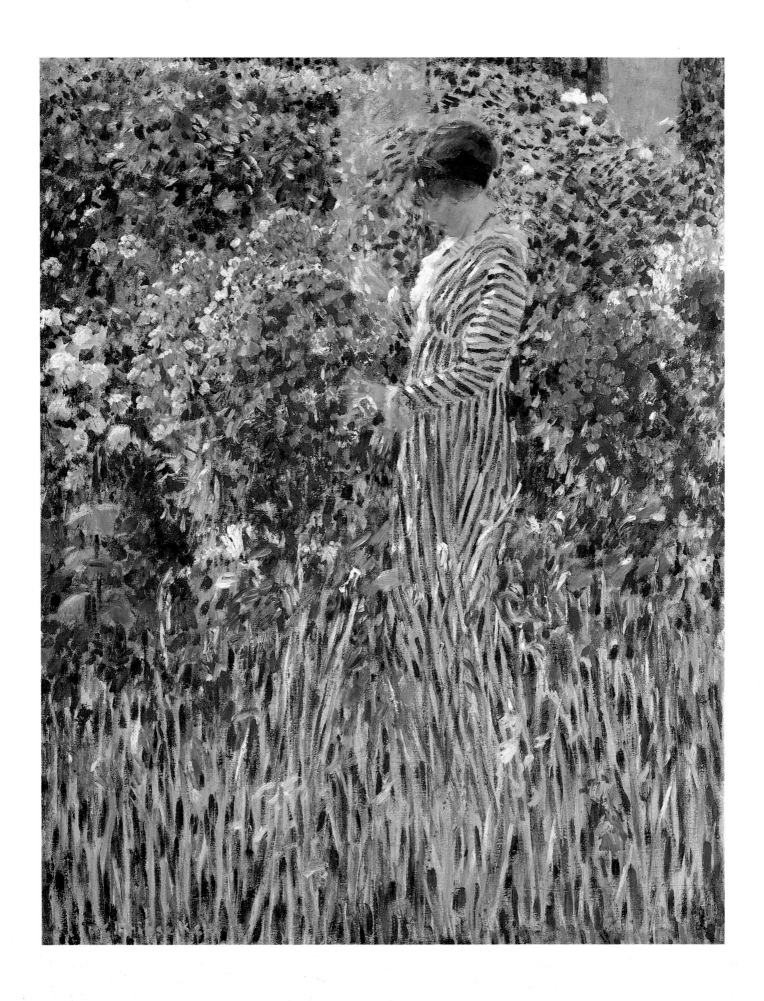

MUSÉE AMÉRICAIN *Giverny*

Lasting Impressions

AMERICAN PAINTERS IN FRANCE
1865–1915

ACKNOWLEDGMENTS BY Daniel J. Terra and Judith Terra
FOREWORD BY Hélène Ahrweiler
PREFACE BY Roger Mandle
INTRODUCTION BY D. Scott Atkinson

ESSAY BY WILLIAM H. GERDTS

COMMENTARIES BY D. Scott Atkinson, Carole L. Shelby, and Jochen Wierich

Published by
Terra Foundation for the Arts

Published on the occasion of the inaugural exhibition,
Lasting Impressions: American Painters in France, 1865–1915, at the
MUSÉE AMÉRICAIN *Giverny* , Giverny, France, June I–November I, 1992.

MUSÉE AMÉRICAIN *Giverny* has been developed and funded by the
Terra Foundation for the Arts

Senior Consulting Curator, MUSÉE AMÉRICAIN *Giverny* : Claire Joyes
Curator of the exhibition: D. Scott Atkinson
Editor: Virginia Wageman
Designer: Nai Chang
Production Coordinator: Michele Archambault
Translators for the French edition: Nadine Fugier, Claire Joyes,
Jacqueline Niemtzow, and Yvonne Weisberg

Printed in Italy by Arnoldo Mondadori Editore, S.p.A.

Jacket: Theodore Robinson, *The Wedding March,* 1892 (colorplate 6)
Frontispiece: Frederick Frieseke, *Lady in a Garden,* c. 1912 (colorplate 36)

Published by Terra Foundation for the Arts,
3009 Central Street, Evanston, Illinois 60201

Library of Congress Cataloguing-in-Publication Data

Lasting impressions : American painters in France, 1865–1915 / preface by Roger
Mandle ; essay by William H. Gerdts ; introduction by D. Scott Atkinson ;
commentaries by D. Scott Atkinson, Carole L. Shelby, and Jochen Wierich.
 p. cm.
 "Published on the occasion of the inaugural exhibition . . . at the Musée
américain Giverny, Gasny, France, June I–November I 1992"—
 Includes bibliographical references and index.
 ISBN 0-932171-05-2 (English ed.)
 I. Painting, American—French influences—Exhibitions. 2. Painting,
Modern—19th century—United States—Exhibitions. 3. Painting,
Modern—20th century—United States—Exhibitions. 4. Artist colonies—
France—Influence—Exhibitions. 5. Expatriate painters—France—
Exhibitions. 6. Painters—United States—Exhibitions. I. Gerdts, William
H. II. Atkinson, D. Scott, 1953– . III. Shelby, Carole L. IV. Wierich,
Jochen. V. Musée américain Giverny.
ND210L38 1992
759.13'0944'0934—dc20
 92-8951
 CIP

ISBN 0-932171-05-2 (English edition)
ISBN 0-932171-06-0 (French edition)

CONTENTS

ACKNOWLEDGMENTS

Opening a new museum is a most complex undertaking. In the past six years many important persons have been involved in the development of Musée Américain *Giverny*. In addition to recognizing the entire staff of Terra Museum of American Art, Chicago, and of Musée Américain *Giverny*, we wish to acknowledge the following organizations and persons who have assisted us. We are deeply grateful for their help and encouragement.

Robert McC. Adams, for his outstanding support

Hélène Ahrweiler, for her superb support and inspiration

Jacques Ahrweiler, for his never ending help

Ambassador and Mrs. Jacques Andreani, for their advice and inspiration

Bennett and Margaret Archambault, for their constant interest and help

Michele Archambault, for her thoroughness in printing and production

Richard Arndt, for his assistance

The Art Institute of Chicago, lender to the exhibition

D. Scott Atkinson, for his curatorial involvement

Dominique Aupierre, for her understanding

Patrick and Estelle Baeyens, for their early efforts

Bernard Berche, for his constant interest and patience

Jean Bergaust, for her untiring and effective efforts

Laurence Booth, for his architectural help

Arnaud and Alexandra de Borchgrave, for their support

Jean-Pierre Brabant, for his understanding

Grace Brown, for her long-standing help

Didier Brunner, for his general assistance

David Bull, for his conservational help

Barbara Bush, for her support

Tom and Rita Bush, for their general travel advice

Nai Chang, for the design of publication material

William and Joan Clark, for the constancy of their belief

Henri Collard, for his understanding

James and Laura Collins, for their assistance

The Corcoran Gallery of Art, Washington, D.C., lender to the exhibition

Mayalène Crossley, for all her help

Ambassador and Mrs. Walter J. P. Curley, for their unwavering support

Robert Donnelley, for his faith and advice

Quentin Donoghue, for his work with the tourist industry

Guy Dupiech, for his understanding

Jan DuPlain, for her help with press and publicity

Walter and Marion Farabee, for their early Giverny efforts

John Fisher, for his printing advice

Caterine Fournier, for architectural help

Armand and Mania Frydman, for their patience and support

Geneviève Garment, for her cooperation and understanding

William H. Gerdts, author of the text

Richard Graham, preparator of the exhibition

Michel Guenaire, for professional help

Carol Hallett, for her help and understanding

Clyde Hamm, for his all-around assistance

Ambassador and Mrs. Arthur Hartman, for their interest

Tim Hendron, for engineering advice

Jacques Henrot, for legal interpretations

James Hill, for advice and help

Jayne Johnson, registrar of the exhibition

Claire Joyes, for her knowledge and assistance

Roberta Gray Katz, for her work in education

Gerald and Florence van der Kemp, for their achievements and advice

Jerry Kobylecky, for his understanding

Robert Korengold, for his cultural advice

Marcel Landovsky for his enthusiasm and support

David Levy, for his support

Claudette Lindsey, for her help

Marceau Long, for his constant and enthusiastic efforts

Dennis Loy, for his support

Charles H. MacNider Museum, Mason City, Iowa, lender to the exhibition

Dominique Mallet, for his support

Roger Mandle, for his writing and understanding

Richard Manoogian, for his early support

The late Ambassador and Mrs. Emmanuel de Margerie, for their constant faith and encouragement

Thierry Masnou, for his understanding

Jean-Marie Masson, for his understanding

Michel Mathieu, for his patience and understanding

Arnoldo Mondadori Editore, S.p.A., printer of this publication

Martha Moss, for her help on many fronts

Musée des Beaux-Arts de Brest, lender to the exhibition

Musée des Beaux-Arts de Rennes, lender to the exhibition

Musée d'Orsay, Paris, lender to the exhibition

Musée Municipal A.-G. Poulain, Vernon, lender to the exhibition

Museum of Fine Arts, Boston, lender to the exhibition

Gerard Nicolas, for his architectural advice

Jacqueline Niemtzow, for her work in translation

Harold P. O'Connell, for his assistance

Sandra Day O'Connor, for her advice and counsel

Abraham Oren, construction supervisor

Vicki Patrick, for her general devotion and assistance

Isabelle Pineau, for her work with the press

Meyer and Vivian Potamkin, for their constant support

Philippe Robert, for his architectural skills

Ambassador and Mrs. Joe M. Rodgers, for their support

Anne Rosier, for her enlightening observations

Brigitte Rubon, for her understanding

Mark Rudkin, for his design of the museum garden

Michel Sallois, for his support

David Sellin, for his advice

Carole L. Shelby, for her general efforts

Leonard and Elaine Silverstein, for their advice and interest

Daniel J. Terra Collection, lender to the exhibition

James D. and Laura Terra, for their loyalty and support

Terra Foundation for the Arts, lender to the exhibition

Jean-Marie Toulgouat, for his inspiration and encouragement

Union League Club of Chicago, lender to the exhibition

University of Kentucky Art Museum, Lexington, lender to the exhibition

David Vallese, for his advice

Virginia Wageman, for editing the publication material

Stephen Weil, for early inspirational advice

Jochen Wierich, for his help on the publication

Alexander Wood Prince, for his photographic efforts

William and Eleanor Wood Prince, for their faith and support

There are countless others not mentioned above, to whom we also express our gratitude.

Daniel J. Terra and Judith Terra
Founders
MUSÉE AMÉRICAIN *Giverny*

FOREWORD

The flamboyant Daniel J. Terra, U.S. Ambassador-at-Large for Cultural Affairs from 1981 to 1989, and his wife, Judith, have founded the Musée Américain Giverny as a tribute from America to the art of France and to the historic encounter between Impressionism and a great many American artists.

Ambassador Terra is the grandson of an Italian lithographer who emigrated to the United States. A printer himself as well as a chemical engineer, he received training in several other fields, including music (he was a dancer and a singer), before making his fortune with a special patent for quick-drying printing inks. He then became an avid and astute collector of American art. Can one be more American and at the same time more European than Daniel Terra? He is a self-made American, who is by tradition European.

The exhibition that in 1987 opened the Terra Museum of American Art on North Michigan Avenue in Chicago was titled "A Proud Heritage." The inaugural exhibition of the Musée Américain Giverny, which, it seems to me, is a statement of gratitude to France, might have been named "Proud Heirs." For most of the works presented for the inauguration of the museum at Giverny, which is located on the rue Claude Monet, close to the gardens of the father of Impressionism, were painted by American artists in the French countryside.

Early painters in America especially captured the image of man and nature in their new country. For the young American painters in France in the last third of the nineteenth century, Impressionism was a new experience and offered a new perspective on life. Ecology, which was to flourish a century later, perhaps was born from this new outlook: nature's innumerable changes became the principal subject. In his new museum, Daniel Terra has successfully integrated the architecture of the building into the surrounding landscape of Giverny, which Monet painted for more than forty years. The Musée Américain Giverny was built just a few yards from the house of Lilla Cabot Perry, the painter from Boston who was a friend and neighbor of Monet for many years, sharing his passion for gardens and encouraging American artists to come and live at Giverny.

It was at Giverny and several other special places that the break with the art establishment took place and where those "colorful vibrations," according to Jules Laforgue's beautiful definition of Impressionism, were born. It was a momentary, precarious, ephemeral, and transforming art. Modern art began here.

The poet Paul Valéry, nephew of the artist Berthe Morisot, writing in the manner of the Impressionists, said: "Time sparkles and the Dream is knowledge." From a dream, Daniel Terra has created a museum.

Hélène Ahrweiler
Recteur
Université de l'Europe

PREFACE

The idea is simple, bold, and generous: to create a museum that celebrates American artistic achievement at Giverny, one of the places in France most known for inspiring American artists, and thereby to pay homage to Claude Monet, the famous French Impressionist whose presence drew American artists in droves to the tiny village of Giverny. The idea could only come to a collector of American art of the era so influenced by this man and this place. Daniel J. Terra, U.S. Ambassador-at-Large for Cultural Affairs from 1981 to 1989, avid collector of American art, and passionate world traveler, came to delight in the same verdant qualities of the land and the special light around Giverny that had so attracted the great French artist. There, over thirty years ago, the Ambassador was captivated by the echoes of such artists as Theodore Robinson, Willard Metcalf, John Leslie Breck, Theodore Butler, Frederick Frieseke, and Lilla Cabot Perry, who among hundreds of aspiring American artists had made their way to Giverny, hoping to meet with and learn from Monet, and had established an artists' colony around him. Lilla Cabot Perry was a particular friend of Monet and promoted his work in her hometown of Boston.

It was to Perry's house and garden at Giverny, next door to Monet's, that Terra was especially attracted. On the very night of the opening of his museum of American art in Chicago, he learned that Perry's house was available to purchase and immediately made arrangements to acquire the property. Originally intending to restore the house and grounds as a place celebrating Perry's and Monet's friendship, and as a small gallery to exhibit the work of some of the American painters who had been so inspired by Giverny, the Ambassador went on to build a splendid small museum near the house. This museum gives the opportunity for a new understanding by the many thousands of visitors to Giverny of the power of the light and the textures of the landscape that were to influence a generation of American artists. Monet's admonition to "paint what you really see, not what you think you ought to see; not the object as isolated in a test tube, but the object enveloped in sunlight and atmosphere, with the blue dome of Heaven reflected in the shadows," is reflected in the works of the American artists now displayed at Giverny.

The goals of the Musée Américain Giverny are grand. The museum celebrates American artistic achievement in the land that gave birth to Impressionism. It salutes the grandeur and generosity of Claude Monet, who was muse to so many American artists, and amplifies knowledge of the French influence on American art. Through an art movement that was shared between national friends, the ties that bind France and the United States are strengthened. For the Ambassador and Mrs. Terra, this project has been a labor of love, through which their own ties with France have been enriched.

The Musée Américain Giverny will enhance its visitors' enjoyment of art just as the American artists whose works are displayed there would have hoped: what better location than to return the paintings to the very light in which they were painted? Visitors surely will be moved by this setting, by the loving care that has been lavished on this new enterprise and the energy that exudes from every aspect of it. In these respects, the Terras are giving back some measure of gratitude for the delight these artists, whom they love so well, have given them for many years. In hopes that their works of art will engender not only appreciation, but inspiration to new generations of artists from the region and from abroad, they are dedicating this institution to the pleasure of its ready public.

Ambassador and Mrs. Terra are to be congratulated for their generous efforts to create the Musée Américain Giverny. This unique enterprise will help further knowledge of the profound inspiration of French culture on the American art scene at an important moment. To have framed it so concretely in this intimate institution is a remarkable step in cultural education and diplomacy by which we all will benefit.

Roger Mandle
Deputy Director
National Gallery of Art
Washington, D.C.

INTRODUCTION

In the essay that follows, titled "American Art and the French Experience," William H. Gerdts presents an extensive overview of the prolonged inquiry into French art made by American painters and sculptors from 1800 through the 1920s—a period when France was *au courant* in the arts and a tremendous source of guidance in all artistic concerns. Quite unlike the United States, France provided an environment in which American artists could flourish. But it was not simply contact with French art that inspired the Americans, for they were equally susceptible to the less tangible influences that French culture had to offer. As suggested by the title of Professor Gerdts's essay, it was the "French Experience" in its entirety that informed their new artistic visions.

This exhibition, *Lasting Impressions: American Painters in France, 1865–1915,* and its accompanying catalogue examine the results of that French experience during fifty of the one hundred and thirty years when French art dominated the American artistic vision. During those fifty years, which spanned the period from the end of the American Civil War to the beginning of the First World War, Americans in increasing numbers were enrolling in the Parisian academies and entering their works in the French Salons, or painting en plein air in one or more of the provincial art colonies in the Ile de France, Brittany, or Normandy. As a way of clarifying its presentation, the exhibition has been organized by sections that observe these geographical regions.

The exhibition includes the names of both major and minor American artists working in France during the fifty-year period under examination. Many of their individual accomplishments are highlighted, such as Eugene Lawrence Vail's *Le Port de pêche, Concarneau,* c. 1884, significant for being among the first American paintings to be purchased by the French government. There is the rare opportunity to view together both versions of John Singer Sargent's *Oyster Gatherers of Cancale,* 1878, along with three oil studies he made for the completed pictures.

The exhibition reveals the various artistic sources adopted by the Americans living in France. Among them is the influence of the Barbizon School, clearly discernible in the poetic landscape *La Croix, St. Ouen, Oise,* 1883, by Dennis Miller Bunker, or in Winslow Homer's *Haymakers,* 1867, which depicts rustic peasants in the manner of Jean-François Millet. The reaction to Paris is equally well documented in such works as Henry Ossawa Tanner's urban view of *Les Invalides, Paris,* 1896, as well as by the observations of city life of Frederick Childe Hassam in *Les Buttes, Montmartre, July 14,* painted on that day

in 1889, and Richard Emil Miller in *Café de nuit*, which probably dates to 1906. The work of Mary Cassatt, the most famous American artist living in France during the period under consideration, is amply represented in various mediums.

But it is to the Americans' discovery of Giverny, and their subsequent conversion to Impressionism, that this exhibition is devoted. This statement is, in fact, misleading for the credit of discovering Giverny belongs wholly to Claude Monet. When in 1883 he moved his home and studio to the quiet Norman village, situated on the Seine halfway between Paris and Rouen, Monet was recognized as the leading practitioner of French Impressionism. Few places have so completely captivated an artist as Giverny did Monet, and as the years progressed he painted, with increasing exclusivity, the landscape and garden environs of his home. By the time he died in 1926, the flowers, Japanese bridge, and water lily pond adorning his Giverny garden had become the central focus of his painting. They are the pictures that secured Monet, as well as the village, a place in the history of French art, and they remain today the images of Giverny etched indelibly in the popular consciousness.

Although inadvertent, Monet's move to Giverny was to change the life of the village forever. His presence was soon attracting the attention of other artists, and reports of American painters arriving in Giverny began as early as 1885. By 1887 their ranks, especially in the spring and summer months, had grown to the extent that Madame Angélina Baudy converted her café and grocery into a hotel, which quickly became a lively gathering spot and residence for the visiting artists. So fully had the Americans integrated into the village that a tennis court for their use was constructed across the street from the Hôtel Baudy. By the end of the century American artists, including Theodore Butler and Mary and Frederick MacMonnies, were living in Giverny year-round, and others, such as Lilla Cabot Perry, regularly spent their summers there. It had become a place where expatriate Americans could lead a bohemian life in an atmosphere sympathetic to their experimentation and development as painters.

Every year thousands of visitors admire the garden that Monet developed on a tract of land below his house and that inspired his mature Impressionist style. But few of these visitors are aware of Monet's larger legacy beyond his own prodigious artistic output during the years he lived and worked in Giverny. This legacy extends to include paintings executed by the Americans who also worked there, and for whom Monet was so important an influence. Through its selection of American paintings executed in Giverny, the exhibition provides an opportunity to celebrate this legacy.

There could be no more appropriate commemoration for the opening of the Musée Américain Giverny than the exhibition *Lasting Impressions*. This exhibition not only marks the beginning of a new museum, one dedicated to the influence exerted by France on American art and culture, but heralds as well the return to France of a large group of American paintings executed on French

soil. Some of the works in the exhibition are important loans from both French and American museums. But most have been selected from the collection of the Terra Foundation for the Arts from the Daniel J. Terra Collection. They demonstrate the long-standing commitment of Ambassador Daniel J. Terra, founder of the Musée Américain Giverny and the Terra Museum of American Art, Chicago, to the collecting of American works produced under French influence. With the Chicago museum, Ambassador Terra achieved his goal of establishing in the United States an institution dedicated to preserving and exhibiting American art. The opening of the Musée Américain Giverny is the realization of his second goal, which is to bring a greater awareness and understanding of American art to a larger, international forum.

While Ambassador Terra and his wife, Judith, are the force behind the founding of the two sister museums, one in Chicago and the other in France, the champions in France of Giverny as an American art colony are Jean Marie Toulgouat and his wife, Claire Joyes Toulgouat. M. Toulgouat is the grandson of the American artist Theodore Butler, who married Monet's stepdaughter Suzanne Hoschedé (as commemorated in Theodore Robinson's *Wedding March* of 1892), and the son of their daughter, Lili (depicted as a young girl in Butler's *The Artist's Children, James and Lili*, 1896). The Toulgouats have been unwavering in their support of the Musée Américain Giverny, and their vast knowledge of the history of Giverny and of the American artists who lived and painted there has been a continual source of guidance and inspiration in every aspect of the organization of this exhibition.

Lasting Impressions represents the first collaborative effort between the two institutions founded by Ambassador and Mrs. Terra. The Terra Museum of American Art will continue to work closely with the Musée Américain by sharing the collection and providing curatorial assistance. This collaboration will allow the two museums to serve as an example of, as well as reinforce, the long-established cultural bond existing between the two nations. Because of Ambassador and Mrs. Terra's vision, visitors to Giverny will come away with a better understanding of America's rich cultural heritage.

D. Scott Atkinson
Curator
Terra Museum of American Art, Chicago

American Art and
the French Experience

William H. Gerdts

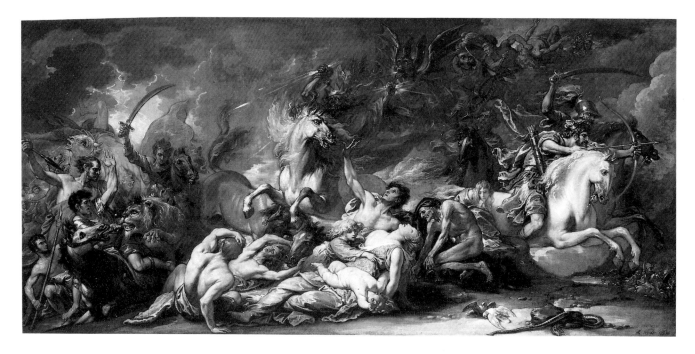

Fig. I
Benjamin West, *Study for Death on a Pale Horse*, 1796, oil on canvas. Detroit Institute of Arts, Founders Society Purchase, Robert H. Tannahill Foundation Fund, 79.33

Fig. 2
John Vanderlyn, *Death of Jane McCrea*, 1804, oil on canvas. Wadsworth Atheneum, Hartford, Purchased by Subscription

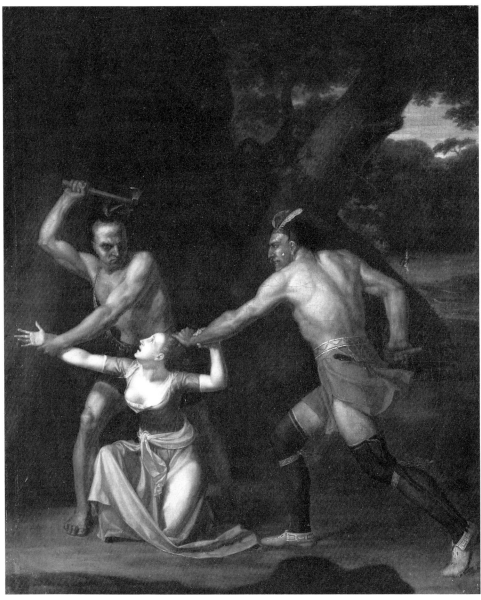

With the temporary cessation of conflict between England and France in 1802, British travelers, including artists, were allowed the opportunity to journey to the Continent. At the Salon that year, Benjamin West, former Colonial from Pennsylvania, and now president of Great Britain's Royal Academy, exhibited his large oil study of *Death on a Pale Horse*, painted in 1796 (fig. 1).[1] Two years later, in 1804, the American artist John Vanderlyn, from Kingston, New York, then temporarily residing in Paris, showed at the Salon his *Death of Jane McCrea* (fig. 2), a work painted in France that year, and exemplifying the artist's allegiance to the dominant Neoclassic aesthetic of the time. Indeed, during his first sojourn in Paris, from 1796 to 1801, Vanderlyn had studied with François-André Vincent, a leading Neoclassic painter, and in 1800 he had become the first American artist to exhibit at the Salon, where he showed a group of portraits, including a self-portrait (fig. 3).

So began American artistic involvement with France,[2] and the compelling need of American painters and, later, sculptors to both learn their craft and test their achievements in competition with the work of the finest of their European contemporaries—who were generally deemed to be French artists, and whose outstanding works were to be seen annually in the Salon exhibitions. Even before the Revolution, Colonial American painters actually had visited Paris and had seen examples of French art. West himself had first arrived in Paris in 1763, too exhausted to stay for the opening of the Salon, and he was possibly back again in the early spring of 1785.[3] Stopping off in Paris in 1774 on his way to Italy, John Singleton Copley wrote several letters to his half-brother, Henry Pelham, back in Boston, describing the works of the old and modern masters he had seen and admired—older French artists such as Nicolas Poussin, as well as Peter Paul Rubens, Raphael, Correggio, and others, but also more recent painters such as Antoine Coypel, one of whose works (*The Forge of Vulcan*) he had copied from a print in his youth.

West's return to Paris in 1802 marked the first significant involvement of an American-born painter with the French artistic establishment. Not only did French critics comment upon his study for *Death on a Pale Horse*, but West met Dominique Vivant Denon, director of the government museums and Napoleon's special adviser, as well as a good many of the leading French painters of the Neoclassic movement. These

Fig. 3
John Vanderlyn, *Self-Portrait,*
c. 1800, oil on canvas.
Metropolitan Museum of Art,
New York, Bequest of Ann S.
Stephens in the name of her
mother, Mrs. Ann S. Stephens,
1918

included Vanderlyn's former teacher Vincent and Jacques-Louis David, but West most preferred the painting of Pierre-Narcisse Guérin.[4] Napoleon himself is supposed to have expressed his admiration for West's painting. The critic for *Journal des arts* praised the picture and found parallels with the work of Poussin, though he would have preferred West to have captured more of "the color of Rubens."[5] On the other hand, David is said to have complained that the work was rather "a caricature of Rubens,"[6] while in turn, West himself was not greatly taken with contemporary French painting. He told the English landscape painter Joseph Farington that the French "paint Statutes [*sic*]," a recognition of the derivation from antique sculpture of much French Neoclassic painting, about which West commented a number of times.[7]

Throughout the nineteenth century, in fact, many Americans remained ambiguous about the merits and superiority of French painting. Americans were aware of French art, not only through visits to Paris, but also by the sporadic appearance in the United States of French painters practicing the successive prevalent styles and illustrating themes popular in their native country, starting with a host of miniature painters who came to America around 1800, as well as an occasional easel painter such as the minor but engaging Neoclassicist Dennis Volozan, who arrived in Philadelphia in 1799.[8] There were, in addition, tours of individual French masterworks, such as a replica of David's *Coronation of Napoleon* (Musée de Versailles),[9] and *The Temptation* and *The Expulsion* (destroyed) by Claude Marie Dubufe, which toured the country in the early 1830s and caused a sensation because of the nudity of the figures,[10] as well as copies of others such as Théodore Géricault's *Raft of the Medusa*, painted in 1830–31 by the American artist George Cooke (fig. 4).[11]

Criticism not only of individual French artists, but of the general character of French painting appeared sporadically in American periodicals

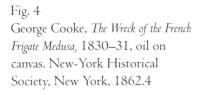

Fig. 4
George Cooke, *The Wreck of the French Frigate Medusa*, 1830–31, oil on canvas. New-York Historical Society, New York, 1862.4

throughout the nineteenth century.[12] One of the first examinations of contemporary French painting to appear in an American magazine was published in Boston in 1807, but this was actually an English translation of a piece written by a member of the French National Institute as a rejoinder to the criticism published by the art historian Johann Dominik Fiorillo at Göttingen, Germany, and thus does not especially reflect American attitudes.[13] American writers tended to respect French proficiency in draftsmanship and in figural and compositional construction, but they noted the French inability to animate figures and to color, and bemoaned, as did West, the French dependency upon earlier (usually antique) art rather than nature. This was judged to be due to the uniform system of teaching imposed by the official government art schools, with the insistence that "the drawing of the picture must be correct, though the subject itself may be devoid of all interest; the chromatic effect must be harmonious, though there be not a single agreeable color on the canvas."[14]

As early as 1810 one American writer, in the Philadelphia magazine *Port Folio,* distinguished between the "antique nature of the Greeks" and the work of contemporary French artists who were "carrying the study of the antique too far with the result that their works were monotonous and destitute of character."[15] A writer in another Philadelphia magazine, the *Analectic,* remarked that "the slightest acquaintance with works of the Parisian school is sufficient to convince us the French works are fruits of toil and not native genius," citing "the hard stiff affectation of classical antiquity of the contemporary painters."[16] West himself, a native son of Pennsylvania, was the subject of numerous articles in these early magazines. In one he spoke of the present state of French painting, complimenting David's teacher, Joseph-Marie Vien, for introducing "the Graecian taste, and nature as the source of all improvement in French art, including the works of Vincent, David, Vernet, Guerain [*sic*], and, in portrait painting, Gerard and Isabey . . . the whole is in striking contrast with the state of the arts in France fifty years before." Yet at the same time West qualified his praise by describing French art as presently "reverting to nonsense and excesses of the mind and vision made to charm the senses."[17]

One might expect American critics of French Romanticism to seize upon the drama and coloristic richness of the movement as an antidote to the dry didacticism of Neoclassicism, but in fact, it was there that Americans first began to discern the French propensity toward subjects of violence. In regard to the writings of Victor Hugo and George Sand, one critic found that these authors "anatomize the darkest corners of the human heart; they plunge into the lowest abyss of crime and infamy; they delight in scenes of torture and scaffolds. They . . . produce an ephemeral effect . . . at the expense of taste, as well as delicacy, innocence, and virtue."[18]

By midcentury, charges of prurience commingled with those of violence in criticism of French painting, one writer noting that women in French painting were "either over or under-millinered, equally at home in

overdress or no dress at all," and expressing "something suggestive of the fact that their Eve must have sinned earlier than ours since all their beauties had a painful consciousness—their gay ones appearing to be mistresses, their serious ones, the muses of a generation of debauchees." The writer concluded by regretting the pain caused by the utilization of art for "meretricious purposes, which blind the eyes and deprave the innocent."[19] Similar criticism continued in the second half of the century. The stateside detractors were haunted by the prurience in the Gallic paintings of the period. Margaret Fuller, for instance, wrote at midcentury that "French painters . . . have not studied the method of Nature . . . in the French pictures suffering is represented by streams of blood,—wickedness by the most ghastly contortions."[20]

Materialism was even charged against the Barbizon masters of the dominant French landscape school. In one of the earliest notices of this group of artists, written in 1856 by the American landscape painter Christopher Cranch, the author noted that "the French landscape painters are chiefly remarkable . . . in developing the *material* side of their branch of art. They excel in drawing, in modelling, in composition, in light and shade, in truth, delicacy and vigor of color, in harmony of tone, in texture, and generally in all that pertains to the outer substance. They have more photographic truth than any other school." But he found that "in the subjects they choose, there is too little variety—There is nothing in these places that interests you. . . . What they lack is Ideality in selection and in conception."[21] Given the poetic mode of Jean-Baptiste Corot, Théodore Rousseau, and the other Barbizon masters, this seems peculiar criticism indeed, but later, when the Barbizon painters were better known in America, they were criticized anew: "There is one strong objection to many of the French landscapes. They are what might be styled, in good honest Saxon, a sort of short-hand kind of pictorial shoddy. They are mere sketches, and not finished pictures . . . some of them grand in idea, but not carried out and finished." The writer concluded his discussion of landscape painting by noting that the "Frenchman has no more conscience in art than he has in morals."[22]

This same writer condemned even further French figure painters of the period: "We should beware if we would have our children grow up with the purity that we have become accustomed to consider inherent in New England life. The figure-painters are, as a rule, corrupt and sensual, because a man gives us, to a great extent, his own character in his works. To be sure, their figures have a certain grace about them that is very charming, and their silks and satins and velvets are wonderful imitations of these indispensable articles of the lady's toilet; but underneath it all there gleams a desire to depict the sensual and voluptuous form. . . . They delight to portray the revels of kings and princes with grisettes and dish up an inkling of the cancan with a suggestiveness that would put Morlacchi to the blush."[23]

By the 1870s more and more American artists were entering French

academies and testing their skills against the standards of the French in
Salon exhibitions and in the international expositions that were taking
place, especially in Paris, successively in 1855, 1867, 1878, 1889, and
1900. While French critics constantly identified whatever proficiency they
recognized among the Americans as mere imitation of French achievement,
Americans continued to identify the limitations of French art. In regard to
the French paintings shown in the 1878 exposition, for instance, the
English writer Gerald Brown tended to agree with the Americans, noting in
Appleton's Journal that, while art fails altogether if it fails as art, no matter how
pure and elevated the ideas expressed, on the other hand, "to make his work
technically blameless is only a part of what the artist has to do." And he
contrasted the feeling for beauty and nature, the delight in brightness and
color, of the English section, with the "bad and unsympathetic cleverness of
the French painters" where "it was impossible for the eye to travel far
without lighting upon some scene of death, and death in its least noble
aspects."[24]

For Brown, the noble example of David had been currently lost
when "classical subjects are at present chosen for the most part as
convenient cloaks for modern indecency." He used as examples paintings by
major French academic masters such as Jean-Léon Gérôme and William
Bouguereau.[25] Other writers, observing the tendency of younger French
artists to concern themselves with contemporary scenes and subjects,
frequently found little more to commend. Sophia Beale, for instance,
writing in 1886, noted: "The tendency of the younger school of French
artists during the last fifteen years has been toward depicting the every-day
life of our great cities and rural districts in its naked truth, and often in its
intense ugliness. . . . Artisans are no longer represented in clean blouses or
Sunday garments, but appear in clothes begrimed with the dirt of the
workshop."[26]

Nevertheless, once large numbers of young American tyros began at
the end of the Civil War to enter the Ecole des Beaux-Arts or to study in
the independent ateliers and academies in Paris, their goal was not only to
learn their craft, but also to emulate the art of their teachers and other
French masters. Before that time, relatively few Americans chose to take
contemporaneous French art as their model. On his third stay in Paris, from
1808 to 1815, Vanderlyn produced his masterly *Ariadne Asleep and Abandoned
by Theseus on the Island of Naxos* (fig. 5). Rembrandt Peale contemporaneously
on visits in 1808 and again in 1809–10 produced portraits infused with
the spirit of Neoclassicism, including those of David and Vivant Denon
(figs. 6 and 7).[27] Despite his sympathetic relationship with a number of
French artists, however, Peale left Paris on both these visits just a month
before the opening of the Salon, suggesting his disinclination or at least his
disinterest in viewing the work of his contemporaries.

What attracted Peale the most in Paris were the great treasures in
the Louvre (at the time, the Musée Napoléon), gorged temporarily by the

Fig. 5 (RIGHT)
John Vanderlyn, *Ariadne Asleep and Abandoned by Theseus on the Island of Naxos*, 1809–14, oil on canvas. Pennsylvania Academy of the Fine Arts, Philadelphia, Gift of Mrs. Sarah Harrison (The Joseph Harrison, Jr. Collection), 1878.1.11

Fig. 6 (BELOW)
Rembrandt Peale, *Dominique Vivant Denon*, 1808, oil on canvas. Pennsylvania Academy of the Fine Arts, Philadelphia, General Fund, 1854.1.2

Fig. 7 (BOTTOM)
Rembrandt Peale, *Jacques-Louis David*, 1810, oil on canvas. Pennsylvania Academy of the Fine Arts, Philadelphia, General Fund, 1854.1.1

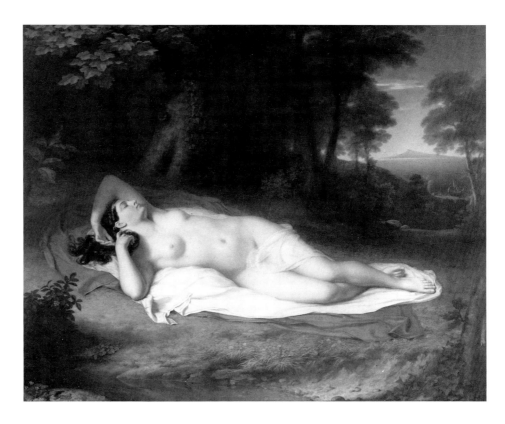

artistic spoils of war that Napoleon had shipped to further enrich the holdings at the Louvre.[28] For American artists and laymen in the first half of the nineteenth century, the great attraction of the French capital was the vast holdings of old and modern masters in the Louvre. This, in turn, was the subject of *Gallery of the Louvre* (colorplate 1), the great and most ambitious canvas painted by one of America's foremost artists of the Romantic movement, Samuel F. B. Morse.

Morse was among a number of American painters of the early nineteenth century who were ambitious to pursue the vocation of history painting, deemed at the time to be the highest calling of an artist, but who became displaced between the theory of historical superiority and the practicality of limited patronage for such works. After training in London with his mentor, Washington Allston, and at the Royal Academy Schools in London, Morse returned to America (as did Vanderlyn at the same time) only to exhibit his classical subject pictures to an indifferent audience. Much of Morse's artistic career was devoted to locating a form of historical painting that would have meaning to a democratic audience. In an attempt to renew his artistic inspiration and at the same time to make a Grand Tour for the purpose of studying the work of the old masters, Morse returned to Europe in 1829; on his first sojourn abroad, from 1811 to 1815, he had been confined to England due to the Napoleonic Wars. His second trip was financed by a number of art patrons who advanced him monies for pictures to be painted in Europe, either original compositions, mostly picturesque landscape and genre scenes, or copies of European old-master paintings by such artists as Raphael, Bartolomé Esteban Murillo, Jacopo Tintoretto, and

Guercino. Morse was enraptured by the treasures of the Louvre and dazzled by the artistic wealth of Italy.

Given his own excitement for artistic masterpieces, along with the enthusiasm of his sponsors for copies of works by the old masters, Morse conceived of creating a vast canvas depicting the Salon Carré of the Louvre—what would prove his largest painting—on his return to Paris in 1831. This would be a work that would bring the treasures of the Old World to a vast audience in the New World, surely a "history painting" about the history of art that would prove both instructional and inspirational. While public art galleries were just at this time beginning to proliferate in Europe, no permanent collections of painting were on view in Morse's native land. The Louvre was an obvious choice as containing "the most splendid as well as the most numerous single collection of works of art in the world."[29]

Morse depicted the pictures displayed in the Salon Carré as museum galleries were hung in those days—stacked, cheek to jowl and row over row. The actual works depicted, however, were Morse's own choices, for at the time this immense gallery was devoted to contemporary French art, which Morse himself did not favor and which would probably have had little interest for his prospective audience. Morse, instead, attempted to create a totality of the history of Western art, beginning with the classical sculpture of *Diana*, and including over forty works by those masters traditionally favored in histories, together, surely, with his own preferences, and certainly acknowledging the partiality of his patrons; Raphael, Tintoretto, and Murillo are among the painters whose works are featured.

Morse was following a long and distinguished tradition of art gallery depictions, a form of art popular in seventeenth-century Holland and Flanders which, however, usually offered homage to a private art collector; Morse's painting was intended for a general audience. Closer in hand was the model of England's most significant painter of public and private art galleries, John Scarlet Davis, who at almost exactly the same time was creating his own view of the Salon Carré (Fine Arts Society, London). Significantly, Davis incorporated the Louvre's great English portrait of Charles I by Anthony van Dyck, which Morse did not choose to include in his creation. Morse's own achievement, the vast canvas itself, could stand as the sole representation of contemporary art, with both his ability to reproduce the forms and styles of the greatest masters of the past, along with his mastery of light, color, space, and perspective.

Morse left France in October 1832 with the painting almost finished. Only the distant view down the Grande Galerie, the figures, and the frames around his miniature reproductions needed to be filled in. The figures themselves are, of course, art students and art lovers, visitors to a public gallery of different ages, genders, and rank in society—those who had come to draw inspiration from the history of art in the Louvre, as Morse was to offer the same in America. The American art historian

William Kloss has suggested that Morse was commenting also on the nature of European art patronage, which had led to so rich an accumulation —the Titian portrait of one of the greatest of these patrons, Francis I, is conspicuously placed three tiers above the central figure, which some scholars believe to be a representation of Morse himself. The picture was completed in New York in the summer of 1833, and opened to the public that September in rooms over a bookstore on Broadway. Unfortunately, though the work received critical encomiums, the general public remained aloof. The three-month exhibition barely paid for the rental space, and the work was even less well received when it was subsequently exhibited at Franklin Hall in New Haven. The following August Morse sold the picture to a private collector for half the price he had originally expected. Yet today the work remains a monument, not only to its author, but to American cultural aspirations of the early nineteenth century and their derivation from France.[30]

In the early nineteenth century, France attracted artists and art lovers far more for the great treasures of painting and sculpture that were to be seen there than for the achievements of that nation's contemporary artists. This began to change at midcentury, however, and here the key figure was the young American art student William Morris Hunt. Dissatisfied with the art instruction offered at the Akademie in Düsseldorf, which drew many Americans during the 1840s, Hunt encountered the painting by Thomas Couture of *The Falconer* (fig. 8) in 1846 and immediately sought out the French artist, becoming the first of many young Americans to study with Couture, learning his distinct, basically nonacademic methodology.[31]

Hunt remained with Couture until about 1852, when his allegiance shifted to the work of Jean-François Millet. He was soon introduced to Millet in the village of Barbizon by another American, William Babcock, who had also been a pupil of Couture.[32] Hunt, like the Americans who

Fig. 8
Thomas Couture, *The Falconer,* c. 1846, oil on canvas. Toledo Museum of Art, Gift of Edward Drummond Libbey, 1954

Fig. 9
William Morris Hunt, *The Belated Kid,* 1857, oil on canvas. Museum of Fine Arts, Boston, Bequest of Elizabeth Howes, 7.135

followed him in Couture's atelier, remained faithful in his methodology to his master's teachings. Many of his paintings, however, particularly those created during the 1850s, took up the theme of rural labor associated with Millet and the figural work of the Barbizon School. In Hunt's case, this was often projected in the guise of childhood, as in *The Belated Kid* (fig. 9). This suggests the additional impact of the work of another contemporary French artist, Edouard Frère, a painter much appreciated in America, in part due to the praise bestowed upon his art by the influential British aesthetician John Ruskin.

Hunt returned to America in 1855, living the remainder of his life in New England, first in Newport and then, from 1862, in Boston. A charismatic figure in the Boston social world to which his marriage to Louisa Perkins gave him entrance, and an influential teacher, Hunt was able to persuade many wealthy Bostonians to collect the works of Millet and of other painters of the Barbizon School. Ultimately, nearly 150 works by Millet entered Boston collections. Hunt was not only Millet's pupil and friend, providing introductions to him for many Boston collectors, but he himself was also an important patron. He purchased Millet's *Sower* (fig. 134) and many other paintings. While Barbizon paintings were not unknown in New York, the impact of Hunt's championing of Barbizon painting created a real distinction between the art worlds of New York and Boston, the latter becoming a bastion of French influence.[33]

It is peculiar that Barbizon figure painting preceded its landscape mode in popularity among Americans, reversing the historical development in France.[34] This was due, in large part, to Hunt's active championing of Millet in the 1850s. Nevertheless, by the 1860s a number of painters were moving away from the specificity of the old Hudson River School manner and its glorification of American scenery—both the raw wilderness as well as the settled rural landscape in which man and nature coexisted in harmony. Influenced by the more moody and poetic interpretations of Camille Corot and Théodore Rousseau, whose works they saw abroad or in art galleries in New York and Boston, such painters as George Inness were creating a new, more personal interpretation of the landscape. In place of titles offering geographic specification, the new, Barbizon-inspired scenes were usually identified as to time of day or year, or even the dominant pictorial element, such as light and color.

Inness, in fact, became the most admired landscape painter in the United States in the last third of the nineteenth century. While he started his career in the mid-1840s working with the strategies of the Hudson River School, Inness appears to have been directly impressed by the work of the Barbizon landscape painters (Rousseau especially) on his second European trip in 1853, when he spent about a year, mostly in France. It may be, too, that after his move to Medfield, Massachusetts, in 1860, his proximity to nearby Boston and its growing contingent of Barbizon-oriented artists and patrons hastened his conversion to the more painterly

and introspective mode of landscape painting that he pioneered in America.[35] During the 1860s Inness's reputation grew rapidly in his native land, and in 1870 he went abroad again for his longest European sojourn, spending four years in Italy where he had been commissioned by the Boston art gallery of Williams & Everett to produce popular and saleable paintings. Then, in the spring of 1874, he moved to Paris, placing his son, George Inness, Jr., under the tutelage of Léon Bonnat, while he himself explored the French landscape. Still on contract to Williams & Everett, Inness was attracted to Etretat on the coast of Normandy. He appears to have painted almost twenty works there in 1874–75, many of them featuring the natural arches of the eroded sea cliffs (colorplate 47 and fig. 129), also a prominent feature in the well-known pictures painted by Gustave Courbet in 1869 and Claude Monet in 1885–86.[36]

What little art training Inness formally received took place in America, but many of the younger men who turned to landscape painting after the Civil War studied in the French ateliers and academies, though these schools gave emphasis to the study of the figure. These landscapists often began to approach that theme during their summers in France away from the art schools, so that many of their freshest and finest works consist of very individual interpretations of the French rural landscape, often painted at the summer art colonies that had sprung up especially in Brittany,[37] Normandy, and in the vicinity of the Forest of Fontainebleau.

William Lamb Picknell was one of the most successful of these artists. He appears to have enjoyed at least informal instruction with Inness when both artists were in Rome in the early 1870s. His most serious training occurred during several years under Gérôme at the Ecole des Beaux-Arts in Paris, beginning in 1874. Picknell sought his landscape subjects in the wild scenery of Brittany, joining the important colony of artists in Pont-Aven, which he gave as his address when exhibiting at the Paris Salon from 1876 until 1881. It was at Pont-Aven that he painted in 1880 what remains his most famous landscape, *The Road to Concarneau* (colorplate 58), acclaimed for its vigorous paint handling and above all for its treatment of intense sunlight.[38]

Another American painter to produce some of his finest works during his many extended visits to Brittany was (Thomas) Alexander Harrison, an artist equally adept at landscape and figural work. Harrison was exhibiting Breton subjects at both the Paris Salon and the Philadelphia Society of Artists as early as 1880. Picknell returned to America in 1882, but Harrison remained in France, a leader of the American expatriate art colony. In his scenic work, Harrison, who began studying with Gérôme in 1879, specialized in long, unbroken panoramas of the sea coast, painted with great specificity and often with an intense blue-purple tonality. These were studio pictures, based upon sketches made out-of-doors on the Breton coast, at one time inspired by a walk along the twilight-lit shore with Harrison's close friend and mentor Jules Bastien-Lepage, the leader of the Naturalist school, of whom Harrison was acknowledged as a disciple. In

their serial nature and in their colorism, these coast and wave pictures might appear to owe a debt to the experiments of contemporary Impressionism, but Harrison was concerned with exploring the emotional nuances of color and light, and the projection of a mood.[39]

A third exceptionally gifted American landscape painter who created his finest pictures in France was Charles Harold Davis, who had studied at the School of the Museum of Fine Arts in Boston before entering the Académie Julian in Paris in 1880. The following year he settled in the village of Fleury, near Barbizon, and later at Saint-Léger, where he produced a series of crepuscular landscapes that won great acclaim in the Salon. Like Harrison, Davis was concerned with projecting a mood of mystery and melancholy, though he employed far more reductive strategies. His French pictures of the 1880s were inspired by those of James Abbott McNeill Whistler, along with the French painters Henri Harpignies and Jean Charles Cazin. These works, such as *The Brook: Effect at Evening* (fig. 10), suggest some French inspiration for Tonalism, the predominantly American landscape movement of the late nineteenth century. Some years after his return to the United States in 1890, Davis abandoned this more evocative mode of landscape work for a high-keyed palette inspired by Impressionism.[40]

The French impact upon the work of American artists that was so pervasive after the Civil War was even more greatly in evidence in the work of figure painters, including even some who did not seek French training, such as Winslow Homer. Homer's formal art training consisted of classes he took at the National Academy of Design in New York in 1859 and 1860 and again in 1863, along with limited time spent for one month in 1861 with the French artist Frederic Rondel, who had expatriated to the United States. After some success as a graphic artist, Homer had turned to oil painting during the Civil War, and he achieved considerable acclaim with his *Prisoners from the Front* of 1866 (fig. 133). This work was included in the

Fig. 10
Charles Harold Davis, *The Brook: Effect at Evening,* 1890, oil on canvas mounted on wood. Pennsylvania Academy of the Fine Arts, Philadelphia, Joseph E. Temple Fund, 1891.2

American division of the fine arts section of the 1867 Paris Exposition Universelle, and Homer traveled to France in December 1866 to attend that event. This was to be his only journey to the Continent; he returned to America a year later.

Relatively little is known of Homer's year in France, beyond about twenty small paintings and three wood engravings that he executed at the time. He appears to have spent his time in Paris and in the small village of Cernay-la-Ville, southwest of Paris, which was something of a haunt for both French Barbizon artists and a few American followers of that movement, such as Joseph Foxcroft Cole of Boston and Joseph Woodwell from Pittsburgh. Barbizon paintings, including a large selection of those by Millet, were on view in the 1867 Salon and may well have inspired the works Homer painted in France, such as his *Haymakers* of 1867 (colorplate 64). Millet's influence is suggested not only in the theme of peasant workers, but in the simplified forms and the hushed solemnity of the scene. Indeed, the iconic projection of the large haystack at the left, its shadow circumscribing the space of the slender peasants, reflects more the work of Millet himself than that of his younger French followers, such as Jules Breton, who were then coming into prominence. Homer, in all likelihood, was already familiar with Millet's work even before he went abroad, given Hunt's proselytizing activities in Boston.[41]

It has been proposed that Homer also became aware of early French Impressionism during his year in Europe, but this has been convincingly contested recently. Certainly his French pictures show no awareness of Impressionism, and there appears to have been no opportunity for him to have seen the work of Monet or his colleagues at the time.[42] A number of writers, however, have seen parallels if not influences of Impressionism in works that Homer painted during the years immediately after his return from France, such as *Croquet Match* of about 1868–69 (fig. 11). Here, in this last in a series of paintings devoted to this subject that he painted during the 1860s, Homer's painting became lighter and brighter than the examples of the subject he had created before his year in France, and forms are flattened, suggesting analogies with the work of Monet and Edouard Manet.[43] Certainly allied with their work also is Homer's concern with a theme from contemporary life; indeed, croquet was introduced only during the 1850s; it was a game especially associated with women in that it allowed them to enjoy physical activity alongside men. In this example, though, Homer has projected a sense of psychological isolation among his figures, who are all women, unlike the active interplay in the best-known examples he painted, in which men are active participants (figs. 12 and 13). The figure at the right in *Croquet Match* appears, in fact, to be playing croquet by herself, while the woman seated is involved rather with badminton; a shuttlecock is on her lap and a racquet leans on the floor. Isolated on the porch floor, yet central to the principal figures, is a slip of white paper, perhaps the cause of both the isolation and the anxiety projected by the

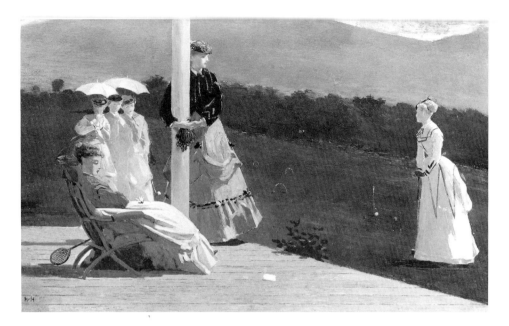

Fig. 11
Winslow Homer, *Croquet Match*, 1868–69, oil on millboard. Daniel J. Terra Collection, 32.1985

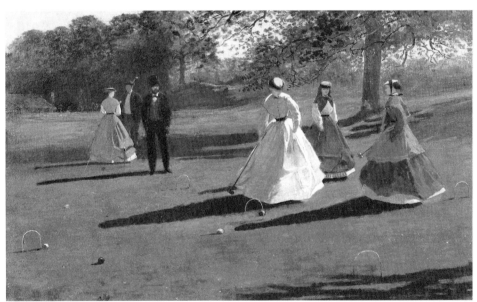

Fig. 12
Winslow Homer, *Croquet Players*, 1865, oil on canvas. Albright-Knox Art Gallery, Buffalo, New York, Charles Clifton and James G. Forsyth Funds, 1941

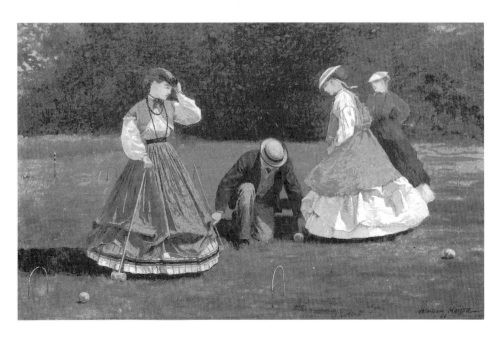

Fig. 13
Winslow Homer, *Croquet Scene*, 1866, oil on canvas. Art Institute of Chicago, Friends of American Art Collection, 1942.35

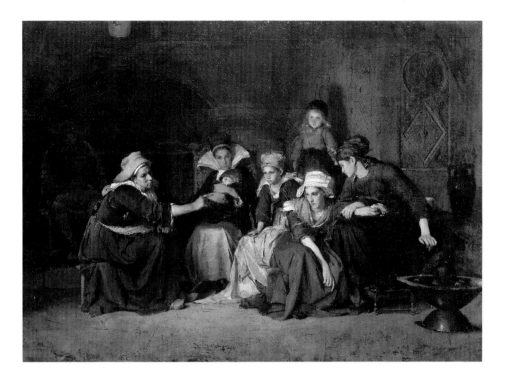

Fig. 14
Robert Wylie, *A Fortune Teller of Brittany*, 1871–72, oil on canvas. Corcoran Gallery of Art, Washington, D.C., Museum Purchase, Gallery Fund, 99.11

figures. The psychological overtones here seem strangely at odds with the gaiety and brightness of Homer's new artistic strategies.[44]

Homer's visit to France coincided with the beginning of the invasion of Paris and its art schools by literally thousands of American students. One of the earliest and most significant of these was Robert Wylie of Philadelphia, who arrived in Paris at the end of 1863, and who studied, perhaps, in the private atelier of one of the faculty at the Ecole des Beaux-Arts, according to his earliest Salon entry in 1869. He also took instruction in animal anatomy from the sculptor Antoine-Louis Barye, at the Jardin des Plantes. The crucial factor in Wylie's career was his visit to Brittany in 1864, where he became the founder of the art colony at Pont-Aven, to which he attracted so many other fellow Americans. Wylie began painting the singular inhabitants of Brittany, exhibiting his works at the Salon beginning in 1869. He won a medal at the Salon in 1872 with *A Fortune Teller of Brittany* (fig. 14), after which the Paris firm of Goupil contracted to take all his paintings. Wylie also offered important guidance to Philadelphia collectors, especially William Wilstach, who acquired many paintings from the Salons of 1868, 1869, and 1870 for his private collection. Wylie's impact upon other Americans who visited Brittany, such as Picknell, Thomas Hovenden, and Frederick Bridgman, both in style and choice of subject, was tremendous. By the time of his early death in 1877, Wylie was an artist of international stature.[45]

Wylie's paintings are today difficult to locate; some of the most important of these were deaccessioned years ago from leading American institutions, among them the Metropolitan Museum of Art in New York and the Philadelphia Museum of Art and the Pennsylvania Academy of the Fine Arts, also in Philadelphia. *The Breton Audience* (colorplate 57) was

certainly painted in Pont-Aven, where Wylie had learned the local language, spending only a few months in the spring in Paris at the time of the Salons. He thus became intimate with the nature and habits of the local Breton inhabitants, qualities he transcribed to this canvas with his typically strong chiaroscuro and rich, painterly palette-knife work.

The Americans in Brittany, initially drawn there by the presence of Wylie, stayed principally in the villages of Pont-Aven and Concarneau. Charles Henry Fromuth was a late addition to the American colony in the region, and like many such as Wylie, was originally from Philadelphia. Fromuth went to Brittany in 1890, stopping at Concarneau where he remained for most of his life, working away unobtrusively and almost forgotten. *Morning Haze, Winter, Concarneau* of 1892 (colorplate 63) is an early work by him, unusual in its land-based theme, for the artist came to specialize in scenes of the harbor and the active sardine fleet. He referred to the work of the early 1890s as his "Concarneau 'Plein-air' oil period" where he was concerned with "Impressionism and Light."[46] The light and color of Impressionism are intrinsic to this, one of Fromuth's most lovely pictures. The picture is also imbued with a strong sense of place, in the harbor configuration, the peasant figures, the distinctive architecture, and the strongly silhouetted church, placed central to the composition. By 1895 Fromuth had begun to abandon oil painting for his preferred medium of pastel.[47]

The theme of the peasant was extremely popular among painters working in France, both among native artists and foreigners such as Wylie, who were attracted to the subject of rural laborers at a time when mechanization was increasingly assuming their traditional roles, and when many country people were migrating to the city. Indeed, Brittany was something of a last bastion of traditional peasant life, but American painters of the peasantry located in many regions of rural France. Daniel Ridgway Knight, who had studied in Paris under Charles Gleyre, established himself in Poissy, and Charles Sprague Pearce, a pupil of Bonnat, was at Auvers-sur-Oise. Both were academically trained expatriates whose peasant paintings enjoyed great popularity among American collectors.

While the theme of the French peasant constituted a form of exoticism for American artists and patrons, some American painters went farther afield for picturesque subjects. Spain had only recently been discovered as providing quaint and unusual themes for artists, first for English painters such as David Wilkie and John Phillip, and then for French painters, above all Manet. Beginning in the late 1860s numerous American artists journeyed from Paris to Spain, in particular to Seville, partly in search of exotic motifs. They went also to Madrid at the recommendations of their academic teachers such as Gérôme and Bonnat, who counseled them on the merits of the seventeenth-century Spanish paintings they would find on display in the Prado museum, above all, the art of Diego Velázquez.

William Turner Dannat was an American artist who studied in Paris

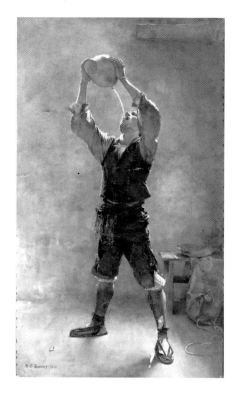

Fig. 15
William Turner Dannat, *Le Contrebandier aragonais*, 1883, oil on canvas. Musée d'Orsay, Paris

Fig. 16
Thomas Eakins, *The Swimming Hole*, 1883–85, oil on canvas. Amon Carter Museum, Fort Worth, 1990.19

with Emile-Auguste Carolus-Duran as well as the Hungarian expatriate Mihály Munkácsy, and the latter's debt to Spanish painting clearly was passed on to his American pupil. During the 1880s Dannat achieved international fame for a series of Aragonese themes based on several sketching tours he had taken in Spain. One of these, *Le Contrabandier aragonais* (fig. 15), was purchased by the French government from the Salon exhibition of 1883.[48]

The most famous American painter to follow up his French instruction with a significant trip to Spain was Thomas Eakins, a student of both Gérôme and Bonnat, who went to Spain late in 1869, and painted his first major picture there in 1870, *A Street Scene in Seville* (private collection).[49] Although still a somewhat tentative effort, the picture is an amalgam of Spanish genre with the Italian theme of the music-making *pifferari*, a tremendously popular subject in nineteenth-century art and one that Gérôme himself had undertaken at least four times. By June 1870 Eakins was back in Paris and then almost immediately returned to Philadelphia for the remainder of his career, applying the lessons he had learned in the Parisian ateliers to depictions of people and subjects of his own milieu.[50] The result of his French training is particularly evident in his paintings of athletes—swimmers, rowers, boxers, wrestlers, and baseball players—where Eakins's mastery of anatomy is especially evident, sometimes revealed in the nude male form, as, for example, in *The Swimming Hole* (fig. 16).

Eakins adapted the forms and strategies of Gérôme to his life and experience in Philadelphia. A more direct heritage from Gérôme was expressed by another American pupil, Frederick Bridgman, who lived as an

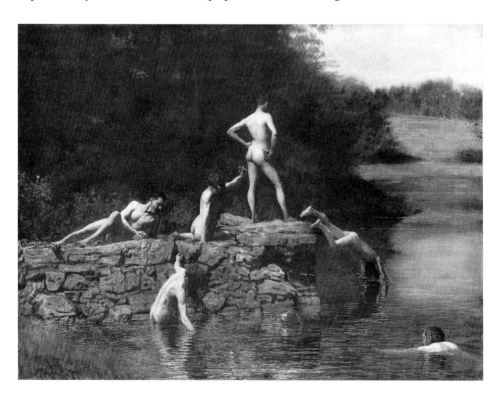

expatriate in France and became the most successful American painter of North African imagery, very much in the tradition of his teacher, who was the most famous of all Orientalist artists. Bridgman began his study with the great French academician in 1867, having spent the previous summer in Wylie's circle at Pont-Aven. Bridgman's earliest successes consisted of peasant imagery, and it was logical enough for him to extend the aura of exoticism after he followed in the footsteps of his teacher and traveled to Morocco and Algeria in 1872, and to Egypt in the winter of the following year. Bridgman's works are often painted a good deal more freely than Gérôme's, which maintain a fascinatingly even surface finish, in which nothing disturbs reportorial accuracy. In the wake of Gérôme's tremendous popularity in America from midcentury on, it is not surprising that Bridgman, his closest follower, also enjoyed considerable patronage for his North African exotica.[51]

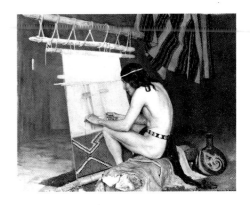

Fig. 17
George de Forest Brush, *The Weaver*, 1889, oil on canvas. Terra Foundation for the Arts, Daniel J. Terra Collection, 1988.23

It was only a short step for American painters, schooled in the rigors of academic teaching, to apply their newly won skills to the exotica of their own land. If peasant themes held attractions because of the indigenous, timeless nature of the subject, and Orientalist imagery was favored for its fascinating unfamiliarity, the mores of the American Indian combined both. No American seems to have learned the lessons of Gérôme more completely than George de Forest Brush, who began his studies with the French master in the autumn of 1873. Brush returned to America in 1880, and the following year he went into the American West, living for some time with the Crow Indians in Montana. His paintings of that decade were devoted to Native American subject matter. Such pictures as *The Weaver* of 1889 (fig. 17) display many qualities that find their parallels in Gérôme's Orientalist images: terrifically competent draftsmanship; a mastery of the human figure and, in this case, the nude; and convincing ethnological accuracy.[52]

A younger artist who followed a somewhat similar course to Brush was Eanger Irving Couse, who began his studies in 1886 at the Académie Julian in Paris, summering at the old artists' colony at Cernay-la-Ville, and then during the next decade painted fisherfolk in the French coastal town of Etaples. Couse interrupted his long French sojourn in 1891–92 to paint the Yakima and Klickitat Indians in southern Washington on the Columbia River, subjects that formed the basis of his Salon entries in 1892–93 in paintings that are more lurid and romantic than Brush's work. Couse returned to the Indian theme again in southern Washington in 1896, before settling in the art colony in Taos, New Mexico, at the beginning of the present century.[53]

Upper-class Parisian life was the province of a number of American artists, fully as much as peasant subject matter. Probably the most successful specialist in this area was Julius Stewart, who came by such an ambience quite naturally, for he was the son of an immensely wealthy sugar plantation owner, William Hood Stewart, who had expatriated to Paris. Stewart senior

was a major collector of art by fashionable contemporaries—Spanish artists such as Mariano Fortuny, Eduardo Zamacois, and Raimundo de Madrazo, as well as Gérôme, Bonnat, Giovanni Boldini, and Ernest Meissonier, among others. The younger Stewart studied with Zamacois, Gérôme, and Madrazo, deriving a facile, highly colored academic technique from them, which he applied to large-scale scenes of upper-class figural imagery, combining specific portraits with genre subjects—elegant balls and dinners, walks along fashionable boulevards, genteel country excursions, and private shipboard outings. The closest parallel to his work among European painters was that of James Tissot. In stark contrast to the peasant women painted by Knight and Pearce, one writer noted that Stewart "never paints a woman who appears to be of lower rank than that of baroness, and all his young girls look like daughters of duchesses."[54]

An unusual, figureless equivalent of Stewart's upper-class imagery is the mature work of Walter Gay, another American who spent his career in France. Gay had been a Boston floral specialist in the mid-1870s before leaving for Paris in 1876 to study with Bonnat. By the end of the decade he was painting figural pieces, first re-creations of eighteenth-century upper-class subject matter in the manner of Meissonier and Fortuny, and subsequently humble craftspersons. In the mid-1890s he turned once again to the eighteenth century, this time to depictions of empty rooms in elegant city homes and country chateaux, featuring rococo decorative arts and architectural motifs. These subjects, primarily French interiors, brought Gay lasting fame.[55]

The central issue in the academic instruction sought by so many American artists in Paris was the ability to render the human figure, a study that generally was undertaken from the nude. Understandably then, artists often chose subjects in which the nude, or partial nude, was integral to the theme. These might be ethnological, such as the Native Americans painted by Brush, or historical, allegorical, or idyllic. American artists enjoyed the freedom to undertake the nude subject in France, but at the same time had to walk a fine line in their choice of themes, given that their most likely patronage would be offered by fellow countrymen who might balk at subjects that were considered to be too erotic, too "racy," or just too naked.

Kenyon Cox was probably the American painter most involved during his career with the rendering of the nude, both as a study of pure form and as allegory. Cox studied under many French teachers—Carolus-Duran, Alexandre Cabanel, and Gérôme—as well as at the Académie Julian, from 1877 to 1882. He acknowledged Gérôme as his primary master, but he attempted to expunge from his own paintings the emphatic sensuality that characterized much of the work of both Gérôme and Cabanel. Cox's disdain for contemporary naturalism and his allegiance to the purity of classical form was made clear in the numerous books and articles he wrote, above all in *The Classic Point of View*, published in 1911.[56]

Probably the most celebrated painting of the nude by an American

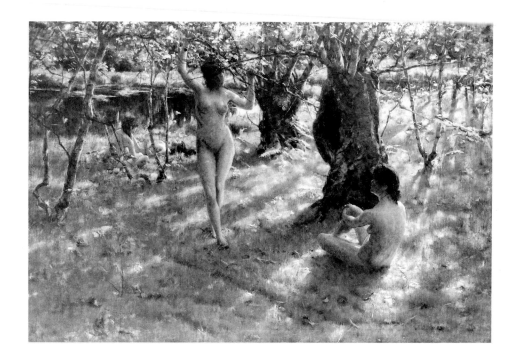

Fig. 18
Thomas Alexander Harrison,
In Arcadia, c. 1886, oil on
canvas. Musée d'Orsay, Paris

artist working in France in the late nineteenth century was *In Arcadia* by
Alexander Harrison (fig. 18). Unlike the studio nudes of Cox or their mutual
teacher, Gérôme, Harrison's work was conceived en plein air in Brittany,
though he scandalized the local residents with this approach. While the
picture was completed in the studio from quick outdoor studies, Harrison's
ability to render the play of outdoor light over the flesh of his unselfconscious
models garnered as much commentary at its 1886 Salon exhibition as did the
provocative nature of his subject. Not surprisingly, the picture's American
debut in 1891 at the Pennsylvania Academy provoked charges of indecency.[57]
Yet the academic rendition of the figures, combined with the naturalism of
the scene, the out-of-doors methodology, and the flickering, dappled light
seemed to place Harrison at the center of a *juste milieu* balance between the
traditional establishment and the radical modernists.

Many American artists, including Bridgman, Harrison, Stewart, and
Gay, expatriated to France, remaining in their adopted country except for
occasional visits home, though their paintings were acquired by American
collectors, often purchased in France from exhibitions, from Parisian
dealers, or directly from the artists. Such painters also kept up their
American connections through participation in shows back in America. But
the great majority of Americans who sought training in Paris returned to
the United States with their new-found skills, while a few had
demonstrated exceptional artistic ability even before they went abroad. One
such painter was Charles Courtney Curran. Curran, who grew up in
Sandusky, Ohio, on the shore of Lake Erie, had achieved great acclaim in
New York during the 1880s with paintings that were quite obviously
inspired by those sent back from Paris by his French-trained colleagues.
Some of the works that Curran displayed in New York were scenes of rural

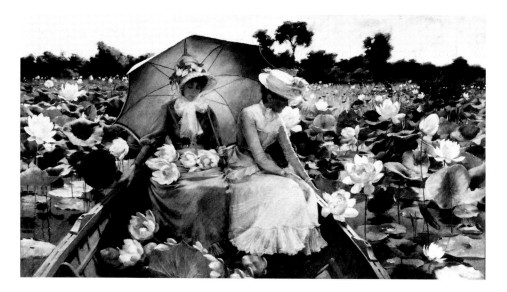

Fig. 19
Charles Courtney Curran,
Lotus Lilies, 1888, oil on
canvas. Daniel J. Terra
Collection, 10.1980

workers and one, shown at the National Academy of Design in 1885, was even entitled *Breton Girl* (location unknown), but during these years Curran was moving toward more elegant and decorative themes centered upon the female figure. The finest of these was his *Lotus Lilies* of 1888 (fig. 19), painted just before he left to study in France, a work that commenced the artist's lifelong interest in the equation of women and flowers. In the autumn of that year, Curran enrolled at the Académie Julian, studying with Jules-Joseph Lefebvre and Benjamin Constant. *Lotus Lilies* was shown at the 1890 Salon as *Les Lotus du lac Erié; Etats-Unis d'Amérique.* Before returning to America in 1890, confident with his newly developed skills, Curran spent several years in Paris investigating a variety of directions, including French Symbolism, the results of which would be seen in his art only at the close of the century. In paintings such as *Paris at Night* of 1889 (colorplate 70), he explored contemporary urban scenes in the manner of Jean Béraud and Curran's American contemporary Childe Hassam.[58] What so distinguishes Curran's Parisian scene is his interest in urban nocturnal illumination; light, including lamplight, was a special preoccupa-tion of the artist throughout his career.

While many of the artists who had come to France in the 1860s and 1870s stayed with traditional themes, such as historical subjects and the French peasantry, some of the younger Americans immersed themselves in scenes of modern life. Another to do so was Fernand Lungren, who had grown up in Toledo, Ohio, and had developed as a competent illustrator in New York before going abroad for two years in 1882. His *Paris Street Scene* of that year (colorplate 69), with its plunging perspective of umbrella-enveloped figures in the rain, is startlingly similar to the works that Hassam would paint in Boston in the next few years. Lungren's time in France was spent in examining the works of the old and modern masters in galleries and museums, and frequenting the art colony at Grèz-sur-Loing, rather than engaging in formal study.[59]

American artists at the end of the century remained fascinated with Paris—her street scenes, night life, and celebrated monuments. This was

true for America's most celebrated Black artist, Henry Ossawa Tanner, who grew up in Philadelphia and studied there at the Pennsylvania Academy of the Fine Arts under the celebrated Thomas Eakins. Tanner was already an expert animal and landscape painter before traveling to Paris in 1881, studying for several years at the Académie Julian while summering in Brittany at Pont-Aven and Concarneau. Tanner's earliest mature works are depictions of French peasant genre and analogous scenes of Black life in America, painted between 1892 and 1895.

In 1896 Tanner turned to religious themes drawn primarily from the New Testament, upon which he would make his reputation. *Les Invalides, Paris* (colorplate 81) was painted in that crucial year, when the artist turned from more naturalistic renderings to an approach tinged with the aesthetics of the contemporaneous Symbolist mode.[60] As was usually the case with his scenic work, this picture is an objective rendering in vividly Impressionist-related brushwork, contrasting the casual pedestrians in an open plaza with the distant yet dominating architecture of the structure housing Napoleon's tomb. Tanner's recent biographer has suggested the possibility of social relevance here in the darkly garbed woman in the foreground, either contemplating the fall of the mighty French military leader, or a war widow, gazing at what was once a home for military veterans. It seems more likely, however, as he also suggests, that the work was rather a diversion from Tanner's more weighty and complex figural themes.[61]

Scenes of modern Paris, in fact, remained (and still remain) attractions for both American painters and patrons in the twentieth century. Two late examples of such subjects are the pair of watercolor images by the Cincinnati native Elizabeth Nourse, *Flower Market at Notre Dame* of 1927 and *Rue d'Assas, Paris* of 1929 (figs. 20 and 21), the latter representing the

Fig. 20
Elizabeth Nourse, *Flower Market at Notre Dame*, 1927, watercolor and chalk on paper. Daniel J. Terra Collection, 5.1990

Fig. 21
Elizabeth Nourse, *Rue d'Assas, Paris*, 1929, watercolor, chalk, and pastel on paper. Daniel J. Terra Collection, 10.1990

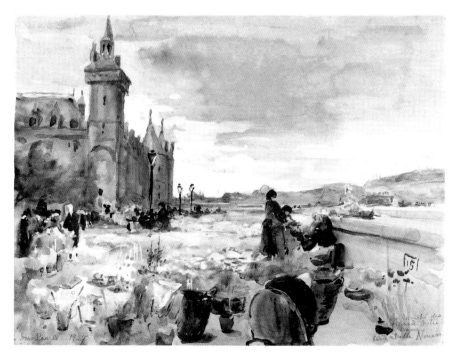

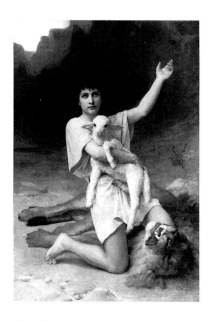

Fig. 22
Elizabeth Jane Gardner, *The Shepherd David*, c. 1895, oil on canvas. National Museum of Women in the Arts, Washington, D.C., Gift of Wallace and Wilhelmina Holladay

Fig. 23 (OPPOSITE TOP)
James Abbott McNeill Whistler, *The White Girl (Symphony in White, No. 1)*, 1862, oil on canvas. National Gallery of Art, Washington, D.C., Harris Whittemore Collection, 1943.6.2

Fig. 24 (OPPOSITE BOTTOM LEFT)
James Abbott McNeill Whistler, *Arrangement in Gray and Black, No. 1: The Artist's Mother*, 1871, oil on canvas. Musée d'Orsay, Paris

Fig. 25 (OPPOSITE BOTTOM RIGHT)
James Abbott McNeill Whistler, *Note in Red: The Siesta*, 1882–83, oil on panel. Daniel J. Terra Collection, 44.1982

grounds of the Couvent de Sion, across the street from Nourse's studio. By the 1920s Nourse was a long-time expatriate in France, having arrived in Paris in 1887. She began to show her work at the Salon the following year. She joined the many painters, French and American, who specialized in peasant images, often mothers with their children, which she painted in Brittany, among the fisherfolk in Picardy, and also in Volendam in Holland. The strong, dramatic chiaroscuro of her early work gave way at the turn of the century to softer, more colorful strategies, and she soon moved toward more sedate and upper-class, modern-life imagery painted in an Impressionist manner. During her long career Nourse achieved a degree of international acclaim that very likely would not have been available to her had she returned to her native land.[62]

Nourse had had sufficient training in her home city of Cincinnati that after having been enrolled at the Académie Julian for three months, she was dissuaded from further instruction so as not to curb her originality. The opportunities for Americans for formal study in Paris were not, of course, limited to men, and women in increasing numbers flocked to Paris in the years after the Civil War. Contrary to some accounts, women were not barred from art classes in the United States—the schools of the National Academy of Design, for instance, were open to women art students from their beginning—but such opportunities were limited both in number and scope. Actually, women perhaps received less encouragement for artistic education in France than in America, for the prestigious state-supported school, the Ecole des Beaux-Arts, did not admit women until 1897.

The first women to go abroad for study in France necessarily sought instruction in the private ateliers, but a viable alternative was available to women by 1873 at the Académie Julian. Rodolphe Julian was a less-than-successful painter who opened his private studio in 1868, making the model available for drawing or painting, without instruction. After the Franco-Prussian War he reorganized his school, offering regular visits by teams of well-known French painters, and by 1873 women were admitted alongside men. By 1887 three branches of the Julian academy were available exclusively to women, though even then their charges were double those of male students, and Julian's teams of visiting instructors came only half as often to the women's ateliers as to those of the men.[63]

One of the first women to study at Julian's—possibly one of the students who persuaded Julian to begin to accept women—was the American Elizabeth Jane Gardner, who had gone abroad in 1864, studied privately with Hughes Merle, and had already established herself as an independent artist, exhibiting at the Salon as early as 1868, before entering Julian's in 1873. She became one of the American painters most integrated into the French art establishment, painting pastoral, Biblical (fig. 22), and classical subjects very similar to those of her teacher, William Bouguereau, though within that framework she specialized in nostalgic images of childhood. It is likely, in fact, that some of Gardner's paintings have passed

for those of the great French academician, for in 1895 the American painter became Bouguereau's wife.[64]

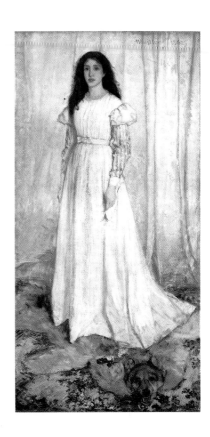

The artists discussed so far gained a tremendous degree of professional artistry from their French associations, but with the possible exception of Benjamin West, few of them had a significant influence upon European or French art. This was the achievement, however, of James Abbott McNeill Whistler, who arrived in Paris in 1856, to study there with the Swiss expatriate painter and art teacher Charles Gleyre. From Gleyre Whistler imbibed a belief in the superiority of artistry over nature, though while his teacher championed the art of antiquity, Whistler viewed the artist himself as the creator of pictorial arrangements, for which nature provided only the basic elements. To achieve his unique synthesis and style, Whistler drew upon a multiple of sources, from his early friendship with Courbet and exposure to that artist's Realist mode, to Oriental art, midcentury Neoclassicism, and the Aesthetic movement—toward the goals of which he himself greatly contributed. While Whistler removed to London in the spring of 1859, he was repeatedly back in France, in the winter of 1861–62 taking a studio in Paris, where he painted *The White Girl* (fig. 23), and he continued to maintain his ties with the French avant-garde. Toward the end of his career, from 1898 to 1900, he oversaw a Parisian art school, the Académie Carmen.[65]

Whistler's simplification of form, his reduction to single-figure compositions, his restrictive palette, and his more suggestive and sketchy rather than finished designs may have been motivated by his own recognition of his limitations, but they emerged as an aesthetic of great inventiveness that would bear tremendous impact upon late nineteenth-century art movements as diverse as Symbolism and Impressionism. Whistler's unique artistic fabric was first announced in his landscape Nocturnes of the late 1860s and in *Arrangement in Gray and Black, No. 1: The Artist's Mother* (fig. 24), painted in 1871 and exhibited at London's Royal Academy in 1872. A distant descendant of that masterwork is Whistler's *Note in Red: The Siesta*, 1882–83 (fig. 25), again a

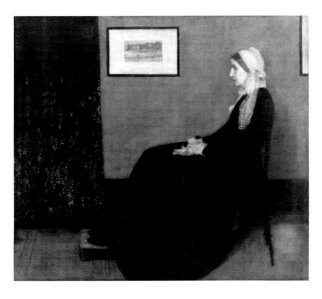

monochromatic rendering of a single figure, but here the vivid pinks-through-deep-reds enhance the lush sensuality of the sleeping woman—probably the artist's model and mistress, Maud Franklin—folded into the chaise longue and wrapped in form-defining draperies.

Whistler's relationship with Impressionism is especially apparent in *A Red Note: Fête on the Sand, Ostend* (fig. 26), painted on a visit to the Belgian coast in the autumn of 1887, referred to, in fact, as "one of the most 'Impressionist' of Whistler's paintings."[66] It was first exhibited at the Royal Society of British Artists in 1887. Whistler was, at the time, president of this once-moribund organization and was attempting to revitalize it through the exhibition of avant-garde works by himself and his friends; significantly, the show also included a substantial number of works by Monet. Though one of the society's members declared in referring to *A Red Note* that, "If he can do that, I'll forgive him—he can do anything,"[67] his modernist

Fig. 26
James Abbott McNeill Whistler, *A Red Note: Fête on the Sand, Ostend*, 1887, oil on panel. Daniel J. Terra Collection, 32.1983

Fig. 27
James Abbott McNeill Whistler, *The Sea, Pourville*, 1899, oil on panel. Daniel J. Terra Collection, 2.1985

inclinations and peremptory manner led to his forced resignation from the presidency the following year. *The Sea, Pourville* (fig. 27), one of a series of small panels that Whistler painted at that French coastal resort during the summer of 1899, is an even more reductive and "impressionist" rendering. Both paintings are quite personal, testifying to Whistler's long-lasting fascination with the sea, and yet at the same time they offer recognition of the growing popularity during the nineteenth century of seaside pleasures, pictorialized in France by Eugène Boudin, in England by William Frith, and in America by Homer.

Whistler's impact was felt by a great number of American artists, some working in the United States and others active abroad, both in England and on the Continent.[68] Among this last group was a party of Munich-trained painters who spent the winter of 1879–80 in Venice at the same time that Whistler was there to prepare a series of etchings commissioned by the Fine Arts Society in London. John White Alexander was one of these, who was later able to renew his friendship with Whistler in 1886 while in London on commission for illustrations for *Century Magazine*. It was only in the last decade of the century, after Alexander expatriated to Paris in 1891, that the full extent upon Alexander of Whistler's creed of art for arts' sake blossomed in a series of stylized paintings of attractive women, ultimately derived from Whistler's manipulation of color to reinforce mood, and of line to create decorative designs independent of naturalistic form. Indeed, critics were quick to identify Alexander's figural work with Whistler's portraiture, when he made his debut in 1893 at the Salon of the new Société Nationale des Beaux-Arts. At the same time, Alexander offered welcome support for Whistler in a legal battle brought in Paris against Whistler by Sir William Eden.[69] Alexander's mature style flourished in France also under the influence of both Art Nouveau and the Symbolist movement.[70]

The mature work of Thomas Wilmer Dewing offers an even more direct homage to Whistler. Dewing's artistic career can be viewed, in fact, as a replacement of his early Académie Julian–influenced aesthetic of descriptive form for the evocative nuances of Whistler. Dewing met Whistler late in 1894 in Paris, where they were introduced to one another by their mutual patron, Charles Lang Freer. The two artists subsequently spent much time together in London, but such association could only have confirmed Dewing's appreciation for the older painter.[71] In reference to his trip to Europe, Dewing stated, "There are no great artists in Europe—I met only two, and they were Americans, Whistler and MacMonnies."[72]

Both the earlier *Madeline* and the later *Portrait of a Lady Holding a Rose* (figs. 28 and 29) are seated profile images in emulation of Whistler's famous portrait of his mother. The latter picture even includes a scroll painting hanging on the otherwise bare wall behind, both mimicking the arrangement in Whistler's portrait and offering recognition of the Oriental concern for placement, along with the balance of empty and solid spaces,

Fig. 28
Thomas Wilmer Dewing, *Madeline*, c. 1890, oil on canvas. Daniel J. Terra Collection, 13.1980

Fig. 29
Thomas Wilmer Dewing, *Portrait of a Lady Holding a Rose*, 1910–15, oil on canvas. Daniel J. Terra Collection, 8.1985

that both artists shared. The soft atmosphere enveloping the figures is also derived from Whistler, and defines one of that painter's major contributions to the Tonalist movement in America, of which Dewing was one of the most significant figural specialists. But the choice of thin, somewhat boney and high-cheeked, elegant models, and the soft, glowing colors are very much Dewing's own. The latter is perhaps the quality that most relates him to Impressionism, and probably constitutes one explanation for his invitation to membership in the Ten American Painters, the Impressionist-oriented movement that was organized in New York late in 1897. Dewing was a regular contributor to the annual exhibitions of the Ten until the demise of the group in 1919.[73]

The transition from more academic strategies to those of Impressionism is nowhere better observed than in the art of Dennis Miller Bunker, though Bunker's painting also demonstrates the dichotomy that can be found to a lesser or greater degree between the figural work and the landscapes of many traditionally trained artists.[74] Bunker entered the Ecole des Beaux-Arts in the autumn of 1882, and began his studies there with Gérôme early in 1883, solidifying his mastery of the human form, which he would use to advantage in the portraits and figure pieces he subsequently painted in Boston, while spending his summers painting in the French countryside. In the pictures painted along the Oise River in 1883, such as *La Croix, St. Ouen, Oise* (colorplate 50), and in Brittany in 1884, such as *Brittany Town Morning* (colorplate 51), painted in Larmor, he utilized the muted harmonies of the Barbizon and Naturalist artists. Bunker's Larmor paintings represent the ultimate expression of Tonal Naturalism in landscape, the strong, glaring light solidly defining the characteristic peasant homes, dominated by the village church, with the artist uniquely able to synthesize the strong, structural definition of the buildings with the freer, painterly handling of the foreground field and bushes. As one writer has noted, Bunker here is able to combine "strength and softness," and "light against shadow," while "horizontals play against verticals."[75]

The decisive factor in Bunker's tragically short career—he died at age twenty-nine, the victim of influenza—occurred back in Boston early in 1888 when he met John Singer Sargent, who was sojourning in the New England metropolis in order to paint the portraits of many of the city's social elite. Attracted by the engaging young artist, Sargent invited Bunker to spend the summer with him in England at Calcot, near Reading, on the Thames River. Bunker accepted the invitation, and Sargent memorialized the visit in his masterly *Dennis Miller Bunker Painting at Calcot* (fig. 132), one of a series of images of artists at work that Sargent had begun earlier in the decade. This was the period of Sargent's greatest involvement with the Impressionist aesthetic, practiced especially during his summer holidays during 1885–89, a direction influenced by his close association at the time with Monet, whom Sargent visited in his home village of Giverny and whose pictures Sargent began to collect at this time.[76]

Bunker was fascinated but confused by the radical strategies of Impressionism as pursued by Sargent that summer; he noted in a letter written from Calcot to his friend Joe Evans, "I did not get anything done in these days. I've done nothing."[77] Indeed, in Sargent's picture Bunker actually is not painting but rather standing away from and staring at the canvas on his easel, suggesting perhaps an indecisiveness born of his exposure to the new aesthetic. Nevertheless, on his return to Boston that autumn, and in his subsequent summer work at Medfield, Massachusetts, Bunker's final landscapes reveal the bright colorism, long, spiky brushstrokes, and free paint application derived from Sargent's own Impressionist work. This was true, however, only of Bunker's landscape paintings from these last two years of his life. In his figural pieces, such as his masterwork, *The Mirror* of 1890 (fig. 30), he remained faithful to the academic strategies he had learned from Gérôme. The figure is conceived in strong, formal definition and emphatic light and dark contrasts, while the subject is traditional, the solitary woman reclusively immersed in her own private world and in her own image. The image is startlingly similar to those of Dewing and other figure painters who had received their academic training in French ateliers; Dewing, in fact, thought it the best canvas Bunker ever painted.[78]

Sargent himself had probably received the most appropriate training in Paris for an artist whose work would, temporarily at least, reflect the new Impressionist mode. Born and reared abroad, at age eighteen Sargent entered the independent atelier of Carolus-Duran, an artist more concerned with virtuoso painting with the brush than long, tedious hours of drawing from the model. The vivacity and emphasis upon direct painting that disheartened Kenyon Cox during his several months with Carolus-Duran were the same factors that went to insure Sargent of his painterly assurance whether in high-style society portraits, vigorous figure compositions, or Impressionist landscapes. Sargent not only emulated his master's technique, but sought to equal him in the field of portraiture, and he succeeded. He achieved success in portraiture first in France, until the 1884 Salon exhibition of his scandalous image of Madame Gautreau with risqué décolletage, shown as *Portrait of Madame XXX* (fig. 31), caused such a furor that Sargent saw fit to remove to England. His first period of true acceptance as the major portraitist of the age occurred, however, during a visit to New England in 1887–88. After that he conquered London society as well.[79]

From the beginning Sargent also sought to make a name for himself by painting every year or so major figure works of startling originality, to be shown at the Salon or at the Royal Academy in London. The first of these, and his second work to be exhibited at the Salon, was *Oyster Gatherers of Cancale* of 1878 (colorplate 56), while the smaller finished study for it (colorplate 55) helped inaugurate the annual exhibition series of the Society of American Artists in New York, also in 1878. These were both studio compositions, based upon such plein air studies as *Young Boy on the Beach, Girl*

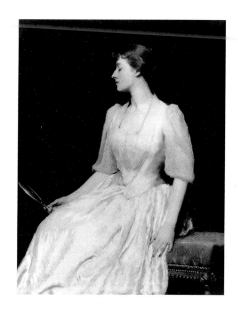

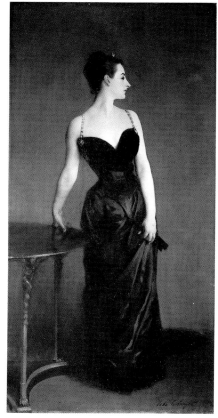

Fig. 30
Dennis Miller Bunker, *The Mirror*, 1890, oil on canvas. Daniel J. Terra Collection, 43.1980

Fig. 31
John Singer Sargent, *Portrait of Madame XXX (Madame Gautreau)*, 1884, oil on canvas. Metropolitan Museum of Art, New York, Arthur H. Hearn Fund, 1916

on the Beach, and *Breton Girl with a Basket* (colorplates 52, 53, and 54), painted during ten weeks spent in the summer of 1877 on the coast of Brittany with a fellow student, Eugene La Chaise. So vivid is Sargent's manipulation of the medium and so fresh is his light and colorism, that the final composition also appears to be done on the spot, unlike the obvious studio qualities of most peasant paintings of the period. Indeed, while the subject here is traditional and the site is the favorite painting ground of Brittany, Sargent has reinterpreted the motif to emphasize the sense of the outdoors, rather than the hardships of rural life or the picturesqueness of the local inhabitants. So it was viewed by the admiring critics who wrote about the two pictures in their debut exhibitions; American writers spoke about the picture's light and color, and indeed, the work might well be considered "proto-Impressionist."[80]

The influence of Carolus-Duran's painterly mode can be seen in the work of numerous other Americans who studied with him. One of the most notable, though an artist who has been overlooked in the rash of recent monographs on late nineteenth-century American artists, is J. Carroll Beckwith, who entered Carolus's atelier in 1873.[81] Carolus's vivid coloration and direct, somewhat "slick" presentation can be seen even in as homely a subject as Beckwith's *Mother and Child* (fig. 140), which projects a palpable reality. Beckwith was primarily a figure painter of portraits and ideal female images. Like many Americans, the artist obviously felt more independent and could indulge in more direct, less self-conscious expression in his casual French landscapes, such as *French Spring* (colorplate 86), again a work characterized by Impressionist strategies of high-keyed color and vivacious brushwork.

One American artist, Mary Cassatt, had already become associated with the French Impressionist movement in Paris by the time Sargent and Beckwith were to some degree becoming involved with the strategies of that avant-garde aesthetic. Born in Pittsburgh, Cassatt had studied at the Pennsylvania Academy of the Fine Arts in Philadelphia before leaving for France around 1865/66. Barred as a woman from study at the Ecole des Beaux-Arts, she took criticism from Gérôme privately and supplemented this with instruction from a variety of sources—from Charles Chaplin, the fashionable painter of women; from the veteran artist and teacher Thomas Couture at Villiers-le-Bel; and in nearby Ecouen from Edouard Frère and his follower Paul Soyer—all popular French painters of sentimental imagery featuring French peasant children.[82]

Cassatt's years of study were interrupted by the Franco-Prussian War in 1870, at which time she was briefly back in America. Once she had returned to Europe at the end of 1871, she remained an expatriate until the end of her life, traveling in Europe but only making two brief visits to her native land. She appears to have begun to make a name for herself in 1872 while studying in Parma in Italy,[83] copying old-master paintings there on a commission from the Cathedral in Pittsburgh, but her first mature body of

work was subsequently painted in Spain in 1872–73. Like so many American artists, she had gone to Madrid to study the works of Velázquez at the Prado, but her paintings appear to have been done in Seville, large-scale Spanish genre subjects not unrelated to the earlier paintings of similar themes by Manet. Soon after her return in April 1873 to Paris, where she exhibited one of her Spanish pictures at the Salon, Cassatt became aware of the work of Edgar Degas, who was to become her mentor and the greatest influence on her art. In 1875 she advised her good friend, the wealthy American Louisine Elder (soon to become one of America's greatest collectors as Mrs. Horace Havemeyer), to purchase a Degas pastel, *Ballet Rehearsal* (1874; Nelson-Atkins Museum of Art, Kansas City), which would be the earliest French Impressionist picture to be exhibited in the United States. Cassatt and Degas appear to have met by 1877, at which time, impressed by Cassatt's art, Degas persuaded her to join the exhibitions of the Impressionist group, which she began to do in 1879. Cassatt's paintings were seen only occasionally in the United States until the 1890s. Although she maintained her American identity, to all intents and purposes she was a member of the French avant-garde.

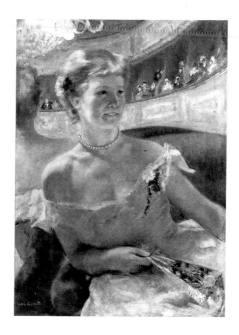

Fig. 32
Mary Cassatt, *Woman in a Loge (Lydia in Loge)*, 1879, oil on canvas. Philadelphia Museum of Art, Bequest of Charlotte Dorrance Wright, 1978-1-5

While during the mid-1870s Cassatt's painting was becoming increasingly more fluid and colorful, it was only in about 1878 that she adopted the strategies of Impressionism. Even so, she worked in emulation of Degas, often adopting indoor, controlled lighting and never fully sacrificing formal solidity for the sake of color and vivacious brushwork. In any case, Cassatt's fullest adherence to Impressionism lasted less than a decade, from about 1878 until 1886, after which time considerations of line, pattern, and design increasingly reasserted themselves, adopted under the influence of Japanese art. Like Degas, Cassatt's subject matter was almost totally figural, and in her case, she concentrated upon upper-class women, seen at home or at the theater, occasionally in garden settings, and increasingly in the maternal role. While women's world was her pictorial ambience, she presented it in a self-sufficient manner, without sentiment or constraints. One of Cassatt's theater subjects, her 1879 *Woman in a Loge* (fig. 32), was probably the first fully Impressionist picture by an American artist that was subject to a critical review by an American writer when it was exhibited in Paris in the 1879 Impressionist exhibition; not surprisingly, it was poorly received and mocked.[84]

Cassatt emulated Degas also in her increasing exploration of pastel, vigorously taking advantage of the graphic possibilities and chalky textures of the medium. The figure in the pastel *The Cup of Chocolate*, 1897 (color-plate 79), is an upper-class, self-assured young woman whose elegant form nevertheless fills the picture plane, flattened and sharply outlined, with well-defined features. More plebeian is *Jenny and Her Sleepy Child*, about 1891 (colorplate 71), which is typical of Cassatt's colorful and vivacious manner but also of her direct, no-nonsense interpretation of the mother-child relationship. "Jenny" both holds and enfolds the child, who is almost totally

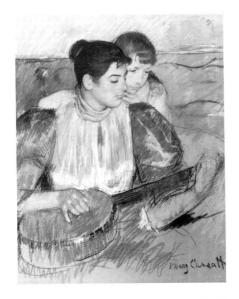

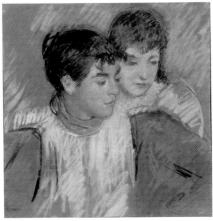

Fig. 33
Mary Cassatt, *The Banjo Lesson*, 1894, pastel on paper. Virginia Museum of Fine Arts, Richmond, Adolph D. and Wilkins C. Williams Fund, 58.43

Fig. 34
Mary Cassatt, *Two Sisters (Study for the Banjo Lesson)*, 1894, pastel on paper. Museum of Fine Arts, Boston, Charles Henry Hayden Fund, 32.98

limp against the large, rounded frame of his mother. This is far from the traditional imagery of the Madonna and Child,[85] or of its popular reinterpretation by contemporary painters of peasant families, such as Cassatt's contemporary and fellow American Elizabeth Nourse. A further departure from tradition is established by the deliberately unfinished nature of the painting; Cassatt has painted only as much as was necessary to clearly define her basic motif.

We move outdoors with Cassatt's *Summertime* of about 1894 (colorplate 72), one of several variations of the motif of mothers and children at leisure in a boat, feeding ducks.[86] Here the composition appears flattened in the manner of Japanese aesthetics by the lack of figural modeling and especially by the absence of a horizon. But, in the emphasis upon bright sunlight and the scintillating, multicolored brushwork defining the rippling water, this may be Cassatt's most forceful return to the strongly Impressionist mode that she had abandoned almost a decade earlier. The picture is, in fact, one of a number painted in the early 1890s related to the series of color prints in drypoint and aquatint that Cassatt created at the time, sometimes considered to be her finest achievement, and certainly among the most splendid graphic works of the late nineteenth century by French and/or American artists.[87]

Feeding the Ducks (colorplate 76) is the color print that corresponds to *Summertime*. *The Banjo Lesson* (colorplate 75) is another print of this period that relates to several corresponding pastels (figs. 33 and 34), in which clarity of drawing and colorful design clearly derive from Japanese models. These prints are slightly later than the original "set" of ten prints that first introduced Cassatt's innovative graphic accomplishments in 1890–91. *The Lamp* and *In the Omnibus* (colorplates 73 and 74) are among those ten prints, interpreting the life of the contemporary French woman in an aesthetic mode derived from Japanese prints, itself a facet of modern artistic life having great repercussion in the Parisian art world. Unlike the later prints, neither of these appear to have a counterpart among Cassatt's oils and pastels. *Under the Horse-Chestnut Tree* and *By the Pond* (colorplates 77 and 78) are still later prints of the 1890s by Cassatt, both dealing with the juxtaposition of sharply outlined mothers and children, rendered in Cassatt's highly distinctive graphic manner. The settings for these, as well as the slightly earlier *Feeding the Ducks*, along with its oil counterpart, may be the grounds of the eighteenth-century Château de Beaufresne at Mesnil-Théribus, fifty miles northwest of Paris, which Cassatt had purchased in 1894.

Cassatt's prints were extremely well received on both sides of the Atlantic, and it was these that first brought her to the full attention of an American audience. One-artist exhibitions were offered Cassatt during the 1890s by her friend, the dealer Paul Durand-Ruel. Her first such show was held in Paris in 1891, where the set of color prints was featured, and

another was in 1893. In New York a selection of her prints was shown at Keppel's Gallery in 1891, but it was not until 1895 that an exhibition of her paintings was on view in that city, at Durand-Ruel's New York gallery. Another took place in 1898, just before her first return to her native land in twenty-three years. Nevertheless, she otherwise remained abroad, influencing wealthy Americans in collecting the work of her colleagues among the French Impressionist painters, but later in her life disdaining more modern aesthetic innovations of the twentieth century.

By the end of the nineteenth century, American artists had overwhelmingly adopted the tenets of Impressionism, but the major introduction to this aesthetic took place as much in Giverny as it did in Paris. Claude Monet had moved to the small French village in 1883, and four years later a host of American art students began to summer there, some residing almost the year round, and they in turn attracted other fellow countrymen and -women, so that by the turn of the century Giverny had become a full-fledged art colony, primarily of painters (and some sculptors) from the United States, but also including artists from Great Britain, Norway, and even Bohemia.[88]

There is some confusion among the reports concerning the initial American contacts with Giverny, and discrepancies regarding who were the first Americans to visit there, and when and why they came. Both Willard Metcalf and Theodore Robinson (separately) are said to have met and visited with Monet as early as 1885, and there are several paintings by Theodore Wendel painted in Giverny that are dated 1886. Nevertheless, the "onslaught" of American tyros there occurred in 1887, when seven artists—the Canadian William Blair Bruce and six from the United States: Metcalf, Robinson, Wendel, Louis Ritter, Henry Fitch Taylor, and John Leslie Breck—along with Breck's brother, Edward, and their mother arrived in Giverny. This would have been sometime between mid May and late June.

Some reports state that the Americans were not aware of Monet's presence there, but were attracted by the outward appearance of the town. In any case, the artists—Metcalf initially—were able to persuade the owners of the local grocery store and café, Lucien Baudy and his wife, Angélina, first to help them find rooms with local families and then to build a studio and keep boarders the year round, thus commencing in 1887 the well-known Hôtel Baudy, the future center of art colony activities. Other artists would rent rooms elsewhere in the village, or rent and even buy domiciles there, some of which long remained in the hands of the artists' descendants.[89] One report states that the initial group of Americans in Giverny did not make Monet's acquaintance that year, though he is also said to have welcomed them to the village, perhaps subsequently; after a few years, however, the French artist became increasingly disturbed at the influx of foreign painters and correspondingly retreated from their presence.[90]

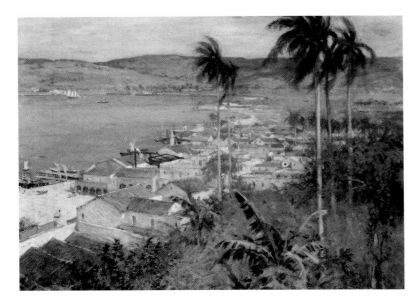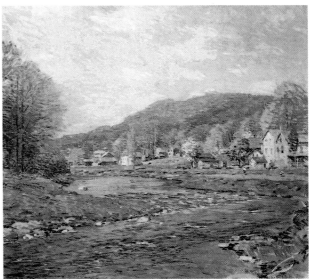

Fig. 35
Willard Leroy Metcalf, *Havana Harbor,*
c. 1902, oil on canvas. Daniel J.
Terra Collection, 28.1985

Fig. 36
Willard Leroy Metcalf, *Brook in June,*
1919, oil on canvas. Daniel J.
Terra Collection, 24.1980

Willard Leroy Metcalf was one of the several painters who visited Monet in Giverny before 1887.[91] Like many of the American Givernois, Metcalf was from Boston and had achieved a modicum of fame even before he went abroad through his illustrations for articles on the Zuñi Indians that had appeared in *Harpers* and *Century* magazines in 1882–83. He went to Paris in the fall of 1883, studying at the Académie Julian and traveling to England and throughout France during the summer months, working in such art centers as Pont-Aven in Brittany, Grèz, and Barbizon, before settling with his companions in Giverny in 1887. *The River Epte, Giverny* (colorplate 9), a study for a larger version of the same scene painted in 1887 (colorplate 10), reveals Metcalf investigating the properties of light and the effect of patterned shadows, with the paint freely applied. In Giverny his work took on a new luminosity and coloristic richness not in evidence in his earlier French scenes, but this may be due as much to a trip he took to North Africa in the winter of 1886–87 as it was to the impact of Impressionism, as he discovered it in Giverny. The painting is also a quintessential Giverny scene as painted by the first generation of Americans there, whose favorite subject consisted of informal scenes along the Epte River, often, as here, with views of village homes and farm buildings seen through the trees.

Late in 1888 Metcalf returned to the United States, and early the next year he enjoyed a one-artist exhibition at the St. Botolph Club in Boston. He was greatly involved with illustration and teaching during the 1890s, and his full adoption of the Impressionist aesthetic was slow and, at first, tentative. He appears not to have followed up after a group of ravishing scenes painted at Gloucester, Massachusetts, in the summer of 1895, while becoming involved immediately after with decorative commissions, murals for the Appellate Court building in New York, and then scenes of Havana as well as ceiling decorations for the Havana Tobacco Company in the St. James Building, also in New York. In the

painting *Havana Harbor* (fig. 35), a result of his visit to the Cuban capital in 1902, the artist succumbs again to the light and color of the tropics as he had done earlier in North Africa.

The full impact of Impressionism was not lastingly felt by Metcalf until the period of the artist's "renaissance," as he termed it, which took place in rural Maine in 1903–4. From this year of regeneration, both personal and artistic, emerged the mature Impressionist, devoted to the portrayal of New England scenery, such as his *Brook in June* of 1919 (fig. 36), a scene in rural Connecticut, where the small village rests in complete harmony with the surrounding natural setting. Metcalf was only an occasional figure painter, though an extremely competent one. *My Wife and Daughter* (fig. 37) is one of his finest figurative works, painted during one of the last of five summers that he and his family enjoyed in a rented Colonial house on Jordan's Cove in Waterford, Connecticut. The joyousness of these Connecticut scenes epitomizes the distinctive nature of Metcalf's Impressionism, the roots of which can be traced to his developing years in Giverny.

Theodore Wendel, another of the initial American group in Giverny, appears to have become more fully involved with Impressionist strategies during his years there. Wendel was Ohio born and studied initially in Cincinnati.[92] Like many art students from the Midwest, he studied abroad first in Munich, in the late 1870s, and after returning to the United States was back in Europe, this time studying at the Académie Julian in Paris in the mid-1880s. Wendel's *Brook, Giverny*, dated 1887 (colorplate 21), probably painted on the Ru River, is a more high-keyed version of Metcalf's scene on the Epte, and includes a prominent pollarded willow, another favorite motif of the American painters. His *Flowering Fields, Giverny* (colorplate 22) depicts still another theme preferred by these artists, and one that echoes Monet's own pictures of broad, horizontal bands of poppies and other flowers, backed by a range of poplar trees. Behind these, in turn, Wendel depicts the low-lying hills from which many of the artists painted their more panoramic views of Giverny and the Seine Valley.

Like Metcalf, Wendel returned to the United States, probably at the beginning of 1889, holding an exhibition of his works in his Boston studio in March of that year. Critics of the two one-artist shows, Metcalf's and Wendel's, distinguished between the rich greens and intense light in Metcalf's landscapes and the more coloristic ones of Wendel, recognizing the latter's conversion to Impressionism. Referring to a second studio exhibition held in 1891, another critic wrote that "Wendel comes the nearest of the Boston impressionists to handling the Monet style with effect."[93] New England remained Wendel's home for the rest of his career.

Louis Ritter is far less known today than either Wendel or Metcalf, perhaps due to his early death (he died in 1892 at the age of thirty-seven). He may also have stayed in Giverny the shortest time of any of the initial

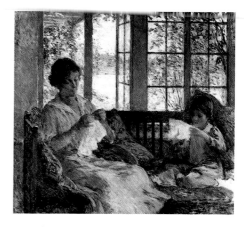

Fig. 37
Willard Leroy Metcalf, *My Wife and Daughter*, 1917–18, oil on canvas. Terra Foundation for the Arts, Daniel J. Terra Collection, 1988.28

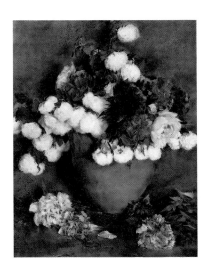

Fig. 38
Louis Ritter, *Flowers: Peonies and Snowballs*, 1887, oil on canvas. Terra Foundation for the Arts, Daniel J. Terra Collection, 1987.29

American Givernois. Like Wendel, Ritter was from Ohio and studied abroad first in Munich, beginning in 1878; he subsequently returned to Cincinnati and then settled in Boston in 1883, before enrolling at the Académie Julian, probably in 1886. For a number of the Paris-trained Americans, still lifes constituted some of their earliest finished compositions, a theme in which they could work out arrangements of color and form in regard to a relatively unchanging, motionless subject. Ritter's *Flowers: Peonies and Snowballs* of 1887 (fig. 38), painted the year he went with his colleagues to Giverny, is one of the most glorious of such still lifes so far located, the artist conceiving a vivid chromatic arrangement while still working within a traditional mode. *Willows and Stream, Giverny,* also painted in 1887 (colorplate 20), is Ritter's contribution to that favorite motif of the willow-bordered stream, where he has adopted to some degree the broken, flecked brushwork of Impressionism. By the following year Ritter had rejoined his Cincinnati and Munich mentor, Frank Duveneck, at the Villa Castellani near Florence, but he was back in Boston by 1890.

Although today little better known than Wendel or Ritter, and never achieving the fame of Robinson, John Leslie Breck may have been the most significant of the original Givernois, both in regard to his initial receptivity to Impressionism and also in the formation of the art colony there, which attracted other artists to the town. Indeed, on Breck's death in 1899, his colleague John Twachtman wrote that Breck had "started the new school of painting in America."[94] Breck grew up in the vicinity of Boston, and like Wendel and Ritter, studied in Munich before returning to Boston in 1882. He was back in Europe in 1886, taking instruction in Paris at the Académie Julian, where he would have renewed his friendship with Wendel and Ritter, and perhaps Metcalf, whom he may well have known in Boston. Of the group of Americans who descended upon Giverny in 1887, he and Robinson were the two who became closest to Monet and his "adopted" family, the Hoschedés; Breck is known to have become acquainted with the Hoschedés by February 1888. Monet is said to have invited Breck to paint with him, and indeed Breck appears to have stayed on in Giverny during much of the winter of 1887–88, and certainly the following year, residing at the Hôtel Baudy from April 4, 1888, to October 30, 1889.

The River Epte, Giverny of about 1887 (colorplate 13) is Breck's contribution to that most popular theme among the Americans, but it is notable for the expansive size of the canvas; Breck was clearly confident in exerting his new skills at colorful, outdoor landscape painting. Breck's compositions, as here, are usually firmly constructed, allowing the painter more freedom to work with rich textural variations and pure color.[95] His confidence with the large-size picture was not misplaced. Giving Giverny as his address, and with two Giverny landscapes on view in the Salon of 1888 and another in 1889, Breck became the first American to publicly exhibit pictures painted in the village. On the other hand, Breck did not adopt Impressionist strategies in all of his landscapes, and some of the largest of

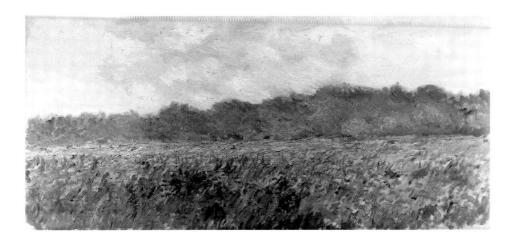

Fig. 39
Claude Monet, *Field of Yellow Irises at Giverny*, 1887, oil on canvas. Musée Marmottan, Paris

these, such as *Autumn, Giverny (The New Moon)*, 1889 (colorplate 15), are painted more in the spirit of Millet and the Barbizon artists; these, in fact, were the works most appreciated when Breck returned to America and exhibited his work in Boston in 1890.[96] The painting's more traditional Tonal aesthetic mode was probably intended for critical approbation, and it was successful, for the picture won an honorable mention at the Exposition Universelle in 1889.

For a time Breck must have appeared as Monet's most promising artistic heir among the Americans. *Yellow Fleur-de-Lis*, 1888 (colorplate 14), would seem to have been inspired by Monet's *Field of Yellow Irises at Giverny*, 1887 (fig. 39), while his *Garden at Giverny*, of about 1890 (colorplate 17), responds fully to the Impressionist aesthetic. This is one of the earliest Impressionist flower garden pictures by an American artist, a theme that in this context is also indebted to Monet, and in fact Breck is known to have painted scenes in Monet's own garden at this time. Indeed, this painting may have been one of those that had been brought back to America by the artist Lilla Cabot Perry and put on display in her Boston studio, probably in the autumn of 1889, and which the writer Hamlin Garland recalled as "a group of vivid canvases by a man named Breck, [which] so widened the influence of the new school. . . . I recall seeing the paintings set on the floor and propped against the wall, each with its flare of primitive colors—reds, blues, and yellows, presenting 'Impressionism,' the latest word from Paris."[97]

Breck returned to New England in the summer of 1890; he displayed a large group of his Giverny pictures at the St. Botolph Club in November, a show in which the critics recognized the impact of Monet and Impressionism to a far greater extent than they had in the exhibits held by Metcalf and Wendel the previous year. Although the reaction was generally negative, it was agreed that the show was "the art sensation of the season"; the garden pictures Breck exhibited there were among those that reviewers found among the more acceptable of his works.[98] Breck was back in Giverny in 1891, and it was then that he painted his greatest homage to Monet: the series of fifteen *Studies of an Autumn Day*, twelve of which are in the Terra collection (colorplate 18). These emulate Monet's Grainstack series of

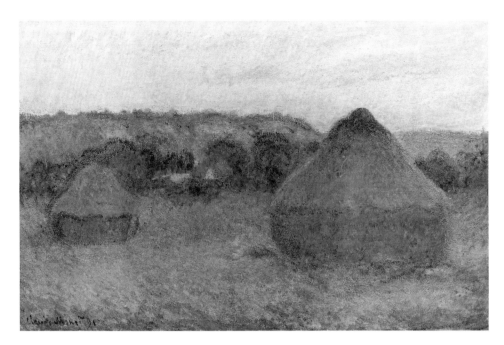

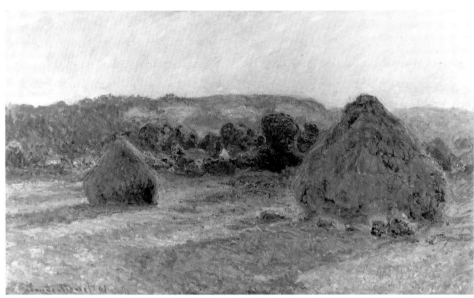

Fig. 40
Claude Monet, *Grainstacks (End of Day, Autumn)*, 1891, oil on canvas. Art Institute of Chicago, Mr. and Mrs. Lewis Larned Coburn Memorial Collection, 1933.444

Fig. 41
Claude Monet, *Grainstacks (End of Summer)*, 1891, oil on canvas. Art Institute of Chicago, Arthur M. Wood in memory of Pauline Palmer Wood, 1985.1103

1888–91 (figs. 40 and 41, for two works in the series), though on a smaller scale and theoretically on a single day (in any case, painted over a brief period of three days as opposed to Monet's seasonal changes). Breck intriguingly studies here the quality of morning haze, the changing shadow patterns, the coloristic richness of full sunlight at midday, and the chromatic variations in the sky, as seen within a simple but effectively structured composition of diminishing grainstacks, with the hills of Giverny beyond.

Shortly after painting this series, Breck left Giverny, this time for good. At some point, very possibly during the summer of 1891, Breck had become romantically involved with one of Monet's stepdaughters, the artist Blanche Hoschedé, but Monet disapproved of the proposed union and successfully discouraged it. This may have led Breck to leave, at which time

he went to England where he painted in the Kentish countryside and exhibited at the New English Art Club in 1892.

Breck may have painted *Morning Fog and Sun,* dated 1892 (colorplate 19), in England, or after he had returned to the United States; although it is a continuation of his Grainstack series, and may have been begun in Giverny, the picture's large scale and more complicated organization suggest that it is a synthetic, studio composition, the culmination of his earlier studies done in homage to Monet. Back in America, Breck painted in various scenic locations in Massachusetts, exploring the seasonal landscape in a variety of styles. His study for *Indian Summer,* done in the autumn of 1892 (fig. 42), must have been one of the earliest pictures created back in the United States, and during the winter of 1892–93 he painted a series of magnificent winter scenes at the family farm in West Rutland, Massachusetts. *Winter Landscape* (fig. 43) is one of these, offering evidence of a new clarity of drawing and composition. His Tonal works may have been the best received, critically, but Impressionism remained a strong factor in his aesthetic make-up. A painting by Breck previously titled "Rock Garden at Giverny" is, in fact, a canvas painted about 1894 and titled *A Bit of Detail* (fig. 44). A more panoramic scene (private collection) was painted, probably in 1894, near Annisquam on the Massachusetts north shore,[99] a location popular with artists in the later decades of the nineteenth century. In such works, Giverny and Impressionism had effectively been transferred to America.

Theodore Robinson, today the best known of the original contingent of American artists to discover Giverny, was also the oldest of the group, and unlike his colleagues he was in France during the 1880s to enjoy the superior conditions and potentials for painting there, not for formal instruction as was the case with Metcalf, Wendel, Ritter, and Breck. Robinson had gone to Paris initially in 1876, studying with Henri Lehmann, Carolus-Duran, Gérôme, and Jean Joseph Benjamin-Constant at

Fig. 42
John Leslie Breck, *Study for "Indian Summer,"* 1892, oil on canvas. Daniel J. Terra Collection, 9.1990

Fig. 43
John Leslie Breck, *Winter Landscape,* c. 1893, oil on canvas. Daniel J. Terra Collection, 1.1990

Fig. 44
John Leslie Breck, *A Bit of Detail,* c. 189, oil on canvas. Daniel J. Terra Collection, 49.1984

Fig. 45
Theodore Robinson, *La Vachère*,
1888, oil on canvas. Baltimore
Museum of Art, Given in memory
of Joseph Katz by his children,
BMA 1966.46

the Académie Julian and exhibiting at the Salon in 1877. He returned to
America late in 1879, painting easel pictures and doing decorative work in
Boston, New York, and on the island of Nantucket. During his initial trip
abroad, he had spent some time at the artists' colony in Grèz-sur-Loing,
and he appears to have been drawn to the comfortable and congenial life in
such a situation, for much of his time after he returned to France in 1884
was spent at Barbizon, though he also painted in Paris, which was essentially
his home.[100]

Very few paintings by Robinson are known from his first summer in
Giverny in 1887, and it may well be true that he did not form a close
relationship with Monet until the next year. However, he is reported to have
been taken to visit Monet by their mutual friend, the artist Ferdinand
Deconchy, as early as 1885, so it would seem unlikely that Robinson would
not have followed up this meeting while actually residing in Giverny two
years later.[101] However, once the two artists did meet, they became good
friends, and Monet served as a mentor to Robinson, though not in any
formal sense.

Evidence of Robinson's "conversion" to Impressionism, admittedly
somewhat tentative, is abundant, his art becoming more painterly and
colorful each succeeding year. His is one of the first names in the Hôtel
Baudy register—he resided there from September 18, 1887, through
January 4, 1888; he was back again from May 12 to December 12, 1889;
May 19 to November 3, 1890; and April 6 to November 20, 1891.[102] In
1892 he spurned the Baudy, taking a room elsewhere in the village and
even taking his meals in a little café.[103] He made trips back to Paris, of
course, and almost every winter he would return to New York, remaining
for the spring exhibition season, before departing again for France. Thus,
Robinson's initial Impressionist works were first seen in New York in
1889, at the annual exhibition of the Society of American Artists, and he
was among the first painters to have been recognized as an Impressionist
by art critics in that city, as Wendel and Breck were in Boston. A large
Giverny picture of 1888, *La Vachère* (fig. 45), was also shown at the Salon
in 1889.

Robinson's paintings divide about equally between figurative work
and pure landscapes. *From the Hill, Giverny*, painted around 1889 (colorplate
2), is typical of the latter, which often consist of scenes painted from the
low-lying hills above the village, the artist anchoring his composition with a
series of long diagonals, often reinforced by the planes of the roofs and
walls of buildings. Paint is laid on in short but unsystematic brushstrokes,
and the colors are bright but usually of limited range, emphasizing a variety
of greens balanced by mauves, pinks, and lavenders. Most of Robinson's
landscapes are quite lush, but as he usually stayed on in Giverny into the
beginning of winter, his art does exhibit a seasonal range, and his *Winter
Landscape* (colorplate 3), painted in December 1889 just before he sailed for
home, won the Webb Prize for the best landscape in the exhibition by an

artist under forty years of age at the annual show of the Society of American Artists the following spring.

Robinson's increasing confidence in manipulating paint and color, and his growing interest in effects of light are seen in a number of his later figurative works, such as *Blossoms at Giverny* (colorplate 4). Though undated, it was probably painted in 1891 and may be the picture originally titled *From a Chamber Window*, which was shown in Robinson's first one-artist exhibition, in February 1895 at the Macbeth Gallery in New York. The plunging perspective of the picture is unusual for Robinson, but can be paralleled in the work of some of his French Impressionist contemporaries, such as Gustave Caillebotte; it allowed Robinson to explore the decorative effects of the patterned blossoms, repeated in the scintillating shadow design cast on the sunlit ground. *Père Trognon and His Daughter at the Bridge* of 1891 (colorplate 5) is one of Robinson's most complex figurative works, richly colored with the blue of the water of the Ru River echoed in Trognon's coat, and the whole composition glistening in bright sunlight. It is a commonplace scene endowed by Robinson with a sense of beauty, and one senses that the artist is extremely comfortable both with his outdoor painting methodology and with his adopted village.

Wheat Field, Giverny (fig. 46), in contrast, is one of Robinson's most sober Giverny pictures, its somber palette heightening the concern expressed here for the agrarian basis of the village's economy. It is also, of course, a less decorative reflection of Monet's own preoccupation at the time with his Grainstack series. We know that Monet consulted Robinson about his own conceptions and offered advice as well to the American in regard to his pictures. It should be pointed out, too, that Robinson's *Wheat Field* would have been painted at much the same time as Breck's *Studies of an Autumn Day* series (colorplate 18). On his return to Giverny in the spring of 1892,

Fig. 46
Theodore Robinson, *Wheat Field, Giverny,* 1891, oil on canvas. Terra Foundation for the Arts, Daniel J. Terra Collection, 1987.7

Fig. 47
Claude Monet, *Rouen Cathedral (Harmony in Gray)*, 1894, oil on canvas. Musée d'Orsay, Paris

Robinson, too, would undertake a number of series of related images, inspired especially by Monet's Rouen Cathedral images (fig. 47, for one in the series), which the French artist had begun early that year.

Boston had its first significant exposure to Robinson's Impressionist mode during the first two weeks of April 1892, when a collection of his paintings was paired with a group of pictures by Theodore Wendel, in an exhibition at Williams & Everett galleries, thus reuniting two of the original Givernois. At the same time there was a Monet show at the St. Botolph Club in that city. On April 14, the day the Boston exhibition closed, Robinson left for France. That summer of 1892 was marked by the marriage on July 16 of Monet to Alice Hoschedé, with whom he had been living for many years, followed immediately by the wedding of another American painter, Theodore Butler, to one of the Hoschedé daughters, Suzanne. As he had with Breck and Blanche Hoschedé, Monet had attempted to discourage this liason too, even considering moving away from Giverny, but under the influence of a number of the other Americans, including presumably Robinson, and with reports sent to him from the United States, Monet relented and Butler and Suzanne were married on July 20.[104] The event was commemorated by Robinson in his well-known picture *The Wedding March* (colorplate 6), one of the few works by him of an immediate event, and one, of course, that is a "constructed" image rather than painted in situ; the picture was begun on August 5. The top-hatted man in the foreground is Monet himself, leading Suzanne (now legally his stepdaughter). The Impressionist concern for light, color, and atmosphere was the ideal mode in which to capture the fascinating transparency of Suzanne's veiling, while the bright sunlight appears to proffer a celestial blessing on the nuptials.

That December Robinson returned to America for good, settling in New York, where he was recognized as one of the leaders of the new art movement. Although he contemplated returning to France during the remaining few years of his life, financial exigencies forced him instead to teach summer classes for the Brooklyn Art School. Many of his colleagues in the New York art world were involved in teaching; summer instruction allowed the artists to supplement their income, while also affording the opportunity for out-of-doors painting. Robinson spent the summer of 1893, a particularly productive one, teaching at Napanoch on the Delaware and Hudson Canal in upstate New York. The finest pictures of that season were those such as *Canal Scene* (fig. 48), painted along the waterway down which barges plied, sometimes with a cargo of Robinson's students. This picture may have been painted from one of the bridges over the canal, the borders and roadway of which offered Robinson that sense of structure that was always mated with Impressionist light and color in his finest works.

The initial appearance in 1887 of American painters in Giverny was only the beginning of the foreign "invasion"; each succeeding year brought fresh faces to the village, as recorded both in artists' memoranda and letters,

Fig. 48
Theodore Robinson, *Canal Scene,*
1893, oil on canvas. Daniel J.
Terra Collection, 33.1980

and in the guest register of the Hôtel Baudy, and confirmed in paintings of
Giverny scenes in both Parisian and American exhibitions. For its impact
upon the artistic make-up of Giverny itself, the most significant newcomer
in 1888 was Theodore Butler, who four years later would become Monet's
stepson-in-law.[105]

Butler, who was from Columbus, Ohio, studied art in New York
and arrived in Paris at the beginning of 1887, studying first at the
Académie Julian, and then joining the atelier of Carolus-Duran before the
end of the year. Sometime during 1887 he became friendly with Theodore
Wendel, and when Wendel returned for his second season in Giverny late in
May 1888, he brought Butler with him. The two resided at the Baudy from
May 20. Butler spent 1889 in New York, but he was back in Giverny in the
summer of 1890, soon painting landscapes much in the manner of Monet
and some of his American colleagues. He does not appear to have met
Monet until after his involvement with Suzanne Hoschedé had begun in the
late fall or early winter of 1891. Following their marriage in the summer of
1892 and the birth of their son, James, the following year, Butler turned his
attention more to figurative and genre subjects, based primarily upon his
family.

Butler's figurative work of the 1890s constitutes his finest achieve-
ments, pictures such as *The Artist's Children, James and Lili,* painted in 1896
(colorplate 26). Here Butler's Impressionist technique is exercised not only
in the interpretation of childhood, but in the creation of decorative motifs
and juxtapositions, as with the colorful designs of the drapery and rugs, and
the contrast of their curvilinear patterns with the sharp geometry of the rear
wall panels and the open door at the right. Butler evokes a great deal of

spontaneity in the children themselves, the hoop that Jimmy holds repeating the rounded form of his younger sister. The full, warm dress of the children suggests that this is a winter painting, and Butler probably painted such indoor scenes in the colder months, while reserving the summers for landscape and outdoor figural work. During the 1890s Butler moved progressively from a decorative Impressionism to a more Expressionist manipulation of form and space, and increasingly strident colorism, almost anticipating Fauvism. Such effects can be seen in *The Card Players* of 1898 (fig. 125), a depiction of friends and family in the intimate environment of his Giverny home.

Butler had met the painter Philip Leslie Hale while both were students at New York City's Art Students League, and they traveled to Paris together in January 1887. Both enrolled at the Académie Julian, and Hale also matriculated at the Ecole des Beaux-Arts. Hale followed Butler to Giverny in 1888, staying at the Baudy from June 1 to October 1. Hale's *Landscape with Figure,* painted in Giverny that year (colorplate 23), shows the artist still working in a strongly Tonal manner, though it is a freely brushed outdoor work, and the iris growing wild at the left bring to mind Breck's picture *Yellow Fleur-de-Lis* of that same year (colorplate 14). The subject of a woman washing clothes in the stream is a reminder that such peasant themes, common among the first generation of Americans in Giverny, remained popular until the end of the century.

Hale returned frequently to Giverny during the succeeding summers through 1893, except for 1890, which he spent at the summer home maintained by his aunt, Susan Hale, at Matunuck, Rhode Island, in the United States. During these ensuing years after his initial stay in Giverny, Hale developed one of the most original and formally radical interpretations of Impressionism—pictures of young women in intense yellow sunlight, tinged with elements of both Pointillism and Symbolism. The majority of these that have so far come to light would appear to have been painted in America. Hale started exhibiting Giverny pictures at the Salon in 1888, and after switching to the new Salon of the Société Nationale des Beaux-Arts in 1890, his paintings were frequently concerned with summer and sunlight. Hale wrote one of his colleagues in 1895 that he had gone "très Impressioniste" and that he was trying to pitch his paintings a "little lower than my Giverny things but higher than my last year's work."[106] Hale's avant-garde Impressionist phase culminated in a major one-artist show at Durand-Ruel's New York gallery in December 1899.[107]

Arriving in Giverny a bit earlier than Butler and Hale in 1888 was the English painter Dawson Dawson-Watson, who had studied in England with the American expatriate artist Mark Fisher, one of the first painters in Great Britain to reveal affinities with Impressionism in his art. Dawson-Watson had arrived in Paris in 1886 for instruction first with Carolus-Duran, and then, after Carolus gave up his student atelier, with Raphael

Collin. Dawson-Watson was already an admirer of Monet's art when he met Breck, who advised him to go to Giverny. Dawson-Watson did, with the intention, as he later wrote, of staying two weeks; he remained for five years.[108] Relatively few of Dawson-Watson's Giverny pictures have come to light. Several are monumental images of peasants hard at work, but tinged with the bright light and the telltale lavender and purple tones of Impressionism. Others are village street scenes, such as the two views of Giverny in the Terra collection (colorplates 24 and 25), in which academic structure goes hand in hand with rich colorism and bright sunlight. Indeed, in these works Dawson-Watson allows light to amplify form by defining broad planes of walls, roofs, and streets in what I have elsewhere defined as the "glare" aesthetic.[109] The deep perspectival plunge in both pictures was a common device in late nineteenth-century painting, chosen by both more traditional artists such as William Picknell and avant-garde painters like Vincent van Gogh. At the same time, Dawson-Watson appears to share the fascination with the particular nature and configuration of Giverny that one finds in village scenes by Robinson and other visitors.

Dawson-Watson first remained at the Baudy for a year and a half, leaving only on September 15, 1889. He was back in September 1890 for over five months, in mid August 1891 for over six months, and finally in April 1892 for over a year. During his long residence in Giverny, Dawson-Watson collaborated with Butler and other artists, along with the poet Richard Hovey, in publishing a small, hand-printed magazine, the *Courrier innocent*. A special number appeared in celebration of Butler's wedding.[110] The magazine's title was almost certainly meant to recall the popular Parisian journal *Le Courrier français.*

In August 1891 Dawson-Watson had become friendly with J. Carroll Beckwith, who was visiting in Giverny and also staying at the Baudy; Beckwith became a great admirer of Dawson-Watson's painting and convinced the English artist to settle in America. He accepted a position as director of the Hartford Art Society in Hartford, Connecticut, in 1893, and after further peregrinations—back to England in 1897; to Quebec, Canada, in 1901; with the Byrdcliffe art colony in Woodstock, Connecticut—he settled in St. Louis, Missouri, in 1904, and a decade later began visiting San Antonio, Texas, eventually dividing his residence between Missouri and Texas. Thus this English-born artist learned his Impressionism in Giverny and transposed it to the Midwest and the South of the United States.[111]

Another of the painters involved with producing the *Courrier innocent* was Thomas Buford Meteyard, who grew up in Chicago and then Scituate on the Massachusetts south shore, studied at Harvard, and went to Europe in 1888, where he enrolled in the atelier of Léon Bonnat in Paris, subsequently also studying with Alfred Roll and Auguste-Joseph Delacluse. Although Meteyard's training was totally academic and traditional, by the spring of 1890 he had been thoroughly inspired by the French and

American Impressionists, as he wrote to Hovey, back in America, noting that "there are some whom I admire immensely—Puvis de Chavannes, Cazin, Monet and Besnard. . . . if you should hear of an exhibition of pictures by a man named Breck this summer in N.Y. or Boston, be sure to see them. . . . He is an impressionist, rather of the Monet school, and a friend of Monet's. I admire his work immensely."[112]

That same summer Meteyard joined the colony in Giverny. Monet was working at the time on his Grainstack series, which Meteyard emulated with a group of watercolors of the subject, created either then or in 1891, when he was back at the Baudy briefly in late July and then for over five months beginning September 1, perhaps painting his grainstack pictures at the same time as Breck. Working also in oils, Meteyard created a series of panoramic views of the valleys of the Epte and Seine rivers, but probably his most impressive works are more intimate nocturnes done of the village streets in moonlight such as *Giverny, Moonlight* (colorplate 28), a more mysterious and romantic equivalent of the street scenes of his colleague Dawson-Watson. Hovey arrived in Giverny a week after Meteyard, and that autumn the *Courrier innocent* was born.

Meteyard was among the vanguard group of artists who showed their pictures in exhibitions of "peintres impressionistes et symbolistes" at the gallery of Le Barc de Boutteville, Meteyard's work appearing in the second and third exhibitions, both held in 1892. After staying at the Baudy again during the late spring and summer of 1892, Meteyard traveled to Italy and to southern France, and then returned for the last time to Giverny for two months in April 1893, before settling back in Scituate. That year he showed Giverny paintings both at the Salon of the Société Nationale des Beaux-Arts and at the Columbian Exposition in Chicago. The Meteyard home in Scituate subsequently became a reflection of Giverny, with the appearance there of Hovey and Dawson-Watson and the publication of two final issues of the *Courrier innocent*.[113]

The painter who provided the greatest conduit between the artists' colony in Giverny and her native United States was Lilla Cabot Perry, one of the most significant women to become involved with the Impressionist movement, and one of the painters to have the longest residence, albeit not continual, in the village.[114] Lilla Cabot came from an aristocratic Boston family. Over a decade after she married the teacher and writer Thomas Sergeant Perry, she began studying in Boston with Robert Vonnoh and then Dennis Bunker, before traveling to Paris in 1887, where she studied at the académies Colarossi and Julian.

Perry began to exhibit at the Salon in 1889, and that summer she first went to Giverny, where she met Claude Monet. The encounter was fortuitous for Perry and for the colony. She became one of the few Americans to maintain a long-standing friendship with the increasingly reclusive French artist, and her own painting reflects Monet's Impressionist style more than almost any of her fellow Americans. Perry later wrote and

published an important reminiscence of Monet, which is not only a major document describing the personality and art of the French master but testifies as well to their closeness; indeed, a depiction of Perry's youngest daughter, Alice, on a lane in Giverny, still hangs in the Monet home.[115] An extremely sociable individual, Perry became close to many of the Americans in the colony, promoting their work as well as Monet's, helping them to hold exhibitions back home, and assisting them in gaining teaching positions. It is likely that Perry was instrumental in the organization of the Monet exhibition and that of Robinson and Wendel, both held in Boston in 1892, and she was certainly crucial in Hale's appointment at the School of the Museum of Fine Arts in Boston in 1893. The Perrys spent ten seasons from the two decades between 1889 and 1909 in Giverny, and many of her finest pictures were painted there. At first they stayed at the Hôtel Baudy, residing there from June 20 to October 29, 1889. They were back at the Baudy in the summer and early autumn of 1891; subsequently, when they returned for three years in 1894 and for four years in 1905, they rented a series of houses in the town, one of which was next door to Monet's.

Perry's art divides quite evenly between figurative pictures, usually of women and children, and landscapes, and her painting, too, reflects the dichotomy found in the work of many academically trained Impressionists. Her figurative works—which range from her forceful *Self-Portrait* of about 1891 (colorplate 29), painted in Giverny, through another Giverny subject, *By the Brook, Giverny, France,* 1909 (fig. 49), of almost two decades later, to her late portrait of her husband, painted in 1924 (fig. 50)—retain a firm structure and a strong Tonal mode of modeling in light and shade. These qualities would have been part of Perry's heritage from her studies in Boston and Paris, even while progressively acknowledging her interest in color, outdoor light, and fluid brushwork, respectively. In her outdoor landscape work, such as *Autumn Afternoon, Giverny* (fig. 51), an artistic theme for which

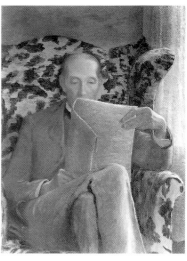

Fig. 49
Lilla Cabot Perry, *By the Brook, Giverny, France,* 1909, oil on canvas.
Daniel J. Terra Collection, 14.1986

Fig. 50
Lilla Cabot Perry, *Thomas Sergeant Perry Reading a Newspaper,* 1924, oil on canvas.
Terra Foundation for the Arts, Daniel J. Terra Collection, 1987.27

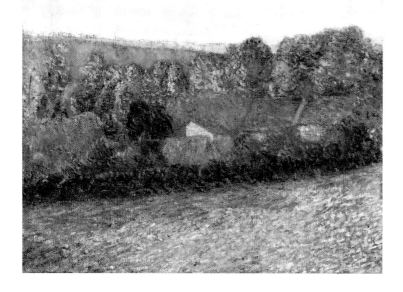

Fig. 51
Lilla Cabot Perry, *Autumn Afternoon, Giverny,* n.d., oil on canvas. Daniel J. Terra Collection, 38.1986

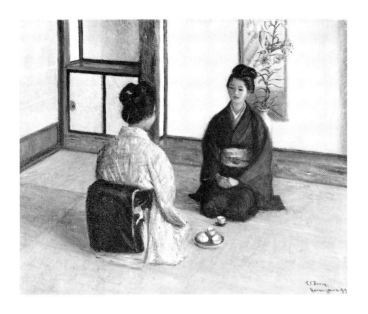
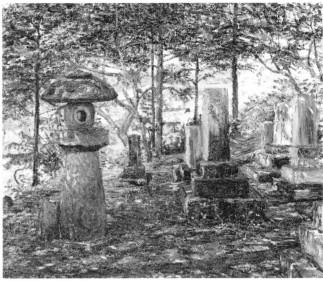

Fig. 52 (ABOVE, LEFT)
Lilla Cabot Perry, *The Visit*, 1899,
oil on canvas. Daniel J. Terra
Collection, 29.1986

Fig. 53 (ABOVE, RIGHT)
Lilla Cabot Perry, *Japan*, 1900, oil
on canvas. Terra Foundation for
the Arts, Daniel J. Terra
Collection, 1987.26

Fig. 54 (OPPOSITE, TOP)
Frederick William MacMonnies,
Diana, 1894, bronze. Terra
Foundation for the Arts, Daniel J.
Terra Collection, 1988.21

Fig. 55 (OPPOSITE, MIDDLE)
Jean-Alexandre-Joseph Falguière,
Diana, 1892, plaster. Musée des
Augustins, Toulouse

Fig. 56 (OPPOSITE, BOTTOM)
Frederick William MacMonnies,
Young Faun with Heron, 1894, bronze.
Terra Foundation for the Arts,
Daniel J. Terra Collection,
1989.13

she had less formal direction, she was free to adapt to the methods of her
much-admired friend, Monet, and she took on the scintillating light, the
high-keyed palette, and the broken brushwork that characterizes so much of
his art. The picture, too, testifies to her devotion to the village where she
spent so much of her creative years.

One of the Perrys' longest hiatuses from Giverny occurred at the
end of the nineteenth century. In 1897 Thomas Perry accepted the
professorship of English literature at Keiogijiku University in Tokyo—his
great uncle, Commodore Matthew Perry, had opened up Japan to Western
trade and influence half a century earlier—and Lilla Perry and the children
joined him the following year, remaining for three years in Japan. Lilla Perry
brought her interpretation of Impressionism from Boston and Giverny to
Tokyo, again displaying the same duality, where pictures such as *The Visit*,
1899 (fig. 52), are strongly structured, with the two figures fitted into a
geometric compositional armature, the better for Perry to define Japanese
customs, costumes, and interior design. *Japan*, of 1900 (fig. 53), on the
other hand, is a sun-filled, light-dappled view into a typical Japanese
landscape, characterized by an abundant use of color—purples and greens,
especially—applied in short, broken brushstrokes. Probably no painter at
the turn of the century, Japanese or foreign, so completely interpreted the
landscape of Japan in the Impressionist mode.

By far the most significant addition to the Giverny art colony in
1890 was Frederick William MacMonnies and his wife, Mary Fairchild
MacMonnies. Indeed, it was the MacMonnies who extended cohesion
between the initial group of artist-visitors to the village and the later
generation of painters who came in the early twentieth century. Most of the
other visitors were relatively short term, except for Perry, whose presence
was sporadic, and Butler, whose career and life style seem to have been
subsumed in those of the Monet-Hoschedé clan. Frederick MacMonnies

appears to have become friendly but not intimate with Monet, and at the same time to have not only socialized with but actively supported American artists visiting Giverny for over two decades, many of whom were his own pupils and friends, and some of whom stayed with the MacMonnies rather than at the Hôtel Baudy.[116]

MacMonnies, however, was primarily a sculptor rather than a painter. With Augustus Saint-Gaudens and Daniel Chester French, MacMonnies was one of the three most important French-trained American sculptors at the turn of the century. These and other sculptors of the period turned away from the dominance of the marmoreal aesthetic perpetuated in Italy. Instead, they studied in Parisian ateliers and at the Ecole des Beaux-Arts, working in the medium of bronze and often having their pieces cast in Paris, where many of them continued to produce their work, traveling back and forth across the ocean.[117]

While all these sculptors exploited the glistening and subtle surface effects of the bronze medium, the work of MacMonnies, by far the youngest of this triumvirate, is characterized by a lightness, and sometimes a playfulness that differs from the sobriety of the sculpture of Saint-Gaudens and French. MacMonnies studied with Saint-Gaudens in 1880, four years before embarking for Paris for what would basically be thirty years of expatriation. Not long after he arrived, he was momentarily diverted to Munich due to a cholera epidemic in France, and after returning he entered the Ecole des Beaux-Arts in 1886. There he studied under Jean-Alexandre-Joseph Falguière; he appears to have received much encouragement and won prizes. He was also a student of Marius-Jean-Antonin Mercié, Falguière's celebrated pupil.

Diana, the most popular mythological subject for American sculptors of the late nineteenth century, was the theme of MacMonnies' earliest independent work, which won an honorable mention when it was exhibited at the Paris Salon in 1889 (see fig. 54; bronze reduction). Its spirited elegance and fluid surfaces project the art of turn-of-the-century Paris and specifically that of Falguière's own *Diana* (fig. 55). While remaining in France, MacMonnies began receiving commissions from America, both private and public. One of his earliest private works is *Young Faun with Heron,* of 1889–90, shown at the Salon of 1890 and done for Joseph H. Choate of Stockbridge, Massachusetts (see fig. 56; bronze reduction). The sleek, youthful figure characterized by great élan is typical of MacMonnies' art and bears some relationship to the New Sculpture movement in England as well as the revival of interest in early Renaissance art, more particularly that of Donatello and Andrea del Verrocchio.

Among the earliest of the sculptor's public commissions was a statue of Nathan Hale, commissioned by the Sons of the American Revolution of the State of New York for New York City, an 1889 competition that MacMonnies won; the statue was completed the next year (see fig. 57; bronze reduction). The elegance of the figure, its expressive refinement, and

Fig. 57
Frederick William MacMonnies,
Nathan Hale, 1890, bronze. Terra
Foundation for the Arts, Daniel J.
Terra Collection, 1988.9

Fig. 58
Frederick William MacMonnies,
Bacchante with Infant Faun, 1894,
bronze. Terra Foundation for the
Arts, Daniel J. Terra Collection,
1988.20

the lustrous, polished surfaces are typical of MacMonnies' art. The
sculpture appeared at the Salon of 1891, where MacMonnies won a
second-class medal. Many of MacMonnies' major works, both public and
private, were popularized through editions of bronze reductions cast over a
period of many years.

　　MacMonnies' most monumental commission was the elaborate *Barge
of State,* which he made for the Columbian Exposition held in Chicago in
1893, the largest single sculpture at the fair. Back in France that year,
MacMonnies created his *Bacchante with Infant Faun* (fig. 58; bronze reduction),
perhaps his best-known sculpture, and a controversial work at the time. The
sculptor gave the piece to the architect Charles F. McKim, who had assisted
him in financing his study in France, and McKim, in turn, donated the
sculpture to the newly designed Boston Public Library in 1896. But after
the installation of the *Bacchante,* conservative forces in Boston fought its
appearance in a public space on the twin objections of nudity and seeming
inebriation. The work was removed and the following year was welcomed at
the Metropolitan Museum of Art in New York.[118] In 1894 the Musée de
Luxembourg in Paris ordered a replica (Sélestat Town Hall), which helped
MacMonnies win a grand prize at the Exposition Universelle of 1900 held
in Paris; this was the first purchase of a sculpture by the French nation.
MacMonnies followed up his *Bacchante* with numerous private pieces, such as
his *Cupid Running* of about 1895 (fig. 59; bronze reduction), and a
tremendous number of public commissions to be found throughout New
York City, in Washington, D.C., in Denver, and in Princeton, New Jersey,
all in the United States, and the Marne Battle Memorial, near Meaux,
France.

　　By the end of the 1890s, MacMonnies, somewhat exhausted by
sculpture and also anxious to broaden his artistic horizons, turned to
painting.[119] While he had never actually studied painting, he had proven his
proficiency in drawing at the School of the National Academy of Design in
New York, where he had taken instruction in the early 1880s, and he had
copied the work of the old masters at the Alte Pinakothek in Munich
during the winter of 1884–85. In Paris he had already begun to take on
young women students from America in his sculpture atelier, teaching
drawing in 1895, and at the Académie Vitti in 1897. MacMonnies'
teaching career in painting was also briefly extended to joining Whistler at
the latter's short-lived Académie Carmen in Paris in 1898. Almost certainly
the environment of Giverny offered him additional incentive to pursue
painting, both the physical situation there and also the camaraderie of so
many fellow painters. Some of MacMonnies' closest painter friends such as
Will Low and William De Leftwich Dodge visited Giverny at the turn of
the century and painted there.

　　The MacMonnies themselves first visited Giverny early in April
1890, staying at the Baudy for a few days, and they were there again the
following month. They rented a villa in the town during the summers of

1894, 1895, and 1896, and then stayed in the village priory, year round, in 1898, though MacMonnies was still spending most of his time in his sculpture studio in Paris. After turning to painting in 1900, he purchased the property the following year and developed a garden there which, though more formal, rivaled that of Monet.[120] After a year painting portraits in America, he returned to Giverny, turned one of the buildings on the property into a painting studio in 1903, and then continued to create both paintings and sculptures there and in the French capital.[121]

In Paris, England, and America, MacMonnies painted formal portraits and also nude studies; in Giverny he concentrated on renderings of his family, himself, and occasional portraits of friends and associates, such as that of his sculpture pupil Mabel Conkling (fig. 60), one of a good many paintings MacMonnies exhibited at the Paris Salon between 1901 and 1906. In this formal portrait, Conkling is posed against the tapestry background found in a number of MacMonnies' works, one of a large collection of tapestries that hung in the Giverny house. It appears also in his *Self-Portrait* (fig. 61). In their subtle tonalities and strong objectivity, such portraits as these display MacMonnies' indebtedness to the art of Velázquez, whose pictures he admired and about thirty of which he copied on a trip to Spain in 1898. After the mixed critical reception of paintings exhibited in a one-artist show in 1903 at the New York galleries of Durand-Ruel, MacMonnies gradually but not completely abandoned the medium and returned to sculpture. His portrait of his second wife, Alice

Fig. 59
Frederick William MacMonnies, *Cupid Running*, n.d., bronze. Terra Foundation for the Arts, Daniel J. Terra Collection, 1988.7

Fig. 60
Frederick William MacMonnies, *Mabel Conkling*, 1902–5, oil on canvas. Daniel J. Terra Collection, 2.1987

Fig. 61
Frederick William MacMonnies, *Self-Portrait*, 1896, oil on canvas. Daniel J. Terra Collection, 15.1987

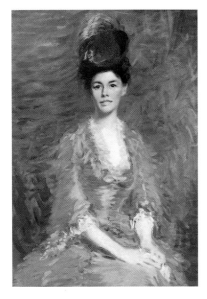

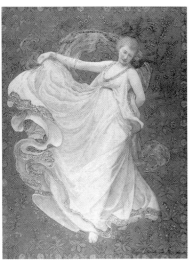

Fig. 62
Frederick William MacMonnies,
Mrs. Alice MacMonnies, c. 1910, oil
on canvas. Terra Foundation for
the Arts, Daniel J. Terra
Collection, 1988.16

Fig. 63
Mary Fairchild MacMonnies Low,
The Breeze, 1895, oil on canvas.
Terra Foundation for the Arts,
Daniel J. Terra Collection,
1987.23

Jones MacMonnies (fig. 62), his former sculpture pupil, which was probably painted in 1910 after the couple returned to Giverny from their marriage in Luzerne, Switzerland, testifies to his continued involvement with the medium.[122]

The first Mrs. MacMonnies, the former Mary Fairchild from St. Louis, married the sculptor in Paris in 1888. She had won a scholarship from the St. Louis School of Fine Arts to go to Paris in 1885, where she studied at the Académie Julian and then with Carolus-Duran. She began to exhibit at the Salon in 1886. Increased recognition led to her reception of a commission in 1891 for a gigantic sixty-foot mural decoration to be painted in France for the Woman's Building of the 1893 Columbian Exposition; this depicted *Primitive Woman* and faced Mary Cassatt's mural of *Modern Woman* (both unlocated). Mary MacMonnies' decorative interest is continued in her large painting *The Breeze,* 1895 (fig. 63), which was formerly thought to be a depiction of Loie Fuller, perhaps because a French critic likened the image to the famous dancer. This is a Parisian canvas, allegorized to some extent in the manner of the renowned French muralist Pierre Puvis de Chavannes, whom she greatly admired, whose work she copied, and whose own art provided the inspiration for her Chicago mural. A study for *The Breeze* was exhibited in 1895 at the Salon of the Société Nationale des Beaux-Arts, along with a companion depiction of Diana (unlocated), both referred to in the Salon catalogue as decorative compositions. The large canvas was exhibited numerous times in the United States and won a medal at the Pan-American Exposition held in Buffalo in 1901.

During the 1890s and 1900s, Mary MacMonnies painted a good deal in Giverny as well as in Paris, spending more time in the country than her husband. The ease and good life that MacMonnies enjoyed in Giverny are abundantly in evidence in her familial subjects such as *Painting Atelier at Giverny* and *Baby Berthe in High Chair with Toys* (colorplates 31 and 32). These works, though not strictly Impressionist, are painted in a high color key and with great vivacity. They have heretofore been attributed to her husband, but since Berthe must have been only about two years old when the two pictures were painted, the works must date to about 1887–1897, three years before Frederick MacMonnies began to work in this medium. They are, in fact, probably identical with the two works that Mary MacMonnies exhibited in the 1899 Salon of the Société des Beaux-Arts, *Dans la nursery* and *C'est la fête à bébé.* Gradually the MacMonnies' interests diverged, both artistically and personally, and he instituted divorce proceedings in 1908. Mary MacMonnies married the American painter Will Low in 1909 and returned to America. Frederick married Alice Jones the following year. They left Giverny in 1915 with the approach of German forces during World War I.[123]

Giverny was only one of innumerable art colonies that sprang up in France in the late nineteenth century, but it was one of the longest lasting

and the one with the highest concentration of American artists. But painters from the United States also could be found among clusters of artists in towns on the coast of Picardy such as Etaples and inland in communities such as Montreuil; eventually an exhibition association, the Société Artistique de Picardie, was formed in 1904, among whose membership numbered a good many Americans, including Henry Ossawa Tanner, its president in 1913. In addition to the older colony of Barbizon, villages on the edge of the Forest of Fontainebleau, such as Moret and Marlotte, abounded with artists. Perhaps the most popular of these was Grèz-sur-Loing, which, from the mid-1870s, was attracting artists and art students from Paris. Scandanavian, British, and Irish artists were there, too, in abundance. The first sizeable contingent of English-speaking artists, including the American Will Low, arrived in 1875. Among Low's fellow countrymen who were subsequently active there was his good friend Theodore Robinson, visiting early in his career, the first time in 1878; Robert Vonnoh was probably the most significant American to work there a decade later, at a time contemporary with the development of the Giverny colony.[124]

Like most of these colonies, Grèz developed in the wake of the heightened concern for plein air painting. This was by no means identical to Impressionism, and much plein air painting practiced in France by both French and foreign artists reflected the outdoor naturalism championed by Jules Bastien-Lepage—characterized by a preference for careful and specific draftsmanship combined with fresh, direct paint application, and for shadowless, gray days that allowed for a consistency of light which bright sunlight did not offer and which helped unify figurative and landscape elements. Grèz was marked by such effects of light and by atmosphere in abundance, provided by a welcoming village with inexpensive hotels and picturesque features centering around the village church and the bridge over the Loing River. Artists working there in the 1870s and 1880s returned home to Northern Europe and America with a somewhat conservative yet modern style of landscape painting.

By the late 1880s, Impressionism had been introduced to Grèz also, and had found a disciple in Robert Vonnoh.[125] Vonnoh had grown up in Boston, where he studied before leaving for further instruction at the Académie Julian in 1881. Vonnoh exhibited at the Salon for the first time in 1883, and that year returned to Boston, becoming a successful portraitist and art teacher. In 1887 he returned to Paris briefly for additional instruction and then joined the Grèz art colony. Like the contemporaneous work of Perry and other academically trained painters, Vonnoh's figural work is firmly constructed in a dramatic, Tonal mode, while his landscapes exhibit more advanced aesthetic tendencies. Many of these, such as his haunting, somber *November* of 1890 (fig. 128), are very much in a typical gray Grèz mode. Others, such as *La Sieste*, 1887 (colorplate 43), explore bright sunlight but are still quite carefully drawn and emphasize the

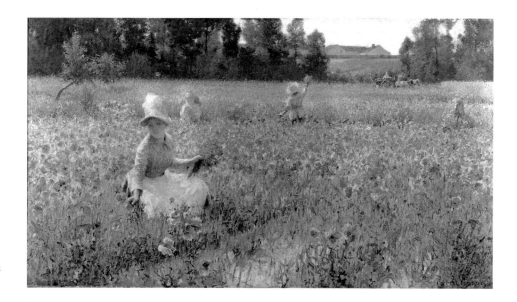

Fig. 64
Robert Vonnoh, *Coquelicots (Poppies),
In Flanders Field*, c. 1890, oil on
canvas. Butler Institute of American
Art, Youngstown, Ohio

traditional agrarian subject; this picture is the earliest located Grèz
landscape by Vonnoh. The later *Jardin de paysanne* of 1890 (colorplate 45)
combines such a peasant theme with a colorful garden in bright light, and
utilizes a flat, reflective wall in the rear. This is a typical device of the
"glare" aesthetic, in which light is not dissolved but rather confirms
structure, even though Vonnoh is now using a fully Impressionist chromatic
palette, with the paint freely applied in a variety of brushstrokes.

Vonnoh's most daring avant-garde paintings created in Grèz are a series
of pictures of poppy fields painted in 1888, such as *Poppies in France* (colorplate
44), a motif we have come to associate with Claude Monet and Giverny.
Vonnoh's small poppy paintings are equally modern. They appear as flames of
thickly impastoed unmixed colors, with the paint laid on, in part with the
palette knife, describing a bed of blossoms randomly chosen and seemingly
uncomposed. It is in works such as these that Vonnoh came to realize, as he
said, "the value of first impression, and the necessity of correct value, pure
color, and higher key . . . becoming a devoted disciple of the new movement."[126]

The origins of Vonnoh's Impressionism are uncertain, but he may
have been influenced in this direction by the work of the Irish artist Roderic
O'Conor, who was in Grèz in 1889 and possibly earlier, and also by the art
of such French painters as Alfred Sisley, who was working nearby at
Moret.[127] Vonnoh's poppy pictures are finished paintings in their own right,
but they are also studies for a vast poppy field panorama with figures, his
Coquelicots of around 1890 (fig. 64). This was Vonnoh's largest picture, and
one which he exhibited in major European showcases, including the Salon
of 1891 and the International Exposition held in Munich in 1892.
Vonnoh's conception here was to create a "subject" painting, proper for the
Salon, and yet one in which the radical aesthetics he had investigated in the
smaller poppy pictures were still manifest.

Vonnoh was the best known of the Americans who "converted" to
Impressionism in Grèz. His fellow Bostonian Edward Wilbur Dean

Hamilton had studied at the Académie Julian and then matriculated at the Ecole des Beaux-Arts in 1889, in which year he began to exhibit at the Salon. He was also first in Grèz in 1889, painting poppy pictures and garden scenes such as *Afternoon, Grèz* (colorplate 46). This picture is as intensely colorful as Vonnoh's, although forms are not as dissolved in light and color, and Hamilton maintains more Tonal chromatic relationships. At this point in his career, Hamilton's art was essentially concerned with recording natural effects at different times of day and in different weather conditions—a decidedly Impressionist aesthetic, and indeed, he was described in 1900 as "essentially an impressionist."[128]

Vonnoh had more direct influence upon another American who visited Grèz in 1889, Edward Henry Potthast, from Cincinnati. Again, like many midwestern artists, Potthast studied in Munich for several years from 1882, and then went to Paris, attending the Académie Julian for just a month and a half in 1884; he was back in the French capital toward the end of the decade, studying with Fernand Cormon. When in Grèz, Potthast "fell under the influence of Vonnoh and O'Connor [*sic*] and became a convert to the new school of impressionism."[129] The results of Potthast's conversion to the new aesthetic were immediate, and were seen in the work Potthast brought back with him to his native town. He continued to paint with the bravura brushwork and colorism of Impressionism after he moved to New York in 1896, and it continued when he began to specialize in scenes of children and other bathers at Brooklyn beaches such as *Ring around the Rosy* (fig. 65), which theme became his specialty after about 1910.[130]

Like the MacMonnies, Robert Vonnoh and his second wife, the former Bessie Potter, were a husband-and-wife painter-sculptor team, only

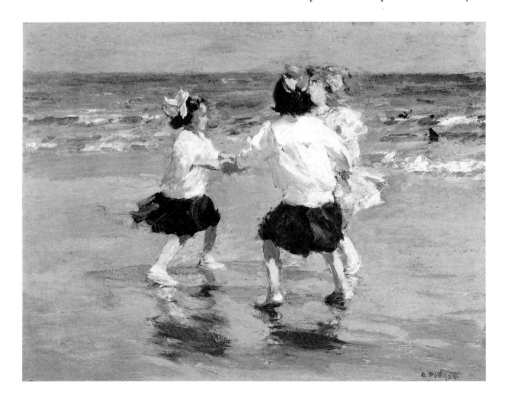

Fig. 65
Edward Henry Potthast, *Ring around the Rosy,* n.d., oil on panel.
Daniel J. Terra Collection, 19.1981

Fig. 66
Bessie Potter Vonnoh, *In Arcadia,* c. 1926, bronze. Terra Foundation for the Arts, Daniel J. Terra Collection, 1989.3

in this case it was Robert Vonnoh who painted and his wife who was the sculptor. Bessie Potter had begun her sculptural career in Chicago and then in 1895 traveled to France, visiting Rodin's studio. Inspired by the small bronzes she had seen at the Columbian Exposition by the Italian-born, French-trained Prince Paul Troubetskoy, she had begun her independent work modeling portrait statuettes of women friends. Tiring of these after her trip abroad, she turned to more generalized female figures and groups, often with children, and gained special celebrity for her treatment of the maternal theme; these were cast in bronze on a scale for the private home. The figures in her small bronzes were at first in modern dress, but later they appeared increasingly in vaguely classicizing garb, influenced by classical Tanagra terra-cottas; as time went on she also chose to model figures of younger women, children, and adolescent girls, producing such work through the 1920s, such as *In Arcadia* of about 1926 (fig. 66).

In 1899 Potter married Robert Vonnoh, whose first wife had recently died. Vonnoh had returned from Europe in 1891, teaching in a number of American cities, and after several years the Vonnohs settled in New York. In 1907 the couple returned to Grèz, where Robert took up painting the familiar landscape, though Bessie spent most of her time in America. His routine interrupted by World War I, Vonnoh was not able to get back to Grèz again until 1922. The French experience was obviously of inestimably greater value to Robert Vonnoh than to his wife, but her work, too, is indebted to the French beaux-arts tradition of bronze sculpture.[131]

The heightened awareness in France of American art was underscored in 1891 by the Exposition de Peintures et Sculptures d'Artistes Américains held in June at the Galeries Durand-Ruel in Paris. The French public had become increasingly aware of the expanding numbers of American paintings and sculptures that were appearing in the Salon exhibitions—second in number only to the work by French artists—and the growing size of the American contributions to the international expositions held in Paris. The 1891 show, however, was a large exhibition of

almost two hundred works solely by leading American painters and sculptors, the stated purpose of which was to assist the French public in the realization of the immense influence that French art and artists had exercised on American art.

A good number of the painters represented in the Terra collection were included in the Durand-Ruel show, including Beckwith, Curran, Hale, and Robinson, as well as several to be discussed later, such as William Merritt Chase, Childe Hassam, Edmund Tarbell, and John Twachtman. However, not all the painters and sculptors were connected with French artistic developments, and the vast majority had no connection with Durand-Ruel. On the other hand, Durand-Ruel's sponsorship was, of course, related to the recent establishment of a branch of that Parisian gallery in New York City, and the effort was strongly supported by Chase, president of the Society of American Artists, an organization primarily of European- and especially Parisian-trained painters and sculptors. While the French public was reported as not displaying tremendous interest in the exhibition, the newspapers were unusually kind in their comments; some reviewers, such as the writer for *Le Temps,* not only analyzed individual works but also displayed some knowledge of the American artists.[132]

The American artistic presence in Paris was sufficiently large and cohesive by 1890 that the American Art Association of Paris was founded that year, with comfortable quarters and sponsoring exhibitions. In 1891 the American Women's Art Association of Paris was begun. The Paris Society of American Painters, later known as the Society of American Artists in Paris, was formed after the close of the Columbian Exposition in Chicago in 1893, for the purpose of securing representation by Americans working in Paris in major exhibitions held on both sides of the Atlantic; its constitution was not promulgated until 1897.[133]

Among the artists whose works appeared in the Durand-Ruel Paris exhibition of American art was Childe Hassam who, by 1891, was already becoming recognized as one of the foremost American Impressionists, and he was destined to become the most successful practitioner of that aesthetic.[134] Hassam trained in Boston and first established a name for himself there as a watercolorist. He made his first journey abroad in 1883, traveling through Europe. His undated *French Peasant Girl* (colorplate 65) was presumably painted at this time, given its simple, naturalistic approach and strong Tonal modeling. The work is akin to similar images by such fellow Americans as Daniel Ridgway Knight and Charles Sprague Pearce, both French expatriates. The picture is also ultimately indebted to Bastien-Lepage, who was extremely highly regarded and influential at the time, not only for the theme, but for the gray palette, the varying paint handling of figure and landscape, and the high horizon, which increases the focus on the upright figure close to the picture plane.

What would seem to have impressed Hassam the most on his trip abroad, however, were paintings by such artists as Giuseppe de Nittis and

Fig. 67
Frederick Childe Hassam, *Le Jour du Grand Prix*, 1888, oil on canvas. New Britain Museum of American Art, Connecticut, Grace Judd Landers Fund, 1943.14

Fig. 68
Frederick Childe Hassam, *Commonwealth Avenue, Boston*, c. 1892, oil on canvas. Daniel J. Terra Collection, 16.1980

Jean Béraud, masters of contemporary urban scenes who specialized in fashionable figures on the boulevards of Paris. Hassam transposed this theme to his home city of Boston during the next few years. Even after he adopted a much more Impressionist aesthetic, Hassam would retain his identification as the foremost American painter of the modern city.

Hassam's work of the mid-1880s suggests that he had no acquaintance with Impressionism, or if he had, that it had made no impression upon him, despite opportunities either in Paris or back in America between 1883 and 1886 to view examples of such painting. In any case, he went abroad again in the latter year, this time to study in Paris at the Académie Julian. He began to display Paris street scenes at the Salon in 1887, when his work first began to exhibit a significant lightening of the palette, and with *Le Jour du Grand Prix*, shown in 1888 (fig. 67), the strategies of Impressionism were evident in his art. While the work of French artists such as Béraud offers the closest parallel to Hassam's paintings of this period, they were now also akin to the modern city scenes of Degas, Monet, and Camille Pissarro.

One of the most attractive and yet intimate of Hassam's Parisian scenes of this period is *Les Buttes, Montmartre, July 14* (colorplate 67), painted on that day in 1889, in which he contrasts the environment of the modern city with the everyday activity of common urban women on their way to market on Bastille Day. The celebratory nature of the scene is emphasized in the attention given to the large tricolor flags, which not only inject a coloristic pattern to the composition but contrast with the somber costume of the figures below. The flatness of the flags is also opposed to the deep, recessive diagonals of the street and the curvilinear green hills, or *buttes*, behind. Although very different, the picture recalls to mind Monet's several flag paintings of 1878, one of which had been shown that year at the large Rodin-Monet exhibition held in Paris at the Galerie Georges Petit, and at the same time looks forward to Hassam's own Flag series of almost three decades later.[135]

Hassam did not "learn" Impressionism at the Académie Julian, of course, but rather attended the school to improve his mastery of the human figure—almost always a tentative proposition in his art. One of his finest figural works is another painting of 1889, his rendering of *Mrs. Hassam and Her Sister* (colorplate 66). Again, the dichotomy of landscape–figure painting by academically trained Impressionists can be invoked, for here traditional strategies of strong chiarascuro and credible structure are much in evidence, compared to the flat, almost ideographic figural images in *Les Buttes, Montmartre.* Very modern, however, is the casual rendering of the women in their shifts, posed informally and spontaneously, and the almost Oriental composition of an empty foreground floor space, behind which is a crowded arrangement of figures and furniture along strong diagonals. Only in the colorful still-life arrangements on top of the piano is Hassam's subscription to Impressionism suggested.

These flowers remind us also that many of Hassam's Parisian street scenes are concerned with flowers—flower markets and flower sellers— components of modern street life, yet colorful and decorative. Hassam's depictions of figures on the modern avenues were not limited to common folk or flower sellers, however, but also portrayed elegant *boulevardiers* and their companions, as in the gouache *Outside the Café on the Grand Boulevard,* dated 1898 (colorplate 68); such subjects attracted him both in the late 1880s and on his return to Paris in 1897. Of all the American Impressionists, Hassam was quintessentially the painter of modern life.

In the autumn of 1889, after spending some time in England, Hassam returned to America with his newly defined Impressionist strategies, settling in New York rather than Boston and becoming, with Theodore Robinson, the New York artist most completely associated by the critics with the new aesthetic. Yet he made frequent trips back to Boston and painted city scenes there as well as in New York; one of these is *Commonwealth Avenue, Boston,* painted about 1892 (fig. 68). The format of the picture—a rushing perspectival view down a long, diagonal street, with pedestrians and carriages—repeats the format of his most successful work painted in the mid-1880s in that city, but the flickering brushwork, the rich coloration, and the glowing light testify to Hassam's Impressionist identification. Such a painting is also a testimonial to a sense of order and continuity that he perceived in the New England metropolis, established in the balance between the upright figures and the long band of nature's green foliage, with all of the scene dominated by the tower of the Brattle Square Church, soaring to the heavens.[136]

Once back in America, Hassam spent the larger part of the year painting city scenes, but during the summers he traveled, generally to New England. Some of his finest Impressionist painting was done during this season, at first on the Island of Appledore among the Isles of Shoals off the coast of New Hampshire and Maine, and then in such old and traditional coastal communities as Newport, Gloucester, and Provincetown. In 1903

he began visiting Old Lyme, Connecticut, which had developed as a Barbizon-related artists' colony in 1899. Hassam's presence there, along with that of Willard Metcalf beginning in the summer of 1905, shortly after his personal and professional "renaissance," turned Old Lyme rather abruptly into a major Impressionist-oriented art colony, changing from an "American Barbizon" to an "American Giverny."

The state of Connecticut, in fact, especially its small communities on the shore of Long Island Sound, offering artists the pleasures and scenic attractions of a rural landscape environment and yet within easy proximity of both New York City and Boston, became something of a bastion for Impressionist painting. Even before Old Lyme developed as a major art colony, the contiguous communities of Greenwich and Cos Cob, even closer to New York, had become a major center both for creative work and for the teaching of outdoor painting, in the person of John Henry Twachtman, who established a home at Greenwich in 1890 and began holding summer classes in Cos Cob a year or two later.[137]

Like his colleagues Theodore Wendel and Louis Ritter, Twachtman was from Cincinnati and studied in the mid-1870s in Munich. He became one of the finest practitioners of the avant-garde Munich style of thick, slashing paint handling and rich, contrasting effects of light and dark neutral pigments, first discernible in the landscapes he painted on a trip to Venice in 1877–78. Twachtman subsequently returned to America, and during the next several years he was traveling back and forth between Cincinnati, New York, and Europe, including a trip to Holland in 1881. By 1882 he appears to have concluded that he had carried the Munich manner as far as he could, and the following year he was in Europe again, this time in Paris, studying at the Académie Julian, while spending summers in the French countryside, especially at coastal communities such as Honfleur and Arques-la-Bataille. At this period he seems, like so many of his American colleagues, to have fallen under the influence of Bastien-Lepage, creating landscapes with more discreet tonal relationships and more calculated compositional strategies than in his earlier work.

Whistler, too, seems to have impacted upon Twachtman with the subtle tonalities of his Nocturnes, while Twachtman also seems to have borrowed the limited chromatic range of the Dutch Hague School, and even certain compositional devices derived from Japanese prints. These influences are visible in his French landscapes of the period, such as *Road near Honfleur,* 1883–85 (colorplate 48), with its carefully graded shades of silvery grays and greens and its balance of diagonal axes and graduated verticals. *The River* (colorplate 49), too, is one of Twachtman's French canvases of this period, less densely painted than his Munich pictures, with the carefully rendered flowers and foliage in the foreground almost a signature motif of Bastien-Lepage.[138]

After revisiting Venice at the end of 1885, Twachtman was back in the United States, but his whereabouts for the next several years are

confusing. His official residence in the late 1880s was New York City, but he was already spending the summers in Connecticut, first near his friend and fellow Impressionist J. Alden Weir, and then at Greenwich, where he first rented, before purchasing a home in 1890–91. It was on this property that Twachtman worked out his final aesthetic manner, which can be seen as an amalgam of his earlier modes, superimposed upon the landscape of his much-loved Connecticut property in a very personal and deeply affecting way.

Twachtman's mature art is informed by Impressionism, probably by the French painting he saw in Paris and in New York, but especially through the influence of his good friend Theodore Robinson who, on his trips back from Giverny to the United States, and after his final return in 1892, was a frequent guest in Greenwich. Yet Twachtman's Impressionism is quite individual and introspective. Like Monet, whom he never met, Twachtman painted the same subjects—the rolling hills, the brook, the small waterfalls, as well as the house, barn, and garden of the property— over and over again, exploring seasonal change and alternating color patterns, but never in the calculated manner of the French master; Twachtman's was not a "serial" art. His most sensitive images are his winter paintings, such as *Winter Landscape* (fig. 131), with subtle gradations of white permeated with touches of other colors, delicately nuanced indications of trees, and sinuous, flowing outlines separating land areas and flowing water, which suggest the abstracted patterns of the European Art Nouveau aesthetic.[139] Twachtman's winter landscapes were much appreciated in their own time. One of America's foremost critics of the period, Clarence Cook, wrote that in these pictures "the treatment of snow, a favorite subject of late with artists at home and abroad has not been surpassed in truth and beauty by anyone." Compared to the work of other painters, Cook wrote, Twachtman's "strikes for some of us a deeper, tenderer note."[140] Twachtman was one of the best-represented American artists in the 1891 Durand-Ruel show in Paris, which included at least one winter scene.

Twachtman painted his winter landscapes on his own property but also at the Holley House in neighboring Cos Cob, where he is known to have stayed for much of the winter of 1901–2, not long before his death the following summer. Holley House had also served during earlier seasons as the base for his summer teaching, beginning around 1892. For much of that decade, Twachtman passed on to numerous pupils, some of whom also took more formal instruction from him in New York City during the rest of the year, his own personal adaptation of the strategies and philosophy of French Impressionism.[141]

Among the many enticements Paris offered young American artists, the opportunity to hone and perfect their skills in the schools and academies there was paramount. However, by the end of the century the situation had begun to change. For one thing, America could boast of a growing number of highly professional art schools of her own, modeled at

least in part upon Parisian examples where many of the directors and teachers had themselves received their professional training. The Art Students League in New York, founded in 1875, where Twachtman and so many of his Paris-trained colleagues taught, was one of the most renowned of these. By 1900 there were many more such institutions, some like that in Boston, associated with one of the growing number of American civic museums. For another, the growing popularity of plein air painting among not only artists but also patrons meant that much of the teaching that evolved in the United States took place in the out-of-doors during the summers, when both art students and their instructors supplemented their more formal education by attending and enjoying outdoor classes, which usually took place in attractive country settlements such as Provincetown, Gloucester, the New Jersey shore, and equivalents in the Midwest and Far West, though some of these summer classes were conducted in Europe as well.[142]

The most famous outdoor summer school held in America was that conducted at Shinnecock on Long Island from 1891 to 1902 by William Merritt Chase. Chase, in fact, was unquestionably the most influential art teacher in America in the late nineteenth and early twentieth century. Paradoxically, he was one of the few major American painters who did not train in Paris, and yet he was probably more responsible than any other single artist for introducing modern French ideals of instruction and aesthetics into American cultural consciousness. He was arguably also the first American painter to create Impressionist works in the United States.[143]

Born in Indiana, Chase followed the pattern of a great many midwestern artists and studied at the Akademie in Munich beginning in 1872. Though a successful student academically, Chase, like his friends and colleagues Frank Duveneck and Twachtman, adopted the avant-garde manner of Wilhelm Leibl, a dramatic bravura technique, while responding to an aesthetic that emphasized technical proficiency for its own sake, somewhat akin to Whistler's "art for art's sake" in theory though not in style. Chase returned to New York in 1878, a fully professional artist who swiftly became one of the dominant figures in the American art world. That year he exhibited with the forward-looking Society of American Artists in its first annual exhibition, and early the next year he was made a member of the society; in 1880 he became its president. He was reelected in 1885 and remained in that position for a decade. He also became an Associate Academician of the rival and more traditional National Academy of Design in 1888 and a full Academician two years later. Chase began his distinguished teaching career in 1878 at the Art Students League; he later offered instruction in Brooklyn, Philadelphia, and Chicago, and started his own academy, the Chase School of Art, in New York in 1896.

Chase's own art mirrored the perception of the Society of American Artists, which critics initially identified as especially espousing the aesthetic ideals of the modern Munich manner. After several years, however, the

society was seen as the bastion of French modernist tenets as practiced both by American artists at home and those who remained abroad. Likewise, in Chase's painting the dark drama of Munich gave way to a more subtle touch and lighter tonalities, visible in the plein air paintings, which he appears to have first undertaken in Holland during European summer trips of 1883 and 1884. Chase's American work began to take on a new colorism in the park scenes that he had begun painting out-of-doors in 1886—first in Prospect Park in Brooklyn and then in Central Park in Manhattan. Chase may well have been sustained in the direction his art was taking during the summer of 1886 by the recent large display of French Impressionist work that had been on view in New York, sent over from Paris by Durand-Ruel. The park pictures were first exhibited publicly in a large one-artist show at the Boston Art Club late in 1886. This display introduced Impressionist-related work by an American to Boston even before the paintings of Wendel, Breck, and Sargent were on view there. The park pictures also appeared in larger numbers in his one-artist show within the art display of the Inter-State Industrial Exposition held in Chicago in 1889.[144]

The relationship of these paintings to French Impressionism was not fortuitous, though Chase preferred being identified as a Realist, rather than an Impressionist. Chase visited Paris in 1881 with J. Carroll Beckwith, where he met Beckwith's former teacher, Carolus-Duran; it may be significant that he also met Mary Cassatt, then at the height of her involvement with Impressionism, and admired her work. This was the first of five successive years that Chase traveled to Europe, during the first three of which his work was exhibited at the Paris Salon, winning an honorable mention in 1883. 1881 was also the year of Chase's earliest documented involvement with French Impressionism, in his encouragement to his fellow painter J. Alden Weir to purchase two works by Manet, *Boy with a Sword* and *Woman with a Parrot* (both Metropolitan Museum of Art, New York), for the New York art patron Erwin Davis—the first Manets to enter an American collection. The pictures were subsequently featured, along with a Degas that Davis had acquired, in the Pedestal Fund Art Loan Exhibition held in New York in 1883, a display organized by Chase and Beckwith to raise funds for the pedestal for the Statue of Liberty by the French artist Frédéric-Auguste Bartholdi, which was erected in New York Harbor in 1886.

Chase had the largest number of works on view in the American section of the art gallery of the Exposition Universelle held in Paris in 1889, where he won a silver medal, and he was represented by two paintings, including his large-scale portrait of Whistler (fig. 69), in Durand-Ruel's American exhibit held in Paris in 1891. Chase would eventually come to own work by Manet, and also by a number of Manet's associates, including Berthe Morisot and Eva Gonzales. While he was reserved in his opinion of Monet's art, Chase referred to Monet in his belief that never "in the history of art was open-air, light and air, attempted or done as well as it is today."[145]

Fig. 69
William Merritt Chase, *James Abbott McNeill Whistler,* 1885, oil on canvas. Metropolitan Museum of Art, New York, Bequest of William H. Walker, 1918

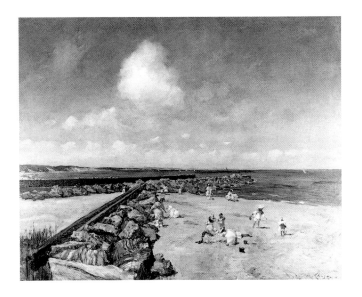 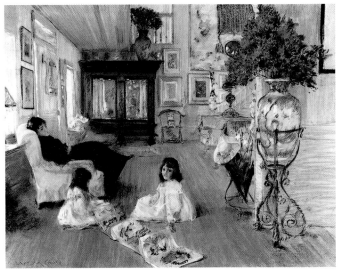

Fig. 70
William Merritt Chase, *Morning at Breakwater, Shinnecock*, c. 1897, oil on canvas. Daniel J. Terra Collection, 5.1980

Fig. 71
William Merritt Chase, *Hall at Shinnecock*, 1892, pastel on canvas. Terra Foundation for the Arts, Daniel J. Terra Collection, 1988.26

In 1891 Chase opened his Shinnecock School of Art amid the dunes of the south shore of Long Island; over the years he drew hundreds of students to study with him, some of whom, in turn, became leaders among the next generation of American artists. But Chase himself also produced there some of his most beautiful painting, done en plein air, fresh, informal works such as *Morning at Breakwater, Shinnecock* of about 1897 (fig. 70). Here his wife and daughters play in the sand with other children while enjoying the expanse of tranquil, sunlit outdoor nature. Such paintings bring to mind the coastal scenes of the Belgian painter Alfred Stevens, who worked in Paris and whom Chase met in 1881; Stevens had advised Chase to work in a modern, rather than old-master manner.[146] One of the many writers about Chase's summer school noted of the artist that "summer vacation is his busiest and his happiest time, and upon the work then done he not infrequently finds his inspiration for the remainder of the year. . . . the advantage of living in such a place is that all an artist has to do is to take out his easel and set it up anywhere, and there in front of him is a lovely picture."[147]

Not all of Chase's Shinnecock pictures are outdoor scenes, however. One of the most noteworthy, documenting his life in his summer home on Long Island, which was designed by the great architect Stanford White, is *Hall at Shinnecock* of 1892 (fig. 71); this is one of the earliest of his Shinnecock pictures and one of his largest pastels. Chase had been one of the organizers and leaders of the Painters in Pastel, an organization that had been formed in New York in 1882 and held a series of exhibitions between 1884 and 1890, reflecting the renaissance of pastel painting, which was being contemporaneously exercised by Degas and Cassatt. In their vivid use of the pastel chalks and their bright colorism, the works exhibited by the Painters in Pastel helped pave the way for the acceptance and admiration of Impressionism in the United States. Though the organization ceased after the 1890 show, pastel painting remained popular and was instead

 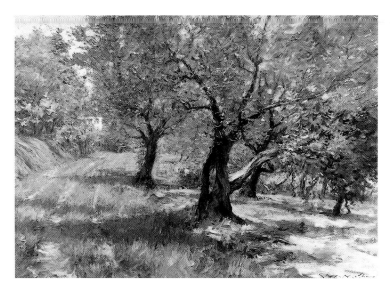

incorporated into the annual exhibitions of the newly formed New York Water Color Club. For all its modernity, *Hall at Shinnecock* can be viewed as an informal equivalent to the great painting *Las Meninas* by Velázquez (fig. 72), whom Chase so admired and whose work he copied extensively on his first visit to the Prado in 1881. The comparison can be pursued even in the reflection of the artist at work in the mirrored panel of the great wooden armoire in the rear of the room, which repeats the reflection of the king and queen in Velázquez's picture.

After Chase gave up his Shinnecock school in 1902, he continued to teach during the summers, but instead of a fixed location, he traveled with his students to various art centers in Europe: in 1903 to Holland; in 1904 to England; in 1905 to Spain; in 1907 and again in 1909–11 to Florence; in 1912 to Bruges; in 1913 to Venice. In 1914 Chase taught at Carmel-by-the-Sea in California. He spent the greatest amount of time in Florence, where he acquired a villa and where he painted works such as *The Olive Grove* (fig. 73), which are among his most "orthodox" Impressionist pictures, informal landscapes in rich colors and bright sunlight, with the paint laid on with short, commalike brushstrokes.

Boston had been the American city most responsive to French art in the 1860s and 1870s when William Morris Hunt was promoting the artists of the Barbizon School, and in the following decade many of the Americans who discovered Impressionism in Giverny came from that city. Yet New York remained the center of the United States art world, with its artists, collectors, and critics the most receptive to avant-garde aesthetic impulses from abroad. Nevertheless, there developed a Boston School of Impressionist-related painting in the last decade of the nineteenth century. The situation there, however, was unusual, in that the original Impressionists—landscape specialists such as Wendel, Breck, and the short-lived Bunker—whose advanced, French-related painting was seen and much discussed in 1888–89, were almost immediately overshadowed by a group

Fig. 72
Diego Velázquez, *Las Meninas,* 1656, oil on canvas. Prado, Madrid

Fig. 73
William Merritt Chase, *The Olive Grove,* c. 1910, oil on paper mounted on canvas mounted to panel. Daniel J. Terra Collection, 6.1980

of Boston figure painters, whose leader was Edmund Charles Tarbell. It may be that these artists had closer contact with the Boston elite than the landscapists, or that the traditionally recognized superiority of figure painting over scenic art still held sway. Most probably, however, the images created by Tarbell and his colleagues were simply both more distinctive, and yet at the same time more reflective of the upper-class life styles and ideals of their champions.[148]

Boston School painting centered around the imagery of attractive, upper-class women and/or fair-haired children, often modeled by members of the artists' families. In its earlier phase, the figures were more often than not posed out-of-doors, usually in a field or garden setting. But in the early twentieth century, under the impact of the revival of the art of Jan Vermeer, much Boston School imagery moved indoors, where the artists adopted a more Tonal approach with extremely subtle effects of light and atmosphere—actually a retreat from the more extreme strategies of Impressionism. Tarbell was recognized as the leader of both phases of the movement. After studying in Boston, he went to Paris in 1884 to study at the Académie Julian, returning in 1886. His reputation grew quickly, and in 1889 he, along with his close friend and colleague Frank Benson, became instructors at the School of the Museum of Fine Arts in Boston; the following year they began to share the directorship there. Tarbell was one of those represented in the 1891 Durand-Ruel Paris exhibition of work by American artists.[149]

Tarbell's acquaintance with French Impressionist work presumably would have been initiated at the Foreign Exhibition in Boston in 1883 even before he went abroad, since he prepared catalogue illustrations based on several of the works in the show. His exposure to the movement in the French capital is unrecorded. He was investigating effects of light in both interiors and outdoors in the late 1880s, perhaps under the influence of the charismatic Bunker, but his first work to fully evoke the impact of Impressionism is *Three Sisters—A Study in June Sunlight,* of 1890 (fig. 74), a picture that may well have been directly influenced by the appearance in Boston early that year of an Impressionist work by John Singer Sargent. Sargent's popularity in Boston was already legendary, and *A Morning Walk* of 1888 (private collection),[150] which appeared at the St. Botolph Club, features many strategies similar to the early outdoor pictures by Tarbell, such as his *Three Sisters.*

Even more similar to the Sargent is Tarbell's *My Wife, Emeline, in a Garden* (fig. 75). In both canvases, an attractive woman in white is walking along a path, behind which is a flowing stream. Light plays over both scenes, dappling the figures' dresses with myriad colors, while the raised viewpoint eliminates horizon and sky. Tarbell's subject is the former Emeline Souther, whom the artist had married in 1888, and the picture was probably painted at New Castle, New Hampshire, where the Tarbell's summered and where many of his outdoor pictures were painted. The

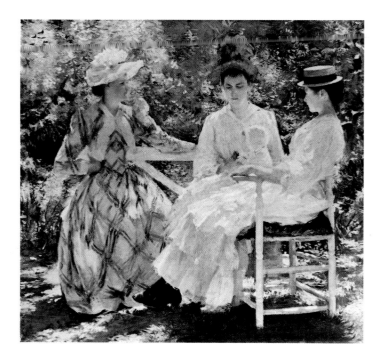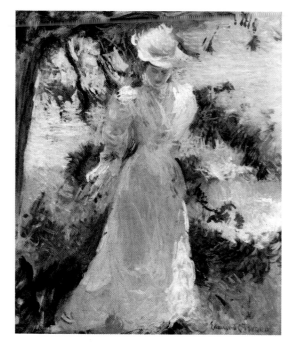

tremendous change in Tarbell's art is apparent in a comparison with this work and his earlier portrait of his wife (private collection), painted in 1888 and exhibited at the Paris Exposition Universelle in 1889, in which she is academically modeled, wearing an elegant red dress and placed in a dark, neutral setting. Though not securely dated, the present work would seem to be one of Tarbell's earliest forays into the Impressionist mode, and the kind of picture that led to recognition of Tarbell's leadership of the school. By the end of the decade critics were referring to Benson and the other Boston figure painters as "Tarbellites."[151] Under Tarbell and Benson, the School of the Boston Museum of Fine Arts became one of the leading teaching institutions in the American art world, perpetuating the aesthetic of the Boston School for generations.

A close friend of both Tarbell and Childe Hassam was Abbott Fuller Graves, New England's leading flower painter. The theme of the flower garden is, of course, especially identified with Monet, and the subject was occasionally painted by some of the first Giverny artists; it would become a favorite motif of their successors early in the twentieth century. Flower gardens were also frequently depicted by some of the New York–based Impressionists such as Hassam in their summer work, but it was not a common motif of the Boston Impressionists, even in their outdoor settings.[152] Graves studied with the well-known French flower painter Georges Jeannin in 1884, rooming with Tarbell in the French capital. After a brief return to teach in Boston, he was back in Paris in 1887 as a pupil at the Académie Julian and of Fernand Cormon, while renewing his friendship with Hassam. Graves again returned to Paris in 1902, remaining until 1905.

Graves painted and taught in Boston, but in the early 1890s he

Fig. 74
Edmund Charles Tarbell, *Three Sisters—A Study in June Sunlight,* 1890, oil on canvas. Milwaukee Art Museum, Gift of Mrs. Montgomery Sears

Fig. 75
Edmund Charles Tarbell, *My Wife, Emeline, in a Garden,* 1890–95, oil on canvas. Daniel J. Terra Collection, 7.1985

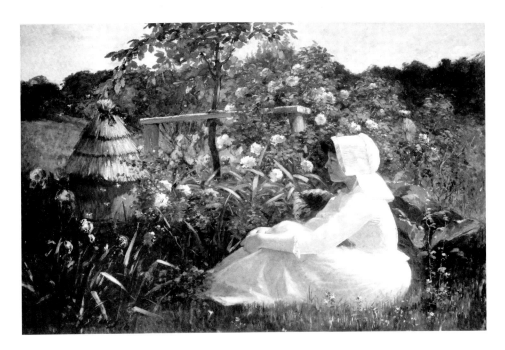

Fig. 76
Abbott Fuller Graves, *In a Field of Flowers*, 1890, oil on canvas. Terra Foundation for the Arts, Daniel J. Terra Collection, 1987.4

began visiting Kennebunkport, Maine, and later purchased a house there, where he spent much of each year, becoming the region's foremost floral specialist. Within his chosen genre, his range was enormous: gardens, both empty and with figures tending the flowers, such as *In a Field of Flowers* of 1890 (fig. 76); flower shows; flower bedecked trellises and doorways; and floral still lifes. *In a Field of Flowers*, formerly titled *Panier des fleurs*, is an early work, painted in France, and is more structured than most of Graves's floral subjects, with the rather primly dressed gardener in white contrasted effectively with the sumptuous floral display. With his freely brushed technique, and given the requisite elements of sunshine and color, Graves's art shares many of the strategies of Impressionism.[153]

By the turn of the century, Impressionism had become the dominant aesthetic mode in many areas of the country. While Boston and New York embraced the French-derived aesthetic, though not without some critical resistance, Philadelphia, the third metropolis of the American Northeast, appears to have been less receptive to French modernism. This was not due to nationalistic preferences, but rather because of the strength of the academic tradition at the Pennsylvania Academy of the Fine Arts, instituted by Thomas Eakins, a favorite student of Gérôme, and continued by his successor Thomas Anshutz.

This is not to suggest that French and American Impressionist works were not seen in Philadelphia. The only French Impressionist represented at the Pennsylvania Academy in the nineteenth century was Monet, with one example on view in the 1891 annual. Four Monets were shown in the display the following year, which also included paintings by Hassam, Chase, Tarbell, and a special collection of forty-two pictures by Vonnoh, then a teacher at the school. The show was advertised as "The Dawn of a New American Art Impressionism!" On the other hand, it was

also criticized for the disproportionate number of pictures exhibited by artists from outside the Philadelphia area, one writer commiserating that "home talent has been literally squelched."[154]

Probably the Philadelphia painter whose work most conformed to the aesthetics of French Impressionism at the beginning of the twentieth century was Hugh Henry Breckenridge. The paintings he showed at the Pennsylvania Academy after his study abroad at the Académie Julian in 1892 were portraits and Tonalist moonlight scenes; even at this time, however, critics discerned an Impressionist component in his work. At the end of the century, probably in 1898, Breckenridge opened an outdoor summer school in Darby, Pennsylvania, soon moving it to nearby Fort Washington, where he named his home Phloxdale. This is significant for his art, since much of his painting done early in the twentieth century consisted of brightly painted flower garden scenes, with phlox his favored flower, pictured in such works as his 1906 *White Phlox* (fig. 77). By that year the flower garden theme had become one of the most popular in American painting, inspired, of course, by the example of Monet, though a direct connection between Breckenridge and the French master, or with any member of the Giverny artists' colony, has yet to be established.[155]

In the early twentieth century the Boston School was frequently compared and contrasted with the so-called Pennsylvania School.[156] This consisted of a group of painters identified not with an urban center but with a country setting centered around the town of New Hope on the Delaware River, and not with a collection of figural masters but with artists specializing in landscape. While the Boston painters were viewed as refined and aristocratic, the Pennsylvania artists were seen as producing pictures that were more virile, down-to-earth, and "democratic," rising from a more thoroughly American artistic heritage, and also more Realist, though they, too, were identified as Impressionists.

The leading spirit of the Pennsylvania School was Edward Willis Redfield, but however "American" his paintings were perceived, Redfield's most significant training took place in France.[157] Redfield had studied at the Pennsylvania Academy before going abroad in 1889 to study at the Académie Julian, and then entering the Ecole des Beaux-Arts the following year. He showed a winter scene at the Paris Salon in 1891, a forerunner of his specialization in the winter landscape after he settled in rural Pennsylvania. He returned to Philadelphia in 1891, but he was briefly in France again in 1893, and for a longer stay of several years in 1898, during which time he painted *France* (colorplate 84). This is a dark, Tonal urban scene, with reference to the strong impact made on American (and European) painting at the end of the century by Whistler's Nocturnes. Unlike Whistler's pictures, however, forms are quite clearly defined in strong planes of light and dark, *France* projecting a sober interpretation of a winter night, down one of those deep perspectives so favored by artists in the late nineteenth century.

Fig. 77
Hugh Henry Breckenridge, *White Phlox*, 1906, oil on canvas. Terra Foundation for the Arts, Daniel J. Terra Collection, 1988.15

Redfield recalled that, when he was studying in France, "our gods were painters like Degas and Monet,"[158] and his predilection for high-keyed outdoor work, especially the cold whites of winter, is evident in *The Breaking of Winter* (fig. 139), a scene on the Delaware River painted about 1914. In 1898 Redfield had settled in Center Bridge, just above New Hope on the river, and after his return there from France in 1900, he began to produce the snow scenes upon which his reputation would rest. A fair number of winter and snow scenes were included in his one-artist show held at Boston's St. Botolph Club in April 1901, and the first article written about him, in 1906, characterized him as "an artist of winter-locked nature."[159] Many of these are panoramic views across to the low-lying hills of New Jersey, the great flat distances contrasted with the lean uprights of tall, thin, leafless trees in the foreground, with the white snow permeated with blue and purple reflections and shadows. These are often very large pictures.

The Pennsylvania landscapists created some of the biggest canvases of American Impressionism, yet they were painted out-of-doors, sometimes at a single session. Although these are direct, objective presentations of the American landscape, their overall appearance and format reflects the impact on Redfield's work of Fritz Thaulow, the Norwegian Impressionist working in France. Redfield had visited Thaulow in Paris and admired his paintings, recommending them to his associates. Though Redfield was not an active art teacher, he in turn drew many other painters to the New Hope area, some of whom emulated his painting and extended the life of the Pennsylvania School through several generations.

One of the most distinctive of the Pennsylvania Impressionists, an artist whose oeuvre is quite independent of Redfield's, was Daniel Garber, a painter particularly sensitive to light and color and arguably the finest painter of the school.[160] Garber was one of the first students at Breckenridge's Darby Summer School and attended the Pennsylvania Academy as well. A fellowship from the academy allowed him to go abroad for two years in 1905; he went first to England and Italy, but spent almost a year, spring 1906 to early 1907, in France, exhibiting at the Salon both years. When Garber returned in 1907, he was a committed landscapist, working in Impressionist-related modes. The stress here is on the plural; in 1907 Garber established a studio in Lumberville, north of New Hope on the Delaware River, and interpreted the local scenery in two distinctive approaches, apparently simultaneously and with equal originality and loveliness. Some of his paintings are quite naturalistic, such as *Fisherman's Hut,* about 1940 (fig. 78), often fairly tightly rendered but with rich sunlight and glowing color. Many of the finest of these, as here, are views across the Delaware River with glimpses of the quarries cut into the New Jersey river front, but they are nevertheless paeans to natural beauty, not diatribes against man's ravages against nature.

The other phase of Garber's landscape art is much more decorative, and often concentrates on woodland scenes, as in the undated *Spring on the*

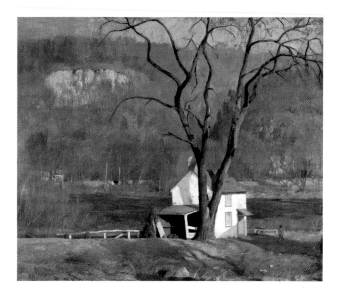
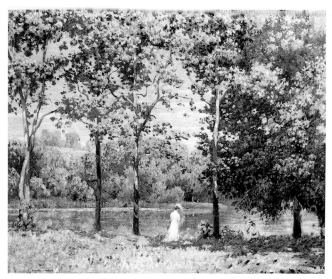

Schuylkill River (fig. 79). These are more painterly and very patterned pictures, with stylized treatment of foliage and land masses, and often with a carefully limited palette of blues and yellow-greens. This more ornamental and somewhat synthetic landscape mode is one direction taken by Post-Impressionist American landscape painting, but one again related to and possibly derived from the work of French artists of the turn of the century, such as Henri Martin, Edmond Aman-Jean, and Ker-Xavier Roussel.[161] Unlike Redfield, Garber was an enormously influential teacher; he was an instructor at the Pennsylvania Academy for four decades, from 1909 until 1950.

By the turn of the century, Impressionist-related aesthetics had penetrated a number of the French artists' colonies, in addition to Giverny and Grèz. Paul Gauguin had transformed Pont-Aven into a center for radical Post-Impressionist theory and practice after his arrival in 1886. The colony there subsequently represented artists of all persuasions—from academic to avant-garde. Redfield visited Pont-Aven with several friends in 1889, Tanner was there two years later, and Americans visited and painted at Pont-Aven and nearby Concarneau even well into the twentieth century, but they did not effect the dominant presence that they had in the early time of Robert Wylie.

Bernhard Gutmann is one such later painter. German born and trained, he emigrated to the United States in 1892, teaching in Lynchburg, Virginia, and then moving to New York in 1899, where he worked as an illustrator. Wishing to devote his career to painting, Gutmann traveled to Europe in 1907, where he remained for five years. By then he was working in a colorful Impressionist manner with overtones of both Georges Seurat's Pointillism and Gauguin's Synthetism, but though he was active in Brittany, where he painted *Breton Lacemakers* (fig. 80) during his last year abroad in 1912, any connection here with Gauguin's own much earlier stay in Pont-Aven should probably be considered fortuitous.[162]

Fig. 78
Daniel Garber, *Fisherman's Hut,* c. 1940, oil on canvas. Daniel J. Terra Collection, 23.1985

Fig. 79
Daniel Garber, *Spring on the Schuylkill River,* n.d., oil on canvas. Daniel J. Terra Collection, 13.1990

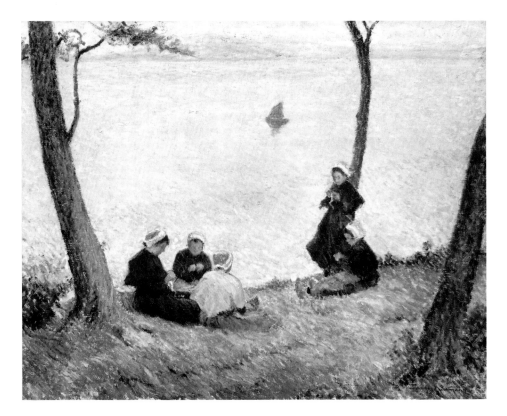

Fig. 80
Bernhard Gutmann, *Breton Lacemakers*, 1912, oil on canvas. Terra Foundation for the Arts, Daniel J. Terra Collection, 1988.18

Giverny remained one of the major bastions of the Impressionist aesthetic during the first several decades of the twentieth century; it was certainly one of the longest lasting of the artists' colonies that developed in France in the later nineteenth century, and it remained one in which the American presence was paramount. While the original colonists of 1887 no longer continued to visit—Robinson and Breck both suffered early deaths before 1900—the presence of a number of those who followed such as Lilla Perry assured continuity, while both Butler and the MacMonnies maintained permanent residences into the twentieth century.

There is even greater uniformity in the painting of these Americans working in Giverny than there had been among their predecessors, but the aesthetics of the later Givernois were quite distinct from that of the artists of the late 1880s. This new artistic approach is manifest in the work of the most successful of these later men, Frederick Carl Frieseke, who also maintained a longer residence in Giverny than did his colleagues. Like almost all of these painters, Frieseke came from the Midwest and studied in Chicago before traveling to Paris for further instruction; by 1898 he had entered the Académie Julian and was also studying at the Académie Carmen with Whistler. The influence of the latter is especially in evidence in Frieseke's early pictures, such as *The Green Sash* of 1904 (colorplate 35); the figure of a tall, stylish woman viewed obliquely in an interior is a more colorful variant of many of Whistler's portraits and figure paintings of the previous several decades.

Color, however, is a key to Frieseke's paintings, as it is to the work of a whole generation of Americans in Giverny. He began to summer in

Giverny as early as 1900, and starting in 1906 he leased a house near to that of Monet; he may have been led initially to Giverny by Frederick MacMonnies, who instructed at Whistler's Paris atelier. By 1909, in such depictions of his wife as *Mrs. Frieseke on the Banks of the River Epte* (fig. 81), the artist had moved outdoors in bright sunlight, here utilizing sparkling, broken brushwork to integrate the figure into the verdant landscape. Even more typical of Frieseke at his finest is *Lady in a Garden,* painted around 1912 (colorplate 36), a riot of sunlit patterns—the figure's striped dress repeating the vertical shoots and leaves of the lilies at her feet, and contrasting in color, brushwork, and overall shape with the flowering bushes behind and to either side.

Frieseke and his colleagues were predominantly figure painters, not landscapists. The pictorial realm of this group of Americans in Giverny was the domestic world, the home and the private, enclosed garden, not the hills and fields of the village and the countryside. And the garden, in turn, was not a peasant vegetable garden, but a lovely and colorful flower garden, which itself bespoke an elegant way of life quite different from the somewhat Bohemian world of Robinson and his colleagues. While the garden theme evolves from Monet's magnificent development of his own property and the paintings that derived from that environment, Frieseke was not interested in floriculture as such, but rather in the colors and patterns that flowers provided. He stated this, in fact: "It is sunshine, flowers in sunshine, girls in sunshine, the nude in sunshine, which I have been principally interested in. . . . I know nothing about the different kinds of

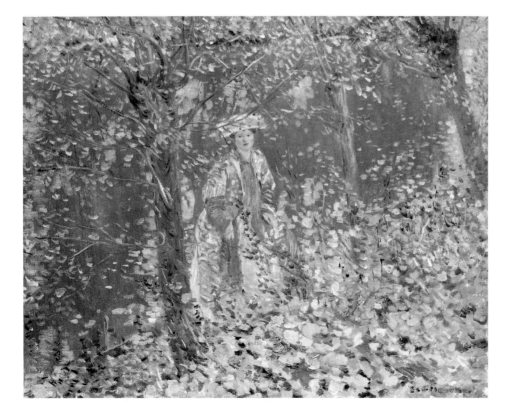

Fig. 81
Frederick Carl Frieseke, *Mrs. Frieseke on the Banks of the River Epte,* 1909, oil on canvas. Terra Foundation for the Arts, Daniel J. Terra Collection, 1987.20

Fig. 82
Frederick Carl Frieseke, *Mrs. Frieseke
at the Kitchen Window*, 1912, oil on
canvas. Terra Foundation for the
Arts, Daniel J. Terra Collection,
1987.12

gardens, nor do I ever make studies of flowers. . . . If you are looking at a
mass of flowers in the sunlight out of doors you see a sparkle of spots of
different colors; then paint them in that way."[163] Paintings such as *Lady in a
Garden* (colorplate 36), or even *Lilies* (colorplate 37), are testimonials to this
aesthetic philosophy, though the latter picture at least offers specific
identification to the dominant floral motif.

Despite Frieseke's proximity to Monet, there seems to have been
little contact between the two artists. Frieseke himself spoke of his
preference for the work of Pierre Auguste Renoir, and his preferred figural
type, certainly, owes a great deal to that French Impressionist master. And
Renoir, like Frieseke, was of course primarily a figure painter. *Lilies* is also a
more spirited, less introspective image than *Lady in a Garden* or the domestic
outdoor scene of *Tea Time in a Giverny Garden* (colorplate 38). All of these are
set in Frieseke's own garden and against his home, and suggest the
importance of color for this later generation of Americans in Giverny. The
garden furniture and the window shutters were brightly colored, as were the
walls of the rooms of the Frieseke house—the living room walls were
painted a lemon yellow and the kitchen a deep blue. This is made
abundantly clear in *Mrs. Frieseke at the Kitchen Window* of 1912 (fig. 82), with
the vivid blue door, shelving, and paneling contrasting with the green of the
window frame. The scene itself is a domestic one, as is the later image
Unraveling Silk, about 1915 (colorplate 39), also titled *Marcelle.*

Frieseke's pictures concentrating upon domestic activity are generally
more carefully finished, the figure somewhat more traditionally rendered,

and they testify to the continued impact of the artist's academic training. At the same time the image remains an elegant one. Frieseke's model is dressed casually but à la mode, and her sewing chore is involved with silk; she is *not* mending a shirt! Frieseke's more aesthetic concerns, and his emphasis upon domesticity, also relate his art to that of some of his Post-Impressionist contemporaries, such as Edouard Vuillard and Pierre Bonnard. Frieseke remained in Giverny through World War I, but in 1920 he bought a summer home in Le Mesnil-sur-Blangy in Normandy and left Giverny; there he remained an expatriate for twenty more years before his death in 1939.[164]

The work of many of the other Americans, such as Richard Emil Miller, who arrived in Giverny in the first decade of the twentieth century, was often, with some justification, compared to that of Frieseke. Miller's background was also midwestern, though he trained first in St. Louis rather than Chicago, before entering the Académie Julian, studying there in 1899. Throughout his career Miller's work was generally somewhat more informed by academic precepts than was Frieseke's, and this was especially true in his early, pre-Impressionist canvases, such as *The White Shawl* of about 1905 (fig. 83). This work, too, may be viewed in relationship to Whistler's "art for art's sake," though here the beautiful woman and her equally lovely gown are themselves works of art, in addition to the canvas itself. Many of the artists of this period, however, whether "Boston School" or "Giverny Group," were dedicated to images of the unemancipated woman, depicted within a sheltered, domestic environment and often turned inward upon herself—her own thoughts and contemplations or, as here, her own image. The mirror remained a favorite device for Miller.[165]

Actually, Miller first came to public notice with several canvases that stand as exceptions to his concentration upon the introspective woman, of which his *Café de nuit* (colorplate 40) is the most famous. This is one of a series of night scenes along the boulevards of Paris. These are bold pictures of elegantly garbed ladies of the night at a café, some with male companions, some lurking in the shadowy passageway, but the most prominent are women alone, very bold and self-confident. One pair has left the foreground table and is entering a carriage—destination unknown to the viewer. Another appears to have arisen from the table at the left, still occupied by the woman in black. Is the man at the flower stall purchasing a bouquet for her? This is modern-life painting with a vengeance, narrative-wise left open-ended, an approach to painting that developed within the canons of French Impressionism, practiced by such artists as Degas and Manet, but seldom undertaken by Americans.

Yet this appears to have been only a brief interlude in Miller's art, and once he became associated with Giverny, he concentrated upon images of the isolated woman, now painted either in interiors or in garden settings, using bright colors and glowing in rich sunlight. *The Pool* (colorplate 41) is archetypical of Miller's Giverny work at its finest, the circular form of the pool not only repeating the curve of the parasol, but also offering a

Fig. 83
Richard Emil Miller, *The White Shawl*, c. 1905, oil on canvas. Daniel J. Terra Collection, 6.1990

reflective, mirrorlike surface which returns us to the imagery introduced in *The White Shawl.* The parasol itself is an emblem of sunlight as well as a shield from it, and here it is colored, adding to the chromatic richness of the pictorial scheme.[166] While light dances over the surface of the canvas, the figure herself is quiet and contemplative. Unlike Frieseke, Miller was an extremely active teacher, both in Paris at the Académie Colarossi, and in Giverny where he taught outdoor classes, including offering instruction to the students from Mary Wheeler's Providence, Rhode Island, school. Thus, Miller spread the gospel of Impressionism in France, remaining until World War I, when he returned to the United States.[167]

Edmund W. Greacen was another member of the later Giverny colony, and the one most devoted to landscape—though he painted the figure also. Greacen had been a student of Chase in America, studying with him not only in New York and at Shinnecock on Long Island, but traveling with the Chase class to Madrid in 1905. When the class returned home, Greacen remained abroad, settling in France and falling under the influence of the Impressionists. In 1907 he was in Giverny, where he spent several years. Greacen became close to Frieseke and other fellow Americans, including Theodore Butler, but he met Monet only once.[168]

Greacen was in Giverny for just two years. His colleague Guy Rose enjoyed one of the longest associations with the colony, spanning the several generations of artists who worked there. Rose was the one significant California-born painter at the colony, who had studied in San Francisco before entering the Académie Julian in Paris in 1888. Rose quickly mastered the demands of academic art, exhibiting peasant subjects at the Salon in 1890 and 1891; after a hiatus, some of which he spent back in California, he showed religious and Symbolist pictures in 1894. In 1890 Rose also began his association with Giverny, beginning a stay of over six months on July 4. He was back for several months in the spring of 1891, again in 1894, but after that he did not return until 1899.

In between, Rose was living in New York and working as an illustrator and teacher, having temporarily abandoned painting after he succumbed to lead poisoning on a trip to Greece in the summer of 1894. Once Rose had returned to France in 1899, Giverny became his principal residence, first at the Baudy and then in a remodeled peasant cottage. Having been friendly with Robinson and others during the colony's early days, Rose now was especially close to Frieseke. Peasant subjects were replaced by idyllic images of young women, sometimes situated in flower gardens or on the Epte River. But during both his early stay and his later long residence there, Rose painted the Giverny landscape. His *July Afternoon* (fig. 84), featuring the grainstack motif so favored by Monet, and depicted in broken brushwork and bright sunlight, is one of many Giverny scenes by Rose that are difficult to date. He remained in Giverny until 1912, when he returned to New York, later settling in Southern California late in 1914.[169]

One of the youngest artists to join the Giverny colony and specialize

Fig. 84
Guy Rose, *July Afternoon*, n.d., oil on canvas. Daniel J. Terra Collection, 22.1986

in the depiction of lovely young women both in domestic interiors and outdoor gardens was Louis Ritman; he, like Frieseke, studied in Chicago before traveling to France in 1909, where he enrolled at the Ecole des Beaux-Arts.[170] The following year he began to exhibit in the Salon and also met Miller and Frieseke; Ritman continued the association in Giverny in 1911. Ritman spent most of the next ten summers in Giverny, even after Miller and then Frieseke had left the village. Ritman's color and the nature of his settings are close to those of Frieseke, though his favored figural type is very much his own, and his interpretation, in work such as *Early Morning* (colorplate 42), projects an appealing wistfulness which is also quite distinct. From the mid-1910s, some of Ritman's images are conceived in a structural manner, with the brushstrokes laid on in blocks of paint, and critics perceptively suggested the influence of Paul Cézanne here. Differentiating between the work of Frieseke and Ritman, one writer noted that "Frieseke knows his Monet, but seems totally unaware of Cézanne. Ritman is always plastic."[171] Ritman also painted a considerable number of pure landscapes in an Impressionist mode, such as *Afternoon Sun* (fig. 85), particularly in the later decades of his career.

 The work of this later generation of Giverny-based artists was extremely popular back in America. Frieseke, Miller, and Rose, together with another Chicago-based Giverny painter, Lawton Parker, working together in Giverny in an analogous manner, were identified as Luminists when they showed at the Madison Gallery in New York late in 1910, and their exhibition earned critical encomiums. Earlier that same year, Greacen,

Fig. 85
Louis Ritman, *Afternoon Sun*, n.d.,
oil on panel. Terra Foundation for
the Arts, Daniel J. Terra
Collection, 1989.20

together with Karl Anderson, still another Chicago painter who had worked
in Giverny, had had a two-artist exhibition at the Madison Gallery. All six
painters were identified as the Giverny Group, and praised for the "full
maturity of their rich impressionism."[172] If the original band of Americans
who had discovered Giverny brought French Impressionism back to Boston
and New York, this later association carried it throughout the country.
Shortly after he returned to the United States, Greacen became a mainstay
of the art colony in Old Lyme in 1910, reinforcing the Impressionist
orientation there. Parker and later Ritman taught back in Chicago where
they had originally trained. Rose became a principal instructor and director
at the Stickney Memorial School of Fine Arts in Pasadena, California, and
Miller joined him there briefly from 1916 to 1918. Miller subsequently
became a resident and major figure in the artists' colony in Provincetown,
Massachusetts.

As American artists at the end of the nineteenth century continued
to visit France, seeking professional academic instruction while at the same
time immersing themselves in the art world, the center of which they
recognized to be Paris, more and more of them not only explored
Impressionism but also reacted favorably to the various manifestations of
Post-Impressionism. Maurice Prendergast was to emerge from such
experience as one of the most original and brilliant of American painters of
the early twentieth century, an artist whose achievements were the direct
result of his exposure to French painting.[173]

Prendergast was born in Newfoundland and grew up in Boston
where he began painting, apparently self-taught. He may have seen the

French Impressionist works in the Foreign Exhibition held in Boston in 1883, and surely would have been aware of the French-influenced modern paintings shown there by such artists as Chase, Metcalf, Wendel, Breck, Hassam, and Sargent during the course of that decade. Following the lead of these Parisian-trained painters, Prendergast was in Paris by the beginning of 1891, studying at the Académie Julian and the Académie Colarossi, and remaining abroad until 1894. The earliest body of mature work by him consists of scenes in both oils and watercolors of women and children along Parisian boulevards and at the French seashore, painted in the early 1890s, such as his *Lady on the Boulevard* (fig. 138) and *The Tuileries Gardens, Paris* (colorplate 82). The latter is quite similar to some of Chase's pictures painted only a few years earlier in New York parks. It may be also, as has been suggested, that Prendergast was following in the direction laid out by Hassam in some of the Parisian street scenes he sent back to Boston and New York in the late 1880s. In these, Hassam concentrated almost exclusively on the female figure, but Prendergast's Parisian scenes are much smaller and more intimate than Hassam's, and that intimacy allies them with the French Nabis, such as Vuillard, as well as with the work of Whistler, who spent much of the 1890s in Paris.

The work of the Nabis was on view in Paris at the Gallery of Le Barc de Boutteville from 1891, Prendergast's first year in the French capital. Under such influences in Paris, Prendergast developed a concern for generalized types rather than individuals, a characteristic that would remain throughout his career. Indeed, Prendergast's relatively rare Parisian oils are *pochades*, small oil sketches that the artist considered complete onto themselves. Like Hassam also, Prendergast investigated temporal conditions in his Parisian work, at times presenting his subjects in the rain or in the darkness of evening; his *Lady on the Boulevard* foretells Miller's *Café de nuit* (colorplate 40) of a decade later.

Prendergast immersed himself in the contemporary Parisian life, as mirrored in such pictures as *Lady on the Boulevard.* It is not known if he became acquainted with Whistler, but among his closest companions in Paris were a number of young English and Canadian painters. Prendergast became especially close to James Wilson Morrice, who introduced the American to the Parisian art world, and who was to become identified as a leading Canadian Impressionist. Morrice's *Along the Seine* (colorplate 83), probably painted at about this time, is very close to Prendergast's work in its sketchy, painterly qualities, though compared to Prendergast, Morrice was even then more concerned with the settings, relative to the figural imagery. Prendergast may have derived his satisfaction with the small *pochade* from Morrice, who introduced him to the form.

Morrice, who had gone to Europe in 1890 and entered the Académie Julian the following year, remained essentially an expatriate, though he traveled extensively, making regular trips back to Montreal and also visiting North Africa and islands in the Caribbean. Much more

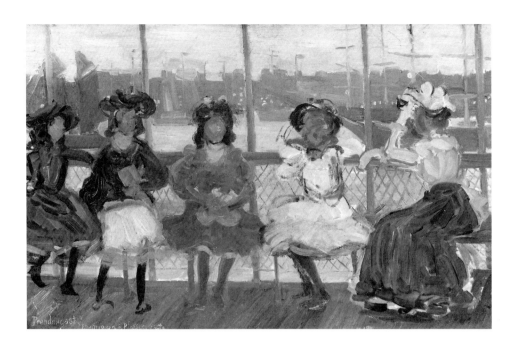

Fig. 86
Maurice Prendergast, *Evening on a
Pleasure Boat,* 1895–97, oil on
canvas. Daniel J. Terra Collection,
28.1980

cosmopolitan than Prendergast, Morrice was drawn to American artists and
frequently exhibited in the United States. In addition to Prendergast,
Morrice was also a friend of Everett Shinn, and especially Robert Henri
and William Glackens. He traveled to Holland with the latter two in 1895.
These three Americans would later, with Prendergast, be members of the
group of Realist painters who exhibited together as the Eight.[174]

Prendergast returned to Boston late in 1894, but both the
methodology he had developed in France and his fascination with
contemporary urban life remained strong. *Evening on a Pleasure Boat* (fig. 86) is
set in Boston harbor, painted in a bravura technique similar to his Parisian
pictures, although the work is now somewhat larger. He remained
preoccupied with women and children—and the children are all female
here—while the city itself, though only sketched in rapidly, is integral to the
scene. This picture appeared at the Society of American Artists' annual of
1898, the first time that Prendergast's oils were shown in New York,
heralding his increasing identification with modernism in the United States.
Franklin Park, (fig. 87) also dates from this same period, and is one of
Prendergast's earliest American scenes staged in a park, which would become
one of his favorite settings. The picture maintains the Nabis-infuenced
characteristics of forms treated as flat patterns of shape and color, qualities
that Prendergast would absorb into his later distinctive manner.[175]

Prendergast treated the same subject, *Franklin Park, Boston*, at the
same time in watercolor (fig. 88), a medium he appears to have utilized far
more than oils during the 1890s. This is one of a series of watercolors the
artist painted of the park, in which the bright colors and the suggestion of
scintillating light enhanced by the fluid use of the medium allies
Prendergast's painting much more than his oils with Impressionism; indeed,
Prendergast is arguably the finest American Impressionist watercolor

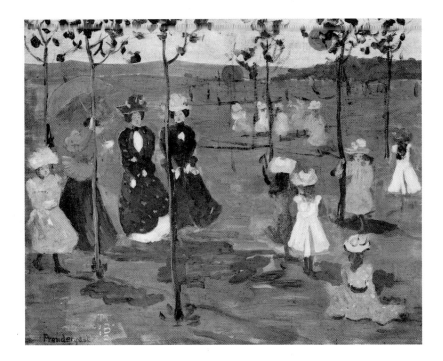

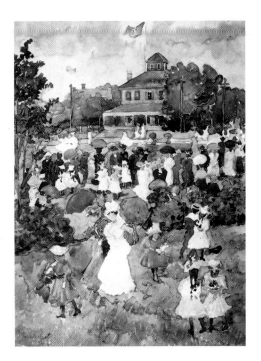

painter. One of Prendergast's Franklin Park watercolors appeared in the annual exhibition of the New York Water Color Club in 1897, the first time a picture of his is known to have been on view in New York. In works such as this, painted after Prendergast returned to Boston, he continued to demonstrate his primary concern with the leisure activities and the pleasure haunts of the populace.

Probably the most beautiful watercolors of Prendergast's career are those he painted in Venice on his second trip to the Continent in 1898–99, works such as *The Grand Canal, Venice* (fig. 89). Prendergast was the last of the many renowned Paris- and Munich-trained American painters, such as Whistler and Sargent, who stayed and painted in Venice in the last quarter of the nineteenth century. Prendergast's trip apparently was financed by the Boston art patron Sarah Sears, a collector of works by the French Impressionists and Mary Cassatt. The glistening waterways of Venice provided an ideal subject for Prendergast's shimmering technique, here contrasted along a long vertical axis with a street full of figures, some in brightly colored garments and holding colored parasols. During this trip Prendergast traveled throughout Italy, visiting Padua, Florence, Siena, Assisi, Orvietto, Rome, Naples, and Capri, and he painted watercolors in many of these places. *Monte Pincio, Rome* (fig. 90) is one of the finest of his Roman scenes. As with so many of his Italian watercolors, architectural elements are introduced here not only as significant foils against which the pageantlike parade of pedestrians and carriages is placed, but they also serve to orient the composition. The subject is distinctly Roman, but such themes drawn from contemporary life were ultimately inspired by modern French art.

In addition to working in oils and watercolor, Prendergast produced a large body of monotypes from his earliest days in Paris through 1902.

Fig. 87
Maurice Prendergast, *Franklin Park*, c. 1895, oil on panel. Daniel J. Terra Collection, 45.1980

Fig. 88
Maurice Prendergast, *Franklin Park, Boston*, 1895–97, watercolor and pencil. Daniel J. Terra Collection, 31.1985

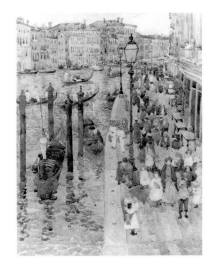

Fig. 89
Maurice Prendergast, *The Grand Canal, Venice*, 1898–99, watercolor. Daniel J. Terra Collection, 29.1980

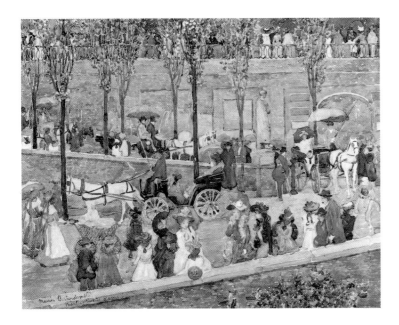

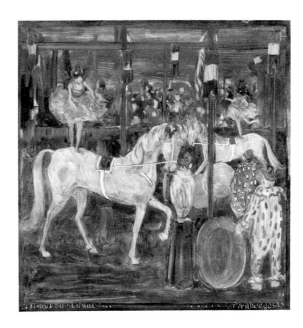

Fig. 90
Maurice Prendergast, *Monte Pincio, Rome*, 1898–99, watercolor. Daniel J. Terra Collection, 13.1982

Fig. 91
Maurice Prendergast, *Nouveau cirque (Paris)*, 1894–95, monotype. Daniel J. Terra Collection, 29.1984

Fig. 92
Georges Seurat, *Le Cirque*, 1891, oil on canvas. Musée d'Orsay, Paris

Monotypes are basically prints, made from pressing onto paper an oil or ink design which has been previously created on a smooth, nonabsorbent surface. This must be done quickly, before the paints dry, with the result that the final design on the paper appears spontaneous; because of the methodology, monotypes usually have blurred edges and flat surfaces. The advantage of the monotype lies in the artist's ability to "pull" two or three prints from the same design, though each will be progressively weaker unless they are reinforced. Here, too, Prendergast's art was indebted to recent French achievements. While the origins of the monotype can be found in mid-seventeenth-century Italy, it was the revival of the medium that took place in France in the late nineteenth century at the hands of Pissarro, Gauguin, and especially Degas that surely inspired Prendergast to adopt the medium.[176]

Early Evening, Paris, of about 1892 (fig. 137), is probably one of Prendergast's earliest monotypes, similar to the artist's early oil *Lady on the Boulevard*. Here again is a night scene, a theme derived from Whistler's Nocturnes, with the artist fascinated by the illumination of the lamplit streets. The prominent foreground figure is a fashionably dressed woman, but seen alone at night on a Paris boulevard, the image projects at least a status of independence, if not invitation. Although the title suggests that *Nouveau cirque (Paris)* (fig. 91) is a Parisian scene, one of a series of circus monotypes that Prendergast created, the date of 1895 on one of these has led to the assumption that they were all done soon after the artist's return to Boston late in 1894. However, some, such as the present example, might have been created just before he left the French capital. The group of circus prints constitutes a theme unique in monotype for Prendergast; otherwise, his prints relate to subjects similar to those he painted in oils and watercolor. As here, many of the circus prints utilize a palette quite restricted for Prendergast. *Nouveau cirque*, Prendergast's largest monotype,

suggests in a general way Seurat's famous *Le Cirque* (fig. 92), which Prendergast could have seen in Paris in 1891 at the Salon des Indépendants. *The Opera Cloak*, about 1898 (fig. 93), is one of a large number of monotypes depicting the single female figure that Prendergast created during the last three or four years of his production of such works; the influence of Whistler's portraiture remains strong in such images.

Prendergast returned to the United States from Italy late in 1899, living first outside Boston in Winchester, Massachusetts, and then in Boston itself, which remained his home from 1904 to 1914, at which time he moved to New York. Already during those years, he began increasingly to spend time in New York, becoming identified with a group of young New York Urban Realists. Many of Prendergast's watercolors were painted in New York's squares and parks, while others depicted the beaches around Boston. In his oils, however, such as *Salem Willows* (fig. 94), he tended to concentrate upon more casual and playful scenes, continuing the tendency toward pageantlike arrangements that were now enhanced by densely brushed surfaces and tapestrylike compositions, with forms compressed against the picture plane. Whether identified by title or not, the specific locale of a scene often became immaterial, while figures are generalized and usually featureless. Prendergast's art increasingly came to be concerned less with subject matter and more with the manipulation of colors and forms for their own sake. *Salem Willows* is dated 1904, but it may have been reworked then, for it appears to have been exhibited previously, as early as 1901. *Opal Sea* (fig. 95), a slightly later work, carries Prendergast's investigation of color and paint further and to a higher key.

Prendergast's next visit to France took place in 1907. He spent a

Fig. 93
Maurice Prendergast, *The Opera Cloak*, c. 1898, monotype.
Daniel J. Terra Collection,
23.1982

Fig. 94
Maurice Prendergast, *Salem Willows*,
1904, oil on canvas.
Daniel J. Terra Collection,
21.1984

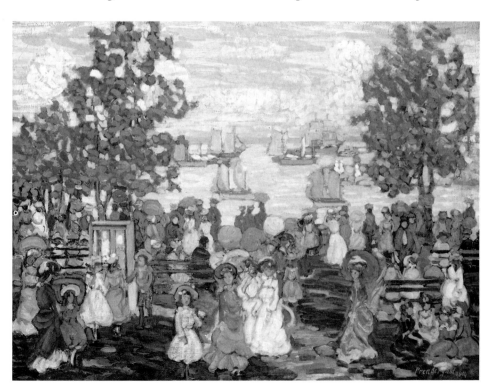

Fig. 95
Maurice Prendergast, *Opal Sea,*
1907–10, oil on canvas.
Daniel J. Terra Collection,
30.1980

Fig. 96
Maurice Prendergast, *St. Malo,*
c. 1907, watercolor.
Daniel J. Terra Collection,
47.1984

Fig. 97
Maurice Prendergast, *Still Life with
Apples and Vase,* 1910–13, oil on
canvas. Daniel J. Terra Collection,
32.1980

good deal of time on the coast at Saint-Malo, which he visited with his old friend the Canadian Morrice. The watercolors he produced there, such as *St. Malo* (fig. 96), reflect the impact of the work of the Fauve painters; he was almost certainly referring to them in a letter to his patron, Mrs. Oliver Williams of Boston, when he wrote: "I am delighted with the younger Bohemian crowd; they outrage even the Byzantine, and our North American Indians, with their brilliant colors would not be in the same class with them."[177] The highlight of this trip, however, was his opportunity in Paris to see the works of Cézanne, then little known in America; in particular, Prendergast visited the Salon d'Automne memorial retrospective of Cézanne's work that October. He wrote Mrs. Williams: "I got what I came over for, a new impulse. I was somewhat bewildered when I first got here, but I think that Cézanne will influence me more than the others."[178] Prendergast, one of the first American painters to champion Cézanne, appears to have been acquainted with his work even before the 1907 trip; another of his patrons, Mrs. Montgomery Sears, also of Boston, owned works by the French artist.

Cézanne's influence is revealed particularly in the series of still-life paintings that Prendergast painted, usually dated about 1910–13, such as *Still Life with Apples and Vase* (fig. 97). Still lifes constitute only a small fraction of Prendergast's total output, but such works especially reflect the impact of Cézanne in the juxtaposition of areas of color to create solid shapes, and the distortion and tilting of planes to effect a balance of two- and three-dimensional space.[179] Cézanne's presence can be identified in all of Prendergast's fruit still lifes; some of the flower pictures, however, such as *Spring Flowers* (fig. 98), present an arrangement of flat planes of color that bespeak the Fauve aesthetic with which Prendergast also came in contact during his Parisian visit of 1907. He was back in France again in 1909 and for the last time in 1914.

A decade earlier, when Prendergast was establishing his ties in the New York art world, he participated along with five others in a show held at the National Arts Club in January 1904. This group of painters was

primarily concerned with vivid depictions of the contemporary urban world; their association subsequently expanded with the addition of two more painters, and culminated in "The Eight," an exhibition held in February 1908 at the Macbeth Galleries in New York, then traveling to Philadelphia, a number of midwestern cities, and finally Newark, New Jersey, and Bridgeport, Connecticut. The display and its resultant publicity established this group as the nucleus of what came to be known as the Ashcan School—a term that appears to have been coined retrospectively only in the 1930s. Ashcan artists were concerned with the realities of modern life, and often depicted scenes involving common people, presented with a dramatic, vivid technique, and antithetical to the continuing domination of academically trained and oriented painters, and even to the increasingly refined and joyous work of the Impressionists. The Ashcan artists were also viewed as more indigenously American, both by virtue of their subject matter and their more Realist mode of presentation, rather than the European-based strategies of both the academics and the Impressionists.[180]

Yet critics also perceived the European, primarily French origins of much of the work of the Eight not only thematically, but also their formal strategies, which were grounded in the modern-life paintings of the Parisian Impressionists of the late nineteenth century. One might suggest, in fact, that the work of the Eight, rather than representing a reaction to Impressionism, constituted a belated homage to the Impressionist figure painters whose works were so condemned when they appeared in New York in the Durand-Ruel show of 1886, where, instead, Americans praised, acquired, and emulated the work of Monet and his fellow landscape specialists. This was, in fact, acknowledged to some degree by writers at the time of the 1908 exhibition and afterwards. The influential critic James Huneker wrote, "Technically, some of these painters stem from France"; and later Frank Jewett Mather noted that they accompanied a determination of seeing with a manner of execution that was "the idiom of Manet."[181]

The art of Everett Shinn, the youngest of the Eight, clearly reflects Parisian antecedents.[182] Like a number of his colleagues, Shinn began his professional career as a newspaper artist in Philadelphia, working for the *Philadelphia Press* beginning in 1893. Four years later he moved to New York and began to work for the *New York World,* while moving on to the less insistently demanding field of magazine illustration. An opportunity in 1898 to provide such work in pastel led Shinn to concentrate on that medium, with the result that his pastels of New York City, ranging from the harbor docks to the Plaza Hotel, often depicting lower-class life, were soon on view in one-artist and group exhibitions in Philadelphia and New York, bringing critical raves to the artist. They were executed often with a minimum amount of color, rather emphasizing strong, dramatic contrasts of black and white, the medium handled in a vivid, gritty manner; such work marked Shinn as a significant young urban Realist.

Fig. 98
Maurice Prendergast, *Spring Flowers,* 1910–13, oil on canvas mounted on panel. Daniel J. Terra Collection, 6.1983

Fig. 99
Everett Shinn, *Theater Scene*, 1903,
oil on canvas. Daniel J. Terra
Collection, 22.1985

But by late 1899 another theme entered Shinn's repertory, that of
the theater. In November 1899 a private showing of five of Shinn's pastels
was held at the New York home of the actress Elsie de Wolfe, three of
which were theater subjects. Shinn went on to produce pastels of actors and
actresses as well as theater buildings themselves, in addition to scenes on the
stage, in the orchestra, and of the audience in theaters and vaudeville. These
were featured in 1900 in his first one-artist show in New York, and he
found further encouragement for such subjects on his first trip abroad to
France and England, in 1901. When he returned, French music hall and
ballet scenes were added to his repertory, surely on the basis of first-hand
experience with French art. Theater and art were, in fact, Shinn's twin
passions. In his New York home, Shinn built a theater for which he served
as playwright, director, producer, and actor, as well as making the scenery
and supervising the casting.

Yet his theatrical subjects, appearing first in pastel but by the
beginning of the century in oils also, such as his 1903 *Theater Scene* (fig. 99),
are not simply a reflection of his avocation.[183] From the first, critics noted
the relationship of both his subjects and his strategies to those of French
artists, particularly Jean Louis Forain, Jean François Raffaelli, and especially
Degas, whose informal viewpoints, oblique, angular perspective, and cut-off
compositions frequently appear in Shinn's work. Shinn is quoted as stating
that he considered Degas "the greatest painter France ever turned out."[184]
Early on the famous critic Albert E. Gallatin noted that not only did Shinn
find his inspiration and his manner in Degas's art, but he had learned "to

see things from Degas' point of view," and that also from Degas "he has learned to draw."[185] Shinn continued to produce theater subjects throughout the decade, exhibiting eight of them in the 1908 exhibition of the Eight, his total submission to that display. There, too, the identification with French art, and especially Degas, was made. Huneker noted: "He owes much to Degas, something to Toulouse-Lautrec, but his own personality is not negligible. Two or three of those ballet girls of his and his female acrobats would please Degas, so tense with vitality are they, so truthfully are their supple attitudes and muscled legs delineated."[186]

Another member of the Eight was Ernest Lawson, who had studied with Twachtman both in New York and at his summer school at Cos Cob in the early 1890s, before going abroad in 1893.[187] Lawson became a student at the Académie Julian that year, exhibiting a landscape at the Salon in 1895, but equally or more significant for his future development was his meeting with the French Impressionist Alfred Sisley in Moret-sur-Loing. Lawson's landscapes of Moret are, in fact, fairly colorful, though they are marked by a thinness and linearity that suggest neither Sisley nor Twachtman. Lawson returned to America briefly in 1894, but was soon back in Paris; he came back to America for good in 1898, settling in Washington Heights in New York City.

Lawson was a confirmed landscape painter, but after settling in New York his preferred landscapes were of that city, particularly of the rugged, urban scene along the Harlem River; he continued to paint this area even after he moved to Greenwich Village in lower Manhattan in 1906. When he painted more rural views, his continued indebtedness to Twachtman is apparent, especially in his preference for the winter landscape and his fondness for a range of color-flecked whites, dotted with delicate, wispy trees, such as *Spring Thaw* of about 1910 (fig. 100). Indeed, this could be viewed as a more roughly executed and expansive equivalent of the snow scenes Twachtman painted on his Greenwich property, such as *Winter Landscape* (fig. 131). Particularly in many of his New York pictures, however, such as *Brooklyn Bridge* (fig. 101), color is more prominent and varied, and often thickly laid on,

Fig. 100
Ernest Lawson, *Spring Thaw*, c. 1910, oil on canvas. Daniel J. Terra Collection, 21.1980

Fig. 101
Ernest Lawson, *Brooklyn Bridge*, 1917–20, oil on canvas. Daniel J. Terra Collection, 26.1984

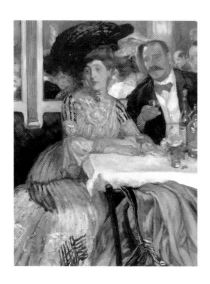

Fig. 102
William James Glackens, *Chez
Mouquin,* 1905, oil on canvas. Art
Institute of Chicago, Friends of
American Art, 1925.295

sometimes producing almost opalescent tones; critics referred to these as
"crushed jewels," a descriptive term that is still invoked for Lawson's tech-
nique.[188] Yet one must recognize his image as a tribute to modernism, with the
opening of the bridge in 1883 considered a triumph of engineering; the struc-
ture itself continues to this day to be a theme taken up by American artists.

Lawson's involvement with the Eight stems principally from his
preference for expressing the beauty of theoretically unpicturesque sites,
often in the urban environment; one early writer referred to Lawson as a
"New Poet-Painter of the Commonplace."[189] Yet Lawson's landscapes, for
all the emphasis given to city scenes, are basically Impressionist; this
identification was universal during his career. They share a lyricism with
those of his much-revered teacher, Twachtman, that seems at odds with the
urban realities that constituted the primary thrust of the art of the Eight.
Actually, the pictures that Lawson exhibited in that historic display in 1908
appear to have all been rural, rather than urban views. One critic even wrote
that Lawson "belongs not in this 'gallery' but with his fellow followers of
the Giverny masters."[190] In fact, the Eight were stylistically a diverse group
of painters, numbering artists working in Realist, Impressionist, and Post-
Impressionist modes, impacted upon by French antecedents.

Another Philadelphia newspaper artist and a close friend of Lawson
was William Glackens.[191] Glackens went to Paris in 1895, though he did not
attend any classes there, and on his return in 1896, he settled in New York,
becoming an illustrator-reporter during the Spanish-American War of 1898.
His draftsmanship became quite celebrated, and his work, too, was compared
to that of Raffaelli as well as Manet. Glackens had begun to produce easel
paintings by the mid-1890s, exhibiting a view of the Brooklyn Bridge
(unlocated) at the Pennsylvania Academy as early as 1894; it is significant
that he chose an icon of modern America for his public debut. In 1896 he
exhibited *Luxembourg Gardens* (private collection) at the Salon, and after he
settled in New York he continued to produce works that strongly reflect the
art of the Impressionist figure painters. These include scenes of figures in
public parks and gardens broadly painted in strong Tonal contrasts,
reflecting the impact especially of the work of Manet, while his rarer indoor
scenes, such as his famous *Chez Mouquin* of 1905 (fig. 102), are equally
informed by the painting of Degas. *Chez Mouquin* was one of five works
Glackens showed at the exhibition of the Eight in 1908. Earlier he had been
one of the contributors to the 1904 National Arts Club show, which
brought attention to the work of these young New York Realists. There he
displayed figure works, street scenes, and circus and ballet subjects.
Contemporaries were well aware of the affinity of his art with that of the
French modern masters; Albert Gallatin wrote in 1910: "Degas had many
cohorts behind him. . . . uncounted legions of artists have learned invaluable
lessons from his masterly pastels and paintings. William J. Glackens, a young
American painter and illustrator, although from Manet, it is true, he has also
derived many of his inspirations, is one of these latter artists."[192]

At the very time Gallatin was writing, however, Glackens was changing his allegiance, though it remained within the purview of French Impressionism. Glackens became the adviser to the inspired if eccentric Philadelphia collector Albert Barnes, whose first acquisition was a work by Renoir, chosen by Glackens in Paris in 1912. Barnes was to bring together a great holding of Renoir's work in what became the Barnes Foundation in Merion, Pennsylvania. Glackens's Renoir phase, which may have begun as early as 1906, on a second trip to France, and was surely in place by 1912, replaced the Tonal drama of his early work with fully Impressionist colorism and soft, feathery brushwork, similar to that of Renoir. Glackens applied these strategies to renderings of many phases of modern life, especially to New York street scenes, and in the summers to views on crowded beaches, especially on the south shore of Long Island in the 1910s, and later in France, in works such as *Beach, St. Jean de Luz* of 1929 (fig. 103). Glackens had gone abroad again in 1925, and his next seven years were divided between Paris, the South of France, and the United States. Such French beach scenes are testimonials to modern recreational enjoyment, figures of sparsely garbed, relaxed men and women, casually intertwined before an Atlantic coast panorama of bright blue water and green hills beyond.

Critics were aware of Glackens's shift of allegiance. Gallatin himself wrote again about Glackens in 1916, this time noting, "In many of his recent portraits and figure compositions the influence Renoir has exerted on his technique and on his palette is quite apparent," while Forbes Watson in 1923 went so far as to proclaim that "Glackens' gifts did not flower fully until he came into contact with the art of Renoir. . . . Renoir for him is part of the beauty of the world. He gladly acknowledges his obligations to Renoir." On the other hand, Glackens deemphasizes the volumetric

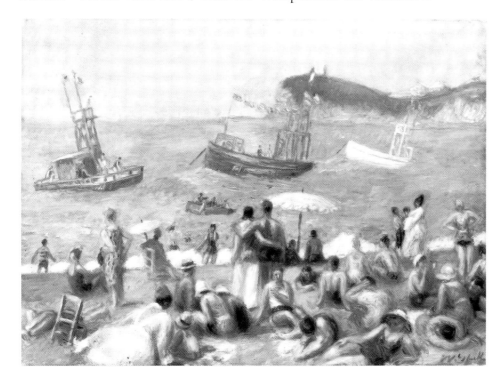

Fig. 103
William James Glackens, *Beach, St. Jean de Luz,* 1929, oil on canvas. Terra Foundation for the Arts, Daniel J. Terra Collection, 1988.8

component of Renoir's art; his leaner forms more readily convey the illustrative and at the same time the decorative dimensions that he was seeking, and which were a heritage from his early newspaper and magazine work.[193] *Beach, St. Jean de Luz,* probably the most celebrated of Glackens's French beach scenes, won the Jennie Sesnan medal as the best landscape in the 1936 annual exhibition at the Pennsylvania Academy of the Fine Arts.

While after 1908 the Eight never exhibited together again as a separate group, Urban Realism remained a preoccupation of many American artists for several generations, grouped under the designation of the Ashcan School. A typical example of this thematic concern is Martha Walter's *A la crémerie,* painted in 1910 (colorplate 80).[194] Walter had studied at the Pennsylvania Academy of the Fine Arts, winning the newly established Cresson traveling fellowship in 1903, which enabled her to study in Paris at the Académie Julian that year, as well as at the Académie de la Grande Chaumière, and to set up a studio in the French capital. She had returned to Philadelphia by 1905, though she henceforth traveled to Europe almost every year. Walter was ultimately to establish her reputation after about 1912 as a painter of colorful scenes of women and children at the ocean, often under parasols and beach umbrellas. These were painted somewhat similar in nature to the work of Edward Potthast, but with forms larger and more decorative—more "Post-Impressionist." However, her earlier paintings of scenes of modern urban life done in France are more dramatic and incisive. *A la crémerie,* depicting an artist and his model in a café, was judged by no less a master than William Merritt Chase, her former teacher at the Pennsylvania Academy, as "the best piece of work Miss Walter has done."[195]

The genteel traditions of late nineteenth-century American art, which had smoothly absorbed Impressionist stylistic innovations, were rudely shocked at the beginning of the twentieth century not only by the sometimes gritty Urban Realism of the Eight but even more by the innovations of European, primarily French modernists. America was witness to avant-garde art at the famous Armory Show held early in 1913 in New York, which included for almost the first time not only sizeable groups of pictures by such Post-Impressionists as Cézanne, Gauguin, and van Gogh, but even more advanced work by such artists as Henri Matisse, Pablo Picasso, Wassily Kandinsky, and Marcel Duchamp, including his famous *Nude Descending a Staircase* (1912; Philadelphia Museum of Art).[196] Some Americans, including a good many artists, were acquainted with European modernism even before 1913. In New York, the photographer Alfred Stieglitz opened the Photo-Secession Gallery at 291 Fifth Avenue in 1905, and from 1907 Stieglitz began to show avant-garde paintings as well, exhibiting the work of Matisse in 1908, and again in 1910 and 1912, and holding one-artist shows of pictures by Cézanne and then Picasso in 1911. Concurrently, he displayed works by young American modernists, some of whom had been to Europe and had been affected by the contemporary art there.[197]

These Americans had the opportunity of viewing European avant-

garde art at the home in Paris of Gertrude Stein and her brother Leo.[198] The Steins offered great hospitality as early as 1905 to many Americans who came to see their collection of works by such painters as Renoir, Cézanne, Matisse, and Picasso, which they had begun acquiring in 1904. Glackens was taken there in 1912 when he was beginning to make purchases of works by some of the same artists for Albert Barnes. Some of the Americans also had the chance to meet such artists there as Matisse, Picasso, Georges Braque, and Robert Delaunay. Inspired by the work they saw at the Steins, at exhibitions held in commercial galleries, and at the more modernist-oriented annual shows held by the no-jury Société des Indépendants and the more recent Salon d'Automne, which had been initiated in 1903, a group of Americans formed their own "secession." This was the New Society of American Artists in Paris, founded in 1908, which broke away from the older and very traditional Society of American Artists in Paris, which they felt had held a monopoly on American representation in major international exhibitions. This new group lasted until 1912, and though some of the members initially studied in traditional Parisian academies, they became dedicated to the pursuit of avant-garde styles such as Fauvism and Cubism. The New Society, in fact, was not able to achieve the kind of exhibition representation that they sought, but the group became a temporary bellwether of modernist change during the five years of its existence.[199]

John Marin was one of the oldest painters of the New Society.[200] He was an art student under William Merritt Chase in Philadelphia, and also in New York, before he arrived in Paris in 1905 to study at the Académie Julian; he remained there for only several months, however, and then worked on his own, producing a body of etchings of the French capital. He also painted in oils and, increasingly, in watercolors, the medium with which he had first worked in the United States and with which he would most become identified.

Marin's earliest Parisian watercolors reflect the subtle tonalities of Whistler's painting, but though he was later to deny awareness of such modern French art to which he might have been exposed in Paris, beginning in 1907 Marin exhibited at the Salon d'Automne a number of times and also at the Salon des Indépendants. His subsequent modernist approach surely reflects the impact of European avant-garde styles of the 1900s, which he could have experienced in such Parisian exhibitions, as well as the works he would have seen at Stieglitz's 291 gallery after his final return to New York in 1911. He himself acknowledged the strong impression of the Cézanne watercolors that were shown at 291 in the spring of 1911.

Marin's adherence to modernism originated during his final years in Paris and was based upon an emotional, even explosive fragmentation of the scenes he depicted, whether urban or nature based. Marin's unique aesthetic persisted throughout his career, and can be seen as late as 1930 in his *Brooklyn Bridge, on the Bridge* (fig. 104), where the seemingly shattered icon of modernism is reconstituted within a Cubist grid and with strong Fauve-derived chromatic

contrasts, in which the urban dynamics of Futurism also play a part.

Marin had met Stieglitz in Paris in June 1909, three months after twenty-four of Marin's watercolors had been shown at the 291 gallery. Marin became a conduit between the New Society and Stieglitz's circle, and in the ensuing years Marin's work was displayed in group or one-artist shows held in the gallery more often than that of any other American painter. The artist made a brief visit to New York at the end of 1909 to arrange for his first one-artist show at 291 the following February, at which time critics responded positively to his watercolors, while recognizing their French antecedents. Elisabeth Luther Cary of the *New York Times* noted: "The painter's instinct for recognizing the possibilities of structure by color alone is extraordinary, and we find his color more and more refreshing and more truly stimulating than the hot harmonies of Matisse. Although he usually is accepted in this country at least as a follower of Matisse, Mr. Marin derives more logically from Cézanne."[201]

Marin's pictures were probably more affirmatively received by New York critics in this decade than were those of most of his modernist colleagues. Subsequently, Marin's art further matured back in Paris in 1910, and following his final return to New York he began a series of watercolors of that city, seven of which appeared at the Armory Show in 1913. After a brief hiatus in the late 1910s, the buildings and other structures of the great metropolis constituted a theme to which Marin returned almost every year from 1920 through the next several decades.[202]

Fig. 104
John Marin, *Brooklyn Bridge, on the Bridge,* 1930, watercolor. Daniel J. Terra Collection, 11.1981

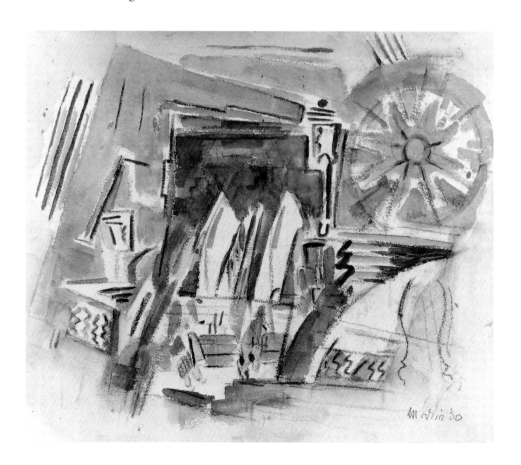

Among the other members of the New Society were Patrick Henry Bruce and Max Weber. To some degree, their early Parisian years were quite similar. Both were included among the coterie of painters who gathered at the Steins, and the two Americans were equally drawn to the structural innovations of Cézanne, as well as to the revolutionary colorism of Fauvism, as they experienced it in the work of Matisse. Both artists, in fact, attended the classes taught by Matisse beginning in 1908. Yet their absorption of French modernism was quite distinct. Weber, in a sense, was a true eclectic, encountering a series of modernist idioms that were subsequently revealed in his art. Bruce, on the other hand, was able to synthesize his experiences and ultimately to create an original form of aesthetic expression.

Bruce had arrived in Paris by early 1904, after some training in New York. Except for a brief visit back to the United States in 1905, he remained an expatriate until 1936, when he returned home only to commit suicide in New York.[203] Bruce showed at the Salon of the Société Nationale des Beaux-Arts in 1904 and 1905, but in 1905 he also began exhibiting at the more progressive Salon d'Automne. He began visiting the Steins in 1906, meeting Matisse at their apartment in 1907; he was one of those who persuaded the French artist to institute his school, which commenced in January 1908. Under the twin influences of Matisse and Cézanne, Bruce produced a series of modernist landscapes and still lifes in which structure was created by color harmonies and contrasts. By 1912 Bruce was working in close association with Robert Delaunay and the Orphist movement in the exploration of the dynamics of color principles, creating his first abstractions, composed of faceted, overlapping color planes, some curvilinear, dynamically arranged; these were shown at the Salon d'Automne in 1913 and 1914, and at the Salon des Indépendants in 1914. By 1916 Bruce had moved away from Delaunay to create an independent group of abstract canvases made up of thickly painted arrangements of opaque, geometric shapes composed, seemingly randomly, along primarily diagonal axes. Among contemporary French artists, these pictures most recall the work of Francis Picabia, a painter with whom Bruce was familiar. Bruce had earlier sent four of his still lifes to the Armory Show in New York, and these large abstract works were shown in that city in 1917.

Beginning around 1917, Bruce's aesthetics once again underwent change in a series of large, abstracted still lifes created in a formally balanced, almost "classical" mode; *Peinture* of 1917–18 (fig. 105) is the earliest of these. In the surviving group of some twenty-five of these pictures, solid geometric forms are defined by flat planes of color, and are arranged on and against a series of flat color faces, some of which appear to function as both two- and three-dimensional surfaces. The forms contained in these works are derived from objects in Bruce's Parisian apartment, which have been simplified and juxtaposed arbitrarily. As time went on, Bruce's compositions became more austere, more clarified, and more pristine, and took on an almost architectural structure. Together, these pictures consti-

Fig. 105
Patrick Henry Bruce, *Peinture*,
1917–18, oil and pencil on canvas.
Daniel J. Terra Collection,
10.1986

tute one of the most original pictorial inventions of the early twentieth
century, deriving from Cubism and related to Purism, but clearly indepen-
dent of the innovations of Picasso and Braque. These works were first
exhibited at the Salon d'Automne in Paris in 1919, and he continued to
show them there and at the Indépendants through 1930. They were never
to appear in exhibitions in the United States during the artist's life.
Relatively few of Bruce's paintings survive, the artist having destroyed a
great many of them shortly before his death.

Born in Russia, Max Weber grew up in New York, studying at Pratt
Institute before going abroad in 1905, the same year as John Marin. In Paris
he took instruction at the Académie Julian in 1905, and at the Colarossi
and Grand Chaumière academies the following year. Much more important
for his development was his exposure to the work of Cézanne at the Salon
d'Automne in 1906 and again in 1907, and in those years he himself
exhibited at the Salons des Indépendants and d'Automne. Weber also
attended the Matisse class in 1908, but he had become familiar with
Matisse's work at the Stein apartment probably as early as 1905, shortly
after he arrived in Paris. Matisse himself emphasized Cézanne's
architectonic pictorial structure in his classes, and Weber's painting of this
period combines the strategies of the two artists. He was also drawn to
Picasso's work, both on a visit to that artist's studio and at the Steins.

While his initial paintings done after he returned to the United
States at the end of 1908 reflect the continued impact of Cézanne, Weber
ultimately rejected Fauve colorism and began to draw from Picasso's early
Cubist work as well as from Gauguin's Primitivism. However, his

subsequent growing commitment to Cubism necessarily developed somewhat independently, nurtured by the art he saw at Stieglitz's gallery as well as by reproductions sent from Europe, since Analytic Cubism had not fully evolved before he left France. Weber, in turn, had a one-artist show at Stieglitz's gallery in 1911, and while he did not participate in the Armory Show, his work was seen in London in 1913.

By the middle of the decade, Weber was responding to the color theories of French Orphism and the dynamics of Italian Futurism, aspects of all of which are at play in his 1915 *Construction* (fig. 106). Forms are geometrically fragmented here, but they are juxtaposed in blue-green-ocher color planes that thrust through the composition in large chevron-shaped arrangements. Weber, in fact, had been critically allied with Futurism as early as his first one-artist show held in 1912,[204] though, as with his explorations of Cubism, Weber's exposure to Futurist art must have been indirect. No Futurist works were exhibited in America until 1915, and then not in New York but at the Panama-Pacific International Exposition in San Francisco.[205] Working on the cutting edge of French modernism in these years, Weber had the distinction of having the first one-artist exhibition in an American museum, that held at the Newark Museum in Newark, New Jersey, in 1913. However, critical reaction in America to Weber's avant-garde art was extreme.[206]

The American artist most committed to the principles of Italian Futurism was Joseph Stella, who discovered this aesthetic in Paris. Italian-born, Stella came to the United States as a teenager and studied in New York before going to Europe in 1909. He first visited his homeland and

Fig. 106
Max Weber, *Construction*, 1915, oil on canvas. Terra Foundation for the Arts, Daniel J. Terra Collection, 1987.31

Fig. 107
Joseph Stella, *Telegraph Poles with Buildings*, 1917–20, oil on canvas. Daniel J. Terra Collection, 9.1986

then in 1911 proceeded to Paris, where he was brought to the Steins by the important art writer and critic Walter Pach. In 1912 he exhibited at the Salon des Indépendants. Stella met Matisse and Picasso in Paris, but most significantly he was there when the Futurists held their first exhibition in the French capital in February 1912 at the Galerie Bernheim-Jeune. Among the Futurists, he met Carlo Carrà and possibly Umberto Boccioni and Gino Severini at the time.[207] Later that year Stella returned to the United States, exhibiting Fauve-like still lifes at the Armory Show in New York the following year.

Futurism was absent from the Armory Show, but as Stella himself wrote, praising that exhibition: "The 'Armory Show' was not a display of futurist work, although everybody was speaking of futurism."[208] He began to produce his own adaptation of Futurism, manipulating forms derived from the industrial world and from the urban environment of New York. Some of the earliest of these approach abstraction, but for the most part those painted toward the end of the decade are somewhat more representational, such as *Telegraph Poles with Buildings* (fig. 107), where forms are greatly simplified while colors glow dynamically. Stella effectively translates the diagonals of Futurist force lines into telegraph wires and striated cloud formations to animate the composition.[209] The painting seems also a pictorialization of his own comments on the America to which he had returned in 1912: "Steel and electricity had created a new world. A new drama had surged from the unmerciful violation of darkness at night. . . . A new architecture was created, a new perspective."[210]

A few years before Bruce had produced his Delaunay-influenced canvases, Arthur G. Dove had created what appear to have been the first abstractions by an American. Dove began his artistic career as an illustrator in New York, where he was a friend of Glackens, before going to France in 1908. Although he remained in Paris only briefly, after which he went to paint in the South of France, Dove was obviously exposed to Cézanne and Fauvism, both of which figure strongly in the paintings he subsequently created. Dove first exhibited at the Salon d'Automne in 1908. *The Lobster*, painted that year (fig. 108), was exhibited at the Salon d'Automne in 1909; the picture is a startlingly advanced composition of flat patterns in brilliant color, much in the manner of Matisse. Dove returned to New York in 1909, and *The Lobster* was shown again at Stieglitz's 291 gallery the following year.[211]

In 1912 Stieglitz gave Dove his first one-artist exhibition, in which were shown a group of abstract pastels, later referred to as *The Ten Commandments*, probably painted in 1911–12; at about the same time he created a group of six small abstract oils.[212] Yet even in these completely nonobjective works, Dove's sources in nature are still decipherable; the six oils, for instance, all draw upon landscape elements. *Nature Symbolized #3: Steeple and Trees* (fig. 109) is one of the pastels. It is obviously referential to the real world, but the artist has abstracted the forms so that man- and nature-based shapes—the church and its steeple along with the trees and hills—are

reduced to repeated, overlapping triangles of contrasting hues, a rhythmic, somewhat decorative evocation of a harmonious world.

Scholars have noted the parallel chronological turn to abstraction in the paintings of Dove and Wassily Kandinsky. Indeed, some of Dove's oils and pastels recall to some extent the early abstractions of Kandinsky, works by whom Dove might have seen in Paris at the Salon d'Automne of 1908 and at the Salon des Indépendants of 1909, but Kandinsky was then still producing imagery from Russian folk tales, not abstractions. Rather, the flattened composition and geometric arrangement of forms in Dove's works at this time suggest the impact of Cubism. Dove may or may not have been aware of early Cubist experimentation in his fourteen months in Europe—he could have seen several paintings by Braque at the 1909 Salon des Indépendants—but there is no record of his visiting the Steins to see their Cubist pictures. However, he certainly would have seen Picasso's work when it was shown at 291 in March 1911, and this group included early Cubist pictures. Dove's work, of course, such as *Nature Symbolized #3*, is not an imitation of Picasso's.

The American's concern for nature's quintessence is also ornamental; forms are flatly created rather than analyzed, and he manipulates space as a series of overlapping, rather than intrusive planes. *Nature Symbolized #3* is a link with the group of small abstract oils, for it derives from the same nature based iconography of landscape and steepled-church as *Abstraction #1* (private collection). *A Walk: Poplars* (fig. 110) is another nature-based pastel of roughly the same dimensions as the identified pictures among *The Ten Commandments*, but scholars are divided as to its date; some suggest the picture was created as early as 1912 and others date it as late as 1920.[213] From the first, Dove was recognized as the most daring aesthetic pioneer among the Americans of his time, and his antecedents in French art were acknowledged. In his pioneering study of modernism, *Cubism and Post-Impressionism*, Arthur Jerome Eddy discusses Dove in his chapter "Les

Fig. 108
Arthur G. Dove, *The Lobster*, 1908, oil on canvas. Amon Carter Museum, Fort Worth, 1980.29

Fig. 109
Arthur G. Dove, *Nature Syumbolized #3: Steeple and Trees*, 1911–12, pastel on board mounted on panel. Daniel J. Terra Collection, 14.1980

Fig. 110
Arthur G. Dove, *A Walk: Poplars*, 1920, pastel on silk mounted on board. Daniel J. Terra Collection, 40.1982

Fig. 111
Charles Sheeler, *Flower Forms*, 1919, oil on canvas. Terra Foundation for the Arts, Daniel J. Terra Collection, 1987.33

Fauves," but distinguishes the artist as "almost the only man in this country who has persistently painted in Cubist fashion."[214]

Flower Forms of 1919 by Charles Sheeler (fig. 111) is also a nature-based abstraction, but one in which the floral essence is more implied than visualized; this work represents Sheeler at his most nonobjective. Sheeler studied with Chase in his native Philadelphia, and was also a member of Chase's summer classes held in London and Holland in 1904 and in Italy in 1905. Sheeler went to Europe again in 1908, traveling through Italy and reaching Paris at the beginning of 1909.[215] At Durand-Ruel's gallery, Sheeler saw the work of Cézanne, and he visited the collection of Sarah and Michael Stein, Gertrude and Leo's older brother and his wife, which was also rich in modern painting, particularly that of Matisse. He may also have visited Gertrude and Leo as well. Sheeler himself recalled seeing the work of Matisse, Picasso, and Braque at the Michael Steins: "I didn't understand them in the least, but they did carry the conviction that the artists knew what they were doing, and if I were interested enough it was up to me to try and find out."[216]

Certainly during his short time in Paris, it appears to have been Cézanne and Matisse whose impact was first felt strongly by Sheeler. After his return to Philadelphia, he produced primarily fruit and flower still lifes.[217] In his work of 1910 Sheeler appears to have been concerned with the structural innovations of Cézanne, but soon thereafter he was working in a Fauve manner, producing a series of intensely colored, swiftly painted still lifes and some landscapes, six of which, painted in 1912, were included in the Armory Show in 1913. Ironically, this exposure, which first acknowledged Sheeler's place as a member of the young American avant-garde, also decisively redirected his painting away from Fauvism and toward more structural concerns through the impact of the Cubist pictures by Picasso, Braque, and Duchamp that he saw there.

This exposure was reinforced for Sheeler in 1916 with the exhibition of advanced modern art held in Philadelphia at the McClees Gallery in which these artists were again represented. About that same year he became a member of the circle in New York of the collectors Walter and Louise Arensberg, through whom he met Duchamp. *Flower Forms* is the outcome of these influences; the curvilinear rhythms and limited, primarily neutral palette relate even more to Duchamp than to Picasso.[218] Sheeler himself expressed his attitude toward such abstraction: "The identification of familiar objects comprising a picture is too often mistaken for an appreciation of the work itself and a welcome opportunity for the cessation of investigation. For this reason, it was the intention . . . to divorce the object from the dictionary and disintegrate its identity."[219]

Just about the time he painted *Flower Forms,* Sheeler's art once again veered in a new direction, though one informed by his recent work, a change facilitated by his move to New York in 1919. He became one of the innovators of the movement of the 1920s known as Precisionism. This constituted an approach that, while not limited to architectural and

industrial subjects, concentrated especially on those themes, presented clearly, cleanly, and unpopulated, with an emphasis upon planar congruence and smooth, unpainterly surfaces, an art that celebrated the mechanical age.[220] This could and has been interpreted as a nationalist celebration of American modernism and the nation's industrial superiority, but the European antecedents of Precisionism should not be overlooked. Nor have they; decades ago Milton Brown perceptively redefined the movement as Cubist Realism, an acknowledgment of the seminal role that French Cubism played in the development of the movement through the work of Sheeler and a number of his colleagues.[221]

The other artist seminal to the development of Precisionism at the end of the decade of the 1910s was Charles Demuth, not coincidentally also a member of the Arensberg circle.[222] Even earlier than Sheeler, Demuth began to produce subjects from the architectural landscape of his native Lancaster, Pennsylvania, informed by the strategies of Cubism. Demuth is believed to have been in Paris, though for only a few weeks, in the autumn of 1904. The following year he began studying at the Pennsylvania Academy of the Fine Arts; among his teachers there was Hugh Breckenridge. Demuth returned to Paris in 1907. This time he surely was exposed to modern French art. He would have attended the 1907 Salon d'Automne, where the works of Cézanne were celebrated, and he would have seen there the painting of the Fauves, and works by many young American modernists, such as Marin, Weber, and Bruce. After returning to the United States and continuing his studies in Philadelphia, Demuth was back in Lancaster in 1912, painting Impressionist-style landscapes and figure pieces in a somewhat Fauve-like manner, related to the watercolors of the French sculptor Auguste Rodin, whose work Demuth could have seen at Stieglitz's 291 gallery in November 1910.

Demuth's real artistic breakthrough began on his third visit to Europe, 1912–14, during which time he studied at the Moderne, Julian, and Colarossi academies and became acquainted with the Steins. He also met Picasso, Duchamp, and other Cubists and began to thrive in this avant-garde ambience. On his return to America, he divided his time between Lancaster and New York. In the latter city he became associated with the new, modernist-oriented Daniel Gallery, where he had his first one-artist exhibition in the fall of 1914, and he fell in with the Arensberg circle, enjoying the Dada ideas that were current there.

In the last years of the decade, Demuth began to produce architectural pictures, starting with a group of watercolors painted in Bermuda early in 1917, technically reflective of Cézanne's work in that medium, but stylistically somewhat similar to the paintings done there by the French Cubist Albert Gleizes, who was in Bermuda at the same time. Demuth's subsequent architectural tempera paintings and oils often have Dada-like, witty titles such as *Rue du Singe qui pêche,* a tempera of 1921 (fig. 112), whose title may be a play on rue du Chat-qui-Pêche, an actual

Fig. 112
Charles Demuth, *Rue du Singe qui pêche*, 1921, tempera on academy board. Daniel J. Terra Collection, 36.1985

Parisian street. These works are painted in vivid, flat planes of color, bifurcated by rays of light that bear some semblance to the force lines of Futurism, but despite their architectural subject, they retain the Cubist preference for shallow space. It was in *Rue du Singe* that Demuth first extensively incorporated lettering into his work, further emphasizing the flatness of his pictorial space, a device he derived from Cubism. The work was done during the artist's last visit to Paris in 1921, almost his only picture actually painted in the French capital. *Rue du Singe qui pêche* and the Lancaster scenes created during these years ushered in the Precisionist or Cubist Realism aesthetic even earlier than Sheeler's work.

Precisionism was probably the most avant-garde artistic development in America during the 1920s, but the decade, in general, constituted a period of retrenchment in the country. A number of the more radical painters of the previous decade, such as Max Weber, turned to less inventive modes, and some of the leading younger artists specialized in more traditional themes, studio-based figurative and still-life compositions. Almost all the major American painters of the period continued to journey to Paris, but the need was no longer so urgent and the effects of such visits became less intense. Fewer Americans entered academic ateliers in the French capital, for the United States now offered similar training in countless schools throughout the nation, while the experience of the work of the French avant-garde was to be enjoyed in America in numerous gallery exhibitions and in private collections. With the break-up of the Stein household in 1913, Leo's move to Italy, and the advent of World War I, that modernist resource figured less significantly as a Paris base for young artists. French painters, in fact, enriched the modernist movement in the United States by settling in America, primarily New York, in the wake of the conflict.[223]

Yet not surprisingly, Stuart Davis, the most innovative American painter of the 1920s, was also one of those most susceptible to the impact of French modernism.[224] Born in Philadelphia, Davis studied in New York beginning in 1910, and his earliest work was aligned with the Urban Realism of the Ashcan School. Five such watercolors were included in the Armory Show in 1913. However, Davis's experience with French painting there decisively directed his art through a series of avant-garde modes in the following years. His figurative paintings of 1914 reflect the impact of Post-Impressionism: the chromatic intensity of Gauguin, the emotional fervor of van Gogh, and the structural innovations of Cézanne. Davis produced landscapes influenced by van Gogh and the Fauves from about 1916, and then, by 1921, he had turned to paintings related to Cubist collages.

By the time that Davis painted *Super Table* in 1925 (fig. 113), he was the most Parisian of the younger American painters, despite the fact that he would not actually be in Paris for three more years. *Super Table* too, of course, is a studio painting, a still-life arrangement that, in overall format, is not unlike some pictures that Sheeler painted during this decade. Its immediate stylistic antecedents can be found in the flattened space and broad planes of Synthetic

Cubism. Specifically, John Lane has suggested that the picture may have been inspired by a 1919 work by Picasso, *Musical Instruments and Score before an Open Window* (unlocated), published in the magazine *Arts* in April 1925. The idiom here, however, as Diane Kelder has noted, is very distinctly Davis, and distinctly American, the kitchen, rather than the drawing room or study.[225]

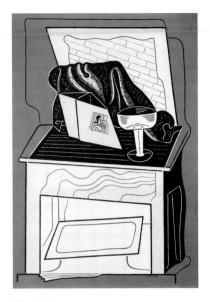

Fig. 113
Stuart Davis, *Super Table*, 1925, oil on canvas. Daniel J. Terra Collection, 8.1986

In the years before he painted this work, Davis wrote a great deal about his artistic philosophy in words that apply directly to *Super Table*. In 1923 he noted: "My reasoning leads me to believe that there should be no modeling at all in the ordinary sense of the word but that every color should be a flat plane of a definite size and shape. The completed picture should be an organization of positively related units in size, color, shape and planal relationship. . . . This ideal has nothing to do with social satire or story-telling illustrations. It is the antithesis of these qualities."[226] About *Super Table* and similar paintings, Davis wrote: "The pictures . . . of 1924 and 1925 were all based on the same idea; a generalization of form in which the subject was conceived as a series of planes and the planes as geometrical shapes—a valid view of the structure of any subject. I had come to feel that what was interesting in a subject or what had really caused our response to it could be best expressed in a picture if these geometrical planes were arranged in direct relationship to the canvas as a flat surface. . . . In paintings like *Super Table* the major relationships—the larger generalizations—were established, but the minor features were still imitative."[227] Davis appeared to have believed that *Super Table* was the picture that most represented his achievements at the time.

Davis was in Paris for a year in 1928. Relatively few American modernists would immediately follow, however, and in the following decade the migration, as it had during World War I, was reversed, with Europeans such as Josef Albers and Hans Hofmann coming to America as they fled Nazism and the horrors of war. Meanwhile, European modern art was publicly on view in New York first at Katherine Dreier's Société Anonyme in 1920, then at Albert Gallatin's Gallery of Living Art, which opened in 1927, and most significantly at the Museum of Modern Art from 1929. American painting of the 1920s, and even more the 1930s, drew inward, concerned with the devastating effects of the economic Depression, which was reflected in an art of Social Realism, while proponents of American Regionalism attempted to reject the dialogue with Europe.

Yet Paris was not totally forgotten or abandoned. Young artists who spent time in France at the end of the 1920s and during the 1930s such as George L. K. Morris, Charles Shaw, Carl Holty, Balcomb and Gertrude Greene, and John Ferren who settled for a decade in Paris the year Davis returned, became the nucleus of the American Abstract Artists, founded in 1937. They were the precursors of the Abstract Expressionist movement, with which New York would, effectively, supersede Paris as the art capital of the world.[228]

NOTES

1. For a full discussion of this painting and its exhibition in Paris, see Allen Staley, "West's Death on the Pale Horse," *Bulletin of the Detroit Institute of Arts* 58, no. 3 (1980), 137–49; an earlier treatment is Fiske Kimball, "Benjamin West au Salon de 1802: La Mort sur le Cheval Pâle," *Gazette des beaux-arts* 7 (June 1932), 403–10.

2. The most significant contribution to the study of American art vis-à-vis France is the brilliant analysis by Lois Marie Fink, *American Art at the Nineteenth-Century Paris Salons* (Cambridge: Cambridge University Press, 1990). See also Howard Mumford Jones, *America and French Culture, 1750–1848* (Chapel Hill: University of North Carolina Press, 1927), 315–26; Yvon Bizardel, *American Painters in Paris*, trans. Richard Howard (New York: Macmillan, 1960); Denys Sutton, "The Luminous Point," *Apollo* 85 (March 1967), 214–23; Lois Marie Fink, "The Role of France in American Art, 1850–1870," Ph.D. diss., University of Chicago, 1970; idem, "American Artists in France, 1850–1870," *American Art Journal* 5 (November 1973), 32–49; Peter Bermingham, *American Art in the Barbizon Mood* (Washington, D.C.: National Collection of Fine Arts and Smithsonian Institution Press, 1975); Michael Quick, Eberhard Ruhmer, and Richard V. West, *American Expatriate Painters of the Late Nineteenth Century* (Dayton, Ohio: Dayton Art Institute, 1976); Laura L. Meixner, *An International Episode: Millet, Monet, and Their North American Counterparts* (Memphis, Tenn.: Dixon Gallery and Gardens, 1982); David Sellin, *Americans in Brittany and Normandy: 1860–1910* (Phoenix, Ariz.: Phoenix Art Museum, 1982); Julia Rowland Myers, "The American Expatriate Painters of the French Peasantry, 1863–1893," Ph.D. diss., University of Maryland, 1989; Denise Delouche, *Artistes étrangers à Pont-Aven, Concarneau et autres lieux de Bretagne* (Rennes: Presses Universitaires, 1989); Michael Marlais, *Americans and Paris* (Waterville, Maine: Colby College Museum of Art, 1990); *Le Voyage de Paris: Les Américains dans les écoles d'art, 1868–1918* (Blérancourt, France: Musée National de la Coopération Franco-Américain, 1990). Recent, but very limited, is the study by H. Barbara Weinberg, *The Lure of Paris: Nineteenth-Century American Painters and Their French Teachers* (New York: Abbeville Press, 1991), curiously more insightful for the art of the French teachers of American painters than for their students. Eagerly awaited is Laura L. Meixner's forthcoming *Culture and Criticism: American Responses to French Realism and Impressionism.*

3. Robert C. Alberts, *Benjamin West: A Biography* (Boston: Houghton Mifflin, 1978), 184–85.

4. Ibid., 262–63; Joseph Farington, *The Diary of Joseph Farington*, 16 vols. (New Haven: Yale University Press, 1978–), 5, pp. 1935, 1961.

5. "Overture du Salon d'exposition annuelle des peintres vivans," *Journal des arts* (1802), 21–25, reprinted in *English in Public Characters of 1805* (London, 1804), 555–57.

6. Alberts, *Benjamin West*, 263; Farington, *The Diary of Joseph Farington*, 5, pp. 1851, 1875.

7. Farington, *The Diary of Joseph Farington*, 5, p. 1820, 6, p. 2045.

8. For Volozan, see David Sellin, "Denis A. Volozan, Philadelphia Neoclassicist," *Winterthur Portfolio* 4 (1968), 118–28; Volozan disappears from the records after 1819.

9. David's painting was exhibited at the American Academy of Fine Arts in New York beginning in December 1825. See the advertisements in the *New-York American*, beginning on December 31, 1825. A year earlier, a so-called but seemingly unrecorded work said to be by David, *Cain Meditating on the Death of His Brother Abel*, was shown at Doggett's Repository in Boston. See *New England Galaxy*, December 24, 1824, and thereafter. I am grateful to Dr. Carrie Rebora for the former information, and to Peter Benes for the latter. The *Coronation* was severely criticized in an article in *New-York Review and Athenaeum Magazine* 2 (April 1826), 371–72, which was, in turn, reprinted in the *New-York Evening Post*, May 6, 1826. See also the undated brochure accompanying the *Coronation* published at an unknown location, *Notice, on the Picture of the Coronation of Napoleon, along with a key to the individuals portrayed*, in the collection of the Boston Athenaeum. Yet a third work by David, either a replica of *Napoleon Crossing the Alps*, or a copy after the picture was shown at the Pennsylvania Academy of the Fine Arts in Philadelphia in 1822–29, and perhaps through 1837; in New York in 1828; and in 1841 at the Boston Athenaeum. See *New-York Evening Post*, November 29, 1828, and *A Guide to the Lions of Philadelphia* (Philadelphia: Thomas T. Ash, 1837), 14. The earliest work given to David to be publicly exhibited in the United States was a representation of *Sampson and Delilah*, which went on view at the Pennsylvania Academy in 1814 and continued to appear sporadically through 1870. Another so-called David that appeared early in the United States was an *Andromache and Astyanax*, said to have been painted for Napoleon, which first appeared in New York in 1840 in the Clark Collection; it was later shown in 1847 at the American National Gallery in New Orleans, operated by George Cooke. See *Synopsis of Valuable Collection of Old Italian Paintings, and Other Rare Articles of Fine Arts, in the Possession of Mr. John Clark, Now Exhibiting at No. 333 Broadway* (New York: Samuel Adams, 1840), 3.

10. Kendall B. Taft, "Adam and Eve in America," *Art Quarterly* 23 (Spring 1960), 171–79.

11. See the review of this picture in "The Fine Arts," *New-York Mirror*, November 19, 1831, 155; and also the brochure accompanying the exhibition, *The Wreck of the French Frigate Medusa, a Large Painting by G. Cooke* (New York: W. Applegate, 1831).

12. I am indebted to the researches of a number of graduate students of the City University of New York for their investigations of this topic. See the unpublished papers: Donna Kehne, "The American Perception of French Painting

in the First Half of the Nineteenth Century," Spring 1983; David B. Dearinger, "Les Lumières in America: Some Thoughts on the Inter-Relationships between French and American Art, 1760–1840," Spring 1986; May Brawley Hill, "Lewd Scenes, Murders and Bloodshed—American Opinion of French Art, 1876–1886," Fall 1981.

13. T. C. Brunn Neergaerdt, "Present State of the Art of Painting in France," *Monthly Anthology* 4 (August 1807), 408–16.

14. Ion Perdicaris, "English and French Painting," *Galaxy* 2 (October 15, 1866), 378.

15. "Progress of the Fine Arts," *Port Folio Magazine* 4 (September 1810), 260.

16. "Remarks on the Progress of the Fine Arts in the U. S.," *Analectic* 6 (1815), 367–68.

17. "Biographical Notice of Benjamin West," *Analectic* 8 (1816), 44.

18. "Moral Tone of Italian Literature," *North American Review* 47 (July 1838), 231.

19. "Fine Art: The Three Galleries," *Literary World* 5 (November 1849), 446.

20. Margaret Fuller Ossoli, *At Home and Abroad, or Things and Thoughts in America and Europe*, ed. Arthur H. Fuller (Boston, 1856), 198.

21. C[hristopher] P. Cranch, "French Landscape," *Crayon* 3 (June 1856), 183.

22. "French and American Art," *Watson's Art Journal* 14 (April 1, 1871), 257.

23. Ibid.

24. Gerald B. Brown, "Modern French Art," *Appleton's Journal* 9 (September 1880), 272–73.

25. Ibid., 273–74.

26. Sophia Beale, "French Art," *Connoisseur* 1 (Fall 1886), 23.

27. Lois Marie Fink, "Rembrandt Peale in Paris," *Pennsylvania Magazine of History and Biography* 110 (January 1986), 71–90.

28. See the letter from Rembrandt's father, Charles Willson Peale, to Thomas Jefferson, February 21, 1808, concerning his son's intended visit to Europe. Thomas Jefferson Papers, Library of Congress, Washington, D.C.

29. See Samuel F. B. Morse, *Descriptive Catalogue of the Pictures, Thirty-seven in Number, from the Most Celebrated Masters, Copied into the Gallery of the Louvre* (New York: James van Norden, 1833), 3.

30. For discussions of this painting, see David Tatham, "Samuel F. B. Morse's *Gallery of the Louvre*: The Figures in the Foreground," *American Art Journal* 13 (Autumn 1981), 38–48; Paul J. Staiti, "Samuel F. B. Morse and the Search for the Grand Style," in Paul J. Staiti and Gary A. Reynolds, *Samuel F. B. Morse* (New York: Grey Art Gallery and Study Center, New York University, 1982), 68–74 ("The Louvre"); Hugh R. Crean, "Samuel F. B. Morse's *Gallery of the Louvre*: Tribute to a Master and Diary of a Friendship," *American Art Journal* 16 (Winter 1984), 76–81; William Kloss, *Samuel F. B. Morse* (New York: Harry N. Abrams, 1988), 124–35; Paul J. Staiti, *Samuel F. B. Morse* (Cambridge: Cambridge University Press, 1989), 175–206. See also Morse's own pamphlet, *Descriptive Catalogue of the Pictures*.

31. See Marchal E. Landgren, *American Pupils of Thomas Couture* (College Park, Md.: University of Maryland Art Gallery, 1970); Albert Boime, *Thomas Couture and the Eclectic Vision* (New Haven: Yale University Press, 1980), 557–612.

32. The literature on Hunt is lengthy. Particularly significant among the earlier volumes is that by his pupil Helen M. Knowlton, *Art-Life of William Morris Hunt* (Boston: Little, Brown, 1899). A more recent study is Martha J. Hoppin and Henry Adams, *William Morris Hunt: A Memorial Exhibition* (Boston: Museum of Fine Arts, 1979). Knowlton also compiled two volumes of Hunt's *Talks on Art* (Boston: Houghton Mifflin, 1875 and 1883), derived from his studio instruction and advice to his pupils, which often echo Couture's published *Méthode et entretiens d'atelier* (Paris, 1867).

33. See Alexandra R. Murphy, "French Paintings in Boston: 1800–1900," in *Corot to Braque: French Paintings from the Museum of Fine Arts* (Boston: Museum of Fine Arts, 1979), esp. xxxii–xli.

34. See Bermingham, *American Art in the Barbizon Mood;* Daniel Rosenfeld and Robert G. Workman, *The Spirit of Barbizon France and America* (San Francisco: Art Museum Association of America, 1986).

35. Still useful is the biography by the artist's son, George Inness, Jr., *Life, Art, and Letters of George Inness* (New York: Century, 1917). See also Leroy Ireland, *The Works of George Inness: An Illustrated Catalogue Raisonné* (Austin: University of Texas Press, 1965). The most recent study of Inness is Nicolai Cikovsky, Jr., and Michael Quick, *George Inness* (Los Angeles: Los Angeles County Museum of Art, 1985).

36. Etretat was well known among Americans. Henry James wrote about it two years after Inness first visited Etretat; see Henry James, Jr., "A French Watering Place," *New York Tribune*, August 26, 1876, 3. The expatriate artist Henry Bacon also wrote enthusiastically about Etretat, where he summered almost every year from the late 1860s through the 1890s; see Henry Bacon, *A Parisian Year* (Boston: Roberts Brothers, 1882), 166–87; his travel book, *Etretat, Hamlet of the Setting Sun* (Paris: Brentano's, 1895); and his fictional story set in the fishing village, *Les Enfants de pêcheurs: Hélène et Léon* (Paris: Librairie Ducrocq, 1888). For Bacon and Etretat, see Sara Caldwell Junkin, "The Europeanization of Henry Bacon (1839–1912), American Expatriate Painter," Ph.D. diss., Boston University, 1981, 193–236.

37. For the art colonies in Brittany, see Delouche, *Artistes étrangers à Pont-Aven;* Sellin, *Americans in Brittany and Normandy;* Michael Jacobs, *The Good and Simple Life: Artist Colonies in Europe and America* (Oxford: Phaidon, 1985), 42–87.

38. Despite the acclaim accorded Picknell in his lifetime, there has been no published study of his life and art; the most comprehensive treatment of which I am aware is a graduate paper by Christine E. Bergman, "William Lamb Picknell," Institute of Fine Arts, New York University, 1980. See also Edward Waldo Emerson, "An American Landscape-Painter, William L. Picknell," *Century Magazine* 62 (September 1901), 710–13. For contemporary reception of his work, see *Criticism about Picknell* (New York: Avery Art Galleries, 1890).

39. Harrison, too, is in need of modern assessment. See the

excellent treatment of the artist by Karen Zukowski, in Annette Blaugrund, ed., *Paris 1889: American Artists at the Universal Exposition* (New York: Harry N. Abrams, 1989), 160–64. The most important early discussions are Charles Francis Browne, "Alexander Harrison—Painter," *Brush and Pencil* 4 (June 1899), 133–44; and esp. Charles Louis Borgmeyer, "Alexander Harrison," *Fine Arts Journal* 29 (September 1913), 515–44.

40. The only recent treatment of Davis is Thomas L. Colville, *Charles Harold Davis, N.A., 1856–1933* (Mystic, Conn.: Mystic Art Association, 1982). Most of the earlier studies of Davis deal primarily with his later, high-keyed American pictures. Probably the best treatment of his total career is the essay by William Howe Downes, "Charles H. Davis's Landscapes," *New England Magazine* 27 (December 1902), 423–37. See also "Art Notes," *Art Review* 1 (March 1887), 17.

41. Homer's French trip is treated in much of the voluminous literature on the artist, but specifically see Henry Adams, "Winslow Homer's 'Impressionism' and Its Relation to His Trip to France," in *Winslow Homer: A Symposium,* Studies in the History of Art 26 (Washington, D.C.: National Gallery of Art, 1990).

42. Adams, "Winslow Homer's 'Impressionism,' " 61–62. Adams is here attempting to refute the theory of Albert Ten Eyck Gardner, especially as stated in his *Winslow Homer, American Artist: His World and His Work* (New York: Clarkson N. Potter, 1961), in which, however, Gardner does not propose Homer's aware of Impressionism, but rather the work of Edouard Manet, who had built his own pavilion at the Exposition Universelle.

43. See Barbara Novak, *American Painting of the Nineteenth Century* (New York: Praeger, 1972), 172–74.

44. See David Park Curry, *Winslow Homer: The Croquet Game* (New Haven: Yale University Art Gallery, 1984).

45. See Sellin, *Americans in Brittany and Normandy,* 11–38, for the fullest recent account of Wylie's career and influence. See also A. V. Butler, "Robert Wylie," *Aldine* 9, no. 2 (1878–79), 77–78. Earlier, "Outremer" in the same magazine had called Wylie "the finest American artist" and charged that this opinion was held by all painters who knew his works; "Art Talks from Paris," *Aldine* 8 (1876–77), 354.

46. Sellin, *Americans in Brittany and Normandy.*

47. See Elva Fromuth Loe, "Concerning Art: The Fromuth Journal, Reflections on Art by an American Painter in France, Extracts from the Journal of Charles Henry Fromuth," M.A. thesis, Catholic University, Washington, D.C., 1960; David Sellin, *Charles H. Fromuth (1858–1937)* (Washington, D.C.: Taggart and Jorgensen Gallery, 1988).

48. See Julia F. Opp, "William T. Dannat," *Munsey's Magazine* 13 (August 1895), 513–17; Armand Dayot, "William T. Dannat," trans. Irene Sargent, *Craftsman* 6 (May 1904), 154–61.

49. Illustrated in Gordon Hendricks, *The Life and Work of Thomas Eakins* (New York: Grossman, 1974), pl. 6.

50. For Eakins in France and in Spain, see the definitive study of his work by Lloyd Goodrich, *Thomas Eakins,* 2 vols. (Cambridge: Harvard University Press, 1982), I, 17–64.

Eakins's indebtedness to his French teachers was perceptively explored by Gerald M. Ackerman, "Thomas Eakins and His Parisian Masters Gérôme and Bonnat," *Gazette des beaux-arts,* ser. 6, 73 (April 1969), 235–56.

51. The definitive modern study of Bridgman, as yet unpublished, is Ilene Susan Fort, "Frederick Arthur Bridgman and the American Fascination with the Exotic Near East," Ph.D. diss., City University of New York, 1990.

52. See Nancy Douglas Bowditch, *George de Forest Brush: Recollections of a Joyous Painter* (Peterborough, N.H.: William L. Bauhan, 1970); Joan B. Morgan, *George de Forest Brush, 1855–1941: Master of the American Renaissance* (New York: Berry-Hill Galleries, 1985). See also idem, "The Indian Paintings of George de Forest Brush," *American Art Journal* 15 (Spring 1983), 60–73; and the earlier Lula C. Merrick, "Brush's Indian Pictures," *International Studio* 76 (December 1922), 186–93. And see Brush's own "An Artist among Indians," *Century Magazine* 30 (May 1885), 54–57.

53. The best presentation of Couse's career is by Virginia Couse Leavitt, "Eanger Irving Couse," in J. Gray Sweeney, *Artists of Michigan from the Nineteenth Century* (Muskegon, Mich.: Muskegon Museum of Art, 1987), 160–67.

54. Rush C. Hawkins, "Report on the Fine Arts," *Reports of the United States Commissioners to the Universal Exposition of 1889 at Paris,* 5 vols. (Washington, D.C.: Government Printing Office, 1890–91), 69; quoted in D. Dodge Thompson, "Julius L. Stewart, a 'Parisian from Philadelphia,' " *Antiques* 130 (November 1986),1047. The primary study of Stewart, unpublished, is Sue Carson Joyner, "Julius L. Stewart, Life and Works," M.A. thesis, Hunter College, City University of New York, 1982.

55. The bibliography by both French and American writers on Walter Gay is extensive. The most significant items are Walter Gay, *Memoirs of Walter Gay* (New York: privately printed, 1930); and Albert Eugene Gallatin, *Walter Gay: Paintings of French Interiors* (New York: E. P. Dutton, 1920). The best modern study of the artist is Gary A. Reynolds, *Walter Gay: A Retrospective* (New York: Grey Art Gallery and Study Center, New York University, 1980).

56. For Cox's years of training in Paris, see H. Wayne Morgan, ed., *An American Art Student in Paris: The Letters of Kenyon Cox, 1877–1882* (Kent, Ohio: Kent State University Press, 1986). For Cox's attitude toward the nude, see Will H. Low and Kenyon Cox, "The Nude in Art," *Scribner's Magazine* 12 (December 1892), 747–49. His championing of the theme of the nude was recognized in the first study devoted to Cox, William A. Coffin, "Kenyon Cox," *Century Magazine* 41 (January 1891), 333–37.

57. "Ishmael," "Through the New York Studios—I. Alexander Harrison," *Illustrated American* 5 (January 3, 1891), 238–39. See also Karen Zukowski's treatment of this picture in Annette Blaugrund, *Paris 1889,* 161–64.

58. No treatise of substance has so far been published concerning Curran's art and career. Margaret Conrads prepared a substantial study of the artist in a seminar paper at the City University of New York Graduate School in 1985.

59. See *Fernand Lungren (1857–1932): Some Notes on His Life* (Santa Barbara, Calif.: Santa Barbara School of the Arts, 1933); John

A. Berger, *Fernand Lungren: A Biography* (Santa Barbara, Calif.: Schauer Press, 1936).

60. American recognition of and involvement with the fin-de-siècle Symbolist movement was relatively minimal, certainly, compared to the concern with naturalism and Impressionism. A number of American painters, including several in the Terra collection such as John White Alexander, Charles Curran, Thomas Dewing, and Philip Hale explored Symbolist themes, at least briefly, or created more traditional works in a manner tinged with Symbolist overtones. See Charles C. Eldredge, *American Imagination and Symbolist Painting* (New York: Grey Art Gallery and Study Center, New York University, 1979).

61. The definitive study of Tanner is Dewey F. Mosby, *Henry Ossawa Tanner* (Philadelphia: Philadelphia Museum of Art, 1991); for this painting, see pp. 132–34.

62. The definitive study of Nourse is the pair of essays by Mary Alice Heekin Burke and Lois Marie Fink in *Elizabeth Nourse, 1859–1938: A Salon Career* (Washington, D.C.: Smithsonian Institution Press, 1983).

63. See Jo Ann Wein, "The Parisian Training of American Women Artists," *Woman's Art Journal* 2 (Spring/Summer 1981), 35–44; and the several essays by Catherine Fehrer in *The Julian Academy, Paris, 1868–1939* (New York: Shepherd Gallery, 1989). Of the many early accounts of women studying at Julian's, see esp. "Women Students in Paris," *New-York Times*, July 8, 1877, 2; May Alcott Nieriker, *Studying Art Abroad, and How to Do It Cheaply* (Boston: Roberts Brothers, 1879), 48–49; Phebe D. Natt, "Art Schools in Paris," *Lippincott's Magazine* 27 (March 1881), 269–76; M[argaret] B[ertha] W[right], "Ateliers des dames," *Art Amateur* 9 (July 1883), 34–35; Emma Bullet, "Julian Studios, Painting Schools Where Women Learn to Be Artists," *Brooklyn Daily Eagle*, July 30, 1885, 1; D. M. Craik, "A Paris Atelier," *Good Words* 27 (1886), 309–13; M. Riccardo Nobili, "The Académie Julian," *Cosmopolitan* 8 (1889), 746–52; Marie Adelaide Belloc, "Lady Artists in Paris," *Murray's Magazine* 8 (September 1890), 371–84; Lucy H. Hooper, "Art Schools of Paris," *Cosmopolitan* 14 (November 1892), 59–62; Daisy Brown, "Experiences in the Julian School," *Corcoran Art Journal* 1 (April 1893), 5–6; J. Sutherland, "An Art Student's Year in Paris, Women's Classes at Julian's School," *Art Amateur* 32 (January 1895), 52.

64. Lida Rose McCabe, "Madame Bouguereau at Work," *Harper's Bazaar* 44 (December 1910), 694–95, states that there were three other women in Julian's academy when Gardner began there. See also "Romance of Exeter Girl Who Married Bouguereau," *Boston Evening Post*, September 3, 1905, 1; Lida Rose McCabe, "Mme. Bouguereau, Pathfinder," *New York Times Book Review Magazine*, February 19, 1922, 16; Madeleine Fidell-Beaufort, "Elizabeth Jane Gardner Bouguereau: A Parisian Artist from New Hampshire," *Archives of American Art Journal* 24, no. 2 (1984), 2–9.

65. For the Académie Carmen, see esp. E[lizabeth] R. and J[oseph] Pennell, *The Life of James McNeill Whistler* (Philadelphia: J. B. Lippincott, 1920), 377–93.

66. Andrew McLaren Young, Margaret MacDonald, and Robin Spencer, *The Paintings of James McNeill Whistler* (New Haven: Yale University Press, 1980), 167.

67. Pennell and Pennell, *The Life of James McNeill Whistler*, 267.

68. Whistler's influence in both Europe and America is dealt with in Allen Staley and Theodore Reff, *From Realism to Symbolism: Whistler and His World* (New York: Wildenstein, 1971).

69. In 1894 Whistler had accepted a commission from Sir William Eden to paint a portrait of Lady Eden, and cashed the check, though he felt his compensation unworthy of his efforts. Subsequently, he refused to deliver the picture after exhibiting it, and instead returned the money. Eden, claiming that his payment originally had been accepted, brought suit against the artist, who was defeated in a French court, made to pay damages, and ordered to deliver the portrait. Whistler, however, had painted out the face and figure of Lady Eden, and an appeals court allowed him to retain the partially destroyed work, so long as he did not make use of it, or allow it to resemble the original subject. The work is now in the collection of the University of Glasgow.

70. Recent treatments of the work of Alexander include Sandra Leff, *John White Alexander, 1856–1915: Fin-de-Siècle American* (New York: Graham, 1980); Julie Anne Springer, "Art and the Feminine Muse: Women in Interiors by John White Alexander," *Woman's Art Journal* 6 (Fall 1985/Winter 1986), 1–8; and two studies by Mary Ann Goley, *John White Alexander (1856–1915)* (Washington, D.C.: National Collection of Fine Arts, 1977); and "John White Alexander's Panel for Music Room," *Bulletin of the Detroit Institute of Arts* 64, no. 4 (1989), 5–17. Sarah Moore is currently preparing a doctoral dissertation on Alexander for the City University of New York. On Whistler and Alexander, see "How Whistler Posed for John W. Alexander," *World's Work* 9 (March 1905), 5993–95. One writer even referred to Alexander as Whistler's pupil; see "The Salons," *Cosmopolis* 6 (June 1897), 674.

71. The major writer on Dewing today is Susan Hobbs. See her articles, "Thomas Wilmer Dewing: The Early Years, 1851–1885," *American Art Journal* 13 (Spring 1981), 4–35; and "Thomas Dewing in Cornish, 1885–1905," *American Art Journal* 17 (Spring 1985), 2–32; on Dewing and Whistler, see p. 19. The most significant study of Whistler's impact upon Dewing is by Sarah Lea Burns, "The Poetic Mode in American Painting: George Fuller and Thomas Dewing," Ph.D. diss., University of Illinois at Urbana-Champaign, 1979, 237–55.

72. Sadakichi Hartmann, *A History of American Art* (1907), 3rd ed., rev. (New York: Tudor, 1934), 2, 328; quoted in Burns, "The Poetic Mode in American Painting," 250.

73. For the Ten American Painters, see *Ten American Painters* (New York: Spanierman Gallery, 1990).

74. For Bunker, see R. H. Ives Gammell, *Dennis Miller Bunker* (New York: Coward-McCann, 1953); Charles B. Ferguson, *Dennis Miller Bunker Rediscovered* (New Britain, Conn.: New Britain Museum of American Art, 1978).

75. Ferguson, *Dennis Miller Bunker Rediscovered*, unpaginated.

76. For Sargent's involvement with Impressionism, see William H. Gerdts, "The Arch Apostle of the Dab-and-Spot School: John Singer Sargent as an Impressionist," in Patricia Hills,

John Singer Sargent (New York: Harry N. Abrams, 1986), 111–46.

77. Quoted in Dennis Miller Bunker Papers, Archives of American Art, Smithsonian Institution, Washington, D.C., letter to Joe Evans, September 11, 1888; see also the letters of May 9 and June 18.

78. Dennis Miller Bunker Papers, letter to Eleanor Hardy, undated; cited in Ferguson, *Dennis Miller Bunker Rediscovered,* unpaginated.

79. Like the Whistler literature, that on Sargent is immense. Of the older studies, see William Howe Downes, *John S. Sargent: His Life and Work* (Boston: Little, Brown, 1925); Evan Charteris, *John Sargent* (New York: Charles Scribner's Sons, 1927). For more recent treatment, see Richard Ormond, *John Singer Sargent: Paintings, Drawings, Watercolors* (New York: Harper and Row, 1970); Carter Ratcliff, *John Singer Sargent* (New York: Abbeville Press, 1982); Stanley Olson, *John Singer Sargent: His Portrait* (New York: St. Martin's Press, 1986); Hills, *John Singer Sargent.* For Sargent's training, see Charles Merrill Mount, "Carolus-Duran and the Development of Sargent," *Art Quarterly* 26 (Winter 1963), 385–417. The fullest treatment of *Fishing for Oysters at Cancale* can be found in Trevor J. Fairbrother, *John Singer Sargent and America* (New York: Garland, 1986), 28–35 (Ph.D. diss., Boston University, 1981).

80. See, for instance, "Fine Arts, The Society of American Artists, I," *New York Evening Mail,* March 5, 1878, 4; S[usan] N. Carter, "First Exhibition of the American Art Association," *Art Journal* (New York) 3 (1878), 126; G[eorge] W. Sheldon, *American Painters* (New York: D. Appleton, 1879), 72.

81. Beckwith wrote the chapter on Carolus-Duran in John Van Dyke, ed., *Modern French Masters: A Series of Biographical and Critical Reviews by American Artists* (New York: Century, 1896), 75–80. The artist was the subject of frequent periodical articles in his lifetime; see Edward Straham, "James Carroll Beckwith," *Art Amateur* 6 (April 1882), 94–97; "Beckwith," *Art Interchange* 7 (October 27, 1882), 84; "J. Carroll Beckwith," *American Bookmaker* 7 (July 1888); Charles William Larned, "An Enthusiast in Painting," *Monthly Illustrator* 3 (February 1895), 131–37; Howard Bliss, "Carroll Beckwith," *Arts for America* 8 (November 1899), 545–46; Gustav Kobbé, "J. Carroll Beckwith," *Truth* 18 (October 1899), 255–58; Robert J. Wickenden, "The Portraits of Carroll Beckwith," *Scribner's Magazine* 47 (April 1910), 449–60. Beverly Rood of East Moriches, N.Y., has been studying Beckwith for a number of years and is the leading authority on his life and art. Beckwith's diaries for forty years are an invaluable source on his life and the art world of his times; all but one volume (that for 1895 at the New-York Historical Society) are on deposit at the National Academy of Design in New York.

82. The Cassatt bibliography is extensive; her expatriation and involvement with the French art establishment resulted in articles and books produced by both American and European scholars. The earliest monographs, in fact, were published in France: Achille Segard, *Un peintre des enfants et des mères: Mary Cassatt* (Paris: Librarie Ollendorff, 1913); Edith Valerio, *Mary Cassatt* (Paris: G. Crès et Cie, 1930). The primary American scholar has been Adelyn Dohme Breeskin; see her *Mary Cassatt: A Catalogue Raisonné of the Oils, Pastels, Watercolors, and Drawings* (Washington, D.C.: Smithsonian Institution Press, 1970). This must be used with caution, however, as a substantial number of the attributions here are suspect, and a revision of this material is presently underway, sponsored by Christie, Manson & Woods International, New York. Among the many other Cassatt studies, especially useful are Griselda Pollock, *Mary Cassatt* (New York: Harper and Row, 1979) (which, however, relies too heavily on some of the more questionable attributions in Breeskin), and Nancy Mowll Mathews, *Mary Cassatt* (New York: Harry N. Abrams, 1987). Mathews has also edited a collection of Cassatt correspondence; see her *Cassatt and Her Circle: Selected Letters* (New York: Abbeville Press, 1984).

83. See the notice of her work in "Art Notes," *Watson's Art Journal* 13 (July 1872), 129, which states that Cassatt had "just finished an original painting, which all Parma is flocking to see at her studio, in the academy in that city. Italian painters of reputation are quite enthusiastic in regard to our fair countrywoman's talents, which they pronounce nearly akin to genius, and they offer her every inducement to make Parma her home, and date her pictures from that city."

84. "Art in Paris," *New-York Times,* April 27, 1879, 2.

85. Nancy Mathews has interpreted Cassatt's imagery as partaking of a new exploration of the theme of the Madonna in the nineteenth century; see her "Mary Cassatt and the 'Modern Madonna' of the Nineteenth Century," Ph.D. diss., Institute of Fine Arts, New York University, 1980, and others have followed suit. It seems to the present writer, however, that Cassatt was at pains to distance herself from this theme, which did, indeed, have contemporary currency.

86. There is also a more expansive, horizontal version of this subject, with the identical title, in the Armand Hammer Museum in Los Angeles, and another oil, *On the Water,* in a private collection.

87. See Adelyn Dohme Breeskin, *Mary Cassatt: A Catalogue Raisonné of the Graphic Work* (Washington, D.C.: Smithsonian Institution Press, 1979); Nancy Mowll Mathews and Barbara Stern Shapiro, *Mary Cassatt: The Color Prints* (New York: Harry N. Abrams, 1989).

88. The present author is writing a book on the artists' colony in Giverny to be published by Abbeville Press, New York, in the autumn of 1993. Until then, see Sellin, *Americans in Brittany and Normandy,* and Meixner, *Millet, Monet, and Their North American Counterparts,* as well as my *American Impressionism* (New York: Abbeville Press, 1984), 57–90, 261–74. See also the two studies by Pierre Toulgouat, "Skylights in Normandy," *Holiday* 4 (August 1948), 66–70, and "Peintres américains à Giverny," *Rapports: France—Etats-Unis,* no. 62 (May 1952), 65–73.

89. In addition to Sellin, *Americans in Brittany and Normandy,* and Gerdts, *American Impressionism,* see Edward Breck, "Something More of Giverny," *Boston Evening Transcript,* March 9, 1895, 13; Dawson Dawson-Watson, "The Real Story of Giverny," appendix to Eliot C. Clark, *Theodore Robinson: His Life and Art* (Chicago: R. H. Love Galleries, 1979), 65–67. The earliest no-

tice of the American presence in Giverny is Greta, "Boston Art and Artists," *Art Amateur* 17 (October 1887), 93. On the Hôtel Baudy, see Claire Joyes, "Giverny's Meeting House, the Hôtel Baudy," in Sellin, *Americans in Brittany and Normandy*, 97–102.

90. Breck, "Something More of Giverny"; Joyes, "Giverny's Meeting House," 101.

91. The definitive study of Metcalf is Elizabeth deVeer and Richard J. Boyle, *Sunlight and Shadow: The Life and Art of Willard L. Metcalf* (New York: Abbeville Press, 1987).

92. John I. H. Baur, "Introducing Theodore Wendel," *Art in America* 64 (November–December 1976), 102–12.

93. "Monthly Record of American Art," *Magazine of Art* 14 (May 1891), p. xx.

94. The most complete study of Breck's career is Kathryn Corbin, "John Leslie Breck, American Impressionist," *Antiques* 134 (November 1988), 1142–49; Twachtman is quoted on p. 1142 (from the Breck family archives).

95. For an analysis of Breck's Impressionist work in Giverny, see Meixner, *Millet, Monet, and Their North American Counterparts*, 124–31.

96. Speaking of two Giverny moonlight scenes, probably similar to *Autumn, Giverny*, one critic noted that "Millet himself, who was strong in the treatment of this class of subjects, hardly surpassed the beauty and solemnity and repose of these nocturnal scenes. . . . The farther away from Monet he gets, the better Mr. Breck does"; "The Fine Arts: Exhibition of Mr. Breck's Paintings at the St. Botolph Club," *Boston Evening Transcript*, November 22, 1890, 12. *Autumn, Giverny* was called "his best as well as his largest canvas" when it was exhibited in Breck's second one-artist show, held at the J. Eastman Chase Gallery in Boston early in 1893; see Louisa Trumbull Cogswell, "Art in Boston," *Arcadia* 1 (February 1, 1893), 404.

97. Hamlin Garland, *Roadside Meetings* (New York: Macmillan, 1930), 30–31.

98. "The Fine Arts," *Boston Evening Transcript*, November 22, 1890, 12; "Fine Art Notes," *Boston Morning Journal*, November 22, 1890, 2; "The Fine Arts," *Boston Sunday Herald*, November 23, 1890, 12.

99. Illustrated in Corbin, "John Leslie Breck, American Impressionist."

100. The major studies of Robinson's art and career are: John I. H. Baur, *Theodore Robinson, 1852–1896* (Brooklyn: Brooklyn Museum, 1946); Sona Johnston, *Theodore Robinson, 1852–1896* (Baltimore: Baltimore Museum of Art, 1973); Clark, *Theodore Robinson*; William Kloss, *The Figural Images of Theodore Robinson, American Impressionist* (Oshkosh, Wis.: Paine Art Center and Arboretum, 1987). Robinson's diaries for 1892–96 are preserved at the Frick Art Reference Library, New York.

101. Toulgouat, "Skylights in Normandy," 67.

102. Guest register of the Hôtel Baudy, 1887–1900, Philadelphia Museum of Art.

103. Will H. Low, *A Chronicle of Friendships 1873–1900* (New York: Charles Scribner's Sons, 1908), 448.

104. For Monet's reaction to the proposed union of Butler and Suzanne Hoschedé, see his letters to Alice Hoschedé cited in Joyes, "Giverny's Meeting House," 103.

105. The definitive monograph on Butler is Richard H. Love, *Theodore Earl Butler: Emergence from Monet's Shadow* (Chicago: Hasse-Mumm, 1985).

106. Hale to William Howard Hart, July 29, 1895, Philip Leslie Hale Papers, Archives of American Art, Smithsonian Institution, Washington, D.C. The Hale Papers are especially rich for references to the artists and their lives in Giverny.

107. There is no definitive monograph on Hale. See the essay by Franklin P. Folts, *Paintings and Drawings by Philip Leslie Hale, 1865–1931, from the Folts Collection* (Boston: Vose Galleries, 1966); and Carol Lowrey, *Philip Leslie Hale, A.N.A. (1865–1931)* (Boston: Vose Galleries, 1988).

108. Dawson-Watson, "The Real Story of Giverny," in Clark, *Theodore Robinson*, 65–67. See also Dawson-Watson's letter to Emily Grant Hutchings, "Art and Artists," *St. Louis Globe-Democrat*, September 12, 1925.

109. Gerdts, *American Impressionism*, 17–21.

110. Dawson Dawson-Watson, "The Rolling-pin in Art," *Literary Review* 1 (May 1897), 70.

111. "Glory of the Morning," *Pioneer* 7 (April 1927), 5, 11.

112. Meteyard to Hovey, April 20, 1890, Richard Hovey Papers, Dartmouth College, Hanover, N.H.; quoted in Nicholas Kilmer, *Thomas Buford Meteyard (1865–1928)* (New York: Berry-Hill Galleries, 1989), 16. This is the primary source for information on Meteyard.

113. Nancy Finlay, *Artists of the Book in Boston, 1890–1910* (Cambridge: Harvard College Library, 1985), 47.

114. The most recent and complete study of Perry is Meredith Martindale, *Lilla Cabot Perry: An American Impressionist* (Washington, D.C.: National Museum of Women in the Arts, 1990). See also Stuart P. Feld, *Lilla Cabot Perry: A Retrospective Exhibition* (New York: Hirschl and Adler Galleries, 1969).

115. Lilla Cabot Perry, "Reminiscences of Claude Monet from 1889 to 1909," *American Magazine of Art* 18 (March 1927), 119–25.

116. Despite the fact that Frederick MacMonnies was one of America's leading sculptors at the turn of the century, there exists no full-length monographic study on his life and art. The most recent significant publications deal with specific monuments: Hildegard Cummings, "Chasing a Bronze Bacchante," *William Benton Museum of Art Bulletin*, no. 12 (1984), 3–19; and Robert Judson Clark, "Frederick MacMonnies and the Princeton Battle Monument," *Record of the Art Museum, Princeton University* 43, no. 2 (1984). Particularly useful also is Edward J. Foote, "An Interview with Frederick W. MacMonnies, American Sculptor of the Beaux-Arts Era," *New-York Historical Society Quarterly* 61 (July–October 1977), 103–23. For both Frederick and Mary MacMonnies, see the essays by E. Adina Gordon in *Frederick William MacMonnies (1863–1937), Mary Fairchild MacMonnies (1858–1946), deux artistes américains à Giverny* (Vernon: Musée Municipal A.-G. Poulain, 1988). The primary holdings of MacMonnies papers are at the Archives of American Art, Smithsonian Institution, Washington,

D.C., and with the artists' descendants. Mary Smart of Lyons, N.Y., is currently writing a biography of the sculptor and has offered invaluable assistance here.

117. For Americans studying sculpture in Paris, see Véronique Wiesinger, "Les Elèves sculpteurs américains à Paris," in *Le Voyage de Paris*, 55–64.

118. See Cummings, "Chasing a Bronze Bacchante," and Walter Muir Whitehill, "The Vicissitudes of Bacchante in Boston," *New England Quarterly* 27 (December 1954), 435–54.

119. Newspapers throughout America gave notice of MacMonnies' turn to painting in 1900; see the clippings in the MacMonnies files at the Archives of American Art. For a perceptive account of his painting and his Giverny home a year later, see Emma Bullet, "MacMonnies, the Sculptor, Working Hard as a Painter," *Brooklyn Daily Eagle*, September 8, 1901, 2.

120. See the description in Will H. Low, "In an Old French Garden," *Scribner's Magazine* 32 (July 1902), 3–19.

121. My gratitude to Mary Smart for her analysis of MacMonnies activities as a painter and in Giverny.

122. I am greatly indebtd to Mary Smart, the leading scholar on Frederick and Mary MacMonnies, for much of the information on the works here described, and for assessing with me the attributions of several of these paintings.

123. The most complete treatment of Mary MacMonnies is Mary Smart, "Sunshine and Shade: Mary Fairchild MacMonnies Low," *Woman's Art Journal* 4 (Fall 1983/Winter 1984), 20–25. See also Gordon, essays in *Frederick William MacMonnies (1863–1937), Mary Fairchild MacMonnies (1858–1946)*.

124. The primary modern study published about the art colony at Grèz is Jacobs, *The Good and Simple Life*, 29–40; see also the unpublished essay by May Brawley Hill, "Grez-sur-Loing as an Artists' Colony, 1875–1890," 1983. Among the major early essays on Grèz are: "Grez par Nemours," *Studio* 2 (July 1883), 15–18; Robert Louis Stevenson, "Fontainebleau: Village Communities of Painters," *Magazine of Art* 7 (1884), 253–72, 340–45; R. A. M. Stevenson, "Grez," *Magazine of Art* 17 (1894), 27–32; and two essays by the American painter Birge L. Harrison: "In Search of Paradise with Camera and Palette," *Outing* 21 (July 1893), 310–13; and "With Stevenson at Grez," *Century Magazine* 93 (December 1926), 306–14. For a descriptive list of the artists in Grèz, see Fernande Sadler, *L'Hôtel Chevillon et les artistes de Grès-sur-Loing* (Fontainebleau, 1938).

125. The definitive study of this subject is May Brawley Hill, *Grez Days: Robert Vonnoh in France* (New York: Berry-Hill Galleries, 1987).

126. "Robert Vonnoh," *National Cyclopaedia of American Biography*, 63 vols. (Clifton, N.J.: James T. White, 1888–94), 7 (1897), 462.

127. S. C. de Soissons, *A Parisian Critic's Notes on Boston Artists* (Boston, 1894), 26–27, states that Vonnoh "was impressed with the clear pictures of Manet, Sisley, and Pizarro [*sic*], and admired in their canvas the warm and harmonious solar rays and the gradation of pure lines; then he banished from his palette the black, bitumen, and ochre, and he now makes

his pictures according to the principles of the impressionists." See also Susan M. Ketcham, "Robert W. Vonnoh's Pictures," *Modern Art* 4 (Autumn 1896), 115–16.

128. *Catalogue of a Collection of Original Works of E. W. D. Hamilton* (Boston: Leonard & Co. Galleries, 1900), 3. See also the *Catalogue of Paintings by Edward W. D. Hamilton on Exhibition and Sale at the Gallery of J. Eastman Chase 7 Hamilton Place Boston*, 1892, in which forty works painted in Grèz and in Venice were divided up among "Hot Sunny Mornings," "Sunny Afternoons," "Cold and Frosty Mornings," and "Evenings and Nights."

129. "In Studio and Gallery," clipping from an unidentified Cincinnati newspaper, Potthast Papers, Archives of American Art, Smithsonian Institution, Washington, D.C.

130. Potthast's life and career are still only sketchily known; see the two essays by Arlene Jacobowitz, "Edward Henry Potthast," *Brooklyn Museum Annual* 9 (1967–68), 113–28; and *Edward Henry Potthast, 1857–1927* (New York: Chapellier Galleries, 1969).

131. Probably the best discussion of Bessie Potter Vonnoh's career that has been published is Janis Conner and Joel Rosenkranz, *Rediscoveries in American Sculpture Studio Works, 1893–1939* (Austin: University of Texas Press, 1989), 161–68. The most complete study of the sculpture is the unpublished M.A. thesis by Roslye B. Ultan, "Bessie Potter Vonnoh, American Sculptor (1872–1955)," American University, Washington, D.C., 1972. See also her own memoir, "Tears and Laughter Caught in Bronze," *Delineator* 107 (October 1925), 8–9, 78, 80, 82.

132. See the review of the exhibition by Charles de Kay, "American Art in Paris," *New-York Times*, July 13, 1891, 3.

133. See E[dmund] H. Wuerpel, *American Art Association of Paris* (Philadelphia: Times Printing House, 1894); idem, "American Artists' Association Paris," *Cosmopolitan* 20 (February 1896), 402–9; Victor Ducieu, "American Woman's Art Association of Paris," *L'Art* 63 (March 1904), 147–49. The Paris Society of American Painters was also referred to as the Society of American Painters in Paris.

134. The most recent monograph on Hassam is Donelson Hoopes, *Childe Hassam* (New York: Watson-Guptill, 1979). In 1902 Albert Gallatin referred to Hassam as "beyond any doubt the greatest exponent of Impressionism in America"; Albert E. Gallatin, "Childe Hassam: A Note," *Collector and Art Critic* 5 (January 1907), 102.

135. For Hassam's later Flag series, see Ilene Susan Fort, *The Flag Paintings of Childe Hassam* (Los Angeles: Los Angeles County Museum of Art, 1988).

136. A. E. Ives, "Mr. Childe Hassam on Painting Street Scenes," *Art Amateur* 27 (October 1892), 116–17. See also Hassam's own *Three Cities* (New York, 1899), reproducing depictions by him of Paris, London, and New York.

137. See the essay by Lisa N. Peters, "Twachtman's Greenwich Paintings: Context and Chronology," in *John Twachtman: Connecticut Landscapes* (Washington, D.C.: National Gallery of Art, 1989), 13–48. The only monographic study of the artist, generally, in recent years is Richard J. Boyle, *John*

Twachtman (New York: Watson-Guptill, 1979).

138. Twachtman's French landscapes of the 1880s are among his most admired works, and yet they have not been the subject of serious published study to date.

139. For Twachtman's winter landscapes, see Deborah Chotner, "Twachtman and the American Winter Landscape," in *John Twachtman: Connecticut Landscapes,* 71–85.

140. Clarence Cook, "Paintings in Oils and Pastels by J. H. Twachtman," *Studio* 6 (March 28, 1891), 162.

141. "An Art School at Cos Cob," *Art Interchange* 43 (September 1899), 56.

142. Lois Marie Fink and Joshua C. Taylor, *Academy: The Academic Tradition in American Art* (Washington, D.C.: Smithsonian Institution Press, 1975); Doreen Bolger, "The Education of the American Artist," in *In This Academy: The Pennsylvania Academy of the Fine Arts, 1805–1876* (Philadelphia: Pennsylvania Academy of the Fine Arts, 1976), 51–74. For the history of outdoor summer teaching in America, see William H. Gerdts, "The Teaching of Painting Out-of-Doors in America in the Late Nineteenth Century," in Bruce Weber and William H. Gerdts, *In Nature's Ways* (West Palm Beach, Fla.: Norton Gallery of Art, 1987).

143. The primary study of Chase is Ronald G. Pisano, *A Leading Spirit in American Art: William Merritt Chase, 1849–1916* (Seattle: Henry Art Gallery, University of Washington, 1983); Pisano has published numerous other articles, monographs, and exhibition catalogues concerning Chase. Of the earlier studies, the most significant is Katherine Metcalf Roof, *The Life and Art of William Merritt Chase* (New York: Charles Scribner's Sons, 1917). This biographical study has recently been updated by Keith L. Bryant, Jr., *William Merritt Chase: A Genteel Bohemian* (Columbia: University of Missouri Press, 1991).

144. For Chase's park scenes, see Kenyon Cox, "William M. Chase, Painter," *Harper's New Monthly Magazine* 78 (March 1889), 549–57; Charles de Kay, "Mr. Chase and Central Park," *Harper's Weekly* 35 (May 2, 1891), 327–28.

145. "Address of Mr. William M. Chase before the Buffalo Fine Arts Academy, January 28, 1890," *Studio* 5 (March 1, 1890), 126.

146. "The Import of Art, by William M. Chase: An Interview with Walter Pach," *Outlook* 95 (June 25, 1910), 442.

147. John Gilmer Speed, "An Artist's Summer Vacation," *Harper's New Monthly Magazine* 87 (June 1893), 3, 8. For Chase's Shinnecock paintings generally, see D. Scott Atkinson and Nicolai Cikovsky, Jr., *William Merritt Chase: Summers at Shinnecock, 1891–1902* (Washington, D.C.: National Gallery of Art, 1987).

148. The most useful and complete studies of Boston painting of this period are Trevor J. Fairbrother, et al., *The Bostonians: Painters of an Elegant Era, 1870–1930* (Boston: Museum of Fine Arts, 1986); and R. H. Ives Gammell, *The Boston Painters, 1900–1930* (Orleans, Mass.: Parnassus Imprints, 1986). The finest study of Tarbell and his associates is unfortunately unpublished: Bernice Kramer Leader, "The Boston Lady as a Work of Art: Paintings by the Boston School at the Turn of the Century," Ph.D. diss., Columbia University, 1980 (Ann Arbor: University Microfilms International, 1980).

149. Tarbell is the principle subject of Patricia Jobe Pierce, *Edmund C. Tarbell and the Boston School of Painting, 1889–1980* (Hingham, Mass.: Pierce Galleries, 1980), but the definitive monograph on the artist still needs to be written. Probably the most perceptive recent analysis of Tarbell's art is by Susan Faxon Olney, *Two American Impressionists: Frank W. Benson and Edmund C. Tarbell* (Durham: University Art Galleries, University of New Hampshire, 1979). The most complete earlier articles on Tarbell are two by Frederick W. Coburn: "Edmund C. Tarbell, Painter," *World Today* 11 (October 1906), 1077–85; and "Edmund C. Tarbell," *International Studio* 32 (September 1907), lxxv–lxxxvii.

150. Illustrated in Gerdts, *American Impressionism,* 81.

151. Sadakichi Hartmann, "The Tarbellites," *Art News* 1 (March 1897), 3–4.

152. For American garden painting, see William H. Gerdts, *Down Garden Paths: The Floral Environment in American Art* (Rutherford, N.J.: Fairleigh Dickinson University Press, 1983).

153. Joyce Butler, *Abbott Fuller Graves* (Kennebunk, Maine: Brick Store Museum, 1979).

154. See Cheryl Leibold, "A History of the Annual Exhibitions of the Pennsylvania Academy of the Fine Arts: 1876–1913," in Peter Hastings Falk, *The Annual Exhibition Record of the Pennsylvania Academy of the Fine Arts, 1876–1913* (Madison, Conn.: Sound View Press, 1989), 15–17.

155. Margaret Vogel, *The Paintings of Hugh H. Breckenridge (1870–1937)* (Dallas: Valley House Gallery, 1967); Gerald L. Carr, "Hugh Henry Breckenridge, A Philadelphia Modernist," *American Art Review* 4 (May 1978), 92–99, 119–22. Most attention has been given to Breckenridge's later, abstract works done after 1920.

156. See the articles by Guy Pène du Bois, "The Pennsylvania Group of Landscape Painters," *Arts and Decoration* 5 (July 1915), 351–54; and "The Boston Group of Painters: An Essay on Nationalism in Art," *Arts and Decoration* 5 (October 1915), 457–60. There has been a fair amount of recent publication on the Pennsylvania Impressionists, but the most definitive study is Thomas Folk, *The Pennsylvania School of Landscape Painting* (Allentown, Pa.: Allentown Art Museum, 1984).

157. Thomas Folk, *Edward Redfield: First Master of the Twentieth Century Landscape* (Allentown, Pa.: Allentown Art Museum, 1987).

158. Barbara Pollack, "Famous American Artist Was Interviewed in 1963 at His Center Bridge Home," *Lambertville Beacon,* July 16, 1981, 10.

159. B. O. Flower, "Edward W. Redfield: An Artist of Winter-locked Nature," *Arena* 36 (July 1906), 20–26.

160. Kathleen A. Foster, *Daniel Garber, 1880–1957* (Philadelphia: Pennsylvania Academy of the Fine Arts, 1980).

161. William H. Gerdts, "Post-Impressionist Landscape Painting in America," *Art and Antiques* 6 (July–August 1983), 60–67.

162. Most of the material written on Gutmann is concerned with his Lynchburg years; see esp. Evelyn L. Moore and Ruth H. Blunt, "Composition, Color, and Sometimes Humor: Artist

Bernhard Gutmann of Lynchburg," *Virginia Cavalcade* 31 (Spring 1982), 206–15. See also Robert R. Preato and Sandra L. Langer, *Impressionism and Post-Impressionism: Transformations in the Modern American Mode, 1885–1945* (New York: Grand Central Art Galleries, 1988), 52.

163. Clara MacChesney, "Frieseke Tells Some of the Secrets of His Art," *New York Times*, June 7, 1914, sec. 6, 7.

164. During his lifetime, Frieseke was the subject of innumerable exhibitions with accompanying catalogues, and more recent catalogues make up the bulk of his modern bibliography. The most perceptive studies of his life and art are Allen S. Weller, "Frederick Carl Frieseke: The Opinions of an American Impressionist," *Art Journal* 28 (Winter 1968), 160–65; and Arleen Pancza, "Frederick Carl Frieseke (1874–1939)," in Sweeney, *Artists of Michigan from the Nineteenth Century*, 168–73.

165. See esp. the writings of Bram Dijkstra here: "The High Cost of Parasols: Images of Women in Impressionist Art," in Patricia Trenton and William H. Gerdts, *California Light, 1900–1930* (Laguna Beach, Calif.: Laguna Art Museum, 1990), 33–51. For the ubiquity of the mirror image, see Dijkstra's *Idols of Perversity* (New York: Oxford University Press, 1986), esp. chap. 5, 129–45 ("Mirror of Venus" section).

166. For a different interpretation of the parasol as an instrument of Social Darwinism in French and American Impressionist painting, see Dijkstra, "The High Cost of Parasols," 39–43.

167. Robert Ball and Max W. Gottschalk, *Richard E. Miller, N.A.: An Impression and Appreciation* (Saint Louis: Longmire Fund, 1968). Marie Louise Kane of Waterbury, Conn., the leading authority on Miller, has, as always, been most helpful in documenting the artist's activities.

168. Joseph Jeffers Dodge, *Edmund W. Greacen, N.A., American Impressionist, 1876–1949* (Jacksonville, Fla.: Cummer Gallery of Art, 1972).

169. The most recent and complete study of Rose is Ilene Susan Fort, "The Cosmopolitan Guy Rose," in Trenton and Gerdts, *California Light*, 93–112.

170. The definitive study here is Richard H. Love, *Louis Ritman: From Chicago to Giverny* (Chicago: Haase-Mumm, 1989).

171. C. H. Waterman, "Louis Ritman," *International Studio* 67 (April 1919), cxiv.

172. The reviews of the December 1910 exhibition were gathered together in the catalogue of a later show of the work of Lawton Parker held in Chicago. See *Paintings by Lawton Parker* (Chicago: Art Institute of Chicago, 1912); it was the writer for the *New York Telegraph*, December 21, 1910, who identified the Giverny Group.

173. The primary source for information on Prendergast is Carol Clark, Nancy Mowll Mathews, and Gwendolyn Owens, *Maurice Brazil Prendergast, Charles Prendergast: A Catalogue Raisonné* (Munich: Prestel-Verlag, 1990). See also Eleanor Green and Ellen Glavin, *Maurice Prendergast: Art of Impulse and Color* (College Park: University of Maryland Art Gallery, 1979), esp. the chronology, pp. 33–79.

174. The latest study of Morrice is Nicole Clouthier, *James Wilson Morrice, 1865–1924* (Montreal: Montreal Museum of Fine Arts, 1985). See also Donald W. Buchanan, *James Wilson Morrice: A Biography* (Toronto: Ryerson Press, 1936); G. Blair Laing, *Morrice: A Great Canadian Artist Rediscovered* (Toronto: McClelland and Stewart, 1984); Lucie Dorais, *J. W. Morrice* (Ottawa: National Gallery of Canada, 1985). For Morrice and his American friends, see Cecily Langdale, *Charles Conder, Robert Henri, James Morrice, Maurice Prendergast: The Formative Years, Paris 1890s* (New York: Davis and Long, 1975).

175. Cecily Langdale, *Monotypes by Maurice Prendergast in the Terra Museum of American Art* (Chicago: Terra Museum of American Art, 1984), 12. Langdale's writing here constitutes one of the most perceptive studies of the artist's work generally, in addition to its primary concern with the monotypes.

176. Langdale, *Monotypes by Maurice Prendergast.* For the history of the monotype generally, see *The Painterly Print: Monotypes from the Seventeenth to the Twentieth Century* (New York: Metropolitan Museum of Art, 1980).

177. Prendergast to Mrs. Oliver Williams, October 10, 1907, Esther Williams Papers, Archives of American Art, Smithsonian Institution, Washington, D.C.; quoted in John Rewald, *Cézanne and America Dealers, Collectors, Artists, and Critics, 1891–1921* (Princeton: Princeton University Press, 1989), 114.

178. Ibid.

179. Nancy Mowll Mathews discusses the influence of Cézanne on Prendergast in "Maurice Prendergast and the Influence of European Modernism," in Clark, Mathews, and Owens, *Maurice Brazil Prendergast, Charles Prendergast*, 36–40. For the still lifes, see also Hedley Howell Rhys, *Maurice Prendergast, 1859–1924* (Boston: Museum of Fine Arts, 1960), 50.

180. The latest publication on this movement is Elizabeth Milroy, *Painters of a New Century: The Eight* (Milwaukee, Wis.: Milwaukee Art Museum, 1991). See also Bennard B. Perlman, *The Immortal Eight* (New York: Exposition Press, 1962); William Inness Homer, "The Exhibition of 'The Eight': Its History and Significance," *American Art Journal* 1 (Spring 1969), 53–64; Mahonri Sharp Young, *The Eight* (New York: Watson-Guptill, 1973). For the nationalist interpretation of the Eight, see Giles Edgerton [Mary Fanton Roberts], "The Younger American Painters: Are They Creating a National Art?" *Craftsman* 13 (February 1908), 512–32.

181. James Huneker, "Eight Painters: First Article," *New York Sun*, February 9, 1908, 8; Frank Jewett Mather, Jr., "Some American Realists," *Arts and Decoration* 7 (November 1916), 15.

182. The standard study of Shinn is Edith DeShazo, *Everett Shinn, 1876–1953: A Figure in His Time* (New York: Clarkson N. Potter, 1974).

183. The definitive study of this subject is Linda S. Ferber, "Stagestruck: The Theatre Subjects of Everett Shinn," in Doreen Bolger and Nicolai Cikovsky, Jr., eds., *American Art around 1900: Lectures in Memory of Daniel Fraad* (Washington, D.C., National Gallery of Art, 1990), 51–67.

184. Quoted in Perlman, *The Immortal Eight*, 107.

185. A[lbert] E. G[allatin], *Whistler Notes and Footnotes and Other Memoranda* (New York: Collector and Art Critic, 1907), 80.

186. James Huneker, "Eight Painters: Second Article," *New York Sun*, February 10, 1908, 6.

187. The only full scale monograph on Lawson is Sidney and Henry Berry-Hill, *Ernest Lawson, American Impressionist, 1873–1939* (Leigh-on-Sea, England: F. Lewis, 1968). See also Adeline Lee Karpiscak, *Ernest Lawson, 1873–1939* (Tucson: University of Arizona Museum of Art, 1979).

188. Frederick Newlin Price, "Lawson of the 'Crushed Jewels,' " *International Studio* 78 (February 1924), 369.

189. "A New Poet-Painter of the Commonplace," *Current Literature* 42 (April 1907), 406–9.

190. "'The Eight' Arrive," *American Art News* 6 (February 8, 1908), 6.

191. See Ira Glackens, *William Glackens and the Ashcan Group* (New York: Crown, 1957).

192. Albert E. Gallatin, "The Art of William J. Glackens: A Note," *International Studio* 40 (May 1910), 68.

193. Albert E. Gallatin, "William Glackens," *American Magazine of Art* 7 (May 1916), 261; Forbes Watson, "William Glackens," *Arts* 3 (April 1923), 252–53. See esp. Violette de Mazia, "The Case of Glackens vs. Renoir," *Journal of the Art Department* (Barnes Foundation) 2 (Autumn 1971), 3–30. Despite the polemical attitude revealed in de Mazia's study, she is quite perceptive in regard not only to the impact of Renoir but also of Manet (pp. 20ff.) on Glackens's art.

194. Carl E. David, "Martha Walter," *American Art Review* 4 (May 1978), 84–91.

195. Charles de Kay, "Martha Walter, Painter," *Arts and Decoration* I (May 1911), 304.

196. Milton W. Brown, *The Story of the Armory Show* (New York: Abbeville Press, 1988).

197. William Inness Homer, *Alfred Stieglitz and the American Avant-Garde* (Boston: New York Graphic Society, 1977).

198. Gail Stavitsky, *Gertrude Stein: The American Connection* (New York: Sid Deutsch Gallery, 1990).

199. D. Scott Atkinson and William Innes Homer, *The New Society of American Artists in Paris, 1908–1912* (Queens, N.Y.: Queens Museum, 1986).

200. For Marin, see Emanuel M. Benson, *John Marin: The Man and His Work* (New York: J. J. Little and Ives, 1935); MacKinley Helm, *John Marin* (New York: Pellegrini and Cudahy, 1948); Sheldon Reich, *John Marin: A Stylistic Analysis and Catalogue Raisonné*, 2 vols. (Tucson: University of Arizona Press, 1970); Ruth E. Fine, *John Marin* (New York: Abbeville Press, 1990).

201. Elisabeth Luther Cary of the *New York Times*, quoted in *Camera Work* 30 (April 1910), 45–46.

202. For Marin's New York pictures, see John I. H. Baur, *John Marin's New York* (New York: Kennedy Galleries, 1981).

203. William C. Agee and Barbara Rose, *Patrick Henry Bruce, American Modernist: A Catalogue Raisonné* (New York: Museum of Modern Art, 1979).

204. "Max Weber, 'The Futurist,' " *American Art News* 10 (February 17, 1912), 2

205. Dominic Ricciotti, "The Revolution in Urban Transport: Max Weber and Italian Futurism," *American Art Journal* 16 (Winter 1984), 46–64. As Ricciotti points out, Arthur Jerome Eddy's important study, *Cubists and Post-Impressionism*

(Chicago: A. C. McClurg, 1914), has a long section on Futurism with a number of illustrations.

206. For Weber's modernist paintings particularly, see Percy North, *Max Weber: American Modern* (New York: Jewish Museum, 1982), and, more recently, idem, *Max Weber: The Cubist Decade, 1910–1920* (Atlanta: High Museum of Art, 1991).

207. For Stella's stay in Paris, see his own "Discovery of America: Autobiographical Notes," *Art News* 35 (November 1960), 42, 64 (written in 1946).

208. Joseph Stella, "The New Art," *Trend* 5 (June 1913), 395.

209. Irma B. Jaffe, *Joseph Stella* (Cambridge: Harvard University Press, 1970); John I. H. Baur, *Joseph Stella* (New York: Praeger, 1971).

210. Stella, "Discovery of America," 64–65.

211. Barbara Haskell, *Arthur Dove* (San Francisco: San Francisco Museum of Art, 1974); Ann Lee Morgan, *Arthur Dove: Life and Work with a Catalogue Raisonné* (Newark: University of Delaware Press, 1984).

212. William Innes Homer, "Identifying Arthur Dove's 'The Ten Commandments,' " *American Art Journal* 12 (Summer 1980), 21–32.

213. Haskell, *Arthur Dove*, 26; Morgan, *Arthur Dove*, 46, 113.

214. Eddy, *Cubists and Post-Impressionism*, 48.

215. Constance Rourke, *Charles Sheeler: Artist in the American Tradition* (New York: Harcourt, Brace, 1938); Martin Friedman, *Charles Sheeler* (New York: Watson-Guptill, 1975); Carol Troyen and Erica E. Hirshler, *Charles Sheeler: Paintings and Drawings* (Boston: Museum of Fine Arts, 1987).

216. "Interview: Charles Sheeler Talks with Martin Friedman," *Archives of American Art Journal* 16, no. 4 (1976), 17.

217. John Driscoll, "Charles Sheeler's Early Work: Five Rediscovered Paintings," *Art Bulletin* 62 (March 1980), 124–33.

218. It has been suggested that the derivation here is from photographs that Sheeler made of the female nude at about the same time, rather than from a floral source, though this contradicts Sheeler's own title; the work was originally exhibited in 1920 as *Forms—Flowers*. See Troyen and Hirshler, *Charles Sheeler*, 76.

219. Charles Sheeler, "Autobiography," unfinished manuscript, c. 1937, Archives of American Art, Smithsonian Institution, Washington, D.C.

220. Martin L. Friedman, *The Precisionist View in American Art* (Minneapolis: Walker Art Center, 1960); Karin Tsujimoto, *Images of America: Precisionist Painting and Modern Photography* (Seattle: University of Washington Press, 1982).

221. Milton W. Brown, "Cubist-Realism: An American Style," *Marsyas* 3 (1943–45), 139–60.

222. Emily Farnham, *Charles Demuth: Behind a Laughing Mask* (Norman: University of Oklahoma Press, 1971); Alvord L. Eiseman, *Charles Demuth* (New York: Watson-Guptill, 1982); Barbara Haskell, *Charles Demuth* (New York: Whitney Museum of American Art, 1988).

223. "The European Art-Invasion," *Literary Digest*, November 27, 1915, 1225–26; Frederick MacMonnies, "French Artists Spur on an American Art," *New York Tribune*, October 24, 1915, sec. 4, 2–3.

224. John R. Lane, *Stuart Davis: Art and Art Theory* (New York:

Brooklyn Museum, 1978); Karen Wilkin, *Stuart Davis* (New York: Abbeville Press, 1987); Lowery S. Sims and William C. Agee, *Stuart Davis, American Painter* (New York: Metropolitan Museum of Art, 1991).

225. Diane Kelder, "Stuart Davis: Pragmatist of American Modernism," *Art Journal* 39 (Fall 1979), 31.

226. Quoted in Diane Kelder, ed., *Stuart Davis* (New York: Praeger, 1971), 41.

227. Quoted in James Johnson Sweeney, *Stuart Davis* (New York: Museum of Modern Art, 1945), 17.

228. Susan C. Larsen, "The Quest for an American Abstract Tradition, 1927–1944," in John R. Lane and Susan C. Larsen, *Abstract Painting and Sculpture in America 1927–1944* (Pittsburgh: Museum of Art, Carnegie Institute, 1983), 15–44.

Catalogue of the Exhibition

WITH COMMENTARIES BY

D. Scott Atkinson · Carole L. Shelby · Jochen Wierich

Samuel Finley Breese Morse
1791–1872

Samuel F. B. Morse's connections with France were long-standing. In 1825 he was awarded by the city of New York the most prestigious portrait commission of the decade: a full-length portrait of the Marquis de Lafayette (fig. 114), the revolutionary hero who had fought for the American cause of independence and had returned to the United States on a triumphal, sixteen-month tour in 1824. Morse visited France several times, and when he went to Paris at the age of seventy-five to see the Exposition Universelle in 1867, he was invited by Napoleon III to a fête at the Tuileries.

From the beginning of his career as a professional painter, portraiture was Morse's major source of income. After his first extended stay abroad, between 1811 and 1815, he was convinced that his future lay not in painting portraits but in elevating American history painting. Back in the United States, however, he spent much of his time as an itinerant portrait painter, traveling from New Hampshire to South Carolina in search of commissions. His first monumental history painting, *The Old House of Representatives*, 1822–23 (fig. 115), toured Boston and New York, but was largely ignored by the public.

Yet Morse was determined to improve the standard of American art. He participated in the founding of the National Academy of Design, the American institution devoted to the advancement of the arts, based on the principles of the Royal Academy in London, where Morse had studied during his first tour abroad. He was elected the first president of the National Academy in 1826 and remained in this influential position until 1845. Moreover, as a public lecturer Morse inspired sophisticated public discourse concerning art and taste. In his "Lectures on the Affinity of Painting with the Other Fine Arts" (1826), he delivered an intellectually demanding definition of the fine arts, described by one scholar as "a professional bill of rights that sanctioned elevated thought in art."[1]

1. Paul J. Staiti, *Samuel F. B. Morse* (Cambridge: Cambridge University Press, 1989), 172.

Fig. 114
Samuel F. B. Morse, *The Marquis de Lafayette*, 1826, oil on canvas. Collection of the City of New York, City Council Chamber, City Hall

By 1829 Morse had laid the theoretical groundwork for his second extended tour through Europe. When he entered the Louvre in January 1830, he was a self-confident, cultured American—an accomplished intellectual as well as draftsman. He copied thirty-eight masterpieces, dispersed throughout the Louvre, and reassembled them in his *Gallery of the Louvre.* In the tradition of gallery pictures, the "rehanging" of paintings in an imaginary display was a tried convention. By this method, Morse decided which of the Old World treasures were worthy of presentation to the New World public (fig. 116). In the painting Morse himself stands in the center of the Salon Carré, leaning over the shoulders of a student and offering his critique. However, the educational and art-political program unfolded in *Gallery of the Louvre* goes beyond Morse's individual efforts. By including the representative of the sister art—literature—in the personage of the American novelist James Fenimore Cooper, conversing with his wife and daughter in the left background, the intellectual appropriation of the old masters becomes a collective enterprise. Although the gentleman in the doorway to the Grande Galerie, gazing at an antique statue of *Diana,* has never been

identified, he may be the American sculptor Horatio Greenough, potentially the representative of the third sister art. Since Greenough had finished a portrait bust of his friend Morse in 1831, it is reasonable to speculate that Morse may have returned the favor when he finished the *Gallery of the Louvre* canvas back in the United States in 1833.

In *Gallery of the Louvre* Morse paid tribute to the treasure house of European art; yet, in his role as artist, collector, and instructor, he turned the Louvre into a democratic work space. He intended his version of the Salon Carré to be an educational vehicle that would refine taste and spark cultural awareness in America. However, the lack of public attention that the exhibition of this work received in the United States caused in Morse a lasting sense of disillusionment. Many years later, when he was already known as the inventor of the electromagnetic telegraph, Morse declared in a letter to his good friend Cooper that "painting has been a smiling mistress to many, but she has been a cruel jilt to me. I did not abandon her, she abandoned me."[2]—J. W.

2. Quoted in William Kloss, *Samuel F. B. Morse* (New York: Harry N. Abrams, 1988), 150.

Fig. 115
Samuel F. B. Morse, *Old House of Representatives,* 1822–23, oil on canvas. Corcoran Gallery of Art, Washington, D.C., Museum Purchase, 11.14

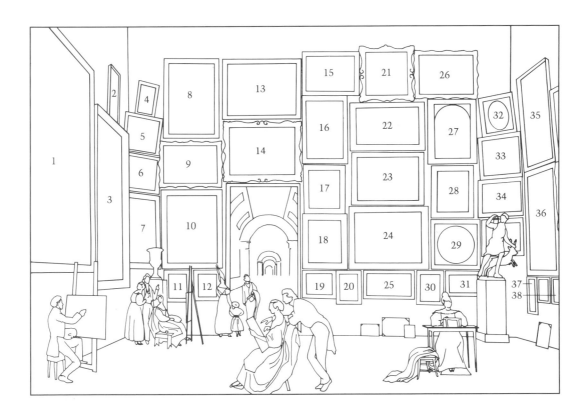

Fig. 116
Key to Samuel F. B. Morse's *Gallery of the Louvre*

1. Veronese, *The Marriage at Cana*
2. Murillo, *The Immaculate Conception*
3. Jouvenet, *The Descent from the Cross*
4. Tintoretto, *Self-Portrait*
5. Poussin, *The Deluge*
6. Caravaggio, *The Fortune Teller*
7. Titian, *The Crowning with Thorns*
8. Van Dyck, *Venus Entreating Vulcan*
9. Claude Lorrain, *The Landing of Cleopatra*
10. Murillo, *The Holy Family*
11. Teniers, the Younger, *The Knife Grinder*
12. Rembrandt, *Tobias and the Angel*
13. Poussin, *Diogenes Casting Away His Cup*
14. Titian, *The Supper at Emmaus*
15. Huysmans, *Landscape*
16. Van Dyck, *Portrait of a Lady and Her Daughter*
17. Titian, *Francis I, King of France*
18. Murillo, *A Beggar Boy*
19. Veronese, *Christ Fallen under the Cross*

20. Leonardo da Vinci, *The Mona Lisa*
21. Correggio, *Mystic Marriage of St. Catherine*
22. Rubens, *Flight of Lot and His Family from Sodom*
23. Claude Lorrain, *Sunset—View of a Seaport*
24. Titian, *The Entombment*
25. Le Sueur, *Christ Bearing the Cross*
26. Salvator Rosa, *Landscape with Soldiers and Hunters*
27. Raphael, *La Belle Jardinière*
28. Van Dyck, *Man Dressed in Black*
29. Guido Reni, *The Union of Design and Color*
30. Rubens, *Suzanne Fourment*
31. Simone Cantarini, *Rest on the Flight to Egypt*
32. Rembrandt, *Head of an Old Man*
33. Van Dyck, *The Woman Taken in Adultery*
34. Vernet, *A Marine View by Moonlight*
35. Guido Reni, *Dejanira and the Centaur Nessus*
36. Rubens, *Thomysris, Queen of the Massagetae*
37. Mignard, *Madonna and Child*
38. Watteau, *Embarkation for Cythera*

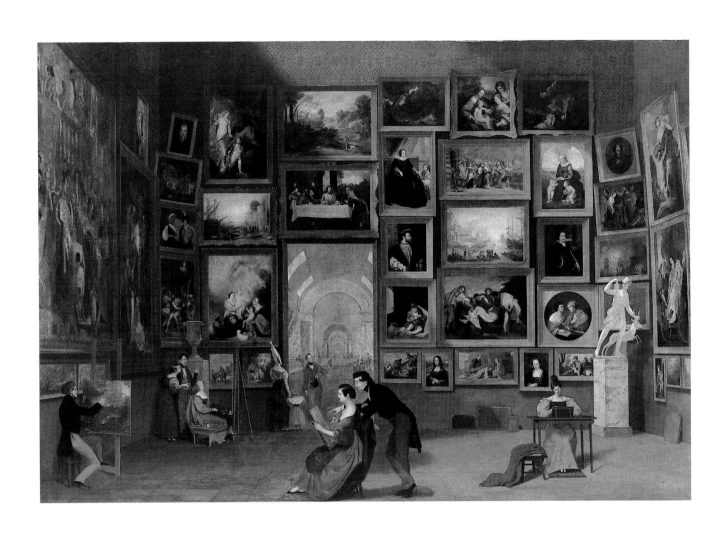

I
Gallery of the Louvre, 1831–33
Oil on canvas; 73¾ x 108 inches (187.4 x 274.3 cm)
Signed and dated bottom center: *SFBM / 1833*
Daniel J. Terra Collection, 9.1982

Theodore Robinson
1852–1896

Born in Irasburg, Vermont, the third of six children, and raised in Evansville, Wisconsin, Theodore Robinson began his artistic education in 1870 at the Chicago Academy of Design. His study was cut short by severe attacks of asthma, a malady that was to plague him all of his life, and after less than a year he returned to Evansville to recuperate. He was not able to resume his art education until 1874, when he enrolled at the National Academy of Design in New York. In 1876 Robinson traveled for the first time to France, where he studied in Paris with Carolus-Duran and Jean-Léon Gérôme. This trip included a stint in Venice, where he met James Abbott McNeill Whistler before returning to New York in late 1879. Robinson had by this time the training he needed to earn his living as an artist. In 1881 he began giving art classes, and though he disliked teaching he returned to it periodically as a reliable source of income. During the last half of 1881 he also began to assist first John La Farge, then Prentice Treadwell with their decorative mural commissions for various public and private buildings in New York. For the next few years he alternated between teaching and mural decoration, until he again traveled to France, in the spring of 1884.

Robinson spent most of the next eight years in France, with frequent trips back to the United States. Unlike many artists in the nineteenth century, he did not restrict his artistic investigations to Paris, slavishly imitating the academic tradition. Indeed, he spent less and less time in the capital, instead joining his compatriots Willard Metcalf, Birge Harrison, and Will Low at Barbizon and Grèz, artists' colonies where the tradition of painting en plein air had been established. In this environment the solidified forms of Robinson's academic training were challenged by a diffuse, Tonalist approach. It was during these years that Robinson began a search for a deeper, more intense way of looking at nature—a search that would lead beyond a superficial vision to an investigation of the subtle variegations of light, atmosphere, and color evident in even the most ordinary landscape. This search culminated in 1888 with his discovery of the Normandy village of Giverny, where Robinson's conversion to Impressionism began.

The rapidity of this conversion can be readily attributed to Robinson's direct contact with Giverny's most renowned resident, Claude Monet. Although Robinson was never formally his student, Monet had a profound influence on him as well as on the other American painters who had been gathering in Giverny since 1885. But unlike the others, Robinson established a close and lasting friendship with Monet. He eventually became a part of Monet's family circle, and the two artists corresponded until the end of Robinson's life.

Dating from Robinson's first years in Giverny, *From the Hill, Giverny* is an early example of a group of pictures that grew to encompass panoramic representations of the Seine River Valley. The strong diagonal established high in the picture plane by the hill and the horizon line is a typical feature in the foreground of the early Giverny landscapes. This scene depicts part of the village of Giverny nestled against the hillside above the Seine. The foliage of late spring or summer is rendered lushly in a predominantly green palette. The buildings of the village appear in the middle ground as a complex arrangement of rectangular patches of color.

The brushwork in *From the Hill, Giverny* exemplifies an ambivalence in Robinson's approach to Impressionism. On the one hand, his academic training would not allow him to abandon completely the solidity of form, which he builds up with layered Tonalist patches of color. On the other, his network of individual color dabs, applied in the foliage and distant trees, creates the diffused interplay of light and color characteristic of Impressionism. Robinson's aim was to tread a middle ground where the two seemingly disparate styles could cohabit. This picture demonstrates how he combined an academic approach with the new and freer mode of representation, resulting in a work uniquely his own.

Although part of the larger group of paintings representing Giverny from the hillside, *Winter Landscape* presents a slightly different vantage point. Here the structures of the village fill more of the picture plane. But it was the portrayal of this subject under the changing effects of weather and atmosphere, and not the subject itself, that sustained Robinson's interest.

2
From the Hill, Giverny, c. 1889
Oil on canvas; 15⅞ x 25⅞ inches (40.3 x 65.7 cm)
Terra Foundation for the Arts, Daniel J. Terra Collection, 1987.6

3
Winter Landscape, 1889
Oil on canvas; 18¼ x 22 inches (46.4 x 55.9 cm)
Signed and dated lower right: *TH ROBINSON / DEC. 1889*
Daniel J. Terra Collection, 34.1980

Representing a single subject at different times of year was a concept that was to engage Monet two years later in his paintings of haystacks. Robinson's interest in depicting Giverny in both summer and winter conditions may be attributable to his direct contact with the older painter.

The brushwork in *Winter Landscape* is drier and even more layered than in *From the Hill, Giverny*, painted earlier the same year. Robinson applied the pale hues of blue-lavender emerging from the cool gray of the sky along the high horizon so dryly that his brush left small bits of raw canvas exposed. The pigments blended as they were laid atop one another. The snow covering the land and the roofs of the village is rendered with opaque white strokes over the mauve earthen tones of the foreground.

Winter Landscape was exhibited extensively in the United States during Robinson's lifetime. It was shown in 1890 and 1891 at both the twelfth and thirteenth annual exhibitions of the Society of American Artists. At the 1890 exhibition it won the Webb Prize for the best landscape, and Robinson was awarded three hundred dollars. It appeared once again at the Society in the 1892 retrospective exhibition. It also had the distinction of being among the paintings exhibited in the Fine Arts Building at the 1893 Chicago World's Columbian Exposition.

From 1888 to 1892 Robinson moved between Paris and Giverny, visited Holland, and made a return trip to Italy. During these years he returned annually to New York for the spring exhibitions. In April 1891 he was in Giverny once again. It is likely that *Blossoms at Giverny* was executed that spring. Like the two hillside landscapes, Robinson has chosen an unusual point of view that bestows interest upon an otherwise ordinary scene. This picture is a fine example of Robinson's developed synthesis of Tonal ground, Impressionist brushstrokes, and linear structure. The scene is depicted from an unusually high vantage point, perhaps through a second-story window. The picture plane is filled with mottled patches of pink, mauve, lavender, and tan, overlaid with a tangled network of green and white dabs representing the leaves and blossoms. The framework created by the tree trunks and branches ties the painting together compositionally. A small girl followed by a woman carrying a watering can are visible walking along a diagonal path through the blossoming branches. They are solidly composed though blurred in detail, typical of

Robinson's figures in the early 1890s and consistent with his melding of academic Realism with the more Impressionistic French mode of representation.

Faintly visible in several areas are the lines of an underlying grid, indicating that this work may have been painted from a photographic study. Although there is no evidence of an existing photograph that might have served as the model for this particular picture, there are numerous examples where photographs and finished works are virtually identical, as in the painting *Gathering Plums*, 1891 (fig. 117), which is based on the photograph *Woman Picking Fruit* (fig. 118), which is squared for transfer to canvas. Lending further credibility to the speculation that Robinson painted this picture from a photograph, and that he made not one but two shots from the same vantage point in quick succession, is the existence of a similar painting of 1891 titled *In the Orchard* (fig. 119), which represents the same woman having made further progress down the diagonal path, the watering can now at her feet, and speaking with the

Fig. 117
Theodore Robinson, *Gathering Plums*, 1891, oil on canvas. Georgia Museum of Art, University of Georgia, Eva Underhill Holbrook Memorial Collection of American Art, Gift of Alfred H. Holbrook, 45.76

Fig. 118

Fig. 119

child who has turned toward her. There are numerous examples in Robinson's oeuvre where the solid forms, blurred detail, and dappled light evident in many photographs of the period are transferred to his paintings.

As with *Blossoms at Giverny*, in *Père Trognon and His Daughter at the Bridge*, Robinson depicts two residents of Giverny. The man mounted on the horse is identified in the title as Père Trognon and the woman must be Josephine Trognon, the figure that appears also in the paintings *At the Fountain* (fig. 120) and *The Watering Pots* (fig. 121), which Robinson had executed the summer before, where the woman is standing by, and sitting on, the cistern in the garden adjacent to Monet's home, wearing the same peasant costume depicted here. She has exchanged only her straw hat for the scarf. The reflective surface of the water, comprised of varying hues of lavender and green, is a thick impasto applied as heavy glazes over the picture plane. Using the same canvas dimensions, but turned vertically, Robinson depicted this combination of water foreground, equestrian figure, bridge, and architectural foil in *The Watering Place*, also of 1891 (fig. 122). Due to the reduced width of the picture plane, however, much of the bridge is lost and the figure of Josephine is absent all together.

Fig. 120

Fig. 121

Robinson was in Giverny for the last time
between May and December of 1892, during which
period he produced his best Giverny paintings,
depicting the rural charm of Normandy and the
inhabitants of Giverny. None did this more elegantly
than *The Wedding March.* This picture is one of the few by
Robinson that records a historical event; it documents
the betrothal of the American painter and Robinson's
close friend, Theodore Butler, to Monet's stepdaughter,
Suzanne Hoschedé, on July 20, 1892. Of this event
Robinson wrote in his diary: "The wedding party in
full dress—ceremony first at the mairie—then at the
church. Monet entering first with Suzanne, then Butler
and Mme. Hoschedé."[1] What Robinson has depicted is
the march from the mairie, the city hall pictured in the
upper right corner, where the civil ceremony was
performed, to the village church where the religious
vows took place. In the foreground appears Monet
escorting the veiled bride, followed by Alice Hoschedé,
Monet's second wife, escorted by the groom. The girl
between the couples may be another one of Madam
Hoschedé's daughters. Bathed in a warm light, no other

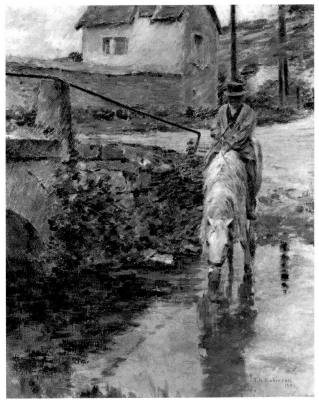

Fig. 122

1. Quoted in Sona Johnston, *Theodore Robinson, 1852–1896*
(Baltimore: Baltimore Museum of Art, 1973), 42.

4

Blossoms at Giverny, 1891–93
Oil on canvas; 21⅝ x 20⅛ inches (54.9 x 51.1 cm)
Daniel J. Terra Collection, 8.1984

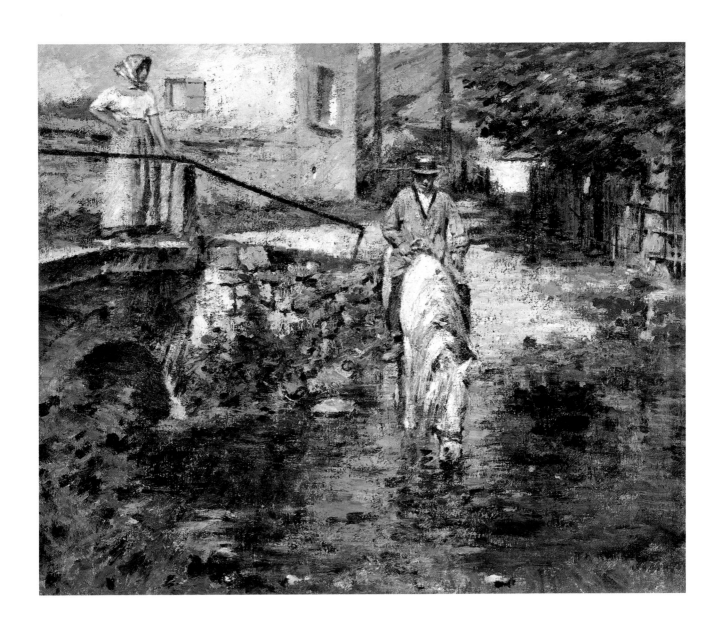

5

Père Trognon and His Daughter at the Bridge, 1891
Oil on canvas; 18¼ x 22⅟₁₆ inches (46.4 x 56.1 cm)
Signed and dated lower right: *Th. Robinson / 1891*
Terra Foundation for the Arts, Daniel J. Terra Collection, 1988.29

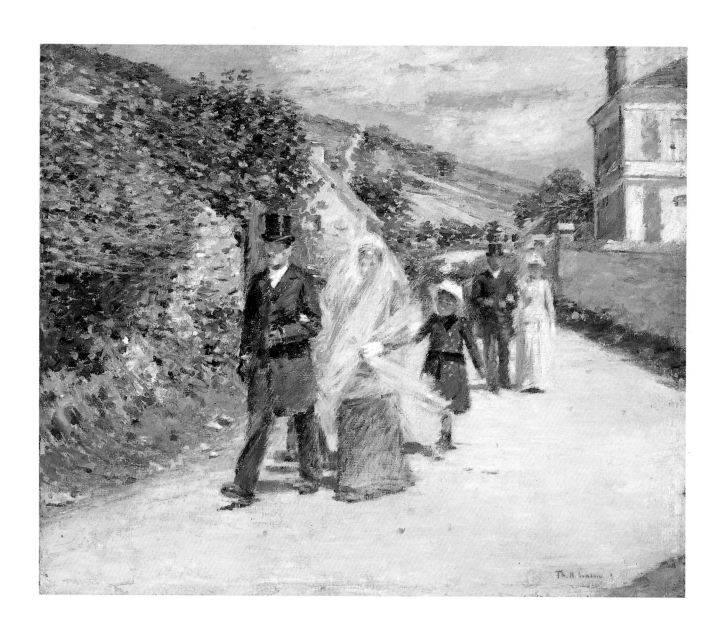

6
The Wedding March, 1892
Oil on canvas; 22⁵⁄₁₆ x 26½ inches (56.7 x 67.3 cm)
Signed lower right: *Th Robinson*
Daniel J. Terra Collection, 35.1980

painting by Robinson is more successful in capturing the spontaneous, transitory moment so evident in the paintings of his mentor, Monet.

The entry in Robinson's diary for August 5, 1892, reads: ". . . commenced my Wedding March my model being the groom's silk hat."[2] For one of the American artists at Giverny to marry into the first family of French Impressionists was an event of lasting consequence. Evidence of the profound impact this union had on Robinson is that he began painting from memory, with only a silk hat to serve as model, two weeks after the event. Implicit in *The Wedding March* is its confirmation that from 1892 on Giverny was an American artists' colony—and Robinson's painting records that fact. *The Wedding March* is Robinson's best-known work, the masterpiece that announced his fully mature style.

In the works Robinson executed during his last visit to Giverny, he successfully struck a balance between his academic training and the Impressionist theory that had always motivated his artistic explorations. *The Layette* exemplifies his attainment of this balance. This painting depicts Yvonne, a village resident, knitting baby clothes under the shade of a tree. This is Robinson's largest, and final treatment of this subject, which he had executed in two smaller versions in 1891. There is an existing photograph, also squared for transfer to canvas, that might have served as the study for this painting (fig. 123), but Robinson's diary entry for October 30 makes mention of working directly with Yvonne on the large version of *The Layette.*[3] Reminiscent of a Renaissance Madonna, the volume of the woman's form and full dress fill the central portion of the composition. Robinson placed his figure against a high garden wall and surrounded her with a burst of dappled foliage. The result is a formal figure study within an Impressionist setting—the response to both the artist's years of academic study and his long association with Claude Monet.

Valley of the Seine from Giverny Heights is one of three versions of this subject that Robinson produced simultaneously during the summer of 1892. The vantage point of all three, which he referred to as his "Vues de Vernon," is the hill above Giverny looking across the Seine to the village of Vernon. They differ only in atmospheric conditions—one view is under a gray, overcast sky while the other two are enveloped in

Fig. 123
Theodore Robinson, *The Layette*, c. 1892, cyanotype. Terra Foundation for the Arts, Gift of Ira Spanierman, 1985.1.2

sunlight. This is the sunlit version that Robinson, like Monet—who saw the series in mid September—preferred over the other two. Robinson's diary entry for September 15 states: "A call from the master [Monet] who saw my things—he liked best the 'Vue de Vernon'—the one I tho't nearest my ideal—he said it was the best landscape he had seen of mine—he liked the gray—the other sunlight one less."[4] This series of paintings grew from Robinson's earlier, more intimate views, such as *From the Hill, Giverny* and *Winter Landscape,* which depict the diagonal slope of the hillside. As its title implies, *Valley of the Seine from Giverny Heights* presents the panoramic expanse of the valley with the Seine running diagonally through the picture plane. Its large vision suggests that Robinson had, by 1892, felt confident enough with his abilities to portray a subject outside the familiar confines of Giverny.

2. Ibid.
3. Ibid., 49.

4. Ibid., 44.

7

8

7

The Layette, 1892
Oil on canvas; 58⅛ x 36¼ inches (147.6 x 92.1 cm)
Signed lower right: *Th. Robinson*
The Corcoran Gallery of Art, Washington, D.C., Museum Purchase

8

Valley of the Seine from Giverny Heights, 1892
Oil on canvas; 25⅞ x 32⅛ inches (65.7 x 79.1 cm)
The Corcoran Gallery of Art, Washington, D.C.,
Museum Purchase

When Robinson left France for the last time in December 1892, no American painter was more well versed in the tenets of Impressionism. Though in conflict with his early training and his strong inclination to draw the form, the more progressive trends of French art remained evident in his painting for the remainder of his life. He had only three years to live when he returned to the United States. His desire to apply the knowledge he had acquired during the years abroad to domestic subject matter led him to Napanoch, New York; Greenwich and Cos Cob, Connecticut; Princeton and Brielle, New Jersey; Philadelphia, Pennsylvania; and Townshend,

Vermont—alternately painting or teaching in these various locations. His health steadily declined during this time, culminating with a severe attack of asthma that claimed his life on April 2, 1896. Even though Robinson's career ended at the height of his powers, he had done more to secure acceptance of Impressionism in the United States than any other painter of his generation. His development as an artist runs parallel with the assimilation of the French style into the mainstream of American art. Robinson's paintings are testimony as to why he was considered America's leading Impressionist both during and after his lifetime.
—D. S. A.

Willard Leroy Metcalf
1858–1925

Willard Leroy Metcalf was born in Lowell, Massachusetts. In Boston at the age of seventeen he apprenticed to the landscape painter George Loring Brown. Brown, who had lived and worked most of his life in Europe, was best known for his Italian subjects painted in the manner of Claude Lorrain. Metcalf's artistic training remained traditional, and in 1876 he moved on to the School of the Museum of Fine Arts, Boston, where he took anatomical studies under William Rimmer. Yet this conservative background contributed to his early success in Boston, where he exhibited in 1880 with, among others, Winslow Homer, George Inness, and John La Farge. Through periods of his early and middle career, Metcalf worked as an illustrator for magazines. On an assignment for *Harper's Magazine* to illustrate an article on the Zuñi Indians, he went to the Southwest and lived in a Zuñi village for some months in the early 1880s. For the first time he painted under light conditions that were different than those of the East Coast.

In 1882 Metcalf sailed for Europe, and he enrolled at the Académie Julian in the fall of 1883. During the following summers Metcalf explored various regions outside of Paris and their prevalent modes of landscape painting. In 1884 he visited Pont-Aven, where many of his American painter-colleagues, such as the brothers Alexander and Birge Harrison, shared with Jules Bastien-Lepage a concern for integration of figure and landscape painting. The same year, and for longer parts of 1885, Metcalf was in Grèz-sur-Loing, painting in a friend's garden bordering the river bank. Like Theodore Robinson, who was then frequenting Grèz, Metcalf worked in a Barbizon mode, experimenting at the same time with the high-keyed palette of Impressionism. Yet another trip in 1885 brought Metcalf to Dieppe and its environs, most likely to meet John Twachtman with whom he shared an interest in Tonalism. Metcalf stayed briefly in Giverny in 1885 as indicated by the artist's record book of bird's egg finds, which he kept meticulously. In the spring of 1886 Metcalf apparently was invited for lunch at Monet's house. After returning from a trip to Africa, he stayed at Giverny through the summer of 1887 and was back in 1888.

While his earlier work was often concerned with genre painting taken to the out-of-doors, at Giverny Metcalf focused solely on the landscape. In *The River Epte, Giverny,* an on-the-spot study for the larger *Giverny,* Metcalf took advantage of the painterly freedom of Impressionism, using a loose, gestural brushstroke. The canvas ground is unevenly covered with paint and is visible at the fringes. Most likely in the studio, Metcalf transferred design and color values of this impression directly to the composition of *Giverny.* Though maintaining all the Impressionistic features of the study, Metcalf added an overall solidity in his second, more finished version. He accomplished this by rendering in sharper contours the areas where sunlight and shadow meet, as well as by lending more volume to the bridge, houses, and hillside.

Haystacks, representative of what has been called "his oblique approach to Impressionist practice,"[1] encapsulates Metcalf's synthesis of sunlight and shadow, high-keyed Impressionism and Barbizon tonal values. Compared to the tactile quality and broken color of Monet's later Haystack paintings (see figs. 40 and 41), Metcalf's haystacks are subdued in color and remain within the pastoral tradition of the Barbizon School. His *Haystacks* foreshadows the quiet and contemplative landscapes that Metcalf painted in New England as a member of the Ten American Painters, a group of that number of American Impressionists who in 1897 had split away from the Society of American Artists.—J. W.

1. Elizabeth deVeer and Richard J. Boyle, *Sunlight and Shadow: The Life and Art of Willard L. Metcalf* (New York: Abbeville Press, 1987) 201.

9
The River Epte, Giverny, 1887
Oil on canvas; 12¼ x 15⅞ inches (31.1 x 40.3 cm)
Estate stamp lower right
Terra Foundation for the Arts, Daniel J. Terra Collection, 1989.6

10

Giverny, 1887

Oil on canvas; 26 x 32⅛ inches (66.0 x 81.6 cm)

Signed and dated bottom center: *W. L. METCALF. 1887 GIVERNY*

University of Kentucky Art Museum, Lexington, Gift of the Estate of Addison M. Metcalf

11
Haystacks, c. 1888
Oil on canvas; 20⅛ x 24½ inches (51.1 x 62.2 cm)
Signed lower left: *W. L. METCALF*
Charles H. MacNider Museum, Mason City, Iowa

John Leslie Breck
1860–1899

John Leslie Breck was born aboard a clipper ship in the South Pacific on April 10, 1860. His father was a captain in the United States Navy, and Jack Breck, as the artist was always known, was educated in fine boarding schools in the Boston area. Breck's formal art training was typical of the emerging American Impressionist group; after initial study in the United States, he was sent to Europe to receive what was considered a traditional yet fashionable art education. In 1878 Breck enrolled in the Royal Academy in Munich, which was popular with Americans at the time, and over the next three years he mastered the innovations of the Munich School. Working with a limited range of dark colors, he developed a predilection for heavy impasto and energetic brushwork. On a second sojourn in Europe, Breck went to Paris, which was the undisputed art center of the Western world by the 1880s. He enrolled at the Académie Julian where he studied under Gustave Boulanger and Jules-Joseph Lefebvre. Rodolphe Julian's

Fig. 124
John Leslie Breck (seated in the foreground) in Claude Monet's garden at Giverny, c. 1889, photograph. Alice Hoschedé, later Monet's second wife, stands behind her three daughters, Blanche, Germaine, and Suzanne. At the right are Claude Monet, his son, Jean, and the American artist Henry Fitch Taylor. Courtesy Jean Marie Toulgouat, Giverny

studios, which were located throughout Paris, were less exclusive than the Ecole des Beaux-Arts but similarly emphasized traditional drawing and modeling.

In the summer of 1887 Breck was among a small band of artists who later considered themselves the "discoverers" of Giverny. Contemporary accounts differ on the details, and there is debate whether this initial group was aware that Claude Monet had become a permanent resident of the village four years earlier. Yet Breck's role seems clear: he was the most enthusiastic about sharing the discovery with other art students in Paris and was a catalyst for initiating a colony of American artists in Giverny.

In Breck's first years in the new art colony, he managed to have some direct contact with the reclusive Monet. In a photograph that most likely dates from 1889, he sits comfortably with Monet and his family within the Monet garden (fig. 124). And according to Breck's obituary, Monet is quoted as telling Breck, "Come down with me to Givetny [*sic*] and spend a few months, I wont' [*sic*] give you lessons, but we'll wander about the fields and woods and paint together."[1] Breck was primarily a Tonal landscape painter, but in the five years that he lived in close proximity to Monet, the undisputed master of the garden picture, he produced a number of dazzling, highly Impressionistic garden paintings. *Garden at Giverny (In Monet's Garden)*, c. 1887, and *Garden at Giverny*, c. 1890, are fine examples of Breck's new high-keyed, lusciously textured style. Alternating broad strokes of paint with feathery touches, he builds up the dense garden growth. It is likely that these paintings were in Breck's first one-person show, which took place in Boston at the St. Botolph Club in 1890. Although critical reaction was generally negative—the works being considered too radical—the garden paintings elicited excitement.

The River Epte, Giverny, painted in 1887 when Breck was still new to Giverny and just beginning as a landscapist, is the lyrical response of the awe-struck initiate. The Epte, a small branch of the Seine, was a favorite subject matter for the artists in the new colony.

1. *Boston Sunday Globe*, March 19, 1899.

While Breck's painting is primarily descriptive, the compositional elements are powerful and reflect his formal training. The river meanders from the background, fanning outward in a broad spatial effect and filling the width of the canvas. Cropped trees enframe the water and provide a firm diagonal structure. Using short, paint-laden brushstrokes, Breck built form; water, trees, and sky are constructed with regular blocks of dark, rich greens.

In *Yellow Fleur-de-Lis* Breck painted the small clump of yellow irises straight on—from the perspective of the other flowers growing in the garden. The composition is simple, appropriate to the extreme intimacy of the painting. Long, fluid brushstrokes of green are punctuated by patches of thick yellow impasto. The painting is inscribed "To my friend Robinson," referring, of course, to Theodore Robinson, another American expatriate working in the village. In 1888 Breck also painted a very large canvas, *Twilight* (location unknown),[2] depicting a great field of yellow irises, a subject that had also occupied Monet a year earlier (fig. 39).

Breck remained in Giverny through the winters of 1888 and 1889, when most of his American colleagues had returned to Paris. It was during this time that he painted *Autumn, Giverny (The New Moon)*. Breck's subdued palette in this work recalls the paintings of both the Munich School and the Barbizon artists who established a popular art colony in the 1840s outside the Forest of Fontainebleau. In the spirit of Jean-François Millet, the leader of the Barbizon School, Breck painted a muted, tonal landscape that incorporates an agrarian narrative. The work depicts the grand sweep of the Seine Valley with the hills of Giverny in the background. Breck used the large format because he intended the painting to be publicly exhibited. It was entered in the Paris Exposition Universelle of 1889, where it was a critical success and received an honorable mention.

Giverny Hillside of a year later is a more personal, intimate view of the village. While *Autumn, Giverny* portrays an early evening scene with a sliver of new moon rising, *Giverny Hillside* depicts an overcast afternoon. Inclement weather darkens the sky, and the wind blows leaves from the trees. Breck positioned himself on opposite sides of the Seine Valley to paint these two pictures. His enthusiasm for Giverny was well known, and all of his paintings included in this exhibition were either painted in Giverny or were inspired by his experiences in the village.

When Monet became angry over the romantic involvement between Breck and Blanche Hoschedé, Monet's stepdaughter, Breck no longer felt comfortable to remain in Giverny. The series *Studies of an Autumn Day* was painted in 1891 during his last summer in the village. Monet had begun work on his famous Grainstack series a year earlier (figs. 40 and 41), and Breck's series is unequivocally a tribute to the Impressionist master's innovative idea. Adopting his motif and the use of multiple canvases to record the metamorphosis of a single subject in changing light, Breck produced a series of fifteen works, twelve of which are in the present exhibition. Whereas Monet worked through his idea over years, and there is considerable variation in the spatial relationships from one canvas to the next, Breck's paintings have identical compositions and were all completed within a few days.

Studies of an Autumn Day appears to be set against an Eastern sky and represents the span from dawn to dusk. He used the haystacks as a vehicle to explore shadows, color, texture, atmosphere—and even light itself—at different hours of the day. In several of the paintings, Breck experimented with ever lengthening shadows. One painting in the series is especially radical in this regard; shadows take on the form of an opaque liquid, pouring over the stacks and spilling onto the ground. In others, there are subtle changes in the sky where clouds, colors, and mists intrude and evaporate. The large, monolithic haystacks become full, sensuous shapes as Breck reduced and simplified his compositions to an essential form.

After painting this series, Breck left Giverny for the last time. During the following year he traveled to England to spend time with his brother, Edward, visited California, and ended his travels by settling back in Boston. Although his painting *Morning Fog and Sun* is signed and dated 1892, when Breck had returned to the United States, it seems likely that it was begun in Giverny in the fall of 1891. Larger and more compositionally complex than the paintings in the *Studies of an Autumn Day* series, *Morning Fog and Sun* is a continuation of Breck's interest in the grainstack motif. Grainstacks, with their rich connection to the cycle of the seasons and their promise of sustenance, were popular subject matter in late nineteenth-century French painting. But more significantly, these paintings are unique in their testimony to the direct exposure to Monet that Breck experienced during the five years that he lived intermittently in Giverny.—C. L. S.

2. Illustrated in Kathryn Corbin, "John Leslie Breck, American Impressionist," *Antiques* 134 (November 1988), 1142.

12
Garden at Giverny (In Monet's Garden), c. 1887
Oil on canvas; 18⅛ x 21⅞ inches (46.0 x 55.6 cm)
Signed lower right: *JOHN LESLIE BRECK*
Terra Foundation for the Arts, Daniel J. Terra Collection, 1988.22

The River Epte, Giverny, c. 1887
Oil on canvas; 23⅞ x 44 inches (60.8 x 111.8 cm)
Terra Foundation for the Arts, Daniel J. Terra Collection, 1989.18

14

Yellow Fleur-de-Lis, 1888

Oil on canvas; 17⅞ x 21⅞ inches (45.4 x 55.6 cm)

Signed and dated lower left: *To my friend Robinson / John L. Breck '88*

Terra Foundation for the Arts, Daniel J. Terra Collection, 1989.2

15
Autumn, Giverny (The New Moon), 1889
Oil on canvas; 51½ x 85 inches (130.8 x 215.9 cm)
Signed and dated lower right: *John L Breck 1889 / JOHN LESLIE BRECK*
Terra Foundation for the Arts, Daniel J. Terra Collection, 1989.16

16
Giverny Hillside, 1890
Oil on canvas; 18¼ x 22 inches (46.4 x 55.9 cm)
Signed lower left: *BRECK*
Terra Foundation for the Arts, Daniel J. Terra Collection, 1987.10

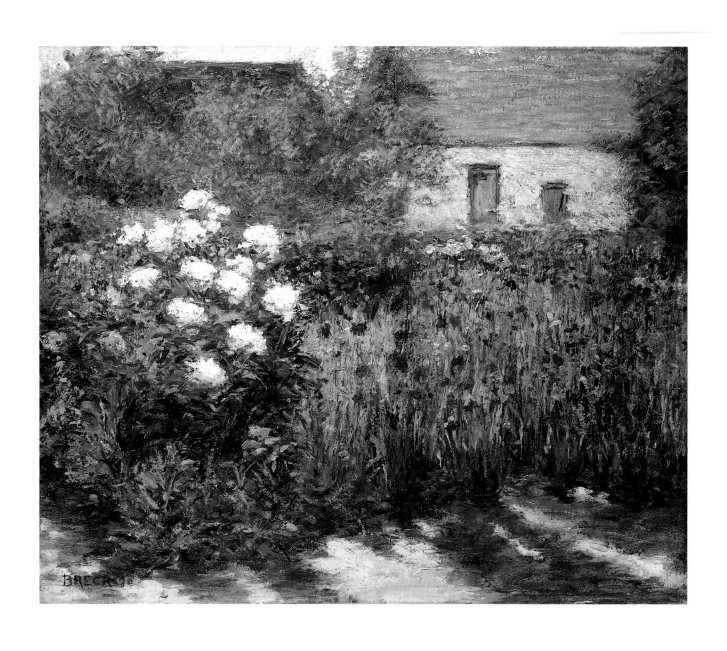

17
Garden at Giverny, c. 1890
Oil on canvas; 18 x 21⅞ inches (45.7 x 55.5 cm)
Signed lower left: *BRECK*
Daniel J. Terra Collection, 25.1987

5

6

3

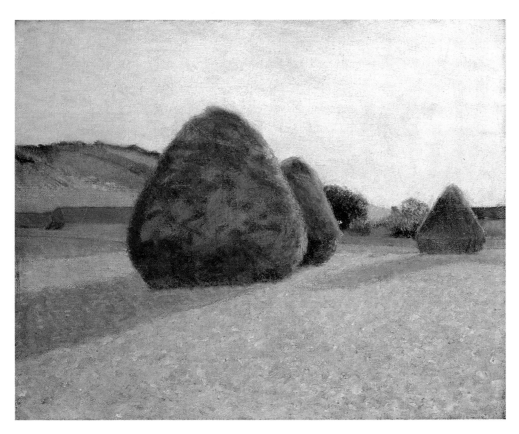

4

18
Studies of an Autumn Day, 1891
Oil on canvas, series of 12

1. 12⅞ x 16⅟₁₆ inches (32.7 x 40.8 cm)
2. 12⅞ x 16³⁄₁₆ inches (32.7 x 41.1 cm)
 Signed and dated lower right: *BRECK / 1891*
3. 12⅞ x 16⅟₁₆ inches (32.7 x 40.8 cm)
4. 12⅞ x 16¼ inches (32.7 x 41.3 cm)
5. 12⅞ x 16³⁄₁₆ inches (32.7 x 41.1 cm)
6. 12⅞ x 16³⁄₁₆ inches (32.7 x 41.2 cm)
7. 13³⁄₁₆ x 16³⁄₁₆ inches (33.5 x 41.1 cm)
8. 12⅞ x 16⅜ inches (32.7 x 41.5 cm)
9. 12⅞ x 16⅟₁₆ inches (32.7 x 40.8 cm)
10. 12⅞ x 16⅛ inches (32.7 x 41.0 cm)
11. 13⅟₁₆ x 16³⁄₁₆ inches (33.2 x 41.1 cm)
12. 13¼ x 16¼ inches (33.7 x 41.3 cm)
 Signed lower left: *JOHN LESLIE BRECK*

Terra Foundation for the Arts,
Daniel J. Terra Collection, 1989.4.1–12

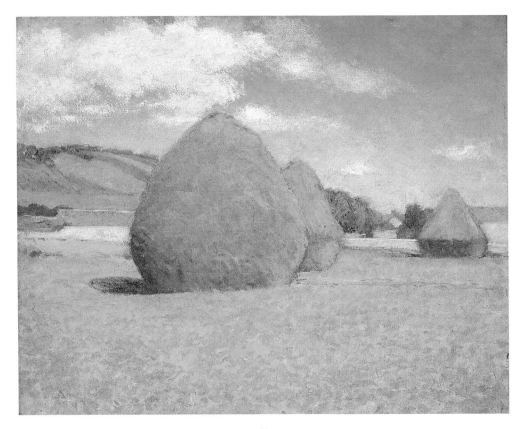

7

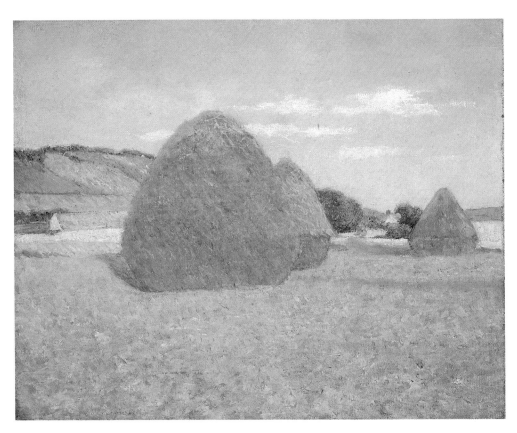

8

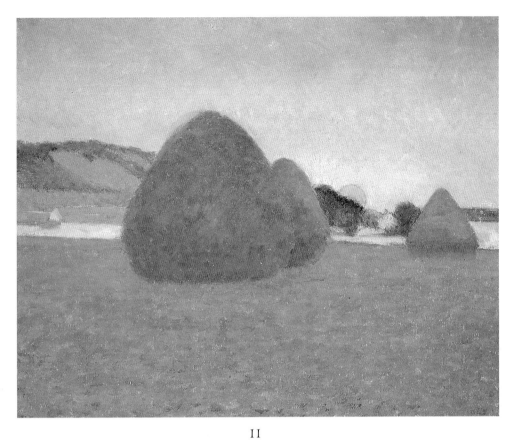

II

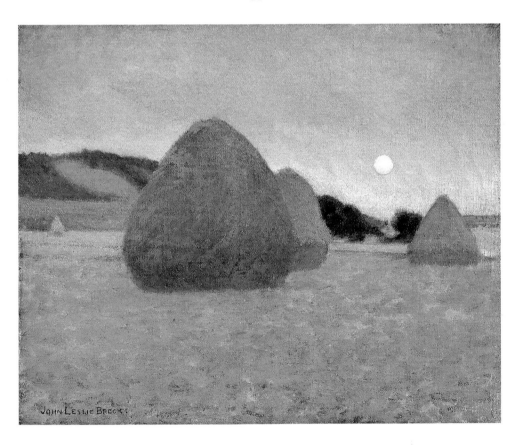

12

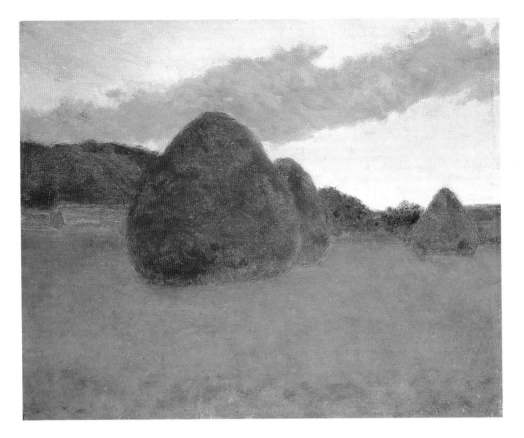

I

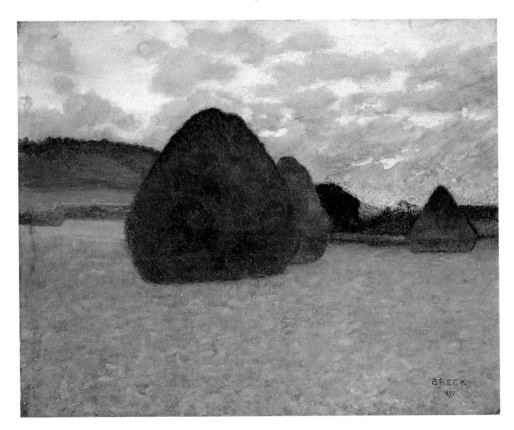

2

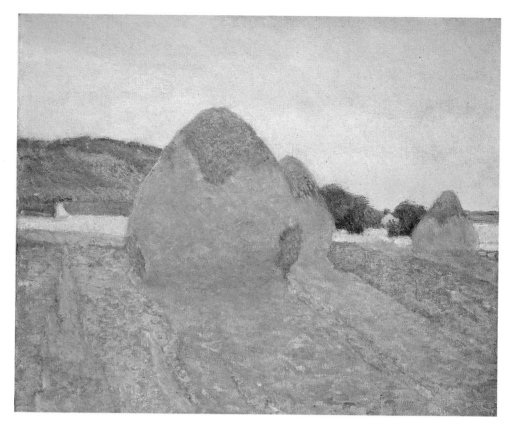

9

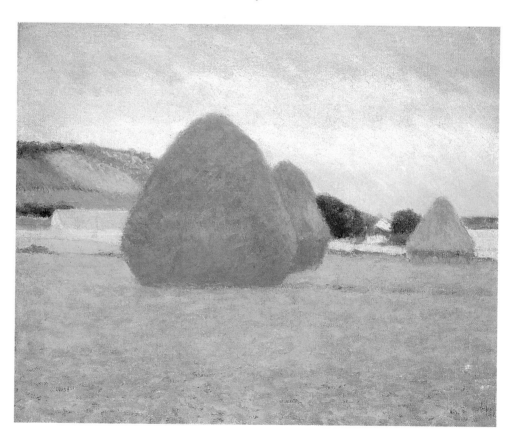

10

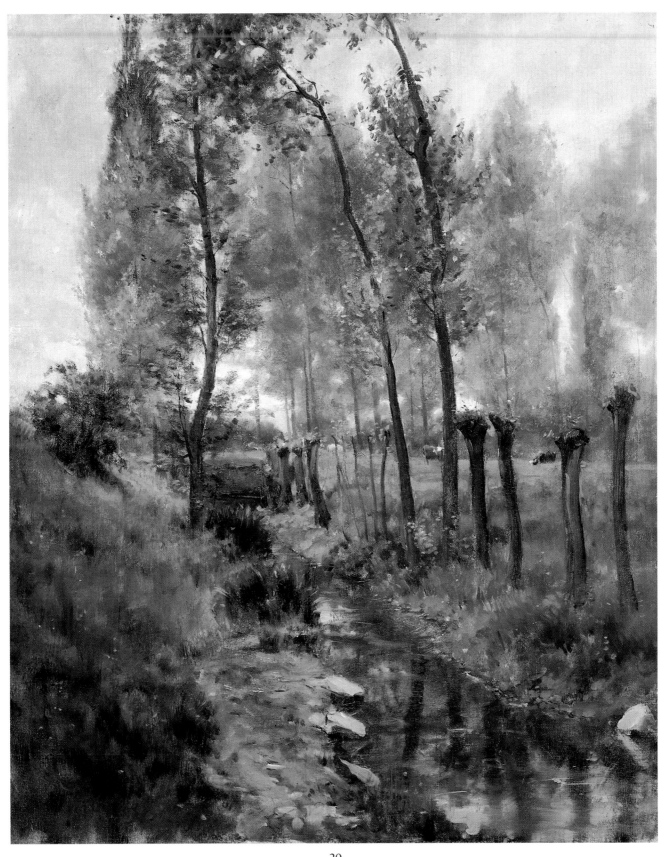

20

Willows and Stream, Giverny, 1887

Oil on canvas; 25⅞ x 21⅜ inches (65.7 x 54.3 cm)

Signed and dated lower left: *Louis Ritter 1887 / Giverny*

Daniel J. Terra Collection, 17.1986

Theodore Wendel
1859–1932

Theodore Wendel was born in Midway, Ohio, where his German-born father ran a general store. He received his first art training in Cincinnati. Together with his student friend Joseph De Camp he went to Munich, studied at the Royal Academy, and was introduced to the Cincinnati artist Frank Duveneck and his circle. In 1879 Wendel most likely joined the "Duveneck Boys," a group of artists who studied and painted with Duveneck, on a painting trip to Polling, outside Munich, but none of his works from this period have survived. He also followed Duveneck and his class to Florence and later to Venice, where he took up etching in addition to oil painting.

After a few years back in the United States, Wendel returned to Europe, possibly as early as 1885, and enrolled at the Académie Julian. During this crucial period in his career, he summered at Giverny in 1886 and 1887. In *Brook, Giverny* Wendel chose to paint a favorite motif of the American painters, to be found, for instance, in Louis Ritter's *Willows and Stream, Giverny* (colorplate 20) and in Willard Metcalf's *The River Epte, Giverny* (colorplate 9), both of which were painted in 1887, the same year as Wendel's version. Rather than depicting the Seine Valley from the surrounding hillside, scenes such as *Brook, Giverny* give a telescopic view of a meandering river and its verdant banks and meadows.

Since he is not reported to have been in Giverny in 1889, but definitely exhibited paintings of French subjects at the Society of American Artists in New York that year, Wendel probably signed and dated *Flowering Fields, Giverny* after his return to the United States. In it a field of poppies and other flowers is framed and rhythmically echoed by a horizontal band of trees, while the sky forms a neutral, unexpressive backdrop.

In the United States Wendel was a respected landscape painter who, after some years in Boston, settled with his wife in Ipswich, Massachusetts. After the initial efforts of Lilla Cabot Perry to familiarize the Boston public with the first generation of Giverny painters, Boston galleries readily exhibited their work. When Wendel and Theodore Robinson showed their paintings at the Williams & Everett Gallery in that city in 1892, it coincided with a large Monet exhibition at Boston's St. Botolph Club.—J. W.

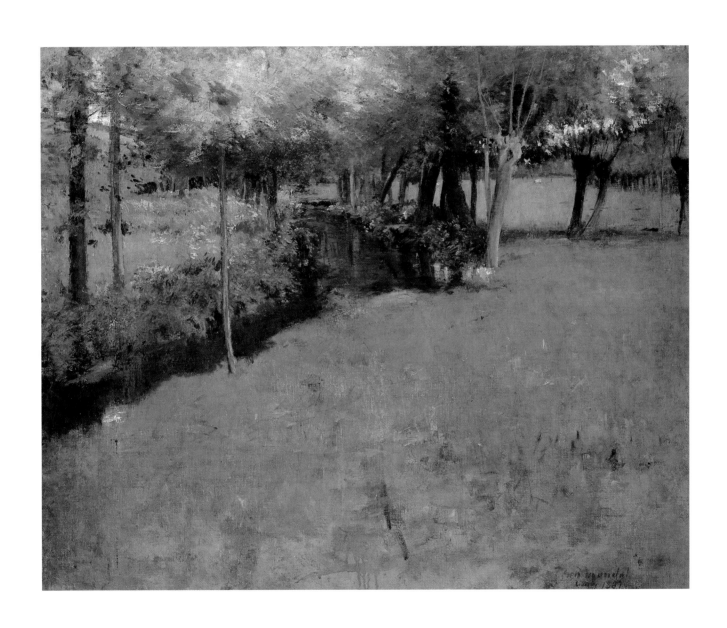

21
Brook, Giverny, 1887
Oil on canvas; 28½ x 35⅝ inches (72.4 x 90.5 cm)
Signed and dated lower right: *Theo Wendel / Giverny 1887*
Terra Foundation for the Arts, Daniel J. Terra Collection, 1987.13

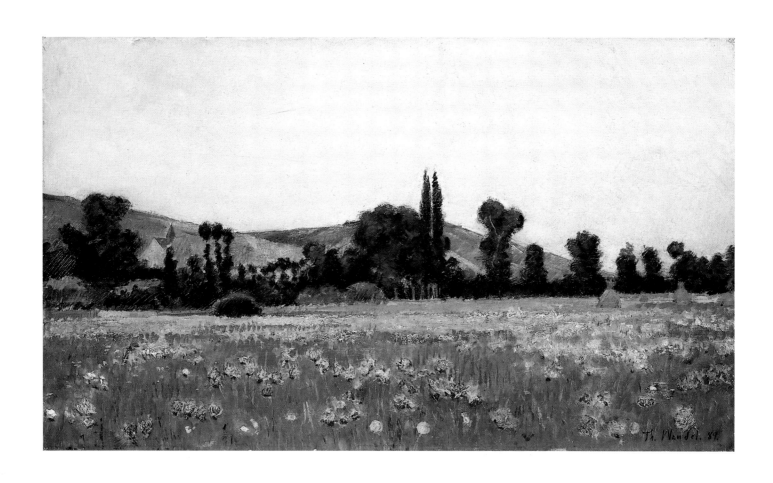

22

Flowering Fields, Giverny, c. 1887
Oil on canvas; 12½ x 21⅜ inches (31.7 x 54.9 cm)
Signed and dated lower right: *Th. Wendel. 89.*
Terra Foundation for the Arts, Daniel J. Terra Collection, 1988.11

Philip Leslie Hale
1865–1931

Philip Leslie Hale was a Boston-born artist, teacher, and critic. The Hales were a distinguished Boston family with artistic and literary inclinations for some generations. In accordance with family tradition, Hale first passed the entrance examination to Harvard before he started formal art education at the Boston Museum School. Around 1884 he moved to New York to study under Kenyon Cox and J. Alden Weir at the Art Students League. Along with his fellow student Theodore Butler, Hale arrived in Paris in 1887 and, following in the footsteps of Cox and Weir, he enrolled at the Ecole des Beaux-Arts. Together with Butler, he also received instruction at the Académie Julian. In the summer of 1888 Hale joined his American artist-colleagues in Giverny. He continued to visit the Norman village during four of the next five summers, developing a decidedly experimental Impressionist style.

The color spectrum in *Landscape with Figure*, painted during Hale's first visit to Giverny, is rather subdued, but the vigorous, hard, and precise brushstroke has a vibrant effect. He displays great freedom in dematerializing the figure of a woman washing clothes in the river, almost merging her with the landscape. In the 1890s Hale's outdoor scenes exposed the figure to a more shimmering and brilliant sunlight. He employed radical techniques of dissolving the figure, similar to the work of the Pointillists Georges Seurat and Paul Signac.

In Boston Hale taught at the Museum School. His late work included portraits, figure painting, and allegorical scenes, and his name became closely connected with the Boston art world of the early years of this century, which included his wife, the painter Lilian Westcott, and the Impressionists Frank Benson and Edmund Tarbell, his colleagues on the faculty of the Museum School.—J. W.

23
Landscape with Figure, 1888
Oil on panel; 10½ x 13¾ inches (26.7 x 34.9 cm)
Signed and dated lower left: *PHILIP HALE / GIVERNY 1888*
Terra Foundation for the Arts, Daniel J. Terra Collection, 1988.17

Dawson Dawson-Watson
1864–1939

Dawson Dawson-Watson was born in London to the English artist John Dawson-Watson and was tutored in England by the American expatriate artist Mark Fisher. In 1886 he arrived in the atelier of Emile-Auguste Carolus-Duran, which over the years had attracted numerous English and American artists to Paris, including John Singer Sargent and J. Carroll Beckwith. Studies with other French teachers in Paris followed. In 1888 Dawson-Watson exhibited at the Royal Academy, London, and in the same year his name appeared for the first time in the register of the Hôtel Baudy at Giverny. He had been encouraged to go to Giverny by John Leslie Breck, who had started summering there the previous year.

Giverny and *Giverny: Road Looking West toward Church* are representations of the village, its buildings and walls amplified by a glaring light. In the later of the two, *Road Looking West,* the plunging perspective is a dynamic spatial device, similar to William Lamb Picknell's *Road to Concarneau,* from 1880 (colorplate 58). Dawson-Watson treats the reflective pavement of the street with vigorous brushwork, building up a rich surface texture. The shadows, breaking wedgelike into the deeply receding street, add an abstract pattern of interlocking shapes.

Dawson-Watson first came to the United States in 1893, and stayed for most of the rest of his life, teaching and painting. He exhibited with the Society of American Artists in New York, as well as at major institutions such as the St. Botolph Club, Boston, the Art Institute of Chicago, and the St. Louis Art Museum.—J. W.

24
Giverny, 1888
Oil on canvas; 14¾ x 19½ inches (37.5 x 49.5 cm)
Signed and dated lower right: *DAWSON WATSON. / 1888.*
Daniel J. Terra Collection, 3.1991

25
Giverny: Road Looking West toward Church, c. 1890
Oil on canvas; 17⅜ x 32½ inches (44.2 x 82.6 cm)
Daniel J. Terra Collection, 4.1991

Theodore Earl Butler
1861–1936

Theodore Butler studied at the Art Students League in New York and at various academies in Paris. When he accompanied Theodore Wendel in May 1888 to the idyllic village of Giverny and registered in the guest book of the Hôtel Baudy, his name was one among a list of visiting Americans. Although for some years after his first arrival in Giverny he continued to be a summer visitor only and produced only a small number of Impressionist landscapes, no other American artist's life was to become so personally connected with Giverny and its eminent artist-citizen, Claude Monet. On July 20, 1892, the Ohio-born Butler married Monet's stepdaughter Suzanne Hoschedé. This momentous event in the history of American involvement with Giverny is recorded in Theodore Robinson's *Wedding March* (colorplate 6). Monet tended to discourage visiting or resident American artists from courting his stepdaughters, and he initially regarded Butler's relationship with Suzanne with strong reservations. However, over the years following the marriage Monet fully accepted Butler and grew to enjoy the American's presence in his family. Before they moved into a larger house in 1895, Butler and his wife lived in the Maison Baptiste, a cottage near Monet's estate. Suzanne gave birth to James (Jimmy) in 1893 and to Alice (Lili) the following year.

Beginning with his marriage, but especially with the birth of his children, Butler focused in his subject matter on domestic scenes, taking place indoors or in the garden. *The Artist's Children* obviously was painted in the winter, James and Lili being bundled in warm clothing. The composition is a stagelike interior consisting of rectangular shapes—doors, wall, and rug. Another play with geometric forms is the repetition of the circle in the round form of Lili and in the hoop that Jimmy holds in his left hand. Lili seems to pull toward the viewer, while Jimmy counterbalances her. Butler's palette here is comparable to that of Monet, whose work he closely studied, but the brushwork shows where Butler departs from his father-in-law. The impasto treatment of the rug

and other variations of brushwork have more in common with Paul Gauguin and the Nabis artists Pierre Bonnard and Edouard Vuillard.

After Lili's birth, Suzanne experienced a lingering illness, which led to her early death in 1899. In *The Card Players* (fig. 125), a domestic scene in Giverny painted a year before Suzanne's death, the artist's family is gathered around the card table. Suzanne has her back to the viewer; to her right her daughter Lili follows the card game; to her left sits her sister Marthe Hoschedé, who was attending the ailing Suzanne. The round is completed by Butler's friend and Giverny neighbor, the American painter William Howard Hart. *The Card Players* is a dynamic painting, its high-key palette applied in dashes and swirls of paint. In the background, undulating shapes, barely discernable as a curtain and the back of a chair or sofa, form an abstract pattern. Butler executed this vibrant composition with a van Gogh–like intensity. In his liberation of color in paintings such as *The Card Players*, Butler displayed a fervor that compares with and anticipates Henri Matisse and the Fauves.

Fig. 125
Theodore Earl Butler, *The Card Players,* 1898, oil on canvas. Daniel J. Terra Collection, 25.1985

26

The Artist's Children, James and Lili, 1896
Oil on canvas; 46 x 45½ inches (116.9 x 115.6 cm)
Signed and dated lower left: *T E Butler '96*
Terra Foundation for the Arts, Daniel J. Terra Collection, 1987.2

27
Late Afternoon at the Butler House, Giverny, c. 1907
Oil on canvas; 46⅞ x 46⅞ inches (118.0 x 118.0 cm)
Collection of Claire and Jean Marie Toulgouat, Giverny

Marthe Hoschedé, who took care of the two children after Suzanne's death, became Butler's second wife in October 1900. The Butler house in Giverny was the hub of social activity for a later generation of American artists and friends, who rented or bought houses instead of lodging at the Hôtel Baudy. The group portrait *Late Afternoon at the Butler House, Giverny* documents the carefree domestic life that the Franco-American community at Giverny enjoyed during the first decade of the new century. In the painting appear from left to right: Guy Rose, James Butler, an unidentified man, Lili Butler, Mrs. Rose, Edmund W. Greacen, Marthe Butler, and Mrs. Greacen. Rose, who had summered in Giverny in the 1890s, resided there with his wife from 1904 until 1912. The Greacens, after their arrival in 1907, rented a house for two years. Conventionally arranged as a group portrait, *Late Afternoon* is a "conversation piece" painted in an Impressionist mode. Butler astutely captured the social and artistic milieu of his Giverny home. While Mrs. Rose engages in a solitary game of cards, a universal leisure activity, Edmund Greacen is playing the banjo, a classic American instrument. In a self-consciously artistic manner, Butler included a still-life arrangement in the foreground and moreover depicted the faint reflection of his own head in the background mirror.

Butler continued to experiment with Fauve principles, using color as a decorative element, applied directly from the tube or mixed only with white. He painted numerous landscapes in the environs of Giverny and Vernon as well as on the Normandy coast, and exhibited in Paris and New York. The Butlers stayed in the United States during the First World War, not returning to Giverny until 1921—J.W.

Thomas Buford Meteyard
1865–1928

Thomas Buford Meteyard grew up in Chicago where his mother, widowed during the Civil War, was a school teacher. To be near her family Mrs. Meteyard moved back to Massachusetts, where her son went to school and then attended Harvard University. Meteyard took philosophy classes under William James and developed a friendship with the poet Bliss Carman, for whose books he would later produce woodcut illustrations. Throughout his life he maintained an affinity for literature and literary publications. Upon his arrival in England in 1888, he immersed himself in the literary and artistic milieu of the Aesthetic Movement, represented by Oscar Wilde and Edward Burne-Jones. In Paris, where he moved in December 1888, his sensibility for the new Post-Impressionist aesthetic, especially the Nabis artists, was reenforced by his social ties with the Norwegian painter and printmaker Edvard Munch, a regular visitor at the gatherings of the literary group centered around the poet Stéphane Mallarmé. From Meteyard's letters we know that he was an admirer of such stylistically diverse artists as Pierre Puvis de Chavannes and Claude Monet.

Beginning in 1890, until about 1893, Meteyard was a regular visitor to Giverny. In direct response to Monet's grainstack images and at the same time as John Leslie Breck's oil studies of grainstacks (colorplate 18), Meteyard painted a watercolor series of the same motif. He also produced a small series of nighttime paintings of Giverny, each apparently done at one sitting. In *Giverny, Moonlight*, Meteyard, in delineating the road, incorporates the curving decorative line of Art Nouveau design. The moonlight scene was an unusual subject among the Giverny painters. Breck made a similar effort on larger scale in his painting of twilight in *Autumn, Giverny (The New Moon)* (colorplate 15). Meteyard, through his penchant for book design, became an active force behind the *Courrier innocent*, a small magazine published by Giverny artists including Theodore Butler and Dawson Dawson-Watson.

Meteyard's work found recognition in France, the United States, and England, where he married and settled in 1910. His greatest triumph was probably the acceptance of his work to the second and third exhibitions of the Peintres Impressionistes et Symbolistes, where he was the only American among a select group of mostly French vanguard artists, including Pierre Bonnard, Maurice Denis, Paul Signac, Henri Toulouse-Lautrec, and Edouard Vuillard.—J. W.

28
Giverny, Moonlight, c. 1890
Oil on canvas; 12¾ x 16⅛ inches (32.4 x 41.0 cm)
Signed lower right: *T. B. Meteyard*
Terra Foundation for the Arts, Daniel J. Terra Collection., 1989.24

Lilla Cabot Perry
1848–1933

Growing up a member of the cultural elite in Boston prepared Lilla Cabot to live most of her early career abroad and to move with ease in the foremost European art circles. In 1874 she married Professor Thomas Sergeant Perry, a scholar of English literature and the grandnephew of Commodore Matthew C. Perry, the American naval officer renowned for opening Japan to the West. After some initial training at the Cowles Art School in Boston under the plein air painters Robert Vonnoh and Dennis Miller Bunker, Perry was almost forty years old and the mother of three young children when she enrolled in two Parisian art academies in 1887. A crucial point in her professional development came two years later when she met and established a lasting friendship with Claude Monet. For nine summers spread over more than twenty years, she and her family lived and worked in Giverny, helping to perpetuate a strong American presence in the art colony. By the 1890s her debt to Monet was unmistakable as she developed a loose compositional style using a high-keyed palette and broken brushwork. Like Mary Cassatt, Perry's enthusiasm for Impressionism was instrumental in introducing the new style to America. Besides promoting Monet's paintings among Boston art patrons, she held private showings for the Americans working in Giverny.

Perry's self-portrait demonstrates her rather reserved approach when she was painting indoors. This is a studio composition with a comparatively traditional spatial treatment. The figure exhibits the fine draftsmanship and strong modeling reflective of Perry's Boston and Paris training. At the same time, Perry transcends pure portraiture with the insertion of an ambiguous element. She often placed portrait subjects next to a window that incorporated a landscape vista, but in this painting the device is puzzling. Are we looking at a window or a picture on the wall? Are there symbolist connections attached to the standing figure? The "window" might suggest the illusion of depth, whereas the "painting within a painting" tends to flatten space.

In her treatment of the lavender smock, Perry's new interest in Impressionism is apparent. This is a decorative, almost optical passage painted with spontaneity and verve. The watery brilliance of the fabric contrasts with the more somber treatment of the background and face. Perry reveals herself as a complex personality. This is an intelligent, professional woman, natural and without pretensions, yet strong-spirited and possessing all of the decorum of her background. Perry enjoyed a solid reputation as a painter in her own time. *Self-Portrait* reflects that self-assurance.—C. L. S.

29
Self-Portrait, c. 1891
Oil on canvas; 31⅞ x 25⅝ inches (81.0 x 65.1 cm)
Signed upper right: *L. C. Perry*
Daniel J. Terra Collection, 13.1986

Guy Rose
1867–1925

Guy Rose was born into a pioneering California ranch family that had developed a large tract of land in the San Gabriel Valley in Southern California. After graduating from Los Angeles High School, Rose attended the California School of Design in San Francisco and worked under Emil Carlsen, a Danish-born artist who had studied in Paris. In the footsteps of Carlsen, Rose went to Paris in 1888 and enrolled at the Académie Julian, studying with Henri-Lucien Doucet, John Joseph Benjamin-Constant, and Jules-Joseph Lefebvre during the next three years. In 1890 two of his works were accepted at the Salon of the Société des Artistes Français, and in 1894 he was the first Californian to receive an honorable mention there.

His initial association with the Giverny colony began in 1890 with a six-month stay, followed by another visit in 1891, and terminated in 1894 when he contracted lead poisoning during a trip to Greece. *Giverny Hillside* dates from this first Giverny period and shows the influence of Theodore Robinson. The center of the composition is the gently sloping hillside of the Seine Valley, as depicted in Robinson's *Winter Landscape* (colorplate 3). Rose chose a perspective with smoother transitions, and his brushwork is more thinly applied than that of Robinson's works of the period.

Rose's illness was caused by the lead-based oil paints he used, and for some years he had to give up oil painting altogether, during which time he worked in New York as an illustrator. When he returned to live in Paris in 1899, he continued to work in illustration, and he also made trips to Algeria and Italy. In 1904 Rose bought a stone cottage in Giverny, where he lived until 1912. At Giverny he took up easel painting again. As a member of the so-called Giverny Group, he exhibited with Richard Emil Miller, Frederick Frieseke, and others in New York. Rose later taught at the Stickney Memorial School of Art in Pasadena and became an important figure in the dissemination of Impressionism in California.—J. W.

30
Giverny Hillside, 1890–95
Oil on panel; 12⁷⁄₁₆ x 16⅛ inches (31.6 x 41.0 cm)
Inscribed on back: *Guy Rose / 157 Fbg St Honoré 19* [illegible] */ Paris*
Terra Foundation for the Arts, Daniel J. Terra Collection, 1992.2

Mary Fairchild MacMonnies Low
1858–1946

Mary Louise Fairchild was born in New Haven, Connecticut, and received her formal art education in St. Louis. A three-year scholarship to study abroad allowed her to go to Paris in 1885. Women artists were not admitted to the prestigious Ecole des Beaux-Arts until 1896, and so Fairchild enrolled at the Académie Julian, which charged women double tuition and taught them in separate classes. She exhibited at the Salon of 1886, that summer painted landscapes in the Picardy with Harry Thompson, an English painter of the Barbizon School, and in 1888 began to study in the studio of Emile-Auguste Carolus-Duran. Also in 1888 Fairchild married the American sculptor Frederick MacMonnies, with whom she had been sharing a Paris studio. With the commission to paint one of two murals for the Woman's Building at the Columbian Exposition in Chicago, 1893, Mary MacMonnies received extraordinary recognition in the United States. She painted a semi-elliptical mural depicting *Primitive Woman*, which was the companion piece to Mary Cassatt's *Modern Woman* (both unlocated).

Although Mary and Frederick MacMonnies were first in Giverny for several short stays in 1890, it wasn't until the summer of 1894, when they rented the Villa Bêsche, that they stayed for any length of time. The MacMonnies summered at Giverny until 1898, when they moved permanently into an old priory there, which was named Le Moutier, but called "MacMonastery" by their friends.[1]

The studio location of *Dans la nursery* and *C'est la fête à bébé* could be either in the Villa Bêsche or in the old monastery. At both residences servants were part of the household and, as depicted in *Dans la nursery*, tended their daughter, Berthe. The bay window in *Dans la nursery* is of a type seen in many Giverny studios of the time. *Dans la nursery* and *C'est la fête à bébé* form a pair to which a third painting, titled *La Repriseuse* (private collection), adds another perspective.[2] This image focuses on the darning *gouvernante* in the left foreground of the room and shows Berthe standing next to her.

Mary MacMonnies clearly made Berthe the center of attention in *C'est la fête à bébé*, which may have been painted on the occasion of Berthe's birthday, and the toys would then be her presents. In *Dans la nursery*, however, she not only depicts Berthe's smallness in relation to the room, but also affirms her own role as painter. The easel, on which the painting *C'est la fête à bébé* or a similar work rests, is a powerful emblem of the artist's presence. Reference to the room's function as a studio is also made by the inclusion of the wall decoration of tapestry and panels, which resemble mural studies in the mode of Pierre Puvis de Chavannes. Since Mary MacMonnies continued her professional career as artist during motherhood, her household nursery and studio were by necessity the same room.

Though of humble appearance, the former monastery in Giverny was the size of an estate, including a barn for a sculpture and painting studio, cottages, and gardens. The classic setting for Giverny painters was the garden. The MacMonnies' cultivated the garden around the former monastery and used it for painting en plein air. Few other artists in Giverny had access to an estate of this size, stretching in terraced gardens, orchards, and cultivated acreage below the manor house, as can be seen in *Blossoming Time*. The painting gives a panoramic view of the property, including two figures apparently engaged in

1. Robert Judson Clark, "Frederick MacMonnies and the Princeton Battle Monument," *Record of the Art Museum, Princeton University* 43, no. 2 (1984), 16.

2. Illustrated in E. Adina Gordon, *Frederick William MacMonnies (1863–1937), Mary Fairchild MacMonnies (1858–1946), deux artistes américains à Giverny* (Vernon: Musée Municipal A.-G. Poulain, 1988), 91, 92.

work. Mary MacMonnies' outdoor scenes are of sunlit spaces rendered in a high-keyed palette. Yet unlike Theodore Robinson's *Blossoms at Giverny* (colorplate 4), in which the blossoms become dashes of white paint, MacMonnies delineates forms and contours in *Blossoming Time.*

MacMonnies observed the changing scene around her domicile during the seasons. Her mastery in painting a brilliant winter light reflected on snow is apparent in *Un coin de parc par temps de neige (A Section of the Grounds during Snowy Weather)*. She chose a perspective looking from her house into her garden but also outside of it toward the hill. A visual axis formed by two sculptures leads the eye beyond the garden terrain, which is confined by a wall and large trees, casting their shadows on the snow. The larger sculpture in the center is a depiction of Frederick MacMonnies' bronze fountain figure of *Pan,* which he made in 1889–90 for the summer house of a New York banker.[3]

Mary MacMonnies' association with Giverny and Le Moutier lasted only a few more years. After her divorce from Frederick in 1908, she married her admirer of long standing, the muralist and writer Will Low, and returned with him to America in 1909.—J. W.

3. Illustrated in Clark, "Frederick MacMonnies and the Princeton Battle Monument," 9.

31

32

31
Dans la nursery (Painting Atelier at Giverny), 1897–98
Oil on canvas; 32 x 17 inches (81.3 x 43.2 cm)
Daniel J. Terra Collection, 3.1987

32
C'est la fête à bébé (Baby Berthe in High Chair with Toys), 1897–98
Oil on canvas; 15 ⅛ x 18 ¼ inches (38.4 x 46.4 cm)
Daniel J. Terra Collection, 1.1987

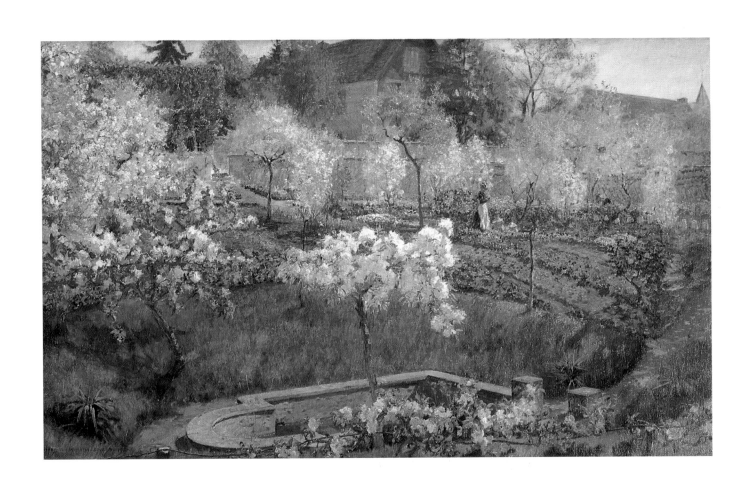

33
Blossoming Time, 1901
Oil on canvas; 39 x 64 inches (99.1 x 162.6 cm)
Signed lower left: *Mary MacMonnies, Giverny*
Union League Club of Chicago

34
Un coin de parc par temps de neige, before 1904
Oil on canvas; 38⅜ x 64½ inches (97 x 165 cm)
Signed lower right: *MARY MACMONNIES*
Musée Municipal A.-G. Poulain, Vernon (Section artistes de Giverny)

Frederick Carl Frieseke
1874–1939

At the age of twenty-four Frederick Frieseke became a permanent expatriate in France, a decision he justified "because I am more free and there are not the Puritanical restrictions which prevail in America."[1] Frieseke was born in Owosso, Michigan, in 1874 and studied briefly at the Art Institute of Chicago and the Art Students League in New York before sailing for Europe. In Paris he enrolled in the Académie Julian, studying under Benjamin Constant and Jean-Paul Laurens. Beginning in 1900 and throughout World War I, Frieseke spent his summers in Giverny, where he was considered the center of a group of American "figural Impressionists" who worked in the art colony. Their subject matter focused almost exclusively on the female figure—clothed or nude, in the boudoir or en plein air—without allegorical reference and often incorporating a subtle sensuality. Frieseke's preference for portraying the full-bodied female figure aligns his aesthetic most closely with Pierre Auguste Renoir among the French Impressionists. During his Giverny period, Frieseke achieved significant acclaim and received numerous awards in both Europe and America. He continued to live in France, but he maintained ties with American dealers and museums. His most notable success in the United States came in 1915 when he was awarded the grand prize at the Panama-Pacific International Exposition in San Francisco.

In 1898, the year that Frieseke first arrived in Paris, James Abbott McNeill Whistler had opened the Académie Carmen for art students in Paris. Although specific study has not been documented, Frieseke admitted to a brief period of working under Whistler's influence. This influence is apparent in the fluid brushwork, muted Tonal passages, and flat, minimal modeling of *The Green Sash*. Like Whistler, Frieseke was drawn to things Oriental. The sensuous line of the figure and the asymmetrical background suggest knowledge of Japanese prints.

In 1905 Frieseke married Sarah O'Bryan of Philadelphia, and the couple soon thereafter leased a house immediately adjacent to the Monet property in Giverny. In Paris, Frieseke had worked inside a studio; by 1912 he was painting out-of-doors, in his own sun-filled Giverny garden depicted in *Lady in a Garden*. This is Frieseke's work at its finest. The painting incorporates the brilliant, saturated colors and vigorous brushwork of the Impressionists with the intense decorative patterning and flattened perspective associated with the French Nabis painters Pierre Bonnard and Edouard Vuillard. Although the woman in this garden setting is most likely Frieseke's wife, the work is neither portraiture nor landscape. It is an ornamental painting, unusual for Frieseke because it approaches abstraction. Unlike Claude Monet, who personally developed his own lush gardens expressly for the purpose of painting them, Frieseke was not a gardener. He did not know the names of flowers or paint them for themselves, but used them as elements of design. In *Lady in a Garden* Frieseke creates a vertical rhythm that completely incorporates the figure within the organic growth of the garden.

Frieseke's house with its charming latticework functioned as a decorative backdrop for many paintings

1. Clara T. MacChesney, "Frieseke Tells Some of the Secrets of His Art," *New York Sunday Times,* June 7, 1914, sec. 6, 7.

35
The Green Sash, 1904
Oil on canvas; 46 x 32 inches (116.9 x 81.3 cm)
Signed and dated lower left: *F. C. Frieseke / Paris 04*
Daniel J. Terra Collection, 24.1983

35

36

37

36
Lady in a Garden, c. 1912
Oil on canvas; 31⅞ x 25¾ inches (81.0 x 65.4 cm)
Signed lower left: *F. C. Frieseke*
Daniel J. Terra Collection, 1.1982

37
Lilies, n.d.
Oil on canvas; 25¾ x 32⅛ inches (65.4 x 81.6 cm)
Signed lower right: *F. C. Frieseke-*
Daniel J. Terra Collection, 37.1986

throughout his Giverny period. The garden and facade of the house, with its brightly colored shutters, are especially well depicted in *Lilies*. With an unusual placement of figures and furniture in a friezelike alignment within a diagonal spatial field, Frieseke achieves a lively and vital composition. The painting reflects a snapshot quality of unposed figures, a delight in the beauty of specific time and place. Consistently across the surface of the painting, there are areas where the rust-colored, primed canvas is exposed. Superimposing this with a variety of thickly painted greens, Frieseke reveals his tendency to unify the whole with a dominant color. The fact that the title suggests a still life is appropriate. This is a painting about design of chairs, arrangements of flowers, fabric against foliage.

Tea Time in a Giverny Garden is painted from almost the identical viewpoint as *Lilies,* and depicts the same garden furniture, which is shown in a photograph from 1913 (fig. 126). In the painting, Frieseke is as interested in mood and his vision of feminine psychology as he is in the formal elements of design. Many paintings of this era place women within the intimacy of a domestic arena. Sarah Frieseke here engages in two activities that are highly symbolic of her limited feminine role, sewing and taking tea. Sheltered and secluded under her helmetlike hat, she appears demure and introspective, removed from harsh realities. In subject matter and composition, *Tea Time in a Giverny Garden* recalls the work of Mary Cassatt. Frieseke was of course aware that the middle class at leisure was appropriated as "modern" imagery by the Impressionists. In the traditional art world, such intimate views were considered unacceptable subject matter, and therefore they appealed to progressive artists.

In contrast to the light-filled garden paintings, *Unraveling Silk,* an indoor view, has a more synthetic character, demonstrating another dimension to Frieseke's technique. While preserving the decorative, abstract aspect of his style, he adds a new structural intent. Marcelle, one of Frieseke's favorite models, becomes an almost archaic form: solid, simply constructed, a pyramidal shape that fills the canvas. A spatial grid of rectangles and squares is repeated in the wallpaper and in the French *boiserie* below. Even the wicker chair operates as a geometric framing device for the frontally placed figure. The basket balances awkwardly on the woman's lap, spilling the yarn forward and closer to the picture plane. Frieseke is taking advantage of the confines of interior space to explore the formality of arrangements and relationships.—C. L. S.

Fig. 126
Mr. and Mrs. Frederick Frieseke with Mrs. Hally-Smith (on the left), Giverny, 1913, photograph.
Courtesy Nicholas Kilmer

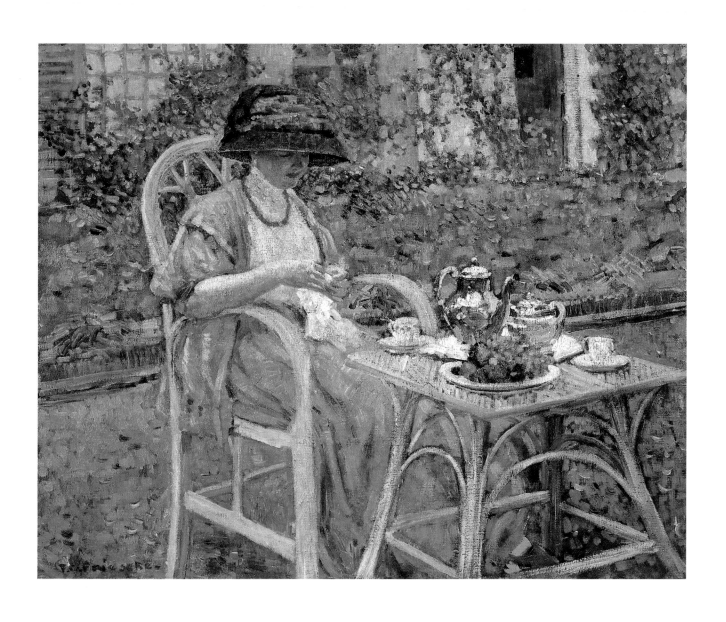

38

Tea Time in a Giverny Garden, n.d.
Oil on canvas; 26 x 32⅚₆ inches (66.1 x 82.1 cm)
Signed lower left: *F. C. Frieseke-*
Terra Foundation for the Arts, Daniel J. Terra Collection, 1987.21

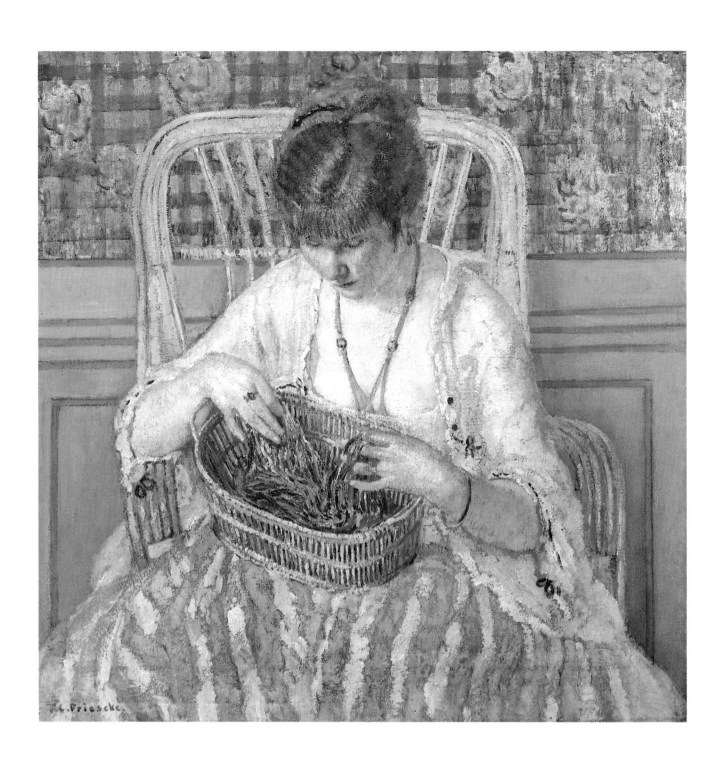

39
Unraveling Silk, c. 1915
Oil on canvas; 32¼ x 32⅜ inches (81.9 x 82.2 cm)
Signed lower left: *F. C. Frieseke*
Daniel J. Terra Collection, I.1981

Richard Emil Miller
1875–1943

The midwesterner Richard Emil Miller had a solidly academic art training. Born and raised in St. Louis, Missouri, he began his art studies with five years at the St. Louis School of Fine Arts. In 1898 he received the school's first scholarship to study in France. With relative ease, Miller became fully integrated into the American expatriate group in Paris. He studied under the French artists Jean-Paul Laurens and Benjamin Constant at the Académie Julian. Beginning in 1900 Miller successfully entered his paintings in the annual Paris Salons. In subsequent years he was awarded Salon medals and other prizes, and in 1906 he received the coveted French Legion of Honor. The French government purchased several of his Salon entries for the Palais du Luxembourg, where works by living artists were exhibited.

In 1905 Miller began working in St. Jean du Doigt (Brittany) and especially in Giverny (Normandy), both summer art colonies. He became a respected instructor, teaching at the Académie Colarossi in Paris during the school year and holding summer classes in these provincial villages. Included among the pupils at his outdoor classes were women from Mary Wheeler's Providence, Rhode Island, school. Miller became closely associated with Frederick Frieseke and other American expatriates who were developing a style that has been labeled "Decorative Impressionism."[1] Miller worked with a conscious concern for patterning and an emphasis on the two-dimensional surface that went beyond traditional Impressionism. Like Frieseke, Miller's preferred subject matter was consistently the female figure, nude or clothed, most often placed in an intimate, luxurious interior. Even when Miller's boudoir or landscape backgrounds are enlivened with voluptuous color and loose brushwork, his treatment of the figure remains firm and classically drawn.

Café de nuit is one of a series of nighttime scenes on the boulevards of Paris that Miller painted around 1906. The café was an important motif for French Impressionists and Post-Impressionists. Along with music halls, cafés dansants, and circuses, the café represented modernity, a convivial center for new notions of leisure. Because it was not considered respectable at this time for a woman without proper escort to frequent the evening pleasure places, this is a scene from the demimonde. The courtesans fulfill our expectations: they are beautiful, contemporary women whose charms include an unclassifiable air. The introspective, oddly idle woman in the foreground is an interesting counterpoint to the gay fin de siècle mood of the painting. There is a suggestion of untold narrative and unanswered questions. It is a public café, but the woman in black is immersed in private thought.

Café de nuit is arresting for its pure, sensual beauty, but it also demonstrates Miller's careful attention to formal elements. Utilizing a dynamic diagonal and cropped composition, Miller arranges his figures into three groupings, each a passage offered separately. And in a nice balance to the bouffant dresses and elaborate hats of the women, there is a strong geometry repeated throughout the painting—smooth, round tabletops, oval chairbacks, rectangles in the flower stall. Revealing a debt to James Abbott McNeill Whistler in his handling of the black gown, Miller creates a palpable sense of sheer fabric with a remarkable economy of brushwork.

The Pool, which is less provocative, both psychologically and pictorially, than *Café de nuit*, was painted several years later and is typical of Miller's Giverny style. In obvious contrast to the smooth, traditional rendering of the face and neck of the figure, the garden is a flat plane of variegated color, a tapestry of short, dense brushstrokes. Miller, a noted colorist, particularly favored green. In *The Pool* he juxtaposes a seemingly endless range of green hues using a lively mix of brushwork. This is plein air painting, but there is a cloistered atmosphere; the woman is confined to a beautiful but limited world. The fact that she sits by an opaque pool, which functions as a mirror, reinforces the notions of self-reflection and inner awareness.—C. L. S.

1. William H. Gerdts, *American Impressionism* (Seattle: Henry Art Gallery, University of Washington, 1980), 87.

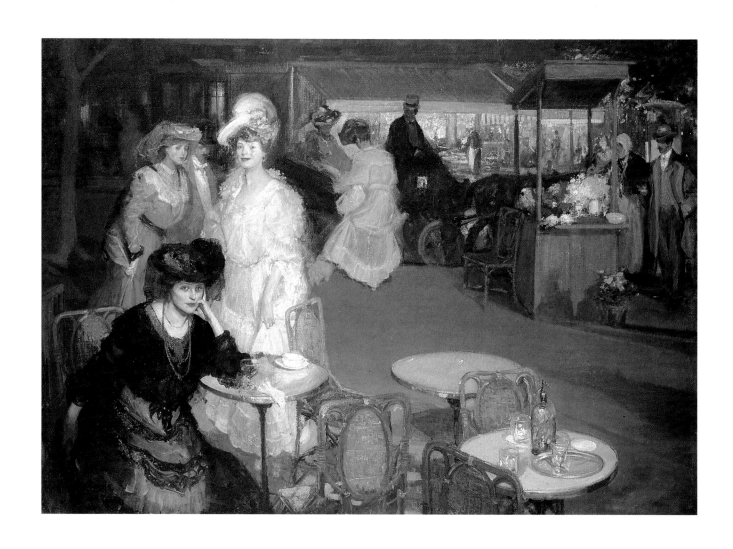

40

Café de nuit (L'Heure de l'apéritif), 1906 (?)
Oil on canvas, 48½ x 67⅜ inches (123.2 x 171.1 cm)
Signed and dated left center: *Miller*/ [date illegible]
Daniel J. Terra Collection, 39.1985

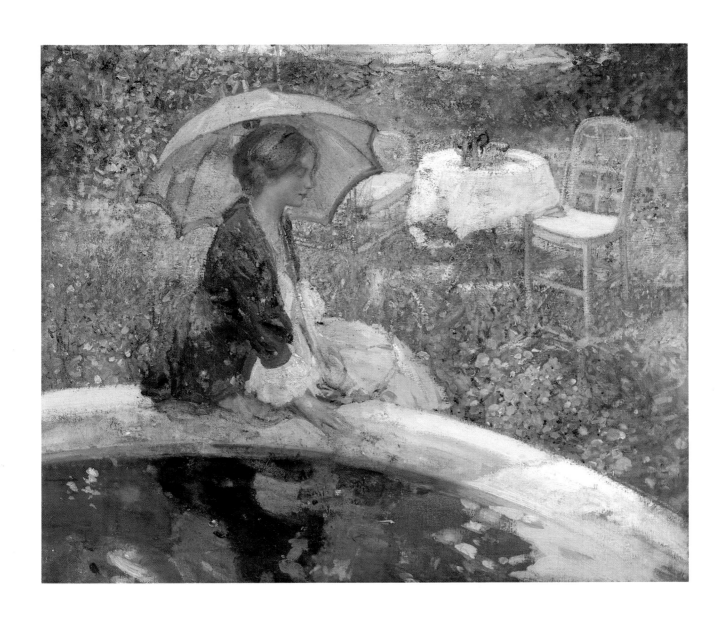

41
The Pool, n.d.
Oil on canvas; 32 x 39⁷⁄₁₆ inches (81.3 x 100.2 cm)
Signed left center: *Miller*
Terra Foundation for the Arts, Daniel J Terra Collection, 1988.13

Louis Ritman
1889–1963

Louis Ritman was born to a family of Jewish designers and weavers in Kamenets-Podolsky, southwestern Russia. Around 1900 the Ritman family immigrated to Chicago, where his father found work in the textile business and Louis became an apprentice to a sign painter. He took drawing lessons at night at Chicago's Hull House, which offered educational and cultural programs for low fees. Sponsored mostly through scholarships, Ritman subsequently studied at the School of the Art Institute of Chicago, the Chicago Academy of Fine Arts, and for a few months the Pennsylvania Academy of the Fine Arts. At the advice of Lawton Parker, a Chicago painter who moved easily in the French art world, Ritman decided to study and work in Paris. In 1909 he enrolled at the Académie Julian and the same year was accepted at the Ecole des Beaux-Arts. Ritman was introduced to Giverny in 1911 by his Paris-based colleagues Richard Emil Miller and Frederick Carl Frieseke, but may have had earlier word of it through Parker. Ritman spent his first summer in Giverny that year, initiating a work habit that would continue for twenty years, surviving even the disruptive years of World War I.

During his first two years in France, Ritman exhibited regularly at the Paris Salon. Though receiving no awards, his Salon paintings of female nudes announced a theme later referred to as "intimism."[1] *Early Morning* exemplifies how Ritman adapted this softly erotic Salon style to the Impressionistic idiom practiced by his fellow American painters, Frieseke and Parker. This second generation of American painters in Giverny cohered in their efforts to render the female figure out of doors in full sunlight or in colorful interiors. In *Early Morning* the seminude figure is surrounded by a decorative design of overlapping patterns, modeled in hues of rose, blue, and yellow. Opening onto a Giverny landscape, the scene through the window in the upper left of the composition repeats this lush pattern, thereby infusing the outside world with the intimacy of the interior.

Though lodging at the Hôtel Baudy during his first three summers in Giverny, Ritman was ready to settle permanently in the Normandy village and began to look for a small house. By 1914 he was able to move into his own studio cottage and paint in its backyard. Earlier, between 1912 and 1913, which were decisive years in Ritman's transition from the academic manner to Impressionism, he painted many of his outdoor scenes in Frieseke's Giverny garden. *At the Brook* (fig. 127) falls into the period during which Ritman's work was strongly influenced by Frieseke. Ritman renders the nude in soft contours, poised against a tapestry of foliage and grass. The brushwork skillfully outlines a few objects; the dress, sprawled on the ground, and the folded parasol are barely recognizable. This secluded scene of a garden nymph, with its immaterial and dreamy atmosphere, captures much the same mood as Ritman's portraits of women indoors, such as *Early Morning*.

In 1929 Ritman left Giverny to become instructor of portrait and figure painting at the School of the Art Institute of Chicago, but during the last thirty years of his life he returned to France many times. *Afternoon Sun* (fig. 85) was probably painted during one such trip between teaching assignments in Chicago. Though dating from a late period in the artist's career, *Afternoon Sun* partakes of the radical plein airism of his earlier work, such as *At the Brook*. Ritman's drawing style is evident in the outlines of trees, but the emphasis is on the light and shade, flickering over the house and landscape.—J. W.

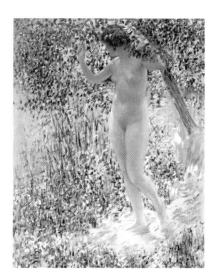

Fig. 127
Louis Ritman, *At the Brook,* c. 1913, oil on canvas. Daniel J. Terra Collection, 28.1986

1. On *intimisme,* see Richard H. Love, *Louis Ritman: From Chicago to Giverny* (Chicago: Haase-Mumm, 1989), esp. 179–85.

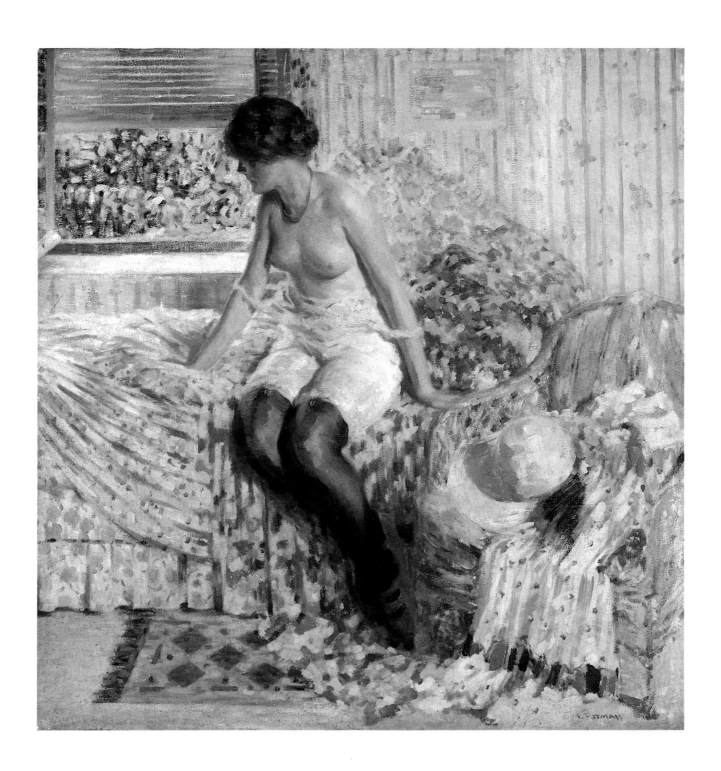

42
Early Morning, c. 1913
Oil on canvas mounted on board; 36 x 35¼ inches (91.5 x 89.6 cm)
Signed lower right: *L. RITMAN*
Terra Foundation for the Arts, Daniel J. Terra Collection, 1987.5

Robert Vonnoh
1858–1933

Robert Vonnoh grew up in Boston, where he worked for a lithography company and attended night classes at a drawing school. Between 1875 and 1879 he completed his training at the Massachusetts Normal School of Art to become a teacher of industrial art and architectural drawing. He supported himself as a teacher at various art schools in Boston, and in 1880 decided to pursue his artistic studies in Paris. At the Académie Julian, Vonnoh was able to further improve his drawing technique, painting a full-length figure almost every week. Upon his return to Boston in 1883, he established himself as a competent portrait painter and instructor. He held teaching positions at the Boston Museum School and later the Pennsylvania Academy of the Fine Arts, where he not only taught portraiture but also introduced his students to Impressionism.

Vonnoh's reputation as plein air painter and American Impressionist was closely connected with the French village Grèz-sur-Loing on the outskirts of the Forest of Fontainebleau. Grèz initially was frequented by French artists, beginning in the 1830s, but when they started to move in large numbers from Paris to the centers of plein air painting around Fontainebleau, Grèz was neglected in favor of Barbizon and Marlotte. The transformation of Grèz into a sizable artists' colony began around 1875, resulting from the arrival of English, American, and later Scandinavian artists. This American and Northern European community of painters was influenced by the naturalism of Jules Bastien-Lepage and became stylistically categorized as the "Grèz School," a plein airism based on soft light and hazy atmosphere, deriving from the predominant weather conditions at Grèz.

Vonnoh's first extended stay in Grèz began in 1887 and lasted four years, with brief interludes in Paris and Boston. *La Sieste*, dating from the year of his arrival, is still allied to an earlier Grèz plein airism of muted color, mixed on the palette. Forms are not dissolved in the midday sunlight but have the solidity of traditional representations of agrarian life. Yet light tonality and directness of touch point up the more progressive aspects of the Grèz School. *La Sieste* seems

to echo the pre-Impressionistic work of Theodore Robinson, who had summered at Grèz in the late 1870s and early 1880s. If the two painters had met each other in France, it most likely was in Paris, since Robinson was already in Giverny by 1887.

Beginning in 1888, some of Vonnoh's plein air paintings marked the definite arrival of Impressionism in Grèz and a challenge to the Grèz School. *Poppies in France* evidences the painter's daring attempt to banish from his palette the earlier muted tonality in favor of a range of unmixed colors. His new departure in landscape painting is especially salient in the impasto brushwork and use of the palette knife, making the poppies appear like brilliant flames. In his series of studies of a poppy field in 1888, Vonnoh seemed to leap beyond Impressionism, toward an aesthetic that had more in common with Post-Impressionism. With his fellow American painters in Giverny, Vonnoh shared the motif of the flower bed, whether in a garden or in a more uncultivated environment; John Leslie Breck, especially, favored similar close-up perspectives of flowers.

In 1889 Vonnoh received an honorable mention at the Salon with an interior scene, and in 1890 he exhibited *November* (fig. 128), his first landscape to be shown at the Salon, which is reminiscent of the earlier

Fig. 128
Robert Vonnoh, *Novembre*, 1890, huile sur toile. Pennsylvania Academy of the Fine Arts, Philadelphia, Joseph E. Temple Fund, 1894.5

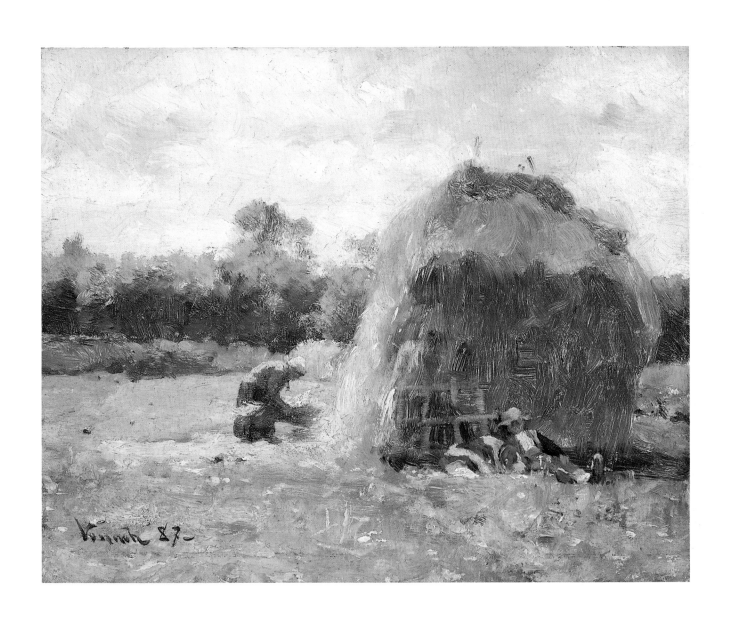

43
La Sieste (The Rest), 1887
Oil on panel; 8½ x 10⅞₆ inches (21.6 x 26.8 cm)
Signed and dated lower left: *Vonnoh 87-*
Daniel J. Terra Collection, 27.1986

Grèz School works. However, in paintings such as *Jardin de paysanne,* executed in the summer of 1890, Vonnoh realized what he later referred to as "the value of first impression and the necessity of correct value, pure color and higher key."[1] Vonnoh's insistence on correct values suggests a delicate balance between the mores of his academic training and the Impressionistic impulses he received from Alfred Sisley and Camille Pissaro. With varied brushstrokes of unmixed color, Vonnoh depicts the play of sunlight and shadow, carefully maintaining the solidity of forms.—J. W.

1. *National Cyclopedia of American Biography,* 1897, vol. 7, p. 462; quoted in William H. Gerdts, *American Impresionism* (New York: Abbeville Press, 1984), 121.

44

44
Poppies in France, 1888
Oil on canvas; 12⅛ x 20⅛ inches (30.8 x 51.1 cm)
Signed and dated lower left: *Vonnoh 1888.*
Terra Foundation for the Arts, Daniel J. Terra Collection, 1987.9

45
Jardin de paysanne (Peasant Garden), 1890
Oil on canvasboard; 25⅞ x 19¾ inches (65.7 x 50.2 cm)
Signed and dated lower left: *Vonnoh 1890*
Terra Foundation for the Arts, Daniel J. Terra Collection, 1987.8

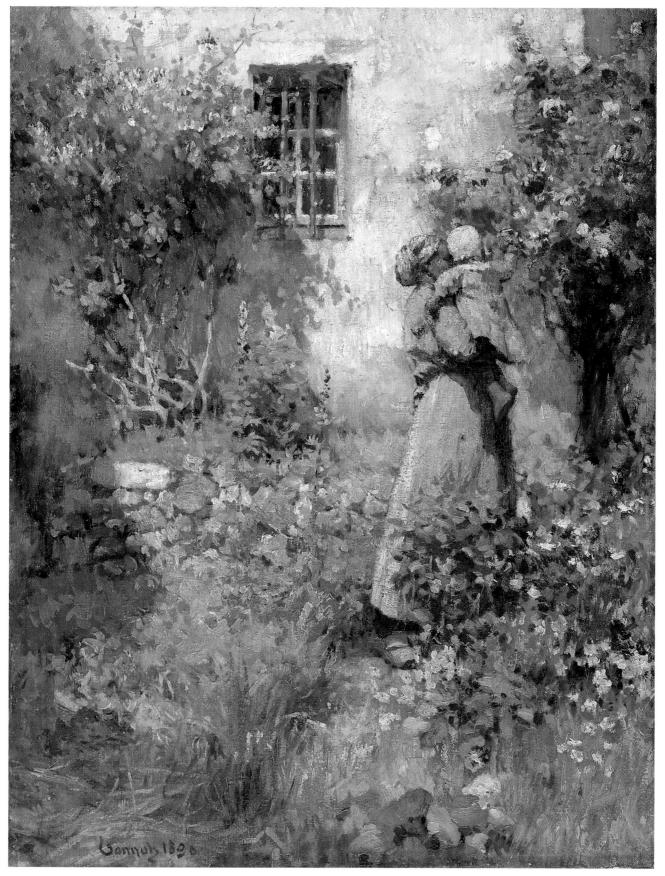

45

Edward Wilbur Dean Hamilton
1864–1943

Edward W. D. Hamilton was an artist and illustrator who worked in Boston most of his life. He pursued the lucrative career of portrait painting and also held teaching positions at the Massachusetts Normal School of Art, where Robert Vonnoh was an instructor, at Boston University, and at the Rhode Island School of Design. Hamilton spent the years between 1885 and 1890 on the European continent. His artistic experience there combined studies at the Ecole des Beaux-Arts, painting in Venice, and experimenting with Impressionism.

Hamilton painted at the artists' colony of Grèz in 1889 and probably returned the next year. Like his fellow Bostonian Vonnoh, and the Cincinnati painter Edward Potthast, Hamilton arrived fairly late at Grèz, when the initial American contingent around Will Low and the brothers Birge and Alexander Harrison had already left the village. Like most of the Anglo-American and Scandinavian artists passing through, he would have stayed at either of the two local pensions, Chevillon's or Laurent's.

Afternoon, Grèz is Hamilton's interpretation of a theme tried by several American Impressionists, the female figure in a garden. R. A. M. Stevenson, one of the first British "discoverers" of Grèz in 1875, later described the typical appearance of a street front in Grèz as "stern stone," while "all the life and amenity lie behind in the large courtyards and ample old terraced gardens."[1] Though different in perspective, *Afternoon, Grèz* renders the Grèz garden scene in a style similar to that of Vonnoh's *Jardin de paysanne* (colorplate 45). Through careful modeling of background architecture and the naturalistic rendering of shadows reaching into the pictorial space, both painters control their Impressionistic experiment with dissolving forms.
—J. W.

1. R. A. M. Stevenson, "Grez," *Magazine of Art* 17 (1894), 28.

46
Afternoon, Grèz, c. 1889
Oil on canvas; 32 x 19½ inches (81.3 x 49.5 cm)
Terra Foundation for the Arts, Daniel J. Terra Collection, 1989.14

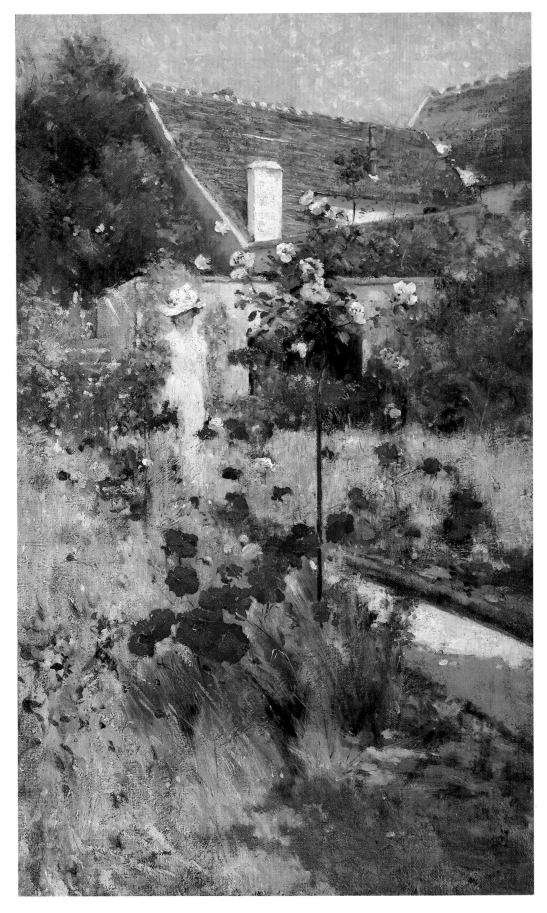

46

George Inness
1825–1894

George Inness was the most important exponent of a Barbizon-influenced style of landscape painting in America. Though born in the Hudson River Valley in New York, he was only marginally associated with what was then the main school of landscape painting in America, the Hudson River School. His training was unsystematic, including as teachers an itinerant artist named John Jesse Barker as well as the French-born painter Régis François Gignoux, and supplemented by methods of self-instruction. Inness studied the art of Claude Lorrain through books, and in 1848, when his landscapes were exhibited at the National Academy of Design, they were believed by critics to be imitations of Claude.

His first trip to Europe between 1851 and 1852, mostly spent in Rome, did not initiate a radical change in his art. More significant was a second visit, late in 1853, mostly spent in France where he was introduced to the Barbizon School. The years after his return he lived in Brooklyn, New York, and in Medfield, Massachusetts. Led by his religious sensibility, Inness familiarized himself in the 1860s with the ideas of the eighteenth-century mystic Emanuel Swedenborg. With a Swedenborgian thinker, the painter William Page, Inness worked at Eagleswood, near Perth Amboy, in New Jersey, a former Utopian community. His paintings were bought by such individuals as Henry Ward Beecher, a Brooklyn pastor and abolitionist. His

third trip to Europe, beginning in 1870, was motivated by an arrangement with the Boston art gallery of Williams & Everett, which commissioned him to produce saleable pictures. To rhetorically divorce aesthetic from commercial interests, Inness liked to distinguish between "painting" and "picture," and he complained that "finish is what the picture-dealers cry for."[1]

After three years in Italy, Inness moved on to France, painting in the area of Etretat on the Normandy coast between 1874 and 1875, where he produced nearly twenty depictions of the eroded sea cliffs at Etretat. *Etretat, Normandy, France* introduces a low viewpoint differing entirely from the downhill perspective of the arched cliffs in *Etretat* (fig. 129). In *Etretat, Normandy, France* the human habitations are removed, almost invisible, while rocks, cliffs, and the sweeping sea are brought to the fore. What is either a morning or evening sky clashes as a reddish band of "hot" chromatics with the coolness of the foreground.

Inness lived in Montclair, New Jersey, from 1878 on. Reaching an even higher degree of abstraction in fusing the tangible world and the immaterial in his late career, Inness became an early modernist concerned with the expression of spirituality.—J. W.

1. Quoted in Nicolai Cikovsky, Jr., and Michael Quick, *George Inness* (Los Angeles: Los Angeles County Museum of Art, 1985), 29.

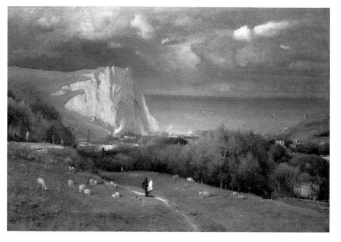

Fig. 129
George Inness, *Etretat*, 1875, oil on canvas. Wadsworth Atheneum, Hartford, Ella Gallup Sumner and Mary Catlin Sumner Collection, 1956.480

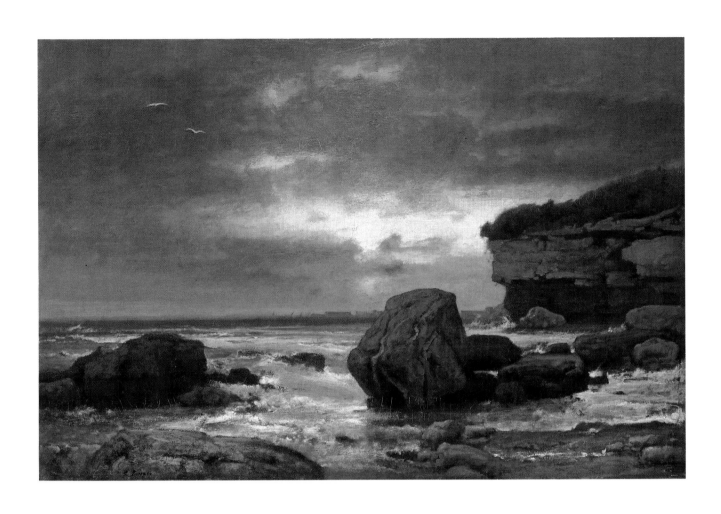

47
Etretat, Normandy, France, 1874–75
Oil on canvas; 30 x 45¼ inches (76.2 x 114.9 cm)
Signed and dated lower left: *G. Inness* [date illegible]
The Art Institute of Chicago, Edward B. Butler Collection, 1913.90

John Henry Twachtman
1853–1902

John Henry Twachtman was born to German immigrants in Cincinnati, Ohio, and was raised there in the German-speaking district. In 1874 he studied at the McMicken School of Design with Frank Duveneck, another Cincinnati-born artist of German descent, and accompanied him to Munich the following year. As a student at the Munich Akademie, Twachtman studied with Ludwig Löfftz and met other practitioners of the Munich School. Wilhelm Leibl, the most radical among the Munich Realists, was inspired by Gustave Courbet—and to be part of the Munich School in the 1870s meant to be at least indirectly under the

Fig. 130
John Henry Twachtman, *Arques-la-Bataille,* 1885, oil on canvas. Metropolitan Museum of Art, New York, Morris K. Jesup Fund, 1968

influence of that French champion of Realism. In 1877 Twachtman followed Duveneck to Venice, where he continued to paint in the dark palette of the Munich School.

By 1883, when he arrived in Paris, Twachtman was eager to overcome what he considered the limitations of his Munich training. To improve his draftsmanship, he took drawing classes at the Académie Julian. During his two years in Paris, Twachtman became an admirer of Jules Bastien-Lepage, who combined plein airism with precise draftsmanship.

James Abbott McNeill Whistler, who had painted with Courbet at Trouville around 1865, seems to have inspired Twachtman's stylistic development more then any other single painter. *Road near Honfleur,* painted during Twachtman's French sojourn, is indebted to Whistler's Tonalism, though it is rendered with the bravura brushstroke of the Munich School. It demonstrates the growing emphasis in Twachtman's mode of landscape painting on mood and introspection.

While he was living and studying in Paris, Twachtman made trips to the Normandy and Picardy countryside. *The River* was probably painted in the Picardy area around Arques-la-Bataille, near Dieppe, since it includes the compositional elements that attracted Twachtman in similar paintings, such as *Arques-la-Bataille* (fig. 130). The tranquil river, flowing beneath a gradual embankment and low growth of flowers, is rendered in subtly diffuse light. Twachtman's

48
Road near Honfleur, 1883–85
Oil on paper mounted on canvas; 30 x 21 inches (76.2 x 53.4 cm)
Signed lower right: *J. H. Twachtman*—
Terra Foundation for the Arts, Daniel J. Terra Collection, 1989.15

48

style changed while he was in France, from the thick and vigorous brushwork of the Munich School to a softer, more feathery application of paint. Although this change is evident in *The River*, Twachtman's painterly concerns continued to embrace a Tonalist mode, distinct from Impressionism. Even his late, more "impressionistic" works, painted at Cos Cob, Connecticut, and at Gloucester, Massachusetts, utilize only certain aspects of the style, although Twachtman is clearly associated with the American Impressionists. In his reliance on nature and its various appearances, Twachtman was more concerned with painterliness and mood than with scientific observation. The supreme

achievement of his career were the contemplative snow scenes, such as *Winter Landscape* (fig. 131), painted in Greenwich, Connecticut, where he lived and worked throughout the 1890s.

Twachtman was a founding member in 1897 of the Ten American Painters, a group of that number of Impressionist Painters in New York and Boston, including Thomas Dewing, Childe Hassam, Willard Metcalf, Edmund Tarbell, and J. Alden Weir. The Ten became a major forum for America's Impressionist artists, organizing exhibitions and promoting new standards for selecting and hanging them.—J. W.

Fig. 131
John Henry Twachtman, *Winter Landscape*, n.d., oil on canvas.
Daniel J. Terra Collection, 11.1982

49
The River, 1883–85
Oil on canvas; 18¼ x 22¼ inches (46.4 x 56.5 cm)
Signed lower left: *J. H. Twachtman.*
Terra Foundation for the Arts, Daniel J. Terra Collection, 1989.1

Dennis Miller Bunker
1861–1890

By the time Dennis Miller Bunker's career as a painter ended with his early death, caused by influenza, he had already produced a significant body of work. He was an established portrait painter in Boston, where portrait commissions secured painters social success and prestige. At the Art Students League in New York, where he began his studies around 1878, Bunker was exposed to the Munich School style through his teacher William Merritt Chase. Later, at the Parisian atelier of Jean-Léon Gérôme, he displayed great drawing skills. His landscapes, many of them painted during his stay in France, from the summer of 1882 to late 1884, reveal a stylistic independence based on a solid knowledge of the artistic movements of his time.

Bunker's French landscapes are reminiscent of Munich School Tonalism and the plein air style of the Barbizon School. Both modes simultaneously appealed to his melancholic personality and his academic training. Barbizon School influence is most apparent in works such as *La Croix, St. Ouen, Oise.* To heighten the sense of naturalism, the nearly invisible brushwork is subservient to the qualities of soft and misty light. The tall trees in their muted autumn orange and green appear like feathers, while the cattails in the left foreground are more crisply outlined. This scene on the Oise River echoes the subdued, almost monochromatic palette to be found in John Twachtman's *Arques-la-Bataille* (see fig. 130), painted the same year near Dieppe.

In 1884 Bunker made many painting excursions into the countryside, one of which brought him to the area around Larmor, Brittany. American plein air painters were fascinated by the brilliant silvery gray light of Brittany, particular to that part of France. Bunker adroitly explored this atmospheric density in *Brittany Town Morning, Larmor.* He achieved a remarkable fusion, giving equal emphasis to strong definition of architecture, intense light effects on the rooftops, and soft tonal values in the foreground landscape. Although there is no evidence for a strong and direct influence by Camille Corot, Bunker combines in *Brittany Town Morning* two distinct phases associated with the work of the Frenchman: the early Italian paintings of clustered villages, and the late misty and atmospheric landscapes of Barbizon. Bunker's synthesis, however, results from his intuition and inventiveness.

50
La Croix, St. Ouen, Oise, 1883
Oil on canvas; 37 ⅜ x 50 ⅛ inches (95.6 x 127.3 cm)
Signed and dated lower left: *DENNIS M. BUNKER / LA CROIX-ST-OUEN / OISE 1883*
Terra Foundation for the Arts, Daniel J. Terra Collection, 1987.11

Bunker's exploration of Impressionism was gradual and tentative. In 1888, after John Singer Sargent had visited Claude Monet in Giverny, the two Americans spent the summer painting at Calcot, England. In *Dennis Miller Bunker Painting at Calcot* (fig. 132), Sargent arrested a moment when Bunker stands back from his easel, contemplative and undecided about his effort at outdoor painting. However, during the last two years of his career, painting landscapes at Medfield, Massachusetts, Bunker demonstrated that he was much at ease in adopting the new aesthetic.—J. W.

Fig. 132
John Singer Sargent, *Dennis Miller Bunker Painting at Calcot*, 1888, oil on canvas mounted on masonite. Daniel J. Terra Collection, 36.1980

51
Brittany Town Morning, Larmor, 1884
Oil on canvas; 14 x 22 inches (35.6 x 55.9 cm)
Signed and dated lower left: *DENNIS M. BUNKER / LARMOR / 1884*
Terra Foundation for the Arts, Daniel J. Terra Collection, 1991.1

John Singer Sargent
1856–1925

John Singer Sargent was the first child born to the American cosmopolitans Dr. Fitzwilliam Sargent and Mary Newbold Singer Sargent. They were among the growing number of affluent Americans who expatriated to Europe during the second half of the nineteenth century. When the Sargents departed for Italy in 1854, it was not at all clear what the duration of their European stay would be. And it was not until 1876 that Mrs. Sargent, her daughter, Emily, and her son, John, then twenty years old, returned to the United States to visit friends and relatives. Like many of their fellow expatriates, the Sargents never gave up their American citizenship and always stressed their patriotism.

Sargent was born in Florence, but received his education in Nice, where his parents resided most of his childhood. In 1874, shortly after he had enrolled at the Accademia delle Belle Arti, Florence, his family moved to Paris, where Sargent took up his studies at the atelier of Emile-Auguste Carolus-Duran, the majority of whose students were American or British. Sargent and his fellow American student J. Carroll Beckwith later assisted Carolus-Duran in painting the monumental canvas *The Triumph of Maria de Medici*, completed in 1878 for the ceiling of the Palais du Luxembourg. Encouraged by Carolus-Duran to sketch directly on the canvas and to emulate the style of Diego Velázquez, Sargent developed a loose and quick brushstroke.

A Velázquez revival pervaded European art schools during the late nineteenth century, and Sargent became the great American practitioner of this fin de siècle grand manner. Using an elegant technique that created volume through flowing color and played with light and shadow over objects, Sargent became the favorite portraitist of upper-class Americans and English aristocrats. During the early 1900s he painted as many as twenty or twenty-five portraits a year. Besides the numerous portraits he painted for private citizens, his most memorable public commission is the murals gracing the Boston Public Library.

Sargent spent the summer of 1877 in Cancale, Brittany, applying for the first time Carolus-Duran's studio methods to plein air painting. The oil sketches *Breton Girl with a Basket, Girl on the Beach,* and *Young Boy on the Beach* are studies made out-of-doors for the large

52
Breton Girl with a Basket, Sketch for "Oyster Gatherers of Cancale," 1877
Oil on canvas; 19 x 11½ inches (48.3 x 29.2 cm)
Signed lower right: *John S. Sargent*
Daniel J. Terra Collection, 37.1980

53
Girl on the Beach, Sketch for "Oyster Gatherers of Cancale," 1877
Oil on canvas; 19 x 11½ inches (48.3 x 29.2 cm)
Daniel J. Terra Collection, 15.1981

54
Young Boy on the Beach, Sketch for "Oyster Gatherers of Cancale," 1877
Oil on canvas; 17¼ x 10¼ inches (43.8 x 26.0 cm)
Daniel J. Terra Collection, 38.1980

52

53

54

studio work *Oyster Gatherers of Cancale* (colorplate 56), which received Honorable Mention at the Salon of 1878; only his second painting shown at the Salon, it established Sargent's reputation in Paris. He also made a debut appearance in the United States by sending a smaller oil study of *Oyster Gatherers of Cancale* (colorplate 55) to the Society of American Artists in New York.

Except for a considerable change in scale, Sargent translated this finished study into the Salon painting with minor alterations. Only in the final version, for instance, does the boy carry a basket behind his back.

The sketches, study, and finished composition document the precociousness of this painter who commanded the bravura brushstroke and colorism

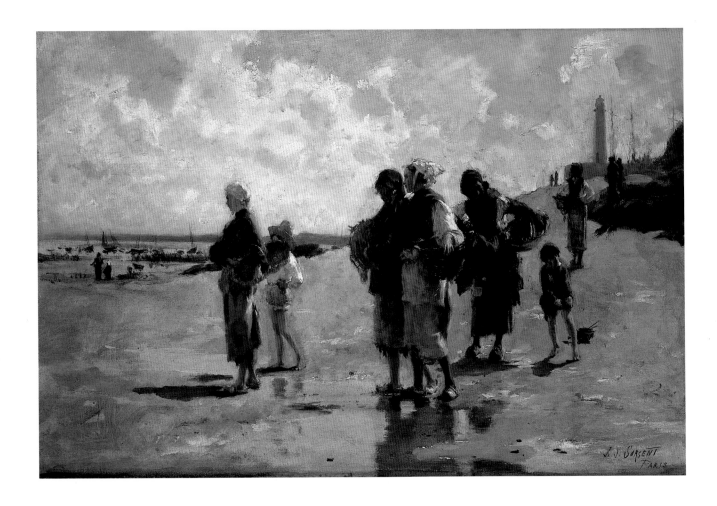

55
Oyster Gatherers of Cancale, 1878
Oil on canvas; 16¼ x 23¾ inches (41.2 x 60.3 cm)
Signed lower right: *J. S. SARGENT / PARIS*
Museum of Fine Arts, Boston, Gift of Mary Appleton, 35.708

derived from his study of Velázquez, Frans Hals, and Edouard Manet. Sargent's palette in rendering Cancale beach and its local people remained muted and Tonal. But his principal concern was to capture on canvas the atmosphere of a space embraced by morning sunlight. With fluid brushstrokes Sargent models the sky as a vast open background against which the procession of Cancale women and children marches through the reflecting low tide puddles. As a result, the two studio compositions appear as natural as the three figure sketches. Sargent displays in *Oyster Gatherers of Cancale* the same finesse for vivid surface textures and light effects that later secured his reputation as a portrait painter.—J. W.

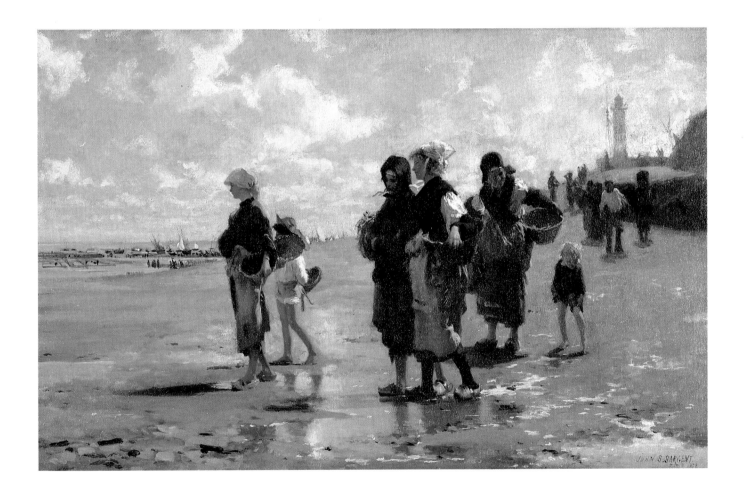

56
Oyster Gatherers of Cancale, 1878
Oil on canvas; 31⅛ x 48½ inches (79.1 x 123.2 cm)
Signed and dated lower right: *JOHN S. SARGENT / PARIS 1878*
The Corcoran Gallery of Art, Washington, D.C., Museum Purchase, Gallery Fund

Robert Wylie
1839–1877

Born on the Isle of Man, Robert Wylie was an orphan when he went to Philadelphia at the age of ten to live with an uncle. Around 1855 the Pennsylvania Academy of the Fine Arts began to offer a systematic curriculum in studio education, thus attracting a number of talented students. Wylie, who had developed a great dexterity in carving, took classes in drawing from plaster replicas of famous statues. Beginning in 1858 he was a coordinator of the Academy's life class and the next year was appointed curator. Among other duties, he handled loans and helped organize annual exhibitions.

Wylie arrived in Paris in 1863 and became the founder of what can be considered the first colony of American artists, located in Pont-Aven. He briefly studied at the Académie Suisse to further improve his draftsmanship and probably did not use oil colors until 1864. That same year he made his first summer trip to the Brittany coast and by 1866 had established himself in Pont-Aven.

He and other American artists found lodgings in the Hôtel des Voyageurs and soon, with the assistance of the village notary, transformed the abandoned Château de les-Aven, also referred to as Lezaven, into a studio building. The atmosphere of a free academy subsequently attracted more American artists, many of them students of Jean-Léon Gérôme, and also artists from France and other countries.

Although they experimented with outdoor painting in Pont-Aven and nearby Concarneau, American artists composed most of their paintings in studio spaces available at Château de les-Aven or in cottages in the village. Typical is Wylie's *Breton Audience*, set in a dark interior, illuminated by a single source of light and painted in what later became anathema to the Impressionists, the atelier brown. No American artist was more at home in Celtic Brittany and on such cordial terms with the local Bretons as was Wylie. In sympathetic character studies such as *The Breton Audience* this cordial spirit becomes apparent, for the Breton models posed for Wylie with the utmost ease.—J. W.

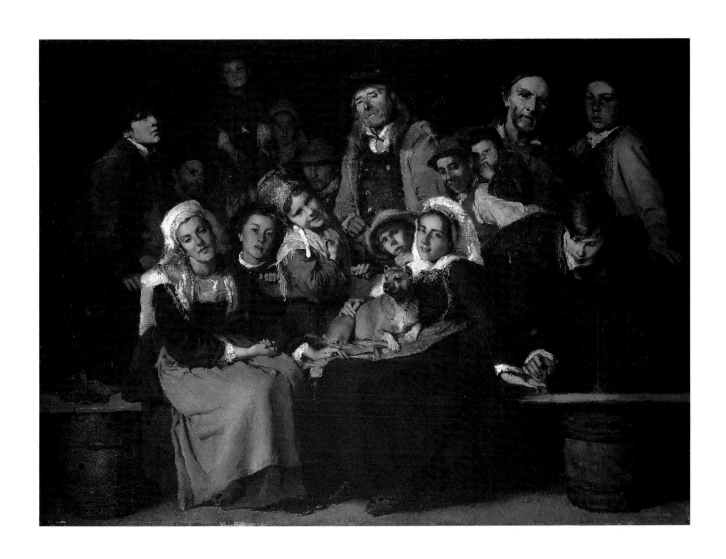

57
The Breton Audience, c. 1870
Oil on canvas; 21½ x 29¼ inches (54.6 x 74.3 cm)
Signed lower right: *R. WYLIE*
Daniel J. Terra Collection, 2.1991

William Lamb Picknell
1854–1897

When William Lamb Picknell was fourteen years old his father died, and his family left its native Vermont for Chelsea, Massachusetts, a suburb of Boston. Young Picknell worked in a Boston frame shop from 1870 until 1872, when an uncle gave him one thousand dollars so that he could go abroad. He studied with George Inness in Rome for two years, until the latter departed for the Normandy coast in 1874. By that year Picknell was in Pont-Aven, where he received guidance from the French landscape painter Léon Pelouse and came under the influence of the American Robert Wylie. Wylie had been a resident of the village for ten years and exerted great intellectual and artistic influence on his younger American colleagues. In December 1874 Picknell enrolled at the Ecole des

Beaux-Arts to study with Jean-Léon Gérôme, but he remained there only until spring 1875, when he returned to Pont-Aven.[1]

Picknell's first ambitious project was a large picture of the new road between Pont-Aven and Concarneau, built in the late 1870s. In analogy to the modernization of Paris in the nineteenth century by the baron Haussmann, the inland road system was overhauled under Napoleon III, affecting in particular the traffic between the coastal towns of Brittany. In *The Road to Concarneau* Picknell tried his brush at the road's

1. The Picknell chronology has recently been updated and corrected by David Sellin in *William Lamb Picknell, 1853–1897* (Washington, D.C., Taggart and Jorgensen Gallery, 1991).

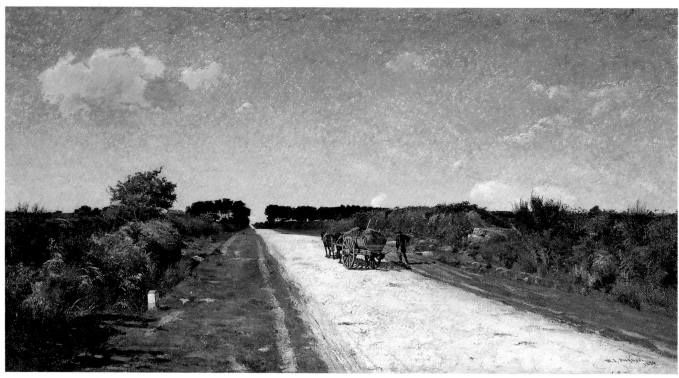

58

58
The Road to Concarneau, 1880
Oil on canvas; 42⅜ x 79¾ inches (107.7 x 202.6 cm)
Signed and dated lower right: *W. L. Picknell / 1880*
The Corcoran Gallery of Art, Washington, D.C.,
Museum Purchase, Gallery Fund

59
In France (Sunday Morning, Moret), 1890–97
Oil on canvas; 29½ x 35½ inches (74.9 x 90.2 cm)
Signed lower left: *Wm. L. Picknell*
Union League Club of Chicago

new crushed quartz surface, which had replaced the old rugged paths. The painting marks his first great accomplishment as a painter of what has been called the "glare aesthetic."[2] Contrary to the Impressionistic dissolution of form, the intensity of glaring light in *The Road to Concarneau* defines solid forms. *The Road to Concarneau* was awarded an honorable mention at the 1880 Salon and was well received by French and American critics.

During most of the 1880s Picknell lived in Waltham, Massachusetts, spending his summers at Annisquam on the Massachusetts coast and traveling to such places as Florida and California during the winter

months. He married Gertrude Powers in 1889, and he went with his wife to France in 1893, painting in Provence and Normandy and at Antibes on the Mediterranean coast, reexamining his pictorial concerns of the Pont-Aven phase in more "the road to" paintings. *In France* was painted at Moret, near Fontainebleau, where the Picknells summered in 1894, and it evidences the artist's emulation of a more Impressionistic treatment of light. Though built up and modeled with the palette knife in a traditional mode, this change can be seen in the brightly lit surface of the foreground plane.

The Picknells remained in France until 1897, the year their two-year-old son died. Six months after his son's death, Picknell died in Marblehead, Massachusetts, at the summer home of an uncle.—J. W.

2. See William H. Gerdts, *American Impressionism* (New York: Abbeville Press, 1984), 17–21

59

Daniel Ridgway Knight
1839–1924

Daniel Ridgway Knight was an American expatriate painter whose work was internationally recognized and who received honors in France and the United States. He began his studies at the Pennsylvania Academy of the Fine Arts and, beginning in 1861, continued in Paris at the Ecole des Beaux-Arts and in the atelier of Charles Gleyre, and in Rome at the Accademia di San Luca. He served in the Union Army during the American Civil War, not returning to France until 1872. After informal studies with Ernest Meissonier at Poissy, Knight settled there and later also at Rolleboise (Seine-et-Oise). In the countryside outside of Paris he found the peasant models and the landscape settings for his genre paintings.

By 1883, when he painted *Waiting for the Ferry*, Knight had been exhibiting at the Salon for ten years. He executed the peasant figures with the finish and accuracy of Meissonier's history paintings, carefully rendering bits of detail such as patches and holes in their coarse garments. The scene is filled with a unifying and soft light, creating an atmosphere of quietism, a *paysage intime* in the Barbizon mode.

Knight pursued a naturalism in the manner of Jules Bastien-Lepage, who had numerous followers among American artists who were reevaluating their adherence to academic regimentation. Bastien's plein airism presented an alternative that was not too radically anti-academic. Knight's work was popular among American collectors but grew somewhat formulaic. Some critics chided his idealization of peasant life, others praised his optimistic vision of rural life: "Mr. Knight selects what is beautiful and pretty in the peasant and avoids all that is hideous and unsightly."[1] He served the French and American governments during World War I and was named Officer of the Legion of Honor.—J. W.

1. Quoted in Annette Blaugrund, ed., *Paris 1889: American Artists at the Universal Exposition* (New York: Harry N. Abrams, 1989), 179.

60
Waiting for the Ferry, 1883
Oil on canvas; 27½ x 36½ inches (69.9 x 92.7 cm)
Signed and dated lower left: *D. Ridgway Knight, Paris 1883*
Union League Club of Chicago

Eugene Lawrence Vail
1857–1934

Eugene Vail's career as a painter was inspired by two cultures. The son of a French mother and an American father, he was born in the Brittany town of Saint-Servan and later educated in Paris and New York. He received instruction in New York at the Art Students League with J. Carroll Beckwith and William Merritt Chase, and in 1882 departed for Paris to continue his studies at the Ecole des Beaux-Arts. He first enrolled in the studio of Alexandre Cabanel and later also studied with Raphael Collin and P.A.J. Dagnan-Bouveret. Sometime after his arrival in France, Vail began to paint at the Brittany coast, specializing in atmospheric renderings of life around the fishing towns.

In 1884, his second year at the Salon, *Le Port de pêche, Concarneau* was the first of many maritime subjects he would exhibit there. A burgeoning art colony at that time, Concarneau had maintained its medieval appearance and presented a world seemingly removed in time and character from late nineteenth-century Paris. Vail was not only a passive observer, he cruised with the fishermen and had a firsthand experience of that industry. *Le Port de pêche* evidences a strong concern for atmospheric veracity expressed in the muted color of Tonalism. It was one of the first American paintings to be bought by the French government for the Musée du Luxembourg. Vail was a member of the international jury for the Paris Exposition in 1889 and received a gold medal for *Le Port de pêche* and other paintings. His work was shown and honored at exhibitions in Berlin, Munich, and Antwerp. In 1894 he was named a chevalier of the Legion of Honor.—J. W.

61
Le Port de pêche, Concarneau, c. 1884
Oil on canvas; 52 x 74¹³⁄₁₆ inches (132 x 190 cm)
Signed lower left: *Eugene Vail*
Musée des Beaux-Arts de Brest

Lowell Birge Harrison
1854–1929

Birge Harrison and his brother Thomas Alexander Harrison both attended the Pennsylvania Academy of the Fine Arts before they went to France. Birge, who had studied under Thomas Eakins and had met John Singer Sargent in Philadelphia, enrolled in Carolus-Duran's atelier in August 1877, preceding by two years his brother's arrival in Paris. The brothers studied at the Ecole des Beaux-Arts; Birge began to attend Alexandre Cabanel's classes in 1878, and Alexander matriculated in Jean-Léon Gérôme's atelier the following year. Around 1880 Birge arrived again ahead of his brother at the art colonies of Pont-Aven and Concarneau, Brittany, and at Grèz-sur-Loing. Both brothers had discovered the works of Jules Bastien-Lepage at the Salon and now sought the right locale to explore his plein air technique. Alexander Harrison worked in close association with Bastien-Lepage at Concarneau, beginning in 1882 until the latter's death in 1884.

Birge Harrison's *Novembre* may well have been painted at Pont-Aven or at Grèz, both being places pervaded in autumn by a gray, atmospheric light. The birchwood interior, however, makes a setting somewhere in the Fontainebleau area around Grèz more likely. The fact that Grèz had attracted a sizable number of Scandinavian painters may serve as another piece of evidence, since Harrison recalled in his book *Landscape Painting* (1909) in discussing *Novembre:* "A Scandinavian painter had shown me the secret of atmospheric painting . . . [and] made clear to me . . . the importance of vibration and refraction in landscape painting."[1] To establish a pensive atmosphere, Harrison chose a silvery gray day in November and posed his model as a daydreaming peasant, lost in meditation as she rakes the dead leaves. This atmospheric density in painting the landscape and the precise drawing of the figure are characteristic features of a naturalism that secured American painters such as Birge Harrison, Alexander Harrison, and Daniel Ridgway Knight success at the Paris Salon. *Novembre* was first exhibited at the Salon of 1882. At the Paris Exposition Universelle seven years later it was Harrison's sole entry, and subsequently the painting was bought by the French government.

Due to an illness Harrison was forced to stop painting temporarily in the 1880s, during which time he traveled to Australia, Asia, and Africa, writing and illustrating articles for popular American magazines. In 1897 he settled in New England, where he specialized in Tonal landscapes, including many snow scenes. As an instructor at the Art Students League in New York, he lectured extensively and conducted experimental summer painting classes in Woodstock, New York.—J. W.

1. Quoted in Annette Blaugrund, ed., *Paris 1889: American Artists at the Universal Exposition* (New York: Harry N. Abrams, 1989), 165..

62
Novembre, 1881
Oil on canvas; 52 x 97⅝ inches (130 x 248 cm)
Signed and dated lower left: *Birge Harrison / 1881*
Musée des Beaux-Arts de Rennes

Charles Henry Fromuth
1858–1937

Born to German immigrants in Philadelphia, Charles H. Fromuth received his formative art training under Thomas Eakins at the Pennsylvania Academy of the Fine Arts. At the Académie Julian, in Paris, where he enrolled in 1889, Fromuth was quickly dissatisfied with his instructors Tony Robert-Fleury and William Bouguereau. Fromuth had difficulties in complying with Bouguereau's curriculum of drawing from the plaster cast, since he had adopted an entirely different method of figure study in Eakins's life classes. In the summer of 1890 he made his first trip to Concarneau, where he moved into the Hôtel de France, which provided him with both living accommodations and a studio loft. He remained resident of the village until his death in 1937.

The fishing village of Concarneau became popular with American artists around 1880 when the art colony of Pont-Aven grew too densely populated. The one or two inexpensive hotels, run by hospitable owners, provided regular meals and fitted their budgets, making conditions just right for the young artists. The friendliness of the villagers, the old fishing fleet, and unpaved roads all contributed to a setting that reminded them of life in the middle ages. The initial discovery of Concarneau may have been partly accidental, but subsequent "artist-colonizers" arrived with a sense of direction and often with a romantic disposition. Fromuth, like many American artists who went to the coastal village in the 1880s, had read Blanche Willis Howard's novel *Guenn*, which was a romance based on the experiences in Concarneau of Edward Simmons, the first American artist to settle there, in 1881.

In *Morning Haze, Winter, Concarneau*, Fromuth depicts a landmark of the village, a little stone church on the shore. Simmons reported that he had observed Jules Bastien-Lepage painting the church and that it was a motif "we had all tried."[1] Specific weather prevailed during winter and early spring at Concarneau, which Birge Harrison, another American artist, described as "a beautiful silvery gray."[2] Inspired by these weather conditions, Fromuth captured the morning sun muted by haze and casting a mysterious light on the sacred monument.—J. W.

1. Quoted in David Sellin, *Americans in Brittany and Normandy: 1860–1910* (Phoenix, Ariz.: Phoenix Art Museum, 1982), 46.
2. Quoted in ibid., 43.

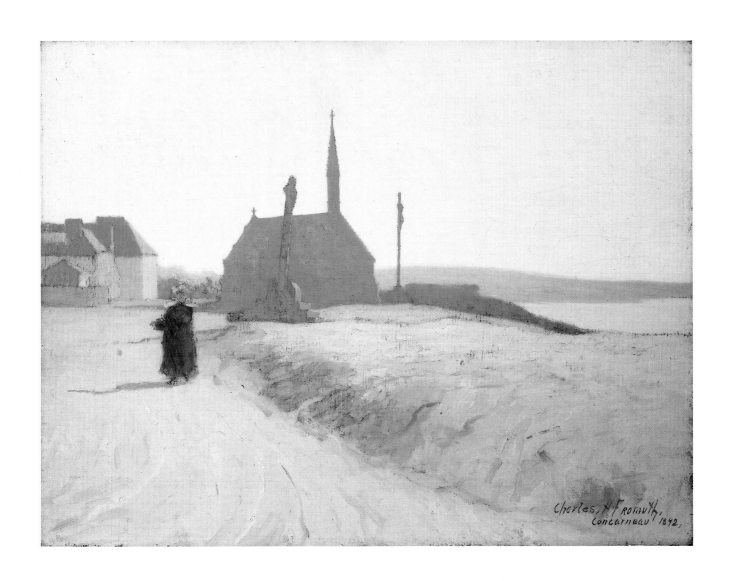

63

Morning Haze, Winter, Concarneau, 1892
Oil on canvas; 18¼ x 24¼ inches (46.4 x 61.6 cm)
Signed and dated lower right: *Charles H. Fromuth, / Concarneau 1892,*
Terra Foundation for the Arts, Daniel J. Terra Collection, 1988.6

Winslow Homer
1836–1910

Winslow Homer was born and grew up in Boston, where he began his painting career during the American Civil War. His first oil paintings were based mostly on sketches of camp life, which he produced as a correspondent for the New York magazine *Harper's Weekly*. *Prisoners from the Front* (fig. 133), which he sent to the Paris Exposition Universelle of 1867 along with another Civil War subject, was the pivotal image of his Civil War oeuvre. Among the eighty-two American paintings at the exposition, which was the first comprehensive show of American art in Europe, Homer's two contributions were rare genre paintings, the majority of the exhibited works being landscapes.

Homer departed for the Continent in December 1866, giving himself time enough to be in Paris when the exposition opened in May 1867. During his ten-month stay in France, Homer divided his time between Paris and Cernay-la-Ville, and let himself be guided by Joseph Foxcroft Cole, a friend of his since the 1850s, when both worked for a lithography firm in Boston. Cole had studied art in Paris and was living there with his Belgian wife when Homer arrived. Cole accompanied Homer to the artists' colony at Cernay, where the French Barbizon painters had a strong presence.

All of Homer's small landscape paintings dating from his few months at Cernay have an affinity with the work of Jean-François Millet. The French painter of heroic peasants, who had settled in Barbizon in 1849, had a great popularity in North America. His work was

Fig. 134
Jean-François Millet, *The Sower*, c. 1850, oil on canvas. Museum of Fine Arts, Boston, Gift of Quincy Adams Shaw through Quincy A. Shaw, Jr., and Mrs. Marian Shaw Haughton, 17.1485

bought by Boston collectors, and his style was emulated by New York and New England artists, including John La Farge and especially William Morris Hunt, Millet's most avid follower and patron. If Homer had not been introduced to Millet's work before his arrival in France, he could not have missed the virtual retrospective that was granted Millet at the Exposition Universelle.

In *Haymakers*, Homer recapitulates and reinterprets Millet's concern with the human figure, the male or female peasant. Both painters relied on simplified compositions to render their depictions of rural life. In a manner similar to Millet's *The Sower* (fig. 134), the figures in *Haymakers* are positioned against a commonplace landscape. Though smaller than Millet's heroic types, these peasant women appear grave and monumental in their erect, stoic pose. Fork and rake over their shoulders, they clearly are representatives of the rural labor force that was so respectfully portrayed by Millet.—J. W.

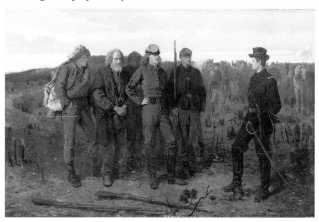

Fig. 133
Winslow Homer, *Prisoners from the Front*, 1866, oil on canvas. Metropolitan Museum of Art, New York, Gift of Mrs. Frank B. Porter, 1922

64
Haymakers, 1867
Oil on canvas; 13 ⅛ x 18¼ inches (33.3 x 46.4 cm)
Signed lower left: *Winslow Homer*
Terra Foundation for the Arts, Daniel J. Terra Collection, 1989.9

Frederick Childe Hassam
1859–1935

Frederick Childe Hassam, who preferred to be called by his second name, was born to an old New England family in Dorchester, Massachusetts, just outside Boston. His father's hardware business, located in downtown Boston, burned down in the fire of 1872, and young Hassam was called upon to contribute to the family income. For a short time he worked for a publishing house, but soon found more suitable employment in a wood engraver's shop. Although he is best known today as one of the foremost American Impressionist painters, Hassam's production in the graphic medium, including lithography and printmaking, was prolific, and he was a successful magazine and book illustrator. In his formative years as a painter, Hassam combined the lessons of his Boston teachers William Rimmer and the German emigrant Ignaz Marcel Gaugengigl with the aesthetic of the Barbizon School as promoted in Boston by William Morris Hunt.

When Hassam left in 1883 for his Grand Tour, he went first to Edinburgh, and from there made his way south via London to the Low Countries, northwestern France, Venice, Florence, and Naples, until he reached Spain. Paris does not appear to have been on his itinerary. *French Peasant Girl* is an early example of Hassam's work in oil, painted during his travels in France, probably in Brittany, which had attracted American artists since Robert Wylie's arrival there in 1864. While Wylie's peasants are rustic types akin to the peasants of older Dutch genre painting (see colorplate 57), Hassam's peasant girl is depicted with the detached perspective of a developing modernist. The artist has established a spatial tension between the solid figure of the young woman close to the picture plane and the field behind her, deeply receding toward the high horizon line. The spectrum of blue, gray, and brown indicates Hassam's training in watercolor with a special affinity to the school of English watercolor painting.

In 1884, when Hassam returned from his first stay in Europe, he established his studio in Boston and painted a number of Tonalist images of the Boston Common and other urban scenes. He married Kathleen Maude Doane that year, and two years later, in 1886, they went to Paris, where they resided at 11 boulevard Clichy. They were later joined by Maude's sister, Cora. Save for an occasional visit with friends in Villiers-le-Bel, Hassam remained in Paris from 1886 to 1889. He exhibited at the Salons of 1887 and 1888, and was represented at the Exposition Universelle the following year.

In *Mrs. Hassam and Her Sister*, the painter depicts the two sisters in the relaxed atmosphere of their Parisian home. With an eye to simplicity and detail, Hassam arranged the figures and objects within a relatively compressed pictorial space. Maude Hassam, depicted in profile, forms a central diagonal running across the plunging diagonal of the floor. Her sister Cora's reflection is faintly seen in the wooden surface of the piano, but this illusionistic effect is suppressed by the overall muted and pastel-like application of paint. Executed shortly before his return to the United States in 1889, *Mrs. Hassam and Her Sister*, with its broken and scratchy brushwork, is testimony to Hassam's stylistic maturity. Though Hassam's "conversion" to Impressionism came on this second trip to the Continent, this work invokes a strong concern for the figure.

Paris was celebrating the centennial of Bastille Day in 1889. Inspired by the festivities and the streets decorated with the French tricolor, Hassam painted his first known group of flag paintings. Although *Les Buttes Montmartre* repeats some of the Tonal qualities of *French Peasant Girl* in the dark attire of the city women, the flag demonstrates Hassam's growing interest in colorism. Loose brushwork, especially evident in the irregular modeling of the road, contrasts with the flatness of the flag and sky. Compared with the flag paintings of Claude Monet and Camille Pissarro, who often established a balcony perspective high above street level, Hassam here introduces a low perspective, which is also unusually angular. With its elevated perspective and deep vista, Hassam's *July 14th, Rue Daunou* (fig. 135), painted during his fourth and last trip to Europe, is more akin to the classic French flag paintings.

Hassam's most concentrated effort at flag paintings is a series of almost thirty images of the decorated streets of New York during the war years of 1916 to 1919. Beginning with one painted on Preparedness Day, May 13, 1916—one year before the United States officially entered World War I—these images are not only testimony of a mature Impressionist style but also capture the patriotic enthusiasm of the nation.

When Hassam returned to the United States in 1889, he moved his studio from Boston to New York. He became an innovator of Impressionism, incorporating into his oeuvre the high-rise buildings that marked the modern transformation of the city. His continuing travels included a one-month sojourn in Cuba in 1895, yet the United States provided ample and fertile subject matter for the artist to employ his Impressionist

aesthetic. Some of his most colorful and vivid paintings from the 1890s derive from summer trips to Appledore, an island off the coast of New Hampshire.

In 1896 Hassam went to Europe a third time, traveling to Italy, France, and England and continuing to investigate modern painterly modes. In a number of paintings of the Spanish Steps in Rome, Hassam developed a colorism that was more scintillating and expressive then any of the Parisian scenes he had painted a decade earlier. He also went to Pont-Aven, still a magnet for American artists, where he explored the possibilities of a Pointillist style, in which colors are applied in dots according to a systematic plan.

Outside the Café on the Grand Boulevard, dated by the artist 1898, was painted in Paris on this third trip to France. An *en passant* view of a typical Parisian café scene, rendered in a quick, pictorial notation, it is a

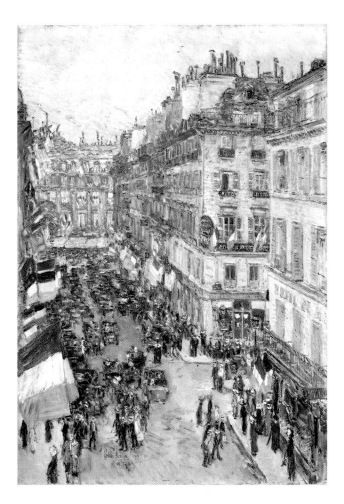

Fig. 135
Childe Hassam, *July 14th, Rue Daunou,* 1910/1914, oil on canvas. Metropolitan Museum of Art, New York, George A. Hearn Fund, 1929

brilliant example of the Impressionist "glimpse" aesthetic. In a sure and facile hand, the artist as casual observer outlines the basic contours of the forms; an elegant woman, a man with a newspaper, a waiter, and a few objects are the components of a quintessential scene of modern life. A French precursor of *Outside the Café* was Jean Louis Forain who painted similar café scenes in gouache, one of which, *Au café* (fig. 136), was exhibited in Paris at the Fourth Impressionist Exhibition in 1879.

Late in his career Hassam divided his time between New York City and East Hampton, a Colonial town in Suffolk County, Long Island. The oil paintings, watercolors, pencil studies, and etchings that Hassam produced in East Hampton idyllic, classically balanced compositions.—J. W.

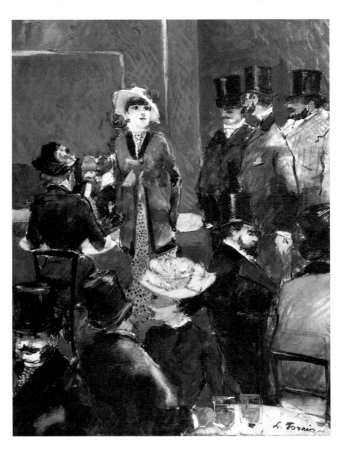

Fig. 136
Jean Louis Forain, *Au café*, c. 1879, gouache.
Courtesy E. J. van Wisselingh & Co., Naarden

65
French Peasant Girl, c. 1883
Oil on canvas; 21⅝ x 13⅞ inches (54.9 x 35.3 cm)
Monogram of the artist lower right
Terra Museum of American Art, Chicago, 1989.21

65

66

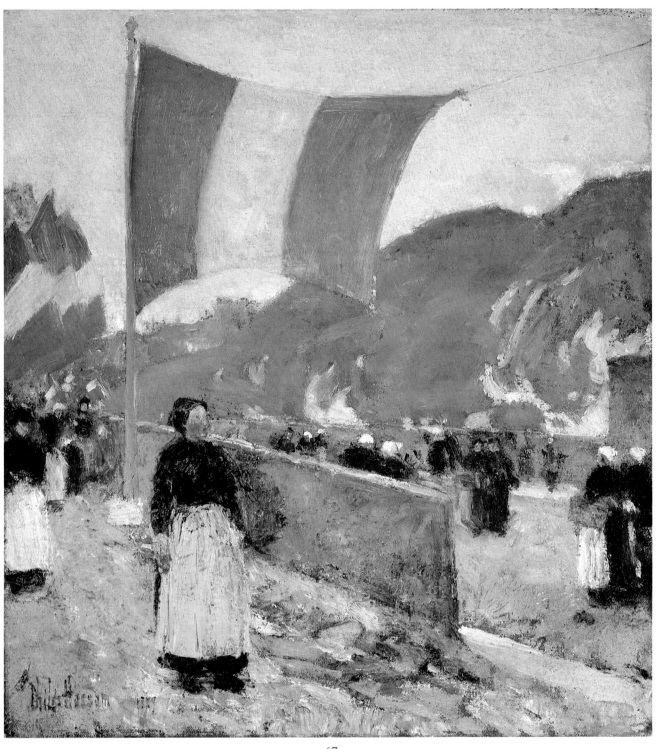

67

66
Mrs. Hassam and Her Sister, 1889
Oil on canvas; 9¹³⁄₁₆ x 6⅛ inches (24.9 x 15.6 cm)
Signed and dated lower left: *Childe Hassam Paris 1889*
Daniel J. Terra Collection, 17.1980

67
Les Buttes, Montmartre, July 14, 1889
Oil on canvas; 11½ x 10⅝ inches (29.2 x 27.0 cm)
Signed and dated lower left: *Childe Hassam 1889*
Terra Foundation for the Arts, Daniel J. Terra Collection, 1991.2

68
Outside the Café on the Grand Boulevard, 1898
Gouache with charcoal on brown paper; 15⅝ x 11¼ inches (39.8 x 28.6 cm)
Signed and dated lower right: *Childe Hassam 1898*
Terra Foundation for the Arts, Daniel J. Terra Collection, 1989.10

68

Fernand Lungren
1857–1932

Fernand Lungren's ancestors were among the first Swedish immigrants to Colonial America in the seventeenth century. Lungren was born in Hagerstown, Maryland, a community of largely Swedish settlers. In Toledo, Ohio, where the Lungrens migrated during the Civil War, and where he grew up, Lungren developed a friendship with the artist Kenyon Cox. In the mid-1870s he planned to accompany Cox to Paris, but the lack of financial support prevented his trip. He went to New York, however, where he was successful as an illustrator for *Scribner's Magazine* and became a member of the Tile Club, an organization for the most accomplished artists in New York. In June 1882 he was able to realize a trip to France, where he remained for two years.

Although he spent some time at the Académie Julian, Lungren did not seek rigorous art training in Paris. One of his favorite activities was taking strolls along the river embankments, looking at, and occasionally buying, Japanese prints at the bookstalls. Painted during the year of his arrival, *Paris Street Scene* obviously was inspired by one of the many visual impressions that Lungren, the American *flâneur*, would absorb during his Parisian walks. In this watercolor, translucent tonal washes define the silhouette of the Parisian skyline. The medium is more opaquely applied in the foreground details of the umbrellas and clothing of the pedestrians. Lungren minimizes the use of color, using only touches of green on the bridge, muted red in a woman's coat, and ocher for another's hair. The subject of crowds of people on their way along wet pavement was not entirely new to him. In New York he had rendered similar aspects of city life in a number of oils and pen-and-ink drawings that were later published as magazine illustrations.

The subject of street life continued to preoccupy Lungren during a stay in London in 1899. Here he met his American compatriot James Abbott McNeill Whistler and became one of his close associates. Always an explorer of the exotic and unknown, Lungren and his wife went to Egypt and sailed down the Nile to Sudan. His Egyptian subjects were exhibited in London in 1901. By 1906 he had settled in Santa Barbara, California, where he concentrated on oil paintings of the American West.—J. W.

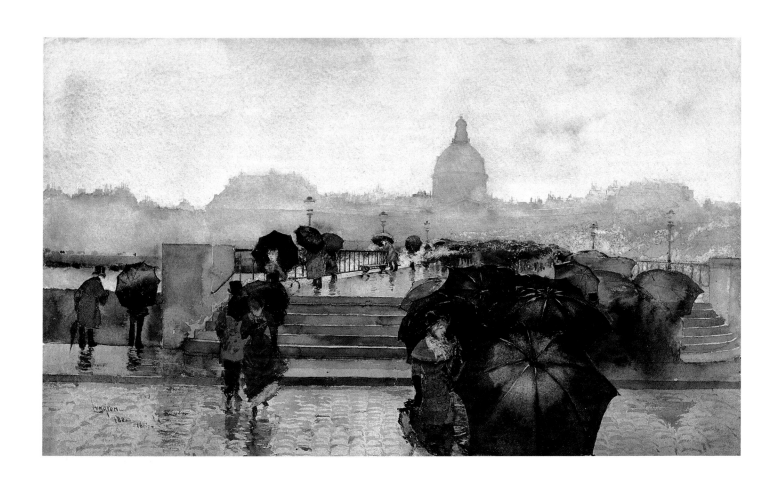

69
Paris Street Scene, 1882
Watercolor; 12⅝ x 21½ inches (32.1 x 54.6 cm)
Signed and dated lower left: *Lungren / 1882 / Paris*
Terra Foundation for the Arts, Daniel J. Terra Collection, 1989.25

Charles Courtney Curran
1861–1942

Kentucky-born Charles Courtney Curran was first trained at the Cincinnati School of Design and later went to New York to study at the National Academy of Design and the Art Students League. Although his educational background was academic and traditional, Curran was familiar with the works produced by his American colleagues who were working in France in the 1880s. In New York during that decade he achieved critical acclaim for his paintings that reflected the French tradition, even though he did not first visit France until late in 1888.

It was during this first visit that he painted *Paris at Night,* a bustling street scene brilliantly illuminated and rendered in diffuse light. Street illumination by means of gas lamps was a significant urban nineteenth-century innovation, allowing safe mobility at night. Curran depicts in this rainy Parisian night scene the dazzling spectacle of street lights reflected by the wet pavement.

Curran would make other trips to Paris, but French Impressionism did not have a strong impact on his work. After 1903 he resided most of the time at the Cragsmoor artists' colony, in upstate New York. There, the modern young woman, crisply outlined in an outdoor setting or silhouetted against the sky, became his principal theme.—J. W.

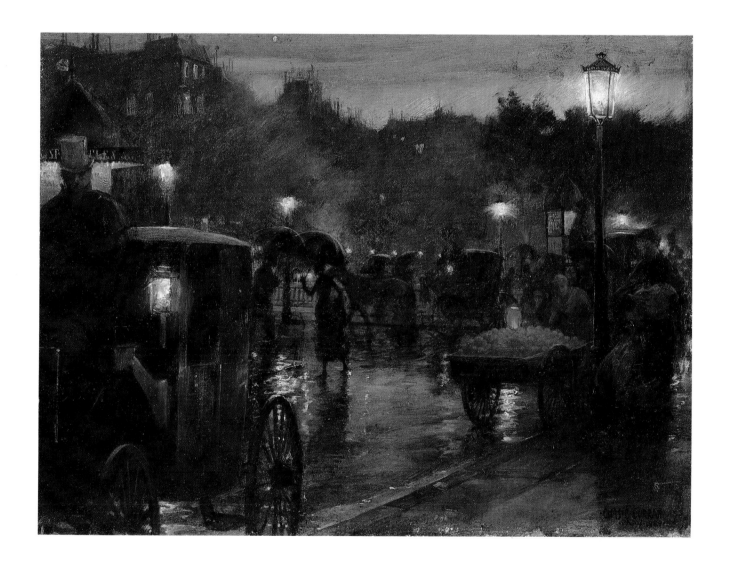

70
Paris at Night, 1889
Oil on panel; 9¹⁄₁₆ x 12¼ inches (23.0 x 31.1 cm)
Signed and dated lower right: *.CHAS.C.CURRAN. / .PARIS.1889.*
Terra Foundation for the Arts, Daniel J. Terra Collection, 1989.12

Mary Cassatt
1844–1926

Mary Cassatt was a prominent American expatriate painter with a cosmopolitan identity comparable to that of James Abbott McNeill Whistler and John Singer Sargent. During Cassatt's lifetime her work found recognition in both her country of choice, France, and her country of birth, the United States.

Born to an affluent family from Pittsburgh, Pennsylvania, Cassatt was still a child when she went to Europe with her parents in 1851. While in Europe, she may well have had a formative experience as an artist; some significant art shows were held in Paris when the Cassatts were there in 1855. Back home, Mary Cassatt was only fifteen when she enrolled at the Pennsylvania Academy of the Fine Arts. When she returned to Paris in 1866 to study painting, the Ecole des Beaux-Arts did not admit women, but Cassatt managed to get private criticism from Jean-Léon Gérôme. Other French influences during the early period of her career came from studies with Thomas Couture and the genre painters Edouard Frère and Paul Soyer.

Cassatt left Europe during the Franco-Prussian War, but returned in 1871. During the early 1870s, she absorbed the European artistic tradition. At the Prado in Madrid she studied the work of the Spanish old master Diego Velázquez, whom she held in high esteem. But she also grew increasingly aware of the more current artistic developments. Reflecting this strive for a modern idiom, her paintings were rejected at the French Salon in 1877. Encouraged by her friend Edgar Degas, Cassatt decided to participate in the annual exhibitions of the Impressionist group, where, beginning in 1879, she successfully presented her modern versions of the mother and child theme.

Cassatt was accompanied by at least one family member during her European sojourns. From the late 1870s and into the 1890s, she enjoyed the company of her parents and her older sister, Lydia, all living in Paris. Lydia, who died in 1882, was Cassatt's most cherished model. Always attached to her family, Cassatt drew inspiration from her nieces and nephews, children of her brothers Alexander and J. Gardner Cassatt and their respective wives Lois and Jenny. However, Cassatt also hired models to sit for her studies of the mother and child theme. Rendering on paper or canvas what must have been to the childless artist a somewhat mysterious bond, Cassatt was both detached observer and sympathetic woman. In its sketchiness and chalky, pastel-like texture, *Jenny and Her Sleepy Child* relates to Cassatt's Impressionism of the preceding decade and a half. Yet it also foreshadows the artist's renewed interest in linearity and rounded forms. Cassatt did a number of images portraying Jenny with one of her children. Here, Cassatt's sister-in-law is shown holding her first child, Gardner, about three or four years old. In her many variations of the mother and child theme, Cassatt reflects the modern acceptance of everyday life as a valid subject for art, rather than looking back to the Renaissance iconography of Madonna and Child.

Beginning in the early 1890s, Cassatt had a summer residence in the country, keeping her Parisian apartment and studio at 10 rue de Marignan. She rented the Château Bachevillers on the Oise, near Chaumont-en-Vexin, until 1894, when she bought and renovated the Château de Beaufresne at Mesnil-Théribus, Oise. Though distracted by the ongoing renovation during her first summer at Beaufresne,

71
Jenny and Her Sleepy Child, c. 1891
Oil on canvas; 28¹⁵⁄₁₆ x 23¾ inches (73.5 x 60.3 cm)
Signed lower right: *Mary Cassatt*
Terra Foundation for the Arts, Daniel J. Terra Collection, 1988.24

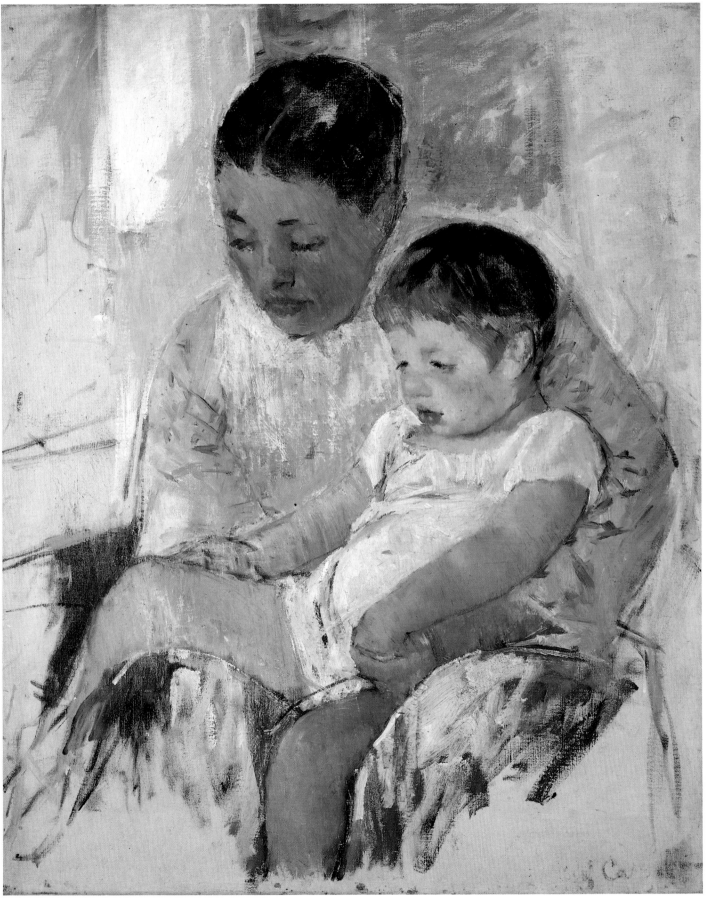

71

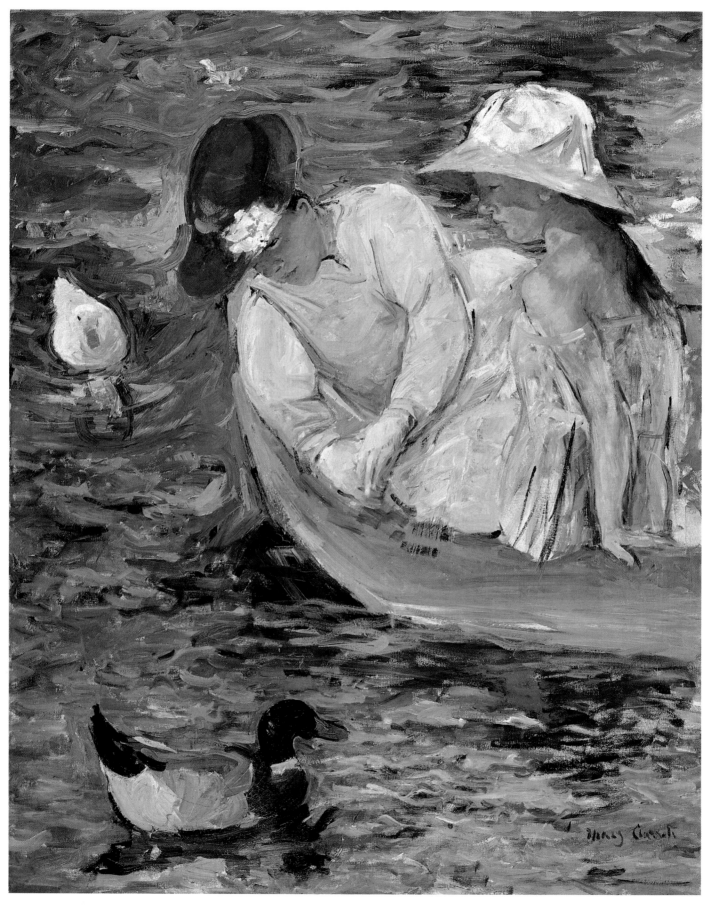

72

Cassatt was still able to produce oil paintings such as *Summertime* and a horizontal version with the same title (Armand Hammer Foundation, Los Angeles). For *Summertime*, depicting a boating scene on the pond that was part of her property, Cassatt may have hired models. Taking full advantage of the outdoor setting of water and reflecting sun, she returned to the loose brushwork that had characterized her Impressionistic works of a decade earlier. A significant inspiration for the cropping of the boat, absence of horizon, and high vantage point came from her studies of Japanese woodcuts.

Cassatt first began to explore the print medium in 1879, when Degas invited her to participate in the projected journal *Le Jour et la nuit,* which was to publish original prints by Cassatt, Degas, and other French Impressionists. The journal never materialized, but Cassatt, Degas, and Camille Pissarro were able to show their prints the following year at the Fifth Impressionist Exhibition. Cassatt continued to experiment with soft-ground etching, one of Degas's favorite print mediums, and also, probably under the guidance of the French printer Desboutin, took up the drypoint medium. In the spring of 1890 she visited the exhibition of Japanese ukiyo-e prints, or woodcuts, at the Ecole des Beaux-Arts, and it was soon after this exhibition that she started to make color prints. In less than a decade, she produced her main body of color prints, nineteen images in a varying number of states.

The color prints *The Lamp* and *In the Omnibus* were among the first group of ten, printed in an edition of twenty-five impressions. Inspired by the thematic coherence of Japanese prints, which often appeared as cycles, Cassatt's set of ten prints depicts aspects of daily life from morning to night. The Orientalism of *The Lamp* is apparent in the ornamentation of table, lamp, fan, and the beautifully elongated woman's neck, subtly echoing the eroticism of Japanese art. *In the Omnibus* is unique among the set of ten prints with its landscape in the background; the river and bridge suggest a Parisian locale. Also unparalleled in Cassatt's work is the transference of the mother and child theme into a clearly public space. The ability to travel independently and enjoy all means of public transportation, an important aspect in the life of modern women, is depicted by Cassatt as a commonplace situation.

Cassatt's first set of ten color prints was exhibited in 1891 at the Galeries Durand-Ruel in connection with but in a separate room from an exhibition of works by members of the Société des Peintres-Graveurs Français, whose membership included only French-born artists. The sale of these prints was slow, though Durand-Ruel tried to sell a number of impressions at his New York gallery.

Ironically, while successfully working in the relatively small drypoint medium, Cassatt was commissioned to paint the monumental mural *Modern Woman,* decorating the Woman's Building at the World's Columbian Exposition in Chicago (now lost). By early 1893 Cassatt had completed and was able to ship her large canvas, and she then began work on a group of prints, paintings, and pastels related to the mural and

72
Summertime, c. 1894
Oil on canvas; 39⅝ x 32 inches (100.7 x 81.3 cm)
Signed lower right: *Mary Cassatt*
Terra Foundation for the Arts, Daniel J. Terra Collection, 1988.25

73
The Lamp, 1890–91
Color print with drypoint, soft ground, and aquatint; third state; plate: 12½ x 9⅞ inches (31.8 x 25.1 cm)
Monogram of the artist on plate bottom center; inscribed lower right margin:
Édition de 25 épreuves Imprimée par l'artiste et M. Leroy / Mary Cassatt
Daniel J. Terra Collection, 47.1985

74
In the Omnibus, 1890–91
Color print with drypoint and soft ground; fourth state; plate: 14⅞₆ x 10⅞₆ inches (36.7 x 26.9 cm)
Monogram of the artist on plate bottom center; inscribed lower right margin:
Imprimée par l'artiste et M. Leroy / Mary Cassatt / (25 épreuves)
Daniel J. Terra Collection, 29.1985

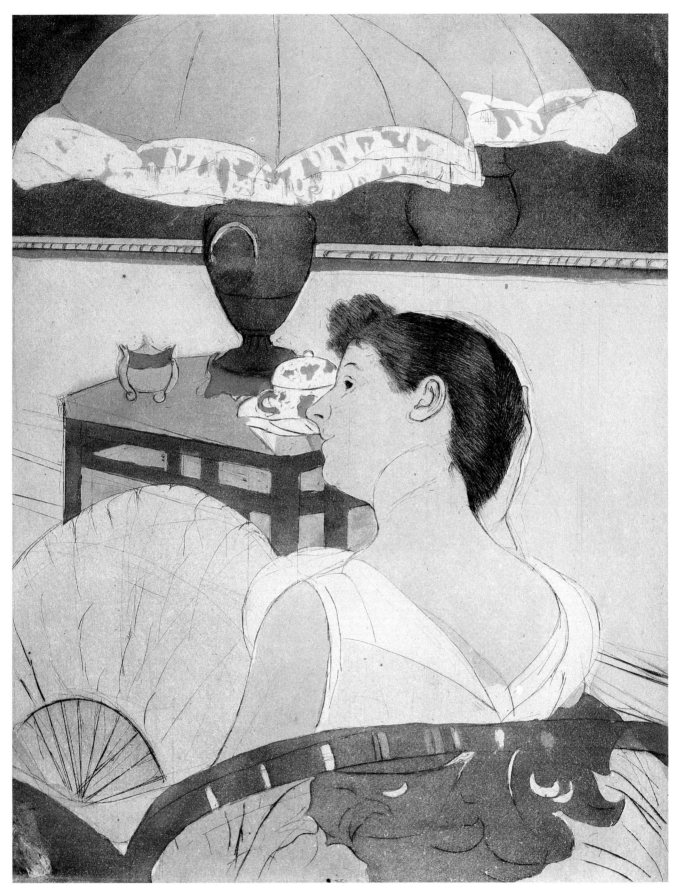

73

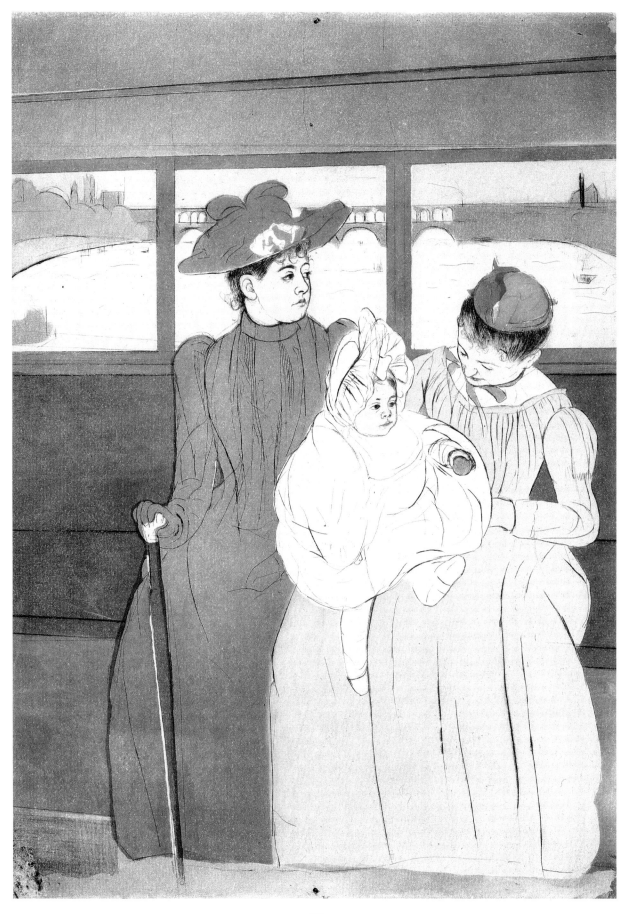

74

its theme, modern woman. *The Banjo Lesson*, which was probably printed in as many as forty impressions, is a loose adaptation of a bucolic scene in the mural, with a female banjo player and two other women, one of them dancing and the other sitting and listening. *The Banjo Lesson* was one of two new color prints that Cassatt exhibited in her first large retrospective at Durand-Ruel's gallery in Paris, late in 1893. Three of its preliminary states were included in the exhibition, an unusual documentation of the artist as practitioner but also of the aesthetic value of each single state of a print. In the fourth and final state of *The Banjo Lesson*, pulled in 1894, Cassatt used the monotype technique to apply color to the girl's dress and other parts of the image.

Feeding the Ducks, which relates directly to the oil painting *Summertime* (colorplate 72), was probably printed at the Château de Beaufresne, where Cassatt moved her press sometime in 1894. The cropped boat and the position of the ducks as well as the color spectrum of yellow, blue, and green, are especially reminiscent of the horizontal version of *Summertime* (Armand Hammer Foundation, Los Angeles). The monotype touches on the purple-to-black duck add a painterly quality to the flatness of the print.

Under the Horse-Chestnut Tree and *By the Pond* belong to a group of color prints that Cassatt completed before she departed in 1898 for her first visit to the United States in twenty-three years. In these two prints she once again returned to the mother and child theme, portraying a dark-haired mother and her blond infant boy. *Under the Horse-Chestnut Tree* was Cassatt's contribution to the print society L'Estampe Nouvelle and the only color print not distributed by Durand-Ruel. *By the Pond* was probably among the prints that she carried to her native country to deliver to Durand-Ruel's New York gallery. Both prints in their final stages feature strong modeling of flesh through the use of aquatint, deemphasizing the linearity of the print medium. Also printed in a larger format than the previous sets, these final color prints were executed in a painterly style.

In her production of color prints, Cassatt went well beyond imitating the Japanese printing tradition. The printing process allowed Cassatt, Pissarro, and others to marry their Impressionism to the recently discovered Oriental aesthetic and to the rigid framework of the printing press.

Cassatt started to paint in pastel early in her career and, especially through her contact with Degas, developed a great facility in the medium. Like Degas, she is known to have used methods of enhancing the durability of the pastel work, such as adding fixture to the pastel particles or mixing pastel with oil paint. *The Cup of Chocolate* evidences Cassatt's sureness in drawing a character sketch in pastel, especially in modeling with great finesse the young upper-class woman. *The Cup of Chocolate* was included in Cassatt's second one-woman exhibition in New York, held at Durand-Ruel's gallery in 1898. Cassatt almost exclusively painted in pastel during her visit to the United States in 1898–99, producing numerous sketches of her family members.

Cassatt continued to elaborate on the mother and child subject and to produce portraits in oil and pastel well into the next century, but in 1915, due to virtual blindness, she had to abandon painting altogether.
—J. W.

75
The Banjo Lesson, 1894
Color print with drypoint and soft ground; fourth state; plate: 11¹¹⁄₁₆ x 9⅜ inches (29.7 x 23.8 cm)
Monogram of the artist on plate bottom center; signed lower right margin: *Mary Cassatt*
Daniel J. Terra Collection, 36.1986

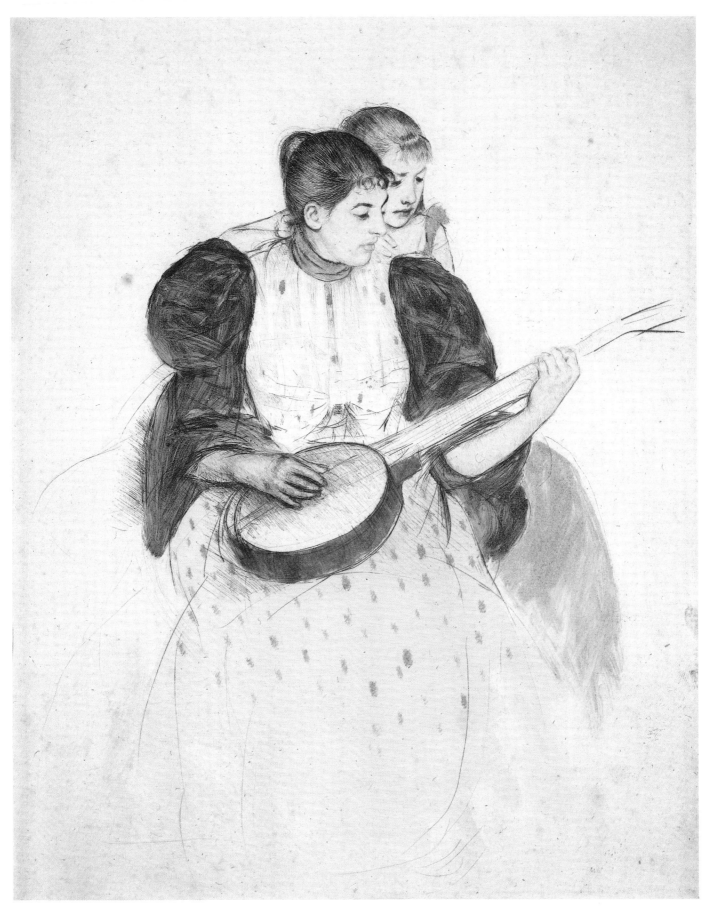

75

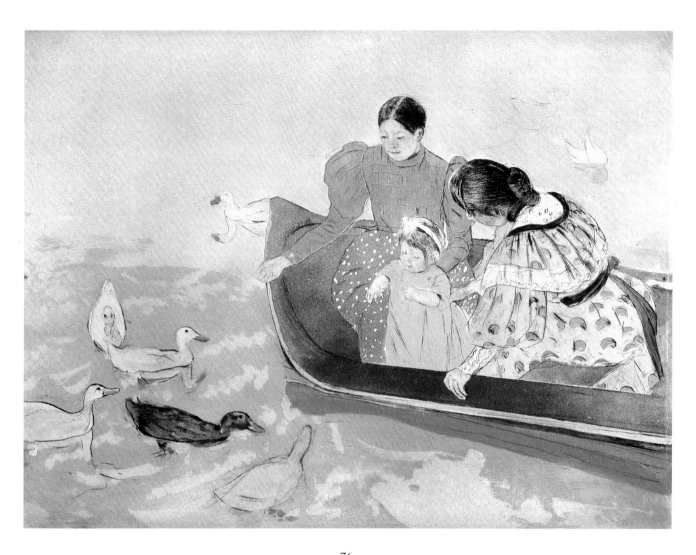

76
Feeding the Ducks, c. 1894
Color print with drypoint over soft ground and aquatint; third state; plate: 11¾ x 15¾ inches (29.8 x 40.0 cm)
Signed lower right margin: *Mary Cassatt*
Daniel J. Terra Collection, 46.1985

77
Under the Horse-Chestnut Tree, c. 1895
Color print with drypoint and aquatint; fourth state; plate: 16 x 11⅚ inches (40.7 x 28.7 cm)
Signed lower right margin: *Mary Cassatt;* inscribed lower left margin: *No 9*
Terra Foundation for the Arts, Daniel J. Terra Collection, 1987.17

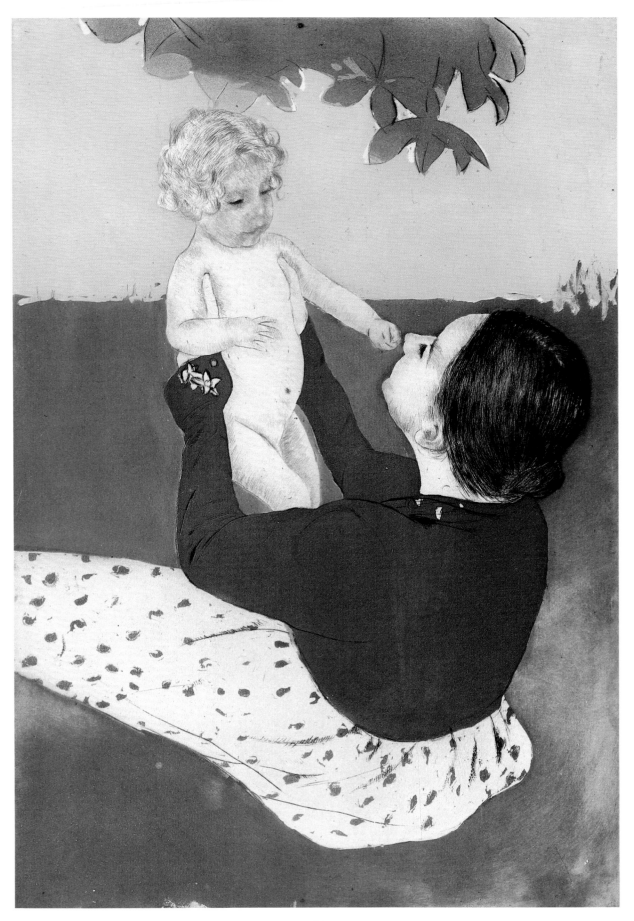

77

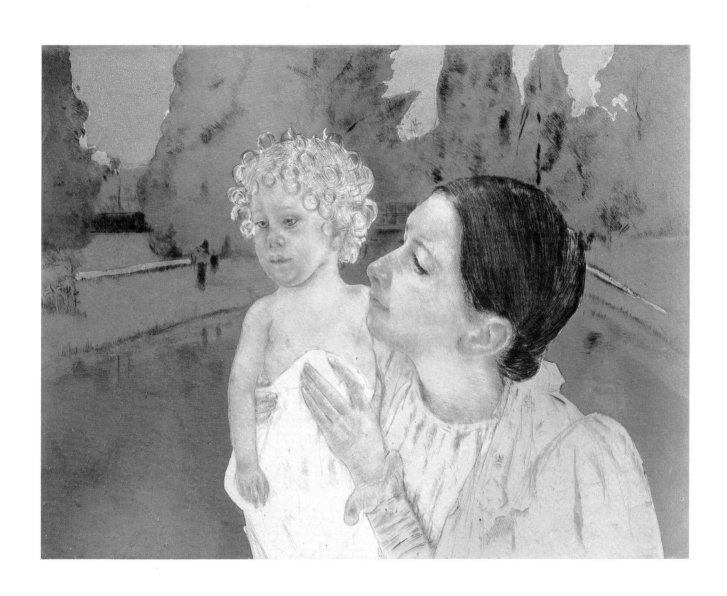

78
By the Pond, c. 1898
Color print with drypoint and aquatint; fourth state; plate: 13 x 16⅞ inches (33.0 x 42.9 cm)
Signed lower right margin: *Mary Cassatt*
Daniel J. Terra Collection, 34.1985

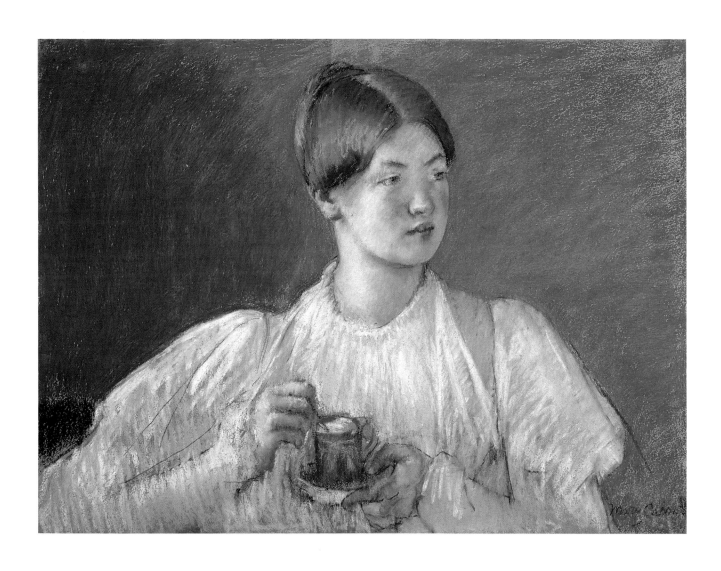

79
The Cup of Chocolate, 1897
Pastel on paper mounted on canvas; 21¼ x 28¾ inches (54.0 x 73.0 cm)
Signed lower right: *Mary Cassatt*
Daniel J. Terra Collection, 30.1986

Martha Walter
1875–1976

Martha Walter was born in Philadelphia and graduated from the Pennsylvania Academy of the Fine Arts, where many women artists started their careers in the second half of the nineteenth century, including Mary Cassatt and Cecilia Beaux. Such faculty members as William Merritt Chase, Robert Vonnoh, and later Hugh Breckenridge introduced students at the Pennsylvania Academy to Impressionist principles. Walter, working under Chase, developed a virtuoso manner derived from her teacher, but also reminiscent of John Singer Sargent's bravura brushstroke. Her reputation as a plein air painter was based on the Impressionism of her beach scenes with children, many of them painted at Gloucester, Massachusetts.

In 1903 Walter went abroad on a fellowship, traveling through Holland, Italy, Spain, and France. In Paris she studied at the Académie de la Grande Chaumière and at the Académie Julian. Beginning in 1905, when she had most likely returned to Philadelphia, she exhibited European subjects at the Pennsylvania Academy. In 1909 the Academy awarded her the Mary Smith Prize for the best painting by a Philadelphia woman artist shown at the annual exhibition. The following year she exhibited *A la crémerie,* one of many Parisian scenes she produced during her lifetime. Walter rendered this sparsely decorated interior of a small restaurant with a facile and broadly applied brush. In a play with perspective—a theme appearing in many variations in French Impressionism—three faces are reflected in a large mirror, identified by an inscription on the back of the painting as Alice Schille (misspelled as "Shilly"), Martha Walter, and Alice Murphy. Walter has portrayed three American artists in Paris, observers of but also contributors to an artistic ambiance. Walter taught at the New York School of Art and in Brittany. She painted well into her nineties.—J. W.

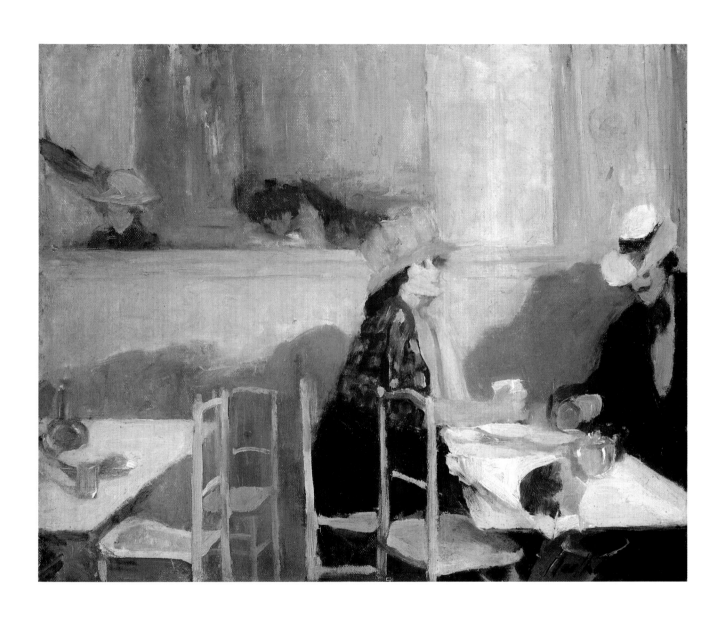

80

A la crémerie (At the Restaurant), 1910
Oil on canvasboard; 12⅞ x 16 inches (32.7 x 40.7 cm)
Signed lower right: *Martha Walter;* inscribed on back:
figures reflected in mirror / left-Alice Shilly / center-Martha Walter / right-Alice Murphy from Kansas City, Mo.
Daniel J. Terra Collection, 13.1981

Henry Ossawa Tanner
1859–1937

Henry Ossawa Tanner was the first African American artist to expatriate to France. His father, Benjamin Tanner, a minister of the African Methodist Episcopal Church, pastored in Washington, D.C., and Baltimore, and edited a religious newspaper in Philadelphia until he was elected bishop of his church in 1888. Henry O. Tanner studied with several amateur artists in Philadelphia before registering in the antique class at the Pennsylvania Academy of the Fine Arts in 1879, where he studied with Thomas Eakins. Tanner first specialized in marine and animal painting, and for a short while he ran his own photography studio in Atlanta, Georgia.

Tanner's first visit to Paris was a brief one in 1881; he returned in 1891 to enroll at the Académie Julian, studying under Benjamin Constant. Though he intermittently returned to the United States, Tanner, his wife Jessie Olssen, whom he married in London in 1899, and their son, Jesse, remained based in France. He became a member of the American Art Club in France in 1893 and from 1894 to 1899 regularly exhibited at the Salon. Four of his Salon works were religious subjects conceived with the spiritual sincerity of a painter rooted in a deep religiosity. Tanner made trips to North Africa and the Near East and may have been inspired by French nineteenth-century Orientalism, deriving from Eugène Delacroix and Jean-Léon Gérôme. He also visited Pont-Aven and Concarneau in the 1890s and later owned a summer house in Trépied, Picardy.

Les Invalides, Paris, which depicts the repository of Napoleon's remains, is one of a small number of urban scenes by Tanner. In painting specific Parisian sites, he chose to represent monuments as isolated buildings with minimal surroundings. *Les Invalides* recalls the *pochade,* a quickly executed sketch favored by American artists around the turn of the century. Though small in size, the painting conveys a sense of monumentality. Tanner introduces a modern, dynamic arrangement of space, with one diagonal dividing street level from architecture and another diagonal along which the figures are positioned. A large area of the composition is occupied by the sky, which may be an indication of Tanner's painting experience at the Brittany coast.—J. W.

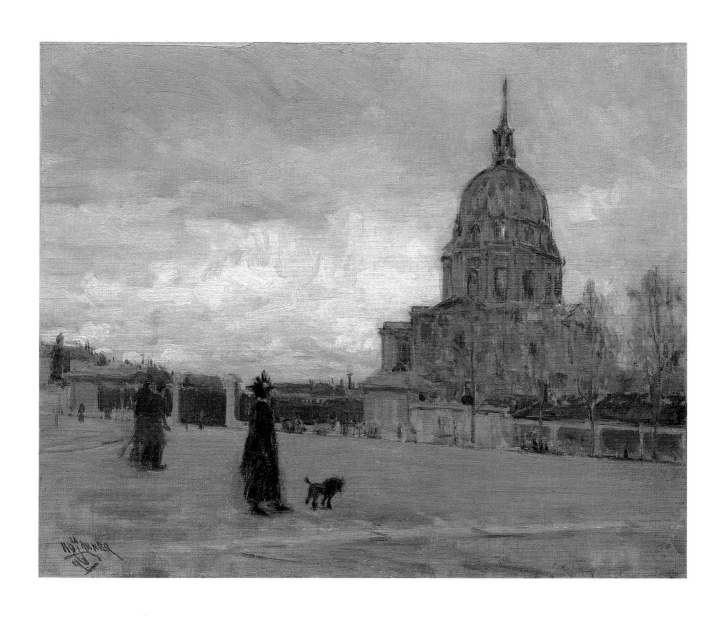

81

Les Invalides, Paris, 1896

Oil on canvas; 13⅛ x 16⅛ inches (33.3 x 41.0 cm)

Signed and dated lower left: *H. O. Tanner / 96*

Daniel J. Terra Collection, 27.1983

Maurice Brazil Prendergast
1858–1924

Born in St. John's, Newfoundland, Maurice Prendergast was raised in Boston, which remained his home until he moved to New York in 1914. Beginning as an apprentice to an illustrator, he eventually became a uniquely modern American painter. Recognizing his technical facilities, a group of Boston patrons sponsored him to study abroad. With his brother, Charles, a distinguished American designer of picture frames, Maurice Prendergast arrived in Paris in 1891. He enrolled at the académies Julian and Colarossi, but does not seem to have followed a strict curriculum. Instead, he began to explore the monotype, drawing heavily on a sketchbook of scenes from Boston that he had brought abroad with him, but also depicting Parisian street scenes such as *Early Evening, Paris* (fig. 137). Prendergast used the same motif of the single female figure on a boulevard for his oil paintings, as in *Lady on the Boulevard (The Green Cape)* (fig. 138). The Canadian painter James Wilson Morrice, his friend and fellow student at Julian's, may have introduced Prendergast to the *pochade*, a small oil study often painted on wooden panel. *The Tuileries Gardens, Paris* is painted in the informal manner of the *pochade*, small in format and executed in a rather free brushstroke.

During his three-year stay in France, from 1891 to 1894, his work showed an affinity with the French Nabis painters Pierre Bonnard and Edouard Vuillard. After another trip to France in 1907, Prendergast's work grew more intense in color and abstract in form, emulating the innovations of Paul Cézanne and Henri Matisse. His position as an American avant-garde artist was underlined by the inclusion of his work in the 1913 International Exhibition of Modern Art in New York, also known as the Armory Show, which for the first time displayed American modernism side by side with the most advanced European art movements. Throughout the rest of his career, Prendergast was recognized and supported by progressive American art collectors.—J. W.

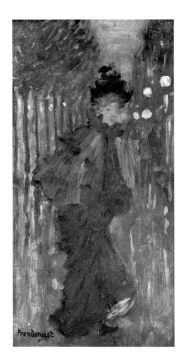

Fig. 137
Maurice Prendergast, *Early Evening, Paris*, 1891–94, monotype. Daniel J. Terra Collection, 16.1982

Fig. 138
Maurice Prendergast, *Lady on the Boulevard (The Green Cape)*, 1892–94, oil on panel. Daniel J. Terra Collection, 27.1980

82
The Tuileries Gardens, Paris, 1892–94
Oil on canvas; 12⅞ x 9⅝ inches (32.7 x 24.5 cm)
Signed lower left: *Prendergast / Paris*
Daniel J. Terra Collection, 46.1980

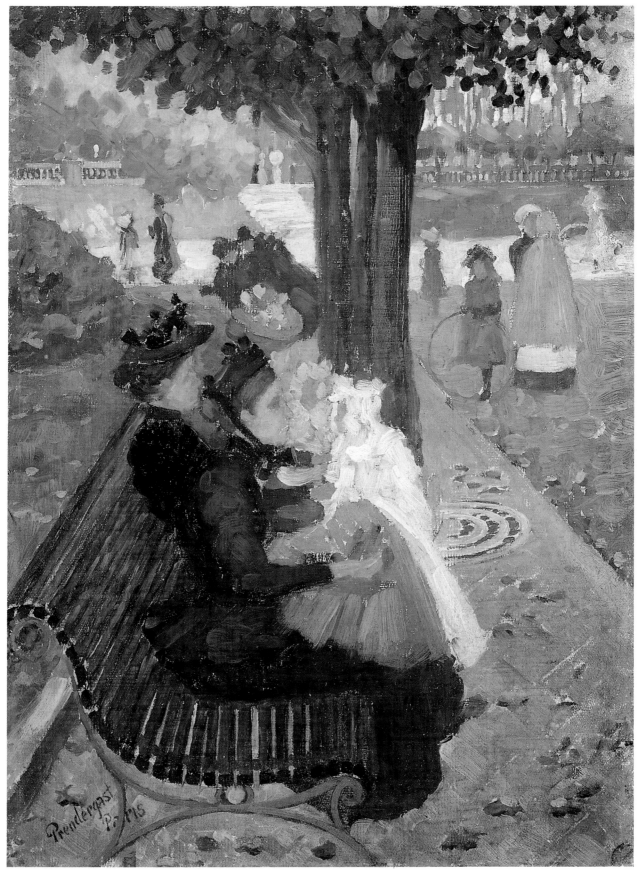

82

James Wilson Morrice
1865–1924

James Wilson Morrice was born in Montreal where his father was a well-to-do textile merchant of Scottish origin. He gave up his law studies at the University of Toronto to pursue his artistic inclinations. One of Morrice's early works, submitted in 1885 to the Royal Canadian Academy, was rejected. However, he received support from a Montreal art dealer and also from a private patron. Around 1890 he settled in Paris, studying at the Ecole des Beaux-Arts and the Académie Julian. Here he met and befriended Maurice Prendergast, who arrived in 1891. In Paris, where he lived on the rue St-Georges and later in the Latin Quarter, Morrice enjoyed friendships with the poets Stéphane Mallarmé and Paul Verlaine. At different stages of his career he became attracted to the art of James Abbott McNeill Whistler, Paul Gauguin, and Henri Matisse. In 1911 he followed Matisse to Morocco. For some years he made regular trips home to Canada, and exhibited his views of Montreal in Paris and London. After his father's death, however, he lost all contact with Montreal.

Morrice's favorite method of outdoor painting was that of the *pochade*, a quickly executed oil sketch, usually on a small wooden panel. *Along the Seine* has all the features of the *pochade*; it is a freely executed impression, sketching the basic composition and color of its subject. First practiced by the English painter John Constable, nineteenth-century landscape painters used the *pochade* as a "first draft," which they took from outdoors into the studio. Morrice and others valued the *pochade* for its own right. In Robert Henri, whom he met in 1895, Morrice found an American artist who shared his appreciation of the *pochade*. Together they traveled along the Seine or sat in cafés and worked on their sketches.—J. W.

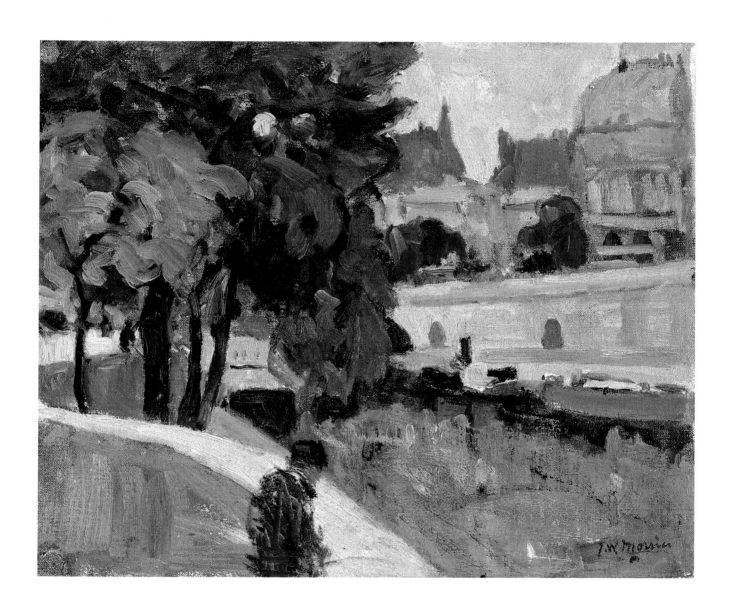

83
Along the Seine, n.d.
Oil on canvasboard; 9 x 16⁵⁄₁₆ inches (22.9 x 28.8 cm)
Signed lower right: *J. W. Morrice*
Terra Foundation for the Arts, Daniel J. Terra Collection, 1989.19

Edward Willis Redfield
1869–1965

Edward Redfield was the central figure of a group of artists referred to as the Pennsylvania School of Landscape Painters. Together with Elmer Schofield and Daniel Garber, Redfield became famous for an original style of landscape painting that flourished in the early twentieth century and evolved separately from American Impressionism. He was born in Bridgeville, Delaware, and grew up in Philadelphia. After two European sojourns, he settled in New Hope, Pennsylvania, which had a small artists' colony, and painted the rural landscape of low hills and detached farm buildings along the Delaware River. Redfield's favorite subject was the winter landscape, as in *The Breaking of Winter* (fig. 139). His renderings of this season are less moody than John Twachtman's and have more in common with the expressive winter scenes of Ernest Lawson.

During his first stay in France, beginning in 1889, Redfield attended the Académie Julian and later the Ecole des Beaux-Arts, academic institutions where American painters traditionally sought instruction. For Redfield, however, the academic training was a transitional period in developing an independant style of landscape painting. During his second extended stay, between 1898 and 1900, Redfield and his wife moved to Alfortville, outside Paris, where the Seine and the Marne meet. The somber winter scene *France*, which was painted in this period, is an example of American Tonalism. Though not a coherent movement in itself, Tonalism challenged Impressionism and its concern with sunlight and high-key colorism as the central elements in modern plein air painting. Redfield's working method was to paint out-of-doors, as in winter landscapes such as *France*. Redfield's friend and colleague Robert Henri painted in a similarly dark mode at this time. His *La Neige*, 1899 (colorplate 85) reveals the two artists as kindred spirits in their Tonalist approach to urban scenes.—J. W.

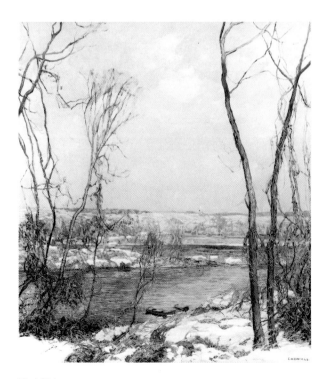

Fig. 139
Edward Willis Redfield, *The Breaking of Winter*, c. 1914, oil on canvas. Daniel J. Terra Collection, 49.1980

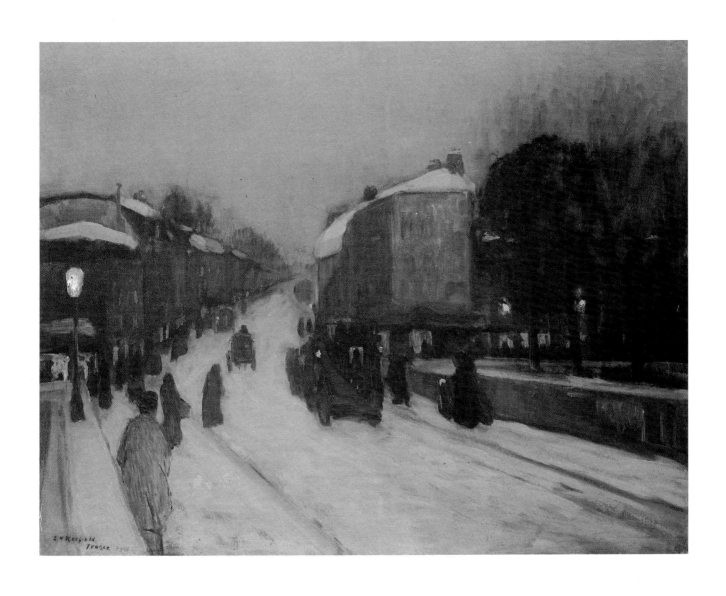

84
France, 1898–99
Oil on canvas; 31¼ x 40³⁄₁₆ inches (79.4 x 102.1 cm)
Signed and dated lower left: *E W Redfield / France* [date illegible]
Daniel J. Terra Collection, 3.1990

Robert Henri
1865–1929

Robert Henri was born in Cincinnati as Robert Henry Cozad. His ancestors were French Huguenots who had fled from Normandy in the sixteenth century. Before he entered the Pennsylvania Academy of the Fine Arts in 1886, Henri had been a sign painter for his father and a political cartoonist. One of his teachers at the Academy was Thomas Hovenden, who had studied with Alexandre Cabanel in Paris and also had been active in Pont-Aven. With a group of fellow students Henri went to Paris in 1888 and enrolled at the Académie Julian, where he remained until 1891, when he was admitted to the Ecole des Beaux-Arts. In 1889 Henri began to paint out-of-doors at Concarneau, experimenting with the quick, sketchy brushstroke that would become his signature. His beach scenes are of a bright palette, evidencing his interest in Impressionism at that time. In his diary of 1891 he commented favorably on Monet's Haystack paintings, which he saw at Durand-Ruel's gallery in Paris. Yet despite his flirtation with Impressionism, Henri embarked on a course that followed other European masters. On a second extended stay in Europe, beginning in 1895, he studied the paintings of Frans Hals, Edouard Manet, and Diego Velázquez, and his work began to acquire a deeper tonality. Especially his portraiture of the following decades was indebted to these painters, displaying much of their bravura manner with his bold brushwork and contrasting of light and dark. His first Salon entries in 1896 and 1897 were portraits.

Henri and his friend and colleague the Canadian painter James Wilson Morrice spent much time in Parisian cafés and on trips along the Marne, painting *pochades,* or small oil sketches on wooden panels. The results of this sketching method were a number of cityscapes by Henri. *La Neige,* a work on canvas, is a larger and more finished painting than the *pochades.* Done in February 1899 during a third trip to Europe, it was exhibited at the Salon in April, and then bought by the French government for the Musée du Luxembourg. The single tone filling the painting, highlighted by fresh snow on the awnings and roofs, marks Henri's unique Tonalism of strong light and dark contrasts. The view could be of the rue de Sèvres near Henri's Paris studio.

Back in the United States, he had a studio in Manhattan and painted New York street scenes, while directing his attention toward figure painting. Henri was an organizer and supporter of independent exhibitions in New York and a critic of conservative academic juries. After some of his friends' works were rejected at the National Academy of Design's annual exhibition, Henri and seven fellow artists exhibited in 1908 as "the Eight" at the Macbeth Gallery in New York. The show included some of the most important Urban Realists of the 1900s, such as George Luks, John Sloan, and Everett Shinn.—J. W.

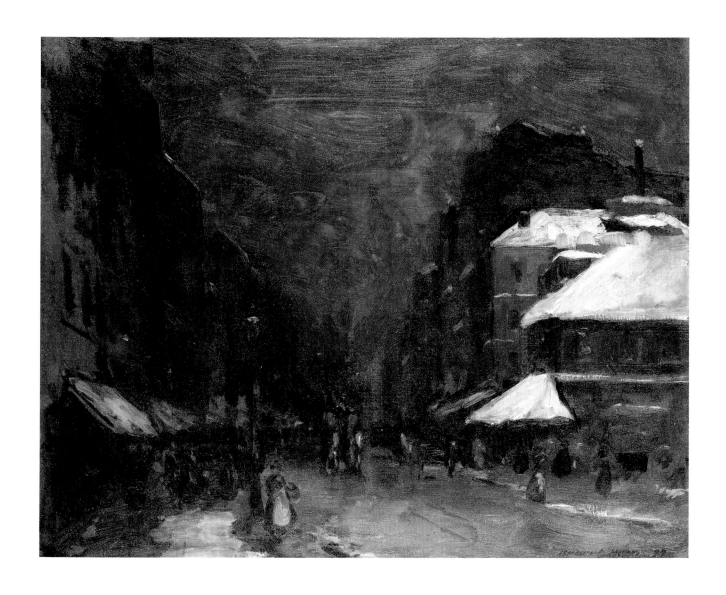

85
La Neige, 1899
Oil on canvas; 25⁹⁄₁₆ x 31⅞ inches (65 x 81 cm)
Signed and dated lower right: *Robert Henri 99*
Musée d'Orsay, Paris, en dépôt à Blérancourt

James Carroll Beckwith
1852–1917

J. Carroll Beckwith was born in Hannibal, Missouri, but grew up in Chicago. He received formal training from Walter Shirlaw, a practitioner of the Munich School style, at the Chicago Academy of Design. Beckwith decided not to follow Shirlaw to Munich but went to Paris instead. Of the two European art centers, Paris was clearly favored by the National Academy of Design, New York, where Beckwith studied for two years after leaving Chicago in 1871. For most of his stay in Paris, between 1873 until about 1878, Beckwith was a student of Emile-Auguste Carolus-Duran. He was a *massier*, or student in charge of collecting fees, in the atelier of Carolus-Duran and together with John Singer Sargent assisted their French mentor in decorating the ceiling of the Palais du Luxembourg. Upon his return to New York, Beckwith became an instructor at the Art Students League and a supporter of other institutions, including the Metropolitan Museum of Art.

French Spring was probably painted during one of Beckwith's frequent summer trips to Europe. He went to Madrid and Paris to continue his study of the old masters, but also enjoyed leisurely trips through the French countryside, where he experimented with plein air painting. Giverny was certainly on his itinerary in 1891, when he stayed ot the Hôtel Baudy and struck upon a friendship with Dawson Dawson Watson. Landscape painting, however, was not Beckwith's primary métier. He was foremost a portrait painter who, as a practitioner and instructor, promoted the importance of solid drawing and undiluted color. These principles are evident in his Renaissance-like portrait *Mother and Child* (fig. 140), which was probably painted between 1910 and 1914, during an Italian sojourn.—J. W.

Fig. 140
J. Carroll Beckwith, *Mother and Child*, n.d.,
oil on canvas. Terra Foundation for the Arts,
Daniel J. Terra Collection, 1987.15

86

French Spring, c. 1885
Oil on panel; 10⅜ x 13¾ inches (26.4 x 34.9 cm)
Signed lower right: *For my friend / J. A. Hawkins / Carroll Beckwith*
Terra Foundation for the Arts, Daniel J. Terra Collection, 1987.14

BIBLIOGRAPHY

Ackerman, Gerald M. "Thomas Eakins and His Parisian Masters Gérôme and Bonnat." *Gazette des beaux-arts*, ser. 6, 73 (April 1969), 235–56.

Adams, Henry. "Winslow Homer's 'Impressionism' and Its Relation to His Trip to France." In *Winslow Homer: A Symposium*. Studies in the History of Art 26. Washington, D.C.: National Gallery of Art, 1990.

Agee, William C., and Barbara Rose. *Patrick Henry Bruce, American Modernist: A Catalogue Raisonné*. New York: Museum of Modern Art, 1979.

Alberts, Robert C. *Benjamin West: A Biography*. Boston: Houghton Mifflin, 1978.

American Impressionist Painting. Washington, D.C.: National Gallery of Art, 1973.

American Painters of the Impressionist Period Rediscovered. Waterville, Maine: Colby College, 1975.

Atkinson, D. Scott, and Nicolai Cikovsky, Jr. *William Merritt Chase: Summers at Shinnecock, 1891–1902*. Washington, D.C.: National Gallery of Art, 1987.

———, and William Innes Homer. *The New Society of American Artists in Paris, 1908–1912*. Queens, N.Y.: Queens Museum, 1986.

Bacon, Henry. *Les Enfants de pêcheurs: Hélène et Léon*. Paris: Librairie Ducrocq, 1888.

———. *Etretat, Hamlet of the Setting Sun*. Paris: Brentano's, 1895.

———. *A Parisian Year*. Boston: Roberts Brothers, 1882.

Ball, Robert, and Max W. Gottschalk. *Richard E. Miller, N.A.: An Impression and Appreciation*. Saint Louis: Longmire Fund, 1968.

Baur, John I. H. *John Marin's New York*. New York: Kennedy Galleries, 1981.

———. *Joseph Stella*. New York: Praeger, 1971.

———. *Theodore Robinson, 1852–1896*. Brooklyn: Brooklyn Museum, 1946.

———. "Introducing Theodore Wendel." *Art in America* 64 (November–December 1976), 102–12.

Beale, Sophia. "French Art." *Connoisseur* I (Fall 1886), 23.

Belloc, Marie Adelaide. "Lady Artists in Paris." *Murray's Magazine* 8 (September 1890), 371–84.

Benson, Emanuel M. *John Marin: The Man and His Work*. New York: J. J. Little and Ives, 1935.

Berger, John A. *Fernand Lungren: A Biography*. Santa Barbara, Calif.: Schauer Press, 1936.

Bermingham, Peter. *American Art in the Barbizon Mood*. Washington, D.C.: National Collection of Fine Arts and Smithsonian Institution Press, 1975.

Berry-Hill, Sidney, and Henry Berry-Hill. *Ernest Lawson, American Impressionist, 1873–1939*. Leigh-on-Sea, England: F. Lewis, 1968.

Bizardel, Yvon. *American Painters in Paris*. Trans. Richard Howard. New York: Macmillan, 1960.

Blaugrund, Annette, ed. *Paris 1889: American Artists at the Universal Exposition*. New York: Harry N. Abrams, 1989.

Bliss, Howard. "Carroll Beckwith." *Arts for America* 8 (November 1899), 545–46.

Boime, Albert. *The Academy and French Painting in the Nineteenth Century*. London: Phaidon, 1971.

———. *Thomas Couture and the Eclectic Vision*. New Haven: Yale University Press, 1980.

Bolger, Doreen, and Nicolai Cikovsky, Jr., eds. *American Art around 1900: Lectures in Memory of Daniel Fraad*. Washington, D.C., National Gallery of Art, 1990.

Borgmeyer, Charles Louis. "Alexander Harrison." *Fine Arts Journal* 29 (September 1913), 515–44.

Bowditch, Nancy Douglas. *George de Forest Brush: Recollections of a Joyous Painter*. Peterborough, N.H.: William L. Bauhan, 1970.

Boyle, Richard J. *American Impressionism*. Boston: New York Graphic Society, 1974.

———. *John Twachtman*. New York: Watson-Guptill, 1979.

Breck, Edward. "Something More of Giverny." *Boston Evening Transcript*, March 9, 1895, 13.

Breeskin, Adelyn Dohme. *Mary Cassatt: A Catalogue Raisonné of the Graphic Work*. Washington, D.C.: Smithsonian Institution Press, 1979.

———. *Mary Cassatt: A Catalogue Raisonné of the Oils, Pastels, Watercolors, and Drawings*. Washington, D.C.: Smithsonian Institution Press, 1970.

Brown, Daisy. "Experiences in the Julian School." *Corcoran Art Journal* I (April 1893), 5–6.

Brown, Gerald B. "Modern French Art." *Appleton's Journal* 9 (September 1880), 272–73.

Brown, Milton W. *The Story of the Armory Show*. New York: Abbeville Press, 1988.

———. "Cubist-Realism: An American Style." *Marsyas* 3 (1943–45), 139–60.

Browne, Charles Francis. "Alexander Harrison—Painter." *Brush and Pencil* 4 (June 1899), 133–44.

Brunn Neergaerdt, T. C. "Present State of the Art of Painting in France." *Monthly Anthology* 4 (August 1807), 408–16.

Brush, George de Forest. "An Artist among Indians." *Century Magazine* 30 (May 1885), 54–57.

Bryant, Keith L., Jr. *William Merritt Chase: A Genteel Bohemian*. Columbia: University of Missouri Press, 1991.

Buchanan, Donald W. *James Wilson Morrice: A Biography*. Toronto: Ryerson Press, 1936.

Bullet, Emma. "Julian Studios, Painting Schools Where Women Learn to Be Artists." *Brooklyn Daily Eagle*, July 30, 1885, I.

Burke, Mary Alice Heekin, and Lois Marie Fink. *Elizabeth Nourse, 1859–1938: A Salon Career*. Washington, D.C.: Smithsonian Institution Press, 1983.

Burns, Sarah Lea. "The Poetic Mode in American Painting: George Fuller and Thomas Dewing." Ph.D. diss., University of Illinois at Urbana-Champaign, 1979.

Butler, A. V. "Robert Wylie." *Aldine* 9, no. 2 (1878–79), 77–78.

Butler, Joyce. *Abbott Fuller Graves.* Kennebunk, Maine: Brick Store Museum, 1979.

Carr, Gerald L. "Hugh Henry Breckenridge, A Philadelphia Modernist." *American Art Review* 4 (May 1978), 92–99, 119–22.

Catalogue of a Collection of Original Works of E. W. D. Hamilton. Boston: Leonard & Co. Galleries, 1900.

Catalogue of Paintings by Edward W. D. Hamilton on Exhibition and Sale at the Gallery of J. Eastman Chase 7 Hamilton Place Boston. Boston, 1892.

Charteris, Evan. *John Sargent.* New York: Charles Scribner's Sons, 1927.

Cikovsky, Nicolai, Jr., and Michael Quick. *George Inness.* Los Angeles: Los Angeles County Museum of Art, 1985.

Clark, Carol, Nancy Mowll Mathews, and Gwendolyn Owens. *Maurice Brazil Prendergast, Charles Prendergast: A Catalogue Raisonné.* Munich: Prestel-Verlag, 1990.

Clark, Eliot C. *Theodore Robinson: His Life and Art.* Chicago: R. H. Love Galleries, 1979.

Clark, Robert Judson. "Frederick MacMonnies and the Princeton Battle Monument." *Record of the Art Museum, Princeton University* 43, no. 2 (1984).

Clouthier, Nicole. *James Wilson Morrice, 1865–1924.* Montreal: Montreal Museum of Fine Arts, 1985.

Coburn, Frederick W. "Edmund C. Tarbell." *International Studio* 32 (September 1907), lxxv–lxxxvii.

———. "Edmund C. Tarbell, Painter." *World Today* 11 (October 1906), 1077–85.

Coffin, William A. "Kenyon Cox." *Century Magazine* 41 (January 1891), 333–37.

Cogswell, Louisa Trumbull. "Art in Boston." *Arcadia* 1 (February 1, 1893), 404.

Colville, Thomas L. *Charles Harold Davis, N.A., 1856–1933.* Mystic, Conn.: Mystic Art Association, 1982.

Conner, Janis, and Joel Rosenkranz. *Rediscoveries in American Sculpture Studio Works, 1893–1939.* Austin: University of Texas Press, 1989.

Cook, Clarence. "Paintings in Oils and Pastels by J. H. Twachtman." *Studio* 6 (March 28, 1891), 162.

Corbin, Kathryn. "John Leslie Breck, American Impressionist." *Antiques* 134 (November 1988), 1142–49.

Corn, Wanda M. *The Color of Mood: American Tonalism, 1880–1910.* San Francisco: M. H. de Young Museum, 1972.

Couture, Thomas. *Méthode et entretiens d'atelier.* Paris, 1867.

Cox, Kenyon. "William M. Chase, Painter." *Harper's New Monthly Magazine* 78 (March 1889), 549–57.

Craik, D. M. "A Paris Atelier." *Good Words* 27 (1886), 309–13.

Cranch, C[hristopher] P. "French Landscape." *Crayon* 3 (June 1856), 183.

Crean, Hugh R. "Samuel F. B. Morse's *Gallery of the Louvre:* Tribute to a Master and Diary of a Friendship." *American Art Journal* 16 (Winter 1984), 76–81.

Criticism about Picknell. New York: Avery Art Galleries, 1890.

Cummings, Hildegard. "Chasing a Bronze Bacchante." *William Benton Museum of Art Bulletin,* no. 12 (1984), 3–19.

Curry, David Park. *Winslow Homer: The Croquet Game.* New Haven: Yale University Art Gallery, 1984.

David, Carl E. "Martha Walter." *American Art Review* 4 (May 1978), 84–91.

Dawson-Watson, Dawson. "The Real Story of Giverny." In Eliot C. Clark, *Theodore Robinson: His Life and Art* (Chicago: R. H. Love Galleries, 1979), 65–67.

———. "The Rolling-pin in Art." *Literary Review* 1 (May 1897), 70.

Dayot, Armand. "William T. Dannat." Trans. Irene Sargent. *Craftsman* 6 (May 1904), 154–61.

de Kay, Charles. "Martha Walter, Painter." *Arts and Decoration* 1 (May 1911), 304.

———. "Mr. Chase and Central Park." *Harper's Weekly* 35 (May 2, 1891), 327–28.

Delouche, Denise. *Artistes étrangers à Pont-Aven, Concarneau et autres lieux de Bretagne.* Rennes: Presses Universitaires, 1989.

de Mazia, Violette. "The Case of Glackens vs. Renoir." *Journal of the Art Department* (Barnes Foundation) 2 (Autumn 1971), 3–30.

DeShazo, Edith. *Everett Shinn, 1876–1953: A Figure in His Time.* New York: Clarkson N. Potter, 1974.

de Soissons, S. C. *A Parisian Critic's Notes on Boston Artists.* Boston, 1894.

deVeer, Elizabeth, and Richard J. Boyle. *Sunlight and Shadow: The Life and Art of Willard L. Metcalf.* New York: Abbeville Press, 1987.

Dijkstra, Bram. *Idols of Perversity.* New York: Oxford University Press, 1986.

Dodge, Joseph Jeffers. *Edmund W. Greacen, N.A., American Impressionist, 1876–1949.* Jacksonville, Fla.: Cummer Gallery of Art, 1972.

Dorais, Lucie. *J. W. Morrice.* Ottawa: National Gallery of Canada, 1985.

Downes, William Howe. *John S. Sargent: His Life and Work.* Boston: Little, Brown, 1925.

———. "Charles H. Davis's Landscapes." *New England Magazine* 27 (December 1902), 423–37.

Driscoll, John. "Charles Sheeler's Early Work: Five Rediscovered Paintings." *Art Bulletin* 62 (March 1980), 124–33.

Ducieu, Victor. "American Woman's Art Association of Paris." *L'Art* 63 (March 1904), 147–49.

Eddy, Arthur Jerome. *Cubists and Post-Impressionism.* Chicago: A. C. McClurg, 1914.

Edgerton, Giles [Mary Fanton Roberts]. "The Younger American Painters: Are They Creating a National Art?" *Craftsman* 13 (February 1908), 512–32.

Eiseman, Alvord L. *Charles Demuth.* New York: Watson-Guptill, 1982.

Eldredge, Charles C. *American Imagination and Symbolist Painting.* New York: Grey Art Gallery and Study Center, New York University, 1979.

Emerson, Edward Waldo. "An American Landscape-Painter,

William L. Picknell." *Century Magazine* 62 (September 1901), 710–13.

Fairbrother, Trevor J., et al. *The Bostonians: Painters of an Elegant Era, 1870–1930*. Boston: Museum of Fine Arts, 1986.

———. *John Singer Sargent and America*. New York: Garland, 1986. Ph.D. diss., Boston University, 1981.

Falk, Peter Hastings. *The Annual Exhibition Record of the Pennsylvania Academy of the Fine Arts, 1876–1913*. Madison, Conn.: Sound View Press, 1989.

Farington, Joseph. *The Diary of Joseph Farington*. 16 vols. New Haven: Yale University Press, 1978– .

Farnham, Emily. *Charles Demuth: Behind a Laughing Mask*. Norman: University of Oklahoma Press, 1971.

Fehrer, Catherine. *The Julian Academy, Paris, 1868–1939*. New York: Shepherd Gallery, 1989.

Feld, Stuart P. *Lilla Cabot Perry: A Retrospective Exhibition*. New York: Hirschl and Adler Galleries, 1969.

Ferguson, Charles B. *Dennis Miller Bunker Rediscovered*. New Britain, Conn.: New Britain Museum of American Art, 1978.

Fernand Lungren (1857–1932): Some Notes on His Life. Santa Barbara, Calif.: Santa Barbara School of the Arts, 1933.

Fidell-Beaufort, Madeleine. "Elizabeth Jane Gardner Bouguereau: A Parisian Artist from New Hampshire." *Archives of American Art Journal* 24, no. 2 (1984), 2–9.

Fine, Ruth E. *John Marin*. New York: Abbeville Press, 1990.

Fink, Lois Marie. *American Art at the Nineteenth-Century Paris Salons*. Cambridge: Cambridge University Press, 1990.

———. "American Artists in France, 1850–1870." *American Art Journal* 5 (November 1973), 32–49.

———. "Rembrandt Peale in Paris." *Pennsylvania Magazine of History and Biography* 110 (January 1986), 71–90.

———. "The Role of France in American Art, 1850–1870." Ph.D. diss., University of Chicago, 1970.

———, and Joshua C. Taylor. *Academy: The Academic Tradition in American Art*. Washington, D.C.: Smithsonian Institution Press, 1975.

Finlay, Nancy. *Artists of the Book in Boston, 1890–1910*. Cambridge: Harvard College Library, 1985.

Flower, B. O. "Edward W. Redfield: An Artist of Winter-locked Nature." *Arena* 36 (July 1906), 20–26.

Folk, Thomas. *Edward Redfield: First Master of the Twentieth Century Landscape*. Allentown, Pa.: Allentown Art Museum, 1987.

———. *The Pennsylvania School of Landscape Painting*. Allentown, Pa.: Allentown Art Museum, 1984.

Folts, Franklin P. *Paintings and Drawings by Philip Leslie Hale, 1865–1931, from the Folts Collection*. Boston: Vose Galleries, 1966.

Foote, Edward J. "An Interview with Frederick W. MacMonnies, American Sculptor of the Beaux-Arts Era." *New-York Historical Society Quarterly* 61 (July–October 1977), 103–23.

Fort, Ilene Susan. *The Flag Paintings of Childe Hassam*. Los Angeles: Los Angeles County Museum of Art, 1988.

———. "Frederick Arthur Bridgman and the American Fascination with the Exotic Near East." Ph.D. diss., City University of New York, 1990.

Foster, Kathleen A. *Daniel Garber, 1880–1957*. Philadelphia: Pennsylvania Academy of the Fine Arts, 1980.

French Impressionists Influence American Artists. Coral Gables, Fla.: Lowe Art Museum, University of Miami, 1971.

Friedman, Martin L. *Charles Sheeler*. New York: Watson-Guptill, 1975.

———. *The Precisionist View in American Art*. Minneapolis: Walker Art Center, 1960.

Gallatin, Albert Eugene. *Walter Gay: Paintings of French Interiors*. New York: E. P. Dutton, 1920.

———. *Whistler Notes and Footnotes and Other Memoranda*. New York: Collector and Art Critic, 1907.

———. "The Art of William J. Glackens: A Note." *International Studio* 40 (May 1910), 68.

———. "Childe Hassam: A Note." *Collector and Art Critic* 5 (January 1907), 102.

———. "William Glackens." *American Magazine of Art* 7 (May 1916), 261.

Gammell, R. H. Ives. *The Boston Painters, 1900–1930*. Orleans, Mass.: Parnassus Imprints, 1986.

———. *Dennis Miller Bunker*. New York: Coward-McCann, 1953.

Gardner, Albert Ten Eyck. *Winslow Homer, American Artist: His World and His Work*. New York: Clarkson N. Potter, 1961.

Garland, Hamlin. *Roadside Meetings*. New York: Macmillan, 1930.

Gay, Walter. *Memoirs of Walter Gay*. New York: privately printed, 1930.

Gerdts, William H. *American Impressionism*. Seattle: Henry Art Gallery, University of Washington, 1980.

———. *American Impressionism*. New York: Abbeville Press, 1984.

———. *Down Garden Paths: The Floral Environment in American Art*. Rutherford, N.J.: Fairleigh Dickinson University Press, 1983.

———. "Post-Impressionist Landscape Painting in America." *Art and Antiques* 6 (July–August 1983), 60–67.

Glackens, Ira. *William Glackens and the Ashcan Group*. New York: Crown, 1957.

Goley, Mary Ann. *John White Alexander (1856–1915)*. Washington, D.C.: National Collection of Fine Arts, 1977.

———. "John White Alexander's Panel for Music Room." *Bulletin of the Detroit Institute of Arts* 64, no. 4 (1989), 5–17.

Goodrich, Lloyd. *Thomas Eakins*. 2 vols. Cambridge: Harvard University Press, 1982.

Gordon, E. Adina. *Frederick William MacMonnies (1863–1937), Mary Fairchild MacMonnies (1858–1946), deux artistes américains à Giverny*. Vernon: Musée Municipal A.-G. Poulain, 1988.

Green, Eleanor, and Ellen Glavin. *Maurice Prendergast: Art of Impulse and Color*. College Park: University of Maryland Art Gallery, 1979.

Greta. "Boston Art and Artists." *Art Amateur* 17 (October 1887), 93.

Harrison, Birge L. "In Search of Paradise with Camera and Palette." *Outing* 21 (July 1893), 310–13.

———. "With Stevenson at Grez." *Century Magazine* 93 (December 1926), 306–14.

Hartmann, Sadakichi. *A History of American Art*. 1907. 3rd ed., rev. New York: Tudor, 1934.

———. "The Tarbellites." *Art News* 1 (March 1897), 3–4.

Haskell, Barbara. *Arthur Dove*. San Francisco: San Francisco Museum of Art, 1974.

———.*Charles Demuth*. New York: Whitney Museum of American Art, 1988.

Hassam, Childe. *Three Cities*. New York, 1899.

Hawkins, Rush C. "Report on the Fine Arts." *Reports of the United States Commissioners to the Universal Exposition of 1889 at Paris*. 5 vols. Washington, D.C.: Government Printing Office, 1890–91.

Helm, MacKinley. *John Marin*. New York: Pellegrini and Cudahy, 1948.

Hendricks, Gordon. *The Life and Work of Thomas Eakins*. New York: Grossman, 1974.

Hill, May Brawley. *Grez Days: Robert Vonnoh in France*. New York: Berry-Hill Galleries, 1987.

Hills, Patricia. *John Singer Sargent*. New York: Harry N. Abrams, 1986.

Hobbs, Susan. "Thomas Dewing in Cornish, 1885–1905." *American Art Journal* 17 (Spring 1985), 2–32.

———. "Thomas Wilmer Dewing: The Early Years, 1851–1885." *American Art Journal* 13 (Spring 1981), 4–35.

Homer, William Inness. *Alfred Stieglitz and the American Avant-Garde*. Boston: New York Graphic Society, 1977.

———. "The Exhibition of 'The Eight': Its History and Significance." *American Art Journal* 1 (Spring 1969), 53–64.

———. "Identifying Arthur Dove's 'The Ten Commandments.'" *American Art Journal* 12 (Summer 1980), 21–32.

Hooper, Lucy H. "Art Schools of Paris." *Cosmopolitan* 14 (November 1892), 59–62.

Hoopes, Donelson F. *The American Impressionists*. New York: Watson-Guptill, 1972.

———. *Childe Hassam*. New York: Watson-Guptill, 1979.

Hoppin, Martha J., and Henry Adams. *William Morris Hunt: A Memorial Exhibition*. Boston: Museum of Fine Arts, 1979.

Huneker, James. "Eight Painters: Second Article." *New York Sun*, February 10, 1908, 6.

Hunt, William Morris. *Talks on Art*. 2 vols. Boston: Houghton Mifflin, 1875 and 1883.

In This Academy: The Pennsylvania Academy of the Fine Arts, 1805–1876. Philadelphia: Pennsylvania Academy of the Fine Arts, 1976.

Inness, George, Jr. *Life, Art, and Letters of George Inness*. New York: Century, 1917.

Ireland, Leroy. *The Works of George Inness: An Illustrated Catalogue Raisonné*. Austin: University of Texas Press, 1965.

Ives, A. E. "Mr. Childe Hassam on Painting Street Scenes." *Art Amateur* 27 (October 1892), 116–17.

Jacobowitz, Arlene. *Edward Henry Potthast, 1857–1927*. New York: Chapellier Galleries, 1969.

———. "Edward Henry Potthast." *Brooklyn Museum Annual* 9 (1967–68), 113–28.

Jacobs, Michael. *The Good and Simple Life: Artist Colonies in Europe and America*. Oxford: Phaidon, 1985.

Jaffe, Irma B. *Joseph Stella*. Cambridge: Harvard University Press, 1970.

John Twachtman: Connecticut Landscapes. Washington, D.C.: National Gallery of Art, 1989.

Johnston, Sona. *Theodore Robinson, 1852–1896*. Baltimore: Baltimore Museum of Art, 1973.

Jones, Howard Mumford. *America and French Culture, 1750–1848*. Chapel Hill: University of North Carolina Press, 1927.

Junkin, Sara Caldwell. "The Europeanization of Henry Bacon (1839–1912), American Expatriate Painter." Ph.D. diss., Boston University, 1981.

Karpiscak, Adeline Lee. *Ernest Lawson, 1873–1939*. Tucson: University of Arizona Museum of Art, 1979.

Kelder, Diane. *The Great Book of French Impressionism*. New York: Abbeville, 1980.

———. "Stuart Davis: Pragmatist of American Modernism." *Art Journal* 39 (Fall 1979), 31.

———, ed. *Stuart Davis*. New York: Praeger, 1971.

Ketcham, Susan M. "Robert W. Vonnoh's Pictures." *Modern Art* 4 (Autumn 1896), 115–16.

Kilmer, Nicholas. *Thomas Buford Meteyard (1865–1928)*. New York: Berry-Hill Galleries, 1989.

Kimball, Fiske. "Benjamin West au Salon de 1802: La Mort sur le cheval pâle." *Gazette des beaux-arts* 7 (June 1932), 403–10.

Kloss, William. *The Figural Images of Theodore Robinson, American Impressionist*. Oshkosh, Wis.: Paine Art Center and Arboretum, 1987.

———. *Samuel F. B. Morse*. New York: Harry N. Abrams, 1988.

Knowlton, Helen M. *Art-Life of William Morris Hunt*. Boston: Little, Brown, 1899.

Kobbé, Gustav. "J. Carroll Beckwith." *Truth* 18 (October 1899), 255–58.

Laing, G. Blair. *Morrice: A Great Canadian Artist Rediscovered*. Toronto: McClelland and Stewart, 1984.

Landgren, Marchal E. *American Pupils of Thomas Couture*. College Park, Md.: University of Maryland Art Gallery, 1970.

Lane, John R. *Stuart Davis: Art and Art Theory*. New York: Brooklyn Museum, 1978.

———, and Susan C. Larsen. *Abstract Painting and Sculpture in America 1927–1944*. Pittsburgh: Museum of Art, Carnegie Institute, 1983.

Langdale, Cecily. *Charles Conder, Robert Henri, James Morrice, Maurice Prendergast: The Formative Years, Paris 1890s*. New York: Davis and Long, 1975.

———.*Monotypes by Maurice Prendergast in the Terra Museum of American Art*. Chicago: Terra Museum of American Art, 1984.

Larned, Charles William. "An Enthusiast in Painting." *Monthly Illustrator* 3 (February 1895), 131–37.

Leader, Bernice Kramer. "The Boston Lady as a Work of Art: Paintings by the Boston School at the Turn of the Century." Ph.D. diss., Columbia University, 1980. Ann Arbor: University Microfilms International, 1980.

Leavitt, Virginia Couse. "Eanger Irving Couse." In J. Gray Sweeney, *Artists of Michigan from the Nineteenth Century*. Muskegon, Mich.: Muskegon Museum of Art, 1987.

Leff, Sandra. *John White Alexander, 1856–1915: Fin-de-Siècle American*. New York: Graham, 1980.

Loe, Elva Fromuth. "Concerning Art: The Fromuth Journal, Reflections on Art by an American Painter in France, Extracts from the Journal of Charles Henry Fromuth." M.A. thesis, Catholic University, Washington, D.C., 1960.

Love, Richard H. *Louis Ritman: From Chicago to Giverny*. Chicago: Haase-Mumm, 1989.

———. *Theodore Earl Butler: Emergence from Monet's Shadow*. Chicago: Hasse-Mumm, 1985.

Low, Will H. *A Chronicle of Friendships 1873–1900*. New York: Charles Scribner's Sons, 1908.

———. "In an Old French Garden." *Scribner's Magazine* 32 (July 1902), 3–19.

———, and Kenyon Cox. "The Nude in Art." *Scribner's Magazine* 12 (December 1892), 747–49.

Lowrey, Carol. *Philip Leslie Hale, A.N.A. (1865–1931)*. Boston: Vose Galleries, 1988.

McCabe, Lida Rose. "Madame Bouguereau at Work." *Harper's Bazaar* 44 (December 1910), 694–95.

———. "Mme. Bouguereau, Pathfinder." *New York Times Book Review Magazine*, February 19, 1922, 16.

MacChesney, Clara T. "Frieseke Tells Some of the Secrets of His Art." *New York Times*, June 7, 1914, sec. 6, 7.

MacMonnies, Frederick. "French Artists Spur on an American Art." *New York Tribune*, October 24, 1915, sec. 4, 2–3.

Marlais, Michael. *Americans and Paris*. Waterville, Maine: Colby College Museum of Art, 1990.

Martindale, Meredith. *Lilla Cabot Perry: An American Impressionist*. Washington, D.C.: National Museum of Women in the Arts, 1990.

Mather, Frank Jewett, Jr. "Some American Realists." *Arts and Decoration* 7 (November 1916), 15.

Mathews, Nancy Mowll. *Cassatt and Her Circle: Selected Letters*. New York: Abbeville Press, 1984.

———. *Mary Cassatt*. New York: Harry N. Abrams, 1987.

———. "Mary Cassatt and the 'Modern Madonna' of the Nineteenth Century." Ph.D. diss., Institute of Fine Arts, New York University, 1980.

———, and Barbara Stern Shapiro. *Mary Cassatt: The Color Prints*. New York: Harry N. Abrams, 1989.

Meixner, Laura L. *An International Episode: Millet, Monet, and Their North American Counterparts*. Memphis, Tenn.: Dixon Gallery and Gardens, 1982.

Merrick, Lula C. "Brush's Indian Pictures." *International Studio* 76 (December 1922), 186–93.

Milroy, Elizabeth. *Painters of a New Century: The Eight*. Milwaukee, Wis.: Milwaukee Art Museum, 1991.

Moore, Evelyn L., and Ruth H. Blunt. "Composition, Color, and Sometimes Humor: Artist Bernhard Gutmann of Lynchburg." *Virginia Cavalcade* 31 (Spring 1982), 206–15.

Morgan, Ann Lee. *Arthur Dove: Life and Work with a Catalogue Raisonné*. Newark: University of Delaware Press, 1984.

Morgan, H. Wayne, ed. *An American Art Student in Paris: The Letters of Kenyon Cox, 1877–1882*. Kent, Ohio: Kent State University Press, 1986.

Morgan, Joan B. *George de Forest Brush, 1855–1941: Master of the American Renaissance*. New York: Berry-Hill Galleries, 1985.

———. "The Indian Paintings of George de Forest Brush." *American Art Journal* 15 (Spring 1983), 60–73.

Morse, Samuel F. B. *Descriptive Catalogue of the Pictures, Thirty-seven in Number, from the Most Celebrated Masters, Copied into the Gallery of the Louvre*. New York: James van Norden, 1833.

Mosby, Dewey F. *Henry Ossawa Tanner*. Philadelphia: Philadelphia Museum of Art, 1991.

Mount, Charles Merrill. "Carolus-Duran and the Development of Sargent." *Art Quarterly* 26 (Winter 1963), 385–417.

Myers, Julia Rowland. "The American Expatriate Painters of the French Peasantry, 1863–1893." Ph.D. diss., University of Maryland, 1989.

National Cyclopaedia of American Biography. 63 vols. Clifton, N.J.: James T. White, 1888–94.

Natt, Phebe D. "Art Schools in Paris." *Lippincott's Magazine* 27 (March 1881), 269–76.

Nieriker, May Alcott. *Studying Art Abroad, and How to Do It Cheaply*. Boston: Roberts Brothers, 1879.

Nobili, M. Riccardo. "The Académie Julian." *Cosmopolitan* 8 (1889), 746–52.

North, Percy. *Max Weber: American Modern*. New York: Jewish Museum, 1982.

———. *Max Weber: The Cubist Decade, 1910–1920*. Atlanta: High Museum of Art, 1991.

Novak, Barbara. *American Painting of the Nineteenth Century*. New York: Praeger, 1972.

———. *Impressionistes américains*. Washington, D.C.: Smithsonian Institution Traveling Exhibition Service, 1982.

Olney, Susan Faxon. *Two American Impressionists: Frank W. Benson and Edmund C. Tarbell*. Durham: University Art Galleries, University of New Hampshire, 1979.

Olson, Stanley. *John Singer Sargent: His Portrait*. New York: St. Martin's Press, 1986.

Opp, Julia F. "William T. Dannat." *Munsey's Magazine* 13 (August 1895), 513–17.

Ormond, Richard. *John Singer Sargent: Paintings, Drawings, Watercolors*. New York: Harper and Row, 1970.

Ossoli, Margaret Fuller. *At Home and Abroad, or Things and Thoughts in America and Europe*. Ed. Arthur H. Fuller. Boston, 1856.

Paintings by Lawton Parker. Chicago: Art Institute of Chicago, 1912.

Pancza, Arleen. "Frederick Carl Frieseke (1874–1939)." In J. Gray Sweeney. *Artists of Michigan from the Nineteenth Century*. Muskegon, Mich.: Muskegon Museum of Art, 1987.

Pène du Bois, Guy. "The Boston Group of Painters: An Essay on Nationalism in Art." *Arts and Decoration* 5 (October 1915), 457–60.

———. "The Pennsylvania Group of Landscape Painters." *Arts and Decoration* 5 (July 1915), 351–54.

Pennell, E[lizabeth] R. and J[oseph]. *The Life of James McNeill Whistler*. Philadelphia: J. B. Lippincott, 1920.

Perdicaris, Ion. "English and French Painting." *Galaxy* 2 (October 15, 1866), 378.

Perlman, Bennard B. *The Immortal Eight*. New York: Exposition Press, 1962.

Perry, Lilla Cabot. "Reminiscences of Claude Monet from 1889 to 1909." *American Magazine of Art* 18 (March 1927), 119–25.

Pierce, Patricia Jobe. *Edmund C. Tarbell and the Boston School of Painting, 1889–1980*. Hingham, Mass.: Pierce Galleries, 1980.

Pisano, Ronald G. *A Leading Spirit in American Art: William Merritt Chase, 1849–1916*. Seattle: Henry Art Gallery, University of Washington, 1983.

Pollack, Barbara. "Famous American Artist Was Interviewed in 1963 at His Center Bridge Home." *Lambertville Beacon*, July 16, 1981, 10.

Pollock, Griselda. *Mary Cassatt*. New York: Harper and Row, 1979.

Poulet, Anne L., and Alexandra R. Murphy. *Corot to Braque: French Paintings from the Museum of Fine Arts*. Boston: Museum of Fine Arts, 1979.

Preato, Robert R., and Sandra L. Langer. *Impressionism and Post-Impressionism: Transformations in the Modern American Mode, 1885–1945*. New York: Grand Central Art Galleries, 1988.

Price, Frederick Newlin. "Lawson of the 'Crushed Jewels,' " *International Studio* 78 (February 1924), 369.

Quick, Michael, Eberhard Ruhmer, and Richard V. West. *American Expatriate Painters of the Late Nineteenth Century*. Dayton, Ohio: Dayton Art Institute, 1976.

Ratcliff, Carter. *John Singer Sargent*. New York: Abbeville Press, 1982.

Reich, Sheldon. *John Marin: A Stylistic Analysis and Catalogue Raisonné*. 2 vols. Tucson: University of Arizona Press, 1970.

Rewald, John. *Cézanne and America Dealers, Collectors, Artists, and Critics, 1891–1921*. Princeton: Princeton University Press, 1989.

———. *The History of Impressionism*. New York: Museum of Modern Art, 1973.

Reynolds, Gary A. *Walter Gay: A Retrospective*. New York: Grey Art Gallery and Study Center, New York University, 1980.

Rhys, Hedley Howell. *Maurice Prendergast, 1859–1924*. Boston: Museum of Fine Arts, 1960.

Ricciotti, Dominic. "The Revolution in Urban Transport: Max Weber and Italian Futurism." *American Art Journal* 16 (Winter 1984), 46–64.

Roof, Katherine Metcalf. *The Life and Art of William Merritt Chase*. New York: Charles Scribner's Sons, 1917.

Rosenfeld, Daniel, and Robert G. Workman. *The Spirit of Barbizon France and America*. San Francisco: Art Museum Association of America, 1986.

Rourke, Constance. *Charles Sheeler: Artist in the American Tradition*. New York: Harcourt, Brace, 1938.

Sadler, Fernande. *L'Hôtel Chevillon et les artistes de Grès-sur-Loing*. Fontainebleau, 1938.

Segard, Achille. *Un peintre des enfants et des mères: Mary Cassatt*. Paris: Librarie Ollendorff, 1913.

Sellin, David. *Americans in Brittany and Normandy: 1860–1910*. Phoenix, Ariz.: Phoenix Art Museum, 1982.

———. *Charles H. Fromuth (1858–1937)*. Washington, D.C.: Taggart and Jorgensen Gallery, 1988.

———. "Denis A. Volozan, Philadelphia Neoclassicist." *Winterthur Portfolio* 4 (1968), 118–28.

———. *William Lamb Picknell, 1853–1897*. Washington, D.C.: Taggart and Jorgensen Gallery, 1991.

Sheldon, G[eorge] W. *American Painters*. New York: D. Appleton, 1879.

Sims, Lowery S., and William C. Agee, *Stuart Davis, American Painter*. New York: Metropolitan Museum of Art, 1991.

Smart, Mary. "Sunshine and Shade: Mary Fairchild MacMonnies Low." *Woman's Art Journal* 4 (Fall 1983/Winter 1984), 20–25.

Speed, John Gilmer. "An Artist's Summer Vacation." *Harper's New Monthly Magazine* 87 (June 1893), 3, 8.

Springer, Julie Anne. "Art and the Feminine Muse: Women in Interiors by John White Alexander." *Woman's Art Journal* 6 (Fall 1985/Winter 1986), 1–8.

Staiti, Paul J. *Samuel F. B. Morse*. Cambridge: Cambridge University Press, 1989.

———, and Gary A. Reynolds, *Samuel F. B. Morse*. New York: Grey Art Gallery and Study Center, New York University, 1982.

Staley, Allen. "West's Death on the Pale Horse." *Bulletin of the Detroit Institute of Arts* 58, no. 3 (1980), 137–49.

———, and Theodore Reff. *From Realism to Symbolism: Whistler and His World*. New York: Wildenstein, 1971.

Stavitsky, Gail. *Gertrude Stein: The American Connection*. New York: Sid Deutsch Gallery, 1990.

Stella, Joseph. "Discovery of America: Autobiographical Notes." *Art News* 35 (November 1960), 42, 64 (written in 1946).

———. "The New Art." *Trend* 5 (June 1913), 395.

Stevenson, R. A. M. "Grez." *Magazine of Art* 17 (1894), 27–32.

Stevenson, Robert Louis. "Fontainebleau: Village Communities of Painters." *Magazine of Art* 7 (1884), 253–72, 340–45.

Straham, Edward. "James Carroll Beckwith." *Art Amateur* 6 (April 1882), 94–97.

Sutherland, J. "An Art Student's Year in Paris, Women's Classes at Julian's School." *Art Amateur* 32 (January 1895), 52.

Sutton, Denys. "The Luminous Point." *Apollo* 85 (March 1967), 214–23.

Sweeney, J. Gray. *Artists of Michigan from the Nineteenth Century*. Muskegon, Mich.: Muskegon Museum of Art, 1987.

Sweeney, James Johnson. *Stuart Davis*. New York: Museum of Modern Art, 1945.

Taft, Kendall B. "Adam and Eve in America." *Art Quarterly* 23 (Spring 1960), 171–79.

Tatham, David. "Samuel F. B. Morse's *Gallery of the Louvre*: The Figures in the Foreground." *American Art Journal* 13 (Autumn 1981), 38–48.

Ten American Painters. New York: Spanierman Gallery, 1990.

Thompson, D. Dodge. "Julius L. Stewart, a 'Parisian from Philadelphia,' " *Antiques* 130 (November 1986).

Toulgouat, Pierre. "Peintres américains à Giverny." *Rapports: France—Etats-Unis*, no. 62 (May 1952), 65–73.

———."Skylights in Normandy." *Holiday* 4 (August 1948), 66–70.

Trenton, Patricia, and William H. Gerdts. *California Light, 1900–1930*. Laguna Beach, Calif.: Laguna Art Museum, 1990.

Troyen, Carol, and Erica E. Hirshler. *Charles Sheeler: Paintings and Drawings*. Boston: Museum of Fine Arts, 1987.

Tsujimoto, Karin. *Images of America: Precisionist Painting and Modern Photography*. Seattle: University of Washington Press, 1982.

Valerio, Edith. *Mary Cassatt*. Paris: G. Crès et Cie, 1930.

Van Dyke, John, ed. *Modern French Masters: A Series of Biographical and Critical Reviews by American Artists*. New York: Century, 1896.

Vogel, Margaret. *The Paintings of Hugh H. Breckenridge (1870–1937)*. Dallas: Valley House Gallery, 1967.

Vonnoh, Bessie Potter. "Tears and Laughter Caught in Bronze." *Delineator* 107 (October 1925), 8–9, 78, 80, 82.

Le Voyage de Paris: Les Américains dans les écoles d'art, 1868–1918. Blérancourt, France: Musée National de la Coopération Franco-Américain, 1990.

W[right], M[argaret] B[ertha]. "Ateliers des dames." *Art Amateur* 9 (July 1883), 34–35.

Waterman, C. H. "Louis Ritman." *International Studio* 67 (April 1919), cxiv.

Watson, Forbes. "William Glackens." *Arts* 3 (April 1923), 252–53.

Weber, Bruce, and William H. Gerdts. *In Nature's Ways*. West Palm Beach, Fla.: Norton Gallery of Art, 1987.

Wein, Jo Ann. "The Parisian Training of American Women Artists." *Woman's Art Journal* 2 (Spring/Summer 1981), 35–44.

Weinberg, H. Barbara. *The Lure of Paris: Nineteenth-Century American Painters and Their French Teachers*. New York: Abbeville Press, 1991.

Weisberg, Gabriel P., ed. *The European Realist Tradition*. Bloomington: Indiana University Press, 1982.

Weller, Allen S. "Frederick Carl Frieseke: The Opinions of an American Impressionist." *Art Journal* 28 (Winter 1968), 160–65.

Whitehill, Walter Muir. "The Vicissitudes of Bacchante in Boston." *New England Quarterly* 27 (December 1954), 435–54.

Wickenden, Robert J. "The Portraits of Carroll Beckwith." *Scribner's Magazine* 47 (April 1910), 449–60.

Wilkin, Karen. *Stuart Davis*. New York: Abbeville Press, 1987.

Wilson, Richard Guy, Diane H. Pilgrim, and Richard N. Murray. *The American Renaissance, 1876–1917*. Brooklyn: Brooklyn Museum, 1979.

Wuerpel, E[dmund] H. *American Art Association of Paris*. Philadelphia: Times Printing House, 1894.

———. "American Artists' Association Paris." *Cosmopolitan* 20 (February 1896), 402–9.

Young, Andrew McLaren, Margaret MacDonald, and Robin Spencer. *The Paintings of James McNeill Whistler*. New Haven: Yale University Press, 1980.

Young, Mahonri Sharp. *The Eight*. New York: Watson-Guptill, 1973.

INDEX OF ARTISTS

PHOTOGRAPHY CREDITS

E. Irving Blomstrann, New Britain, Conn.: fig. 66

Jacques Bocoyran: color plate 61

Kathleen Culbert-Aguilar, Chicago: colorplates 2, 9, 14,
 18.6, 18.12, 42, 45–47, 50, 66, 69, 71; figs. 45, 53,
 55–58, 65, 76

Louis Dechamps: colorplate 63

Clem Fiori, Blawenburg, N.J.: fig. 118

Helga Photo Studio, Upper Montclair, N.J.: figs. 49, 111

Henderson, Chicago: colorplates 1, 3–6, 12, 15, 19, 20,
 24, 28, 31–33, 36–39, 44, 49, 65, 70, 73, 74, 83, 84,
 87; figs. 11, 19, 64, 69, 70, 82, 87, 88, 98, 100, 109,
 112, 126, 130, 131, 137

Jerry Kobylecky, Chicago: colorplates 13, 16, 17,
 18.1–18.5, 18.7–18.11, 21–23, 25–27, 29, 30, 40, 41,
 43, 51–55, 58, 64, 68, 72, 76, 77, 79–81, 85; figs. 17,
 20, 21, 26, 27, 30, 35–38, 42, 43, 47, 50–52, 59–62,
 67, 72, 74, 75, 78–81, 83, 84, 86, 89, 90, 92, 93,
 95–97, 99,102–6, 110, 124, 136, 139

Michael McKelvey: fig. 116

R.M.N., Paris: colorplate 86; figs. 15, 18, 24, 46, 91

Runco Photo Studios, Tonawanda, N.Y.: fig. 12

Michael Tropea, Chicago: colorplates 34, 60, 61, 67, 75,
 78; figs. 25, 28, 29, 48, 77, 85, 94, 108, 138